Postcolonial African Cinema

KENNETH W. HARROW

Postcolonial African Cinema

From Political Engagement to Postmodernism

INDIANA UNIVERSITY PRESS

Bloomington and Indianapolis

This book is a publication of

Indiana University Press
601 North Morton Street
Bloomington, IN 47404-3797 USA

http://iupress.indiana.edu

Telephone orders 800-842-6796
Fax orders 812-855-7931
Orders by e-mail iuporder@indiana.edu

The paper used in this publication meets the minimum requirements of American
National Standard for Information Sciences—Permanence of Paper for Printed Library
Materials, ANSI Z39.48-1984.

Manufactured in the United States of America

Library of Congress Cataloging-in-Publication Data

Harrow, Kenneth W.
 Postcolonial African cinema : from political engagement to postmodernism /
Kenneth W. Harrow.
 p. cm.
 Filmography: p.
 Includes bibliographical references and index.
 ISBN-13: 978-0-253-34909-5 (cloth)
 ISBN-13: 978-0-253-21914-5 (pbk.)
 1. Motion pictures—Africa. I. Title.
 PN1993.5.A35H37 2007
 791.43096—dc22

 2006100896

1 2 3 4 5 12 11 10 09 08 07

To the Ceddo and the Tsotsi:
Sembène Ousmane and Jean-Pierre Bekolo

Once the Author is removed, the claim to decipher a text becomes quite futile. To give a text an Author is to impose a limit on that text, to furnish it with a final signified, to close the writing. Such a conception suits criticism very well, the latter then allotting itself the important task of discovering the Author (or its hypostases: society, history, psyche, liberty) beneath the work: when the Author has been found, the text is "explained"—victory to the critic. . . . In the multiplicity of writing, everything is to be *disentangled,* nothing *deciphered;* the structure can be followed, "run" (like the thread of a stocking) at every point and at every level, *but there is nothing beneath.*

<div align="right">Roland Barthes, "Death of the Author" (my emphasis)</div>

Contents

Preface: Out with the Authentic, In with the Wazimamoto

It is time for a revolution in African film criticism. A revolution against the old, tired formulas deployed in justification of filmmaking practices that have not substantially changed in forty years. Time for new voices, a new paradigm, a new view—a new Aristotle to invent the poetics we need for today.

Something trashy, to begin, straight out of the Nigerian video handbook. Something sexy, without the trite poses of exotic behinds spinning the *ventilateur* for the tourists. Something violent, without the obscenity of trivializing brutality, trivializing phallocentric abuse, and without the accompanying violence of Truth holding the whiphand over thought or difference.

Most of all, it is the retreat into safe and comfortable truisms that must be disrupted by this new criticism, this new third cinema challenge.

Perhaps there is nothing more in the nature of the truism than the notions used to combat modernism, notions we have used to create a curriculum of major sacred cows. I will list some of them and suggest ways to shake them to pieces; I will also suggest new directions: paths to the ultimate freedom of the new jugglers, the new tightrope walkers.

1. African film is important in the communication of history, in the correction of past misrepresentations of history.
2. African film is important in writing back to Hollywood and back to misrepresentations of Africa in the mainstream media
3. African film represents African society, African people, African culture.
4. African film should be the site for truth.
5. African film is African.

To begin, there is no history to represent, to correct, in film. There is only authority that represents itself, and in its power represents its images and narrative as authoritative, as authorized, as official, or worse still, as real.[1] The archives might vary, from those in London to those in Dakar, and periodically one will hear the call for a new perspective, an African-centered view. But the understanding of the past as a rationalization for unstated assumptions about history itself, and the epistemological assumptions built into historicism, never surface.[2] "It happened this way" is the telos of this filmmaking, as historical narratives are becoming dominant ones in the current effort to correct the ills of the past. Nonetheless, the correction is a blind one since it is based on the same values, and the same understandings of history, as the narratives it means to challenge. In its worst form, we have the substitution of one civilization for another—Egypt for Greece, or Ghana and Mali for London or Paris. We have a

competition for first achievers, for first thinkers, for originary worshippers of the One God of identity, of authenticity.

Luise White (1997) demonstrates how popular African accounts seeking to account for emergency vehicles, such as fire engines and ambulances, gave rise to widespread "urban myths" taking the form of "wazimamoto" stories— motor-wizardry or vampire stories. White calls for a subversion of our notions of authenticity, and states, "The study of colonial vampires is authentic not because of any particular legitimacy of the voices I quote, but because it involves writing about the colonial world with the images and idioms produced by the subjects themselves" (438). For me, it is not only the "authorized" historical accounts that need to be subverted, but all notions of authenticity themselves, since there is no site where one can stand from which to evaluate the authentic. This is a central notion of deconstruction, and it concords with the equally subversive Lacanian notions of *méconnaissance* or misrecognition that form the basis for all claims of identity.[3] If one is authentic, knowledge of oneself would have to come from standing outside of oneself and reflexively observing one's authentic being. Where then comes the knowledge about the one who stands outside and observes himself or herself? That model of the divided subject, fundamental to all poststructuralist thinking, demolishes any attempts to assert the presence of the authentic. Butler carries this argument further in her claims that subject identities are performed, that the metaphysics of presence rest conventionally on patriarchal assumptions that function like ideology, that is, that naturalize, or authenticate existing systems of power.

Rather than authentic, we might evoke the domesticated, with the notion that every cultural production, every image and idiom is the product of a process that involves the experience of taking what is other and rendering it familiar or same. This would seem to be especially true of images. The appropriation of the foreign alphabet, its translation into a locally inflected language, and its expression in homegrown accents, mark all African literature in European languages. Likewise, the advent of the camera in the nineteenth century, and then the cinematic image in the early twentieth century, brought new technologies to old styles and modes of expression. It took time for Seydou Keïta and then Malick Sidibé to appropriate the images of the French African studio photographer and then produce their own work. Similarly, the cinematic image was not invented as much as recreated, represented anew, as the African context for understanding and producing knowledge-images made itself felt.

The anxieties that current and past African film criticism must attempt to negotiate have to be read through the continuing insistence that the films respond to the false images generated by Hollywood, to the false history generated by the west. In other words, the anxieties to be dislodged have to be judged by the authenticities they are intended to protect. This accounts for all five shibboleths cited above as indicative of the continuing preoccupation with authenticity in African film criticism: authenticity in the representation of history, of the culture and people, of the screen image, of the truth, and of Africanity. If I can dismiss the claim that anxiety over authenticity represents a response to

the outside since the binary inside/outside is not and has never been an accurate indicator of African culture or society, then it will be possible to move on to the sites of power that have determined who disposes of the means of controlling the production of the image, of the "real" truth, that is the idiom and its content. "Who speaks" becomes here "who can produce the speech," "who can disseminate the discourse," "who can control its production."

To dispose with the basis for this concern, let me note that recent African film criticism repeatedly asks the same questions posted above: what really happened and who gets to tell the real story; who really are these people, and what are their lives really like; what are the real problems to be faced and overcome today; how can we confront the real forces that keep our people subjugated or from developing, and so on. The questions that have been preoccupying much contemporary film criticism, such as the role of desire, the technologies of production, the role of gendering, or institutional power; the subversion of the dominant capitalist or corporate machinery; or dominant masculinist values— these are often dismissed as western, feminist, universalist, and so on. How we might move beyond these familiar paradigms?

This is the central issue for *Postcolonial African Cinema: From Political Engagement to Postmodernism.* The goal is to begin by questioning the past, to clear it away, in the sense that Appiah (1993) means when he states that the "post" in postmodernism is a space-clearing gesture intended to make room for a new era. This study begins with the criticism of past filmmaking and critical practices—the space-clearing gesture; it is more tentative when it comes to the new. In part this is because I make no attempt to deal with video-films, by far the most successful forms of new filmmaking practice, but rather focus attention on those well-known cineastes like Sembène, Mambéty, Cissé, Bekolo, Nacro, Teno, Loreau, and others, who have not joined in the video phenomenon that has been based on new marketing strategies, and thus on more popular genres and styles. In part this is also because the space-clearing gestures are intended not to refute the past, the spirit of the ceddo still being very much with us, as much as to seek to provide a new scaffolding for a future approach. Nietzsche envisioned that function of the scaffolding in his *Zarathustra* so that new epistemologies might be constructed.

This is my goal in deconstructing the binary of surface-depth, the necessary first step in reversing the patterns of dominant thinking that have controlled and limited approaches to African cinema since the earlier publications of Teshome Gabriel (1982) and Ferid Boughedir (1976). Calling into question their doctrinaire approaches is not intended in any sense as a conservative move, but rather as part of the project to destabilize what Derrida and Butler call the metaphysics of presence, that is, those metaphysics underlying anthropology, and responsible for historicist, structuralist, sociological, and psychological truisms.

In the early years of African filmmaking, it was assumed that the superficiality of entertainment or subjective feelings, fantasy and emotions should be

subordinated to the greater social needs identified by an *engagé* criticism, an *engagé* cinema. Achebe's notion of author as teacher went unchallenged. In returning to fantasy in this study, I rely on Žižek so as to build a more meaningful relationship to ideology than that deployed in the 1960s. For Žižek, following Lacan, fantasy emerges in the gap at the center of the symbolic order, "the lack, the void in the Real setting in motion the symbolic movement of interpretation" (1991, 8). In an attempt to deal with that fundamental gap in our ways of making sense within our symbolic orders, an excess is generated that results in fantasy, and in that process the edifice of ideology is laid. The relationship between the two will be central to the theses developed in the second half of this study.

Following White, I would seek in the African images and voices not a higher form of the authentically African creator, but something more akin to Bekolo's "tsotsis," those youthful gangsters so enamored of cinema that it names them, gazes at them, speaks them in such a way as to account for their own world and for their rebellion against the "fathers" of African cinema. There results a tension between past and present that destabilizes the magisterial voices of the ones "who know," but that clears room for the sarcastic, silly, fantasmic ones who stand there now in the ruins of the crumbling cinema halls, holding in their hands the latest pirated productions of Hollywood, Bollywood, and Nollywood.

The first three chapters of *Postcolonial African Cinema: From Political Engagement to Postmodernism* explore the tensions in the socially conscious, politically conscientized film established in Sembène's first wave of films, and paralleled in thought, if not style, by Med Hondo, Haile Gerima, Mahama Johnson Traore, Jean-Pierre Dikongue-Pipa, and indirectly Gaston Kaboré, Safi Faye, and Souleymane Cissé. It was in the generation of filmmakers working in the 1970s that an ethic grounded in depth rather than surface emerged, and as such it absorbed, albeit unwittingly, much of the metaphysical values ensconced in the very modernism that undergirded colonialism, against which their own work railed. Thus the deconstruction of the binary surface-depth forms the core of my argument with the powerful influences now thought to have coalesced around Sembène's films. In the course of this study, I focus much attention on *Xala* (1974), and to a lesser extent *Borom Sarret* (1963), *Faat Kine* (2000), *Guelwaar* (1992), and other Sembène films. In addition, the films of Cameroonian filmmakers Bassek Ba Kobhio, Jean-Marie Teno, and Jean-Pierre Bekolo are also explored, as they form a stratum of new approaches to both the political and the fantastic, the politically didactic and the phantasmagoric, at times in tension with older values within the same film.

The linkage between ideology and fantasy, provided by Žižek, enables me to explore such marginalized "African" films as Dominique Loreau's *Divine carcasse* (1998) and Djibril Diop Mambéty's *Touki Bouki* (1973). The chapters that follow those devoted to the earlier generation of filmmakers explore much in Bekolo's first two films, *Quartier Mozart* (1992) and *Aristotle's Plot* (1996). In addition, his work may be seen in relation to his compatriots Teno and Ba Kobhio, who continue, in relatively different ways, to utilize the camera as a tool in

the service of social and political consciousness-raising. Close studies of Cissé's *Finye* (1982), Loreau's *Divine carcasse*, and Mambéty's *Hyenas* (1992) will depend upon a series of philosophical or psychoanalytical approaches intended to move us away from the earlier, conventional readings of the "African" film.

The ground-clearing gestures completed, it is with two relatively unstudied gems of African film, Fanta Nacro's "Un Certain matin" (1991) and Mambéty's *Parlons Grand-Mère* (1989), that this study concludes. The contention here is that as notions of postmodernism have been largely centered on euro-categories established by Lyotard and Jameson, it is necessary for another ground-clearing gesture to complete the move toward contemporary African cinema, and that is to establish that postmodernism is not yet another invention of the west. The African postmodern is being generated in our times as a function of African cultural responses to globalization, to the late capitalism that has seen both the disintegration of the possibilities to create a widely viewed, serious, politicized African cinema, and the explosion of a popular and accessible African video-cinema that eschews the earlier values of engagement.

From ceddo to tsotsi then, from the heroes of African cinema to the bad boys of "contras city"—or perhaps not from the one to the other, since Mambéty's "Contras City" was there from the start—but always the African cinema as a cinema that is "traveling." In French the term "traveling" designates a tracking shot that moves with its subject. Here it is my goal to make visible the presence of the camera in those shots so that we might begin to understand quite how important fantasy, desire, the gaze, and their inscriptions across the visual surface are in constructing an African cinematic order.

Acknowledgments

The work in this book goes back a number of years, and was enabled and supported by a multitude of friends for whom African cinema is a passion and love. I have dedicated past work to Djibril Diop Mambéty, who seemed to have inspired so many by his extraordinary qualities as well as his visionary accomplishments in cinema. And the younger generation of filmmakers who also have carried the torch would have to include Aberrahmane Sissako, Fanta Nacro, Idrissa Mora Kpai, and Abdoulaye Ascofare. I would like to acknowledge in particular Jean-Pierre Bekolo, whose ideas, innovation, and courage have inspired me, and whose friendship has honored me. I would also like to include those extraordinary souls whose work in Senegal I came to know in 2005–2006, as I lived in Dakar. Above all Modibo Diawara and the people at the Media Center were an inspiration, as was the privilege of meeting Khady Sylla and viewing her work.

I have taught African cinema for a number of years, and my students have all played an important role in innumerable discussions and reflections. I would like to mention in particular Lamia Ben Youssef and especially Carmela Garritano, a pioneer in the work on Ghanaian video films.

The conversations, help, and encouragement I received in various ways from Manthia Diawara, Josef Gugler, Françoise Pfaff, Odile Cazenave, and Alexie Tcheuyap have sustained me in this project.

My wife, Liz Harrow, worked closely with me on creating a presentable manuscript, on thinking through the issues, and on focusing on the larger and smaller details, including the difficulties of generating illustrations from stills that were almost impossible to obtain. My son Joseph Harrow lent a hand to his less technically endowed father in generating presentable images.

Finally, the support I received over the years from Michael Lundell of Indiana University Press, from our initial conversations, to the details of putting together the manuscript and illustrations, played a large role in sustaining my initiative. The same professional assistance from Karen Kodner in copyediting was also greatly appreciated.

To all the above friends and family, jerijef jerijef.

Postcolonial African Cinema

Introduction: The Creation of a Cinema Engagé

How did African cinema come to embrace certain meanings or values first as important, then as central, and then as natural or inevitable in its self-generated charge of creating a cinema engagé? For an answer, it is instructive to look at the work of one of the earliest practitioners of African cinema now often touted as the father of African cinema, Sembène Ousmane.

I intend to present a series of Sembène's films as openings onto the larger questions of African cinema. The ultimate issue I aim to address is the price of following Sembène's approach to an ideologically driven cinema. More generally, since he is regarded as a forerunner, groundbreaker, leader, father, enabler, and more, I will also discuss the price paid by African cinema for having adopted his fundamental assumptions. In the earliest years of African cinema, it was a cinema of revolt against colonialism, and then against neocolonialism, dependency, and eurocentrism. The system of values underlying Sembène's work, as a harbinger of a cinema of revolt, was widely embraced, given the reigning ideological values of the 1960s and 1970s; so now we can examine the consequences of embracing that system of values, an issue perhaps not available for us to examine or question before the present time.

I want to get to this by suggesting a paradigm for the narrative structure of most of Sembène's films. The political assumptions and their limitations or implications will be made clear once the underlying pattern is analyzed. The broad outlines of the paradigm are the following: The films begin with the presentation of a problem, usually involving a crisis that crystallizes around some opposition to the film's protagonist. This is usually followed by a false solution in which the prospects of the removal of the obstacle are shown to be inadequate. Eventually a true solution is found, with the issues related to the film's underlying rhetoric resolved and explicated. This is the threefold path to truth, so to speak: a trajectory at the end of which the audience is enjoined to see and appreciate the truth uncovered by Sembène and, ideally, be motivated to act.

Each film constructed according to this model must silence some figures, must occlude contrary or alternative perspectives that might have led somewhere other than where the director wishes to lead us, and this is the lesser penalty to be paid for accepting the underlying system of values. Finally, the question of the larger system of values may also be seen as leading us to conclusions that are equally limiting in the interpellations of the viewer. We can see these questions of larger systems of value as having pertinence to the field of postcolonial studies as it passed from its earlier years of national independence to

the more recent period of globalization, with the concomitant postcolonial crises of the African nation. Sembène has been there throughout this entire period, and his films continue to have a huge impact, if not on other younger filmmakers then on Africanists in general, as well as that severely specialized audience for African film.

Sembène's career begins with short or medium-length films, such as *Borom Sarret* (1963), *La Noire de . . .* (1966), and *Tauw* (1970), where the basic pattern is established. *Borom Sarret* concerns a cartman who hauls goods or people for a living. The initial problem is that he doesn't earn enough money to make a decent living. The implied solution for him is better pay, a problem related to the fact that his clientele is generally drawn from the relatively impoverished class of ordinary Senegalese. Eventually the cartman is convinced to take a wealthy client to the plateau—the expensive, formerly European quartier of Dakar—as the apparent solution to his need for cash. His action is an infraction of the rules forbidding *charrettes* (or horsedrawn carts) from going to the plateau, and despite the rich client's promise to help, his cart is confiscated. He returns home on foot, as his personal dilemma is now portrayed as the consequence of an unjust economic and social system based on class division. The implied solution lies in working through the injustices of class difference, a solution in harmony with the general acceptance of the socialism widely embraced by African intellectuals in the 1960s.[1] In the final scene, the cartman's wife leaves him with their child, telling him she will find money for the food they need. The false solution of the cartman trying to extend his income by daring to go onto the plateau for a higher fare, and trusting his bourgeois nouveau riche client to protect him, is replaced by the determination of the nononsense wife who might be seen to represent a more idealized proletarian figure. There are other small elements in the film that relate to this, but the gist of the film lies in its presentation of class values along the lines of a revolutionary socialist point of view.

The same might be said of *Tauw,* a film that portrays an unemployed young man as its eponymous protagonist, highlighting the failures of independence to provide Senegalese society with economic development for the poor, ordinary people. The immediate, apparent problem is unemployment, and the inadequate solution is presented simply as Tauw finding employment. The ultimate resolution calls for a broader change in the economic and social system. En route to this position we have two interesting aspects that deserve mention. The first appears in a scene of children begging in the street, a common if scandalous occurrence in the 1970s when qur'anic teachers were thought to be responsible for sending their students out to beg (a recurrent public issue in Dakar[2]). This scene is conjoined to a reflection made by a passing driver on viewing the monument to independence: he says that in the ten years since independence, they haven't come very far.

The second aspect involves family relations. Tauw, the unemployed youth, is the son of a "traditional" father—a patriarch who fails to provide for his family, but who still dominates the mother and children as a tyrant, and who claims

the rights to his position on religious or customary grounds. The critique remains grounded in Sembène's socialist modernism. What is occluded in this critique can be seen in much later developments in postcolonial thought that demonstrate the constructed nature of the notion of tradition[3] and the limitations of this first-wave feminist protest.[4]

Fourteen years after the onset of the "independences" and Senghor's presidency, and after the failures of the early national governments and leaders became the subject of many novels and plays, Sembène achieved a major success with *Xala* (1974). The earlier clear focus on socialism as the correct answer to the problems of comprador capitalism, posed in the works of engagé cineastes, became blurred by the critiques of corrupt and oppressive Senegalese leadership. The representation of a failed ruling class, both political and economic, dependent on the powers from the metropole still exerting control over the African state, is figured within the new paradigm of neocolonialism.

The initial problem in *Xala* is El Hadj's impotency, which emerges early in the film as he fails to achieve an erection on the day of his wedding to his much younger, third wife. The solution is to find a marabout or sorcerer who will have the power to restore his manhood. But even when he succeeds in accomplishing this, his finances collapse, revealing the imperfection, or even falseness, of this solution. In the end we are led to understand that the problem has not been properly posed, that his impotency or *xala* is indicative or symbolic of a larger symptom, that of the unprincipled neocapitalist ruling class. The final scene in the film presents the solution for El Hadj: he is made to submit to a ritual of degradation carried out by the city's beggars, which will not only restore his virility but also effect his reintegration into his African family—a family not to be defined by the thoughtless imitation of foreign ways, but by adherence to African values.

Again the message is somewhat muddled. We understand that the class values of the rich are signs of their corruption; that the corruption consists in imitations of western ways, performed to the point of ludicrousness, at times even implying racial self-hatred.[5] Notions of authenticity ground the critiques of acculturation, as seen in the national bourgeoisie's preference for French over Wolof. Simultaneously, the film's progressive, westernized first-wave feminism entails a rejection of polygamy, debunking El Hadj's justifications for it on the basis of traditional and Islamic custom, "la patrimoine africaine," the very rallying cry for the nationalists' struggle for independence. The revolutionary daughter, Rama, who insists on speaking Wolof, but also on attacking her father's polygamy, is trapped at the end by her fidelity to her family that leads her to suffer at the hands of the very beggars who invade her parents' house and subject El Hadj to their indignities. In the end cultural nationalism and female liberation clash.

The true dialectical solution is ultimately reached, clear in its opposition to neocolonialism, but somewhat fuzzier in its placement vis-à-vis tradition or Africanité. The perspective that frames the issues returns us to the film's "McGuffin," El Hadj's penile erectibility—providing the film with a classic phallocentric

issue. The restoration of his virility, even if now figured in terms of a valid African identity, doesn't alter this perspective, and in this regard it is interesting to speculate on the role of El Hadj's third wife. She is the object of the male gaze, of the sexual challenge, but also of sexual prohibitions since El Hadj cannot have sexual relations with her when she is having her period, even though his virility is restored by the marabout. By the time her period is over, so too is his virility.

Throughout the film she almost never speaks, so we hear nothing from her about how she views her marriage and its failure to be consummated. Nothing of what she sees, what she wants is expressed. We have the gifts El Hadj makes to her and her family, the house, the wedding, the trappings in which he wraps his story of success. Her success and failures, her ambitions or desires, are unexpressed, even indirectly. She is mostly presented as an image, caught in a naked pose in a photograph placed over the marriage bed. Yet, without her El Hadj cannot achieve his proper position as dominant male: she functions as the excluded term on which the male center depends.

The film's phallocentrism carries over to Oumi, El Hadj's highly vocal second wife, who is presented to us entirely in terms of how her relationship with El Hadj is affected by the marriage, as is also the case of Awa, the first, more sympathetic wife. All the wives, and indeed all the characters, wind up as figures caught in a plot that turns on El Hadj's preoccupation with his "manhood." Their other issues disappear, are silenced. So if *Xala* is a film about neocolonialism and how it unmans Senegalese leaders, it is also about the narrow optic of the presentation of that issue.

Xala is perhaps the most quintessentially antineocolonialist film of the period or perhaps within the whole canon of African cinema, and it is built around this series of relations of women turned toward a man whose problem lies in his failed sexual performance. Could it be that this silence of the third wife, and this broader silencing of the other wives as having issues in their lives besides their husband's sexual performance, is indicative of the occlusions engendered by the presentation of neocolonialism in this pure form? If so, we need to ask about the price of presenting Africa's failures in terms of such readings of neocolonialism, just as Radhakrishnan (1992) asked questions about the presentation of the Indian woman as symbol for the nation. We might begin by asking, similarly, if this is a question also of the price of remaining within the optic of a first-wave feminist politics preoccupied with the notion of women oppressed by husbands for whom African traditions or custom, ensconced in religion or village values, justify their patriarchal positions. For instance, we might argue that both the neocolonial and feminist positions taken here are based on straightforward binary opposites that systematically work on exclusionary political perspectives. Or that both positions are articulated by the implied narrator who alone possesses the Truth and speaks for the oppressed. When El Hadj, somewhat out of character, articulates this Truth at the Chamber of Commerce, his speech implies a relationship with an audience assumed to receive this message passively. From the magisterial site of the film's message-

sender, the viewers are interpellated so as to be aligned with a historicist perspective on the sexual and political economies, the terms of which are set by a modernist paradigm of progress. Gikandi (1996) has convincingly shown that this progressivist temporality also informed colonialist ideologies, so that we can say Sembène has absorbed the model, redeployed it for liberationist purposes, but has stayed within its parameters. By doing so, he has had to develop exclusions, occlusions, silencings that prefigure an eventual embrace of an authoritarianism on the part of those who possess the correct vision or truth (this emerges in a later novel, *Le Dernier de l'empire* [1981]). This is the price of staying within a phallocentric paradigm, a modernist paradigm, and especially a progressivist paradigm that fails to acknowledge the Enlightenment rationalism and historical basis on which that model depends. The construction of the modern "self," which accounts for what is occluded or silenced, provides the basis for classic realism or social realism whose narrators assume the obvious nature of a normalized order of reality and of self-evident truth.

In *Camp de Thiaroye* (1987) the problem clearly presented early in the film is that of just remuneration to the African soldiers returning home from the battlefields of World War II. They had been assured of a final payment of their wages, and the French officers deceptively cut the promised wages in two. The soldiers revolted in a famous incident at the Camp de Thiaroye outside of Dakar, and they took a French general hostage. The general promised restitution of the wages, but when he was released, the rebels were slaughtered. The false solution was the accommodation reached between the negotiators and the French. The true solution, found by the audience and the survivors to the killings, lay in rejecting accommodation with the treacherous colonialists, and more broadly in moving from a subordinated colonized status to one of equality and dignity. The occluded figures in this film (or we might say, the inconvenient historical details) are the drivers in the tanks used to level the camp. They were Senegalese soldiers—*tirailleurs senegalais*—whose features are never shown in the film.[6]

A revised shape of Sembène's ideological position emerges when the African soldiers debate what to do after the revolt has begun. They form into discrete units bounded by their own national languages, but in the end come together in a council to formulate a final strategy. This meeting of African peoples is pan-Africanist, and it testifies to a more encompassing vision than the narrowly focused antineocolonialism of *Xala*. Our question shifts with Sembène's, and we ask if there is a price to be paid in this reconstruction of pan-Africanism. The occlusion of the *tirailleurs senegalais* suggests that the multitudes of voices that come together in the film are systematically organized so as to leave out others still willing to work with the French, or those uneasy with a notion of African authenticity that calls into question attempts to create African-European bonds. The central protagonist, whose wife is French and whose cultural baggage encompasses European high culture as well as African American music and thought, is forced in the end to choose between the French officers and his African mates. In Bhabha's terms, we have a portrait of diversity merging into a multicultural vision of pan-Africanism, but not a notion of difference at the

center of this identitarian construction. For Sembène Africans are, at heart, true to themselves when they come to express themselves in their original languages, with their own gestures and modes of expression, not those given in borrowed clothes. Sembène has multiplied, but not replaced, the language of cultural nationalism and authenticity.

Following *Camp*, in 1992 Sembène produced one of his most interesting films to date, *Guelwaar*. The problem is a ridiculous one, on the face of it. The wrong body was taken from the morgue when the time came to bury the eponymous hero Guelwaar, and as he is Christian and is buried inadvertently in a Muslim cemetery, religious differences exacerbate the problem. The Muslims believe they have buried their own man, and that to disinter him would be a sacrilege, so they refuse. The solution would seem to be as simple as the restoration of El Hadj's virility, like the agreement to pay the soldiers their full wages, or simply to find a job for Tauw—it is to disinter the body and examine it, and then to bury the right bodies in the right cemeteries. But the Muslims believe this to be sacrilegious, and further, they have no interest in accommodating their Christian neighbors, relations between the two communities being strained.

The film's conceit is ingenious: Guelwaar, a thorn in the administration's side, cannot be buried and done away with. He is the irrepressible element in the return of the repressed, the protestor who cannot be intimidated or bought off. Guelwaar will not stay buried. So the apparent or false solution of identifying the corpse and burying the right man in the right cemetery is supplanted by the emergence of the real issues that come into the open when the error is discovered. Those issues include, among others, the conflicts within the postcolonial state, expressed as the intercommunal strife between Senegalese Christians and Muslims. Further, it is the problem of a corrupt government that cannot command the moral authority to settle intercommunal strife. As the memory of Guelwaar is unearthed, his resistance to the authorities is cast into the larger orbit of resistance to the government's dependency on foreign aid, its reduction of the independent state to the status of a mendicant. The postcolonial conditions of poverty compel children to support parents, women to support men, daughters to turn to prostitution to meet their family's needs. Guelwaar's honor is built upon the financial support of his daughter, who has turned to prostitution in Dakar while he and his family live at a comfortable distance away from the site of her trade.

When Guelwaar is finally disinterred and his body triumphantly returned to his community, the procession encounters a food aid truck carrying goods to the Muslim village, just as promised by the government representative. The youths leading the procession stop the truck and destroy its contents, thus effecting the passage of Guelwaar's revolutionary spirit from the dead ancestor to the leaders of the future.

What is silenced here comes in several forms. Guelwaar's wife's voice, proclaiming to his empty wedding suit that he will have lots to account for, opens the space for a dialogue occluded by Guelwaar's strong, domineering absence/

Figure 0.1. Guelwaar's wife gives his burial suit a good talking to.

presence. First-wave sexual politics have consistently meant adopting a western notion of the liberated woman; in opposition, cultural nationalists have parodied Frenchified, that is, acculturated Africans. Throughout Sembène's career, the patriarchal dimension of the latter has been in contradiction with the feminist sympathies of the former. So two forms of occlusion have consistently appeared: the first, in relation to the cultural nationalism, is the grey area of hybridity associated with Bhabha's work on colonialism. The second is the occlusion occasioned by a dominant heterosexuality, one that is all the more reinforced as it is presented positively in response to traditionalist patriarchal structures. The model for the woman whose refusal of male domination is associated with assimilation of French ways is to be seen in Oumi, El Hadj's second wife: aggressively assertive, she is the figure of corrupted sexuality who has bought into European notions of female beauty. In *Guelwaar*, Sembène has constructed a similar figure in Hélène, the prostitute friend of Guelwaar's daughter. While she functions as a forerunner for the eponymous protagonist of *Faat Kine*, the modern emancipated woman, both are represented within the economy of a heterosexist norm whose assumptions are never challenged.

More generally, one has to ask if the final vision of *Guelwaar*, one where the spirit of revolution is passed onto the enlightened youth who are ready to reject western aid, adequately addresses the issues when framed in terms of globalization and not neocolonialism. If the film's implied solution is self-sufficiency, along with communal harmony based on cultural nationalism and Afrocentrism, and the elimination of corrupt, dependent leadership, one has to ask what assumptions about authenticity and originary thought are now governing this updated version of resistance or revolutionary thought. My turn to a second-wave African feminist politics, seemingly marginal to these debates, actually addresses the core of the issues since authenticity and originary thought

are predicated upon essentialist and logocentric assumptions about identity, and second-wave or radical feminism has been in the fore in challenging the phallocentric nature of identitarian politics. Second-wave feminism, often misunderstood as asserting an essentialized female nature, disrupts heterosexist binary male/female models, a disruption that carries through to the subversion of phallocentrism and its accompanying history of binary truths.

The pattern of establishing a problem, followed by a false solution, and then ending with a real solution, replicates the conventional Hollywoodian formula for the well-made film, which in turn conforms to the patterns of classical realism, with the limitations of what Roland Barthes called the readable text. Here is a thumbnail sketch of the Hollywood formula, provided by Kristin Thompson and David Bordwell, describing the structure of films since the 1920s: "Each major character is given a set of comprehensible, consistent traits. The Hollywood protagonist is typically goal-oriented, trying to achieve success in work, sports, or some other activity. The hero's goal conflicts with the desires of other characters, creating a struggle that is resolved only at the end—which is typically a happy one" (Thompson and Bordwell 1994, 73). Although it has been argued that Sembène positions himself as the African griot whose narration speaks for the community, in contrast to the westernized focus on the individual, what we have seen is that the community problems are expressed through protagonists whose function, like that of the hero, is to stand in for the group. We could argue that the Hollywood formula creates a focus on individual psychology in contrast to the social dramas in African film or literature, but the structure remains the same, namely, that of the presentation of a problem focalized through a protagonist, the development of a crisis in conflict with others, inhibiting the resolution, and then an intervention that permits resolution. Catherine Belsey provides this key description of the closure that characterizes the classic realist text: "[T]he story moves inevitably towards closure which is also disclosure, the dissolution of enigma through the reestablishment of order which is understood to have preceded the events of the story itself" (1980, 70). She adds further that "the movement of classic realist narrative towards closure ensures the reinstatement of order, sometimes a new order, sometimes the old restored, but always intelligible because familiar" (75). It is my contention that this movement is characteristic of all of Sembène's work, and this is because his embracing of a fixed ideological position precedes the characters' embarkation into the plot. In other words, Sembène is in the position of what Lacan calls the one supposed to know, and that positions the viewer in the place of the passive receiver of that knowledge rather than an active participant in the discovery of knowledge, as the advocates of Third Cinema like Tomas Alea Guttierez or Solanas and Gettino would have it.[7]

The classic structure of Sembène's work leads us to question both in his case and that of the many films his work has inspired, what has been the price paid by classic social realist African filmmakers since the 1960s. Has their approach to the questions of dependency, social and political domination, and the struggle for liberation led them to a series of closures that are now incompatible

with current theoretical models? And is there an opening provided by second-wave feminism that permits us to move beyond this bind? Within what Derrida might term the excess of the occluded term one can locate the possibilities for a new ethical perspective. This is the opposite of the tired antitheoretical chestnut that equates postmodernism with relativism. Rather it is closer to Bhabha's position that looks for difference as the site for resistance to colonialism. I am proposing that it is in the occluded, off-frame, unspoken moments or gestures that we must look for the ethical position. This runs counter to a half-century of revolutionary African rhetoric of liberation that has been built upon an insistence on writing back, speaking back to colonialism's loud contradictory claims of humanism, with Africa's own version of the unified and justified subject. More recent filmmaking in Africa indicates we have entered into the time when other voices can emerge in the cracks of the text, and we can discern such voices in the works of filmmakers like Djibril Diop Mambéty or Jean-Pierre Bekolo.

<p align="center">* * *</p>

The typical pattern with which Sembène constructs his film narratives is dialectical, moving from characters marked by false consciousness to those who achieve higher consciousness. The movement from individual crisis to social resolution, the passage through conflict to resolution, and the sense of a movement forward all attest, in varying ways, to Sembène's embrace of the grand narrative of Marxism that shaped the generation of African intellectuals, creative artists, and thinkers after World War II. This period saw the emergence from the horrors of war, totalitarianism, racism, and fascism; the incorporation of African urban populations into the processes of self-governance; the organization of labor into trade unions; and the promotion of African organs of press and publication like *Présence Africaine, Nouvelles Editions Africaines,* and *Editions Clé,* that voiced the aspirations of the "new Africans" as harbingers of self-rule and independence. This time was the high-water mark for an African modernism unmarked by the cynicism and disillusionment with progress that a broken Europe experienced and ultimately articulated in the privileging of the term "absurd."

The progressivist tone of the period could be captured perfectly in Sembène's *Les Bouts de bois de Dieu* (1960), an anomalous text in many ways. Although it brilliantly reflects the positivity in the spirit of struggle at the time, articulating the hopes and beliefs tied to much of the movements for independence across the continent, it arose out of the specifically French context of a successfully politicized Communist trade union movement, headed by the C.G.T., which dominated French politics in the 1950s. It is difficult to think of any other African novel that evokes the trade union movement or the politics of the working class directing the emergence into a new society. The closest one can come would be a work like Vieira's *The Real Life of Domingos Xavier* (1974), where it is the revolutionary party that most resembles Sembène's trade union movement.

The coincidence of the two is not accidental: the fundamental guiding prin-

ciple in both is historicism[8] presented as the necessity to move forward, to measure one's progress in terms of distance from the past. It is also a notion of inevitable change, the inevitability dramatized in the passage from false to true consciousness. The growing critique of historicism in Europe in the 1950s and 1960s was based on the increasing scandals of Stalinism, and more broadly, with the ascendance of Foucault and then Said on the one hand, and Lacan, Levinas, and, by the 1970s, Derrida, Cixous, and Irigaray on the other hand, all of whom attacked the Enlightenment as the basis for the ideals of progress and rationalism. The Holocaust marked the temper of the times with darkness, but the critiques of Marxist dialectical materialism ultimately did not depend on the aberrations of Hitler and Stalin to make their case as much as they attacked the guiding rationalism that underlay the historicism.

Sembène turns back in *Les Bouts de bois de Dieu* to the earlier period of struggle during the colonial period in Senegal so as to bring the newly independent era in Africa into a relationship with the past, thus establishing a progressivist temporality. With *Emitai* (1971), *Ceddo* (1976), and *Camp de Thiaroye* (1987), he builds the foundations for a vision of history that is there to be recovered as an objective, independent entity. The African perspective he takes on this entity is that it is entirely amenable to transparent representation, but that the biases inherent in colonialism have warped the visions and understandings of Europeans.[9] Thus his versions always become counterhistories, as seen most notably in *Camp de Thiaroye* where the official French whitewashing was seen to hide a shameful massacre of African soldiers awaiting decommissioning after World War II.

The questioning of a universal rationality in the west in the postwar period and especially in the 1960s led many to posit the impossibility of reconciling increasingly severe critiques of systems of domination, surveillance, and control with a nationalism grounded in the historical principle of an inevitable unfolding of the idea of freedom. The Hegelian assumption of self-awareness increasing concomitantly with the freedom of the subject and society was countered with the unfreedom of the Panopticon and the white freedoms of the Western Same that were based on the servility of the Other.[10] Foucault's (1980) indictment of the Enlightenment came to be accepted broadly:

> The movement which, at the close of the colonial era, led it to be asked of the west what entitles its culture, its science, its social organization, and finally its rationality itself, to be able to claim universal validity: was this not a mirage associated with economic domination and political hegemony? Two centuries later, the Enlightenment returns: but not at all as a way for the west to take cognizance of its present possibilities and of the liberties to which it can have access, but as a way of interrogating it on its limits and on the powers which it has abused. Reason as despotic enlightenment. (54)

The failure of Sembène to query the very notion of history was matched by Achebe in the same period in his well-known essays "The Novelist as Teacher" and "The Role of the Writer in a New Nation," appearing respectively in *Morn-*

ing Yet on Creation Day (1975) and *Hopes and Impediments* (1988). Though Achebe never shared Sembène's Marxist views, he thoroughly embraced the same progressivism and his pedagogical, rationalist humanism in his essay "The Role of the Writer in a New Nation":

> This is my answer to those who say that a writer should be writing about contemporary issues—about politics in 1964, about city life, about the last coup d'etat. Of course, these are legitimate themes for the writer but as far as I am concerned the fundamental theme must first be disposed of. This theme—put quite simply—is that African peoples did not hear of culture for the first time from Europeans; that their societies were not mindless but frequently had a philosophy of great depth and value and beauty, that they had poetry and, above all, they had dignity. It is this dignity that many African peoples all but lost in the colonial period, and it is this dignity that they must now regain. The worst thing that can happen to any people is the loss of their dignity and self-respect. The writer's duty is to help them regain it by showing them in human terms what happened to them, what they lost. There is a saying in Ibo that a man who can't tell where the rain began to beat him cannot know where he dried his body. The writer can tell the people where the rain began to beat them. After all the novelist's duty is not to beat this morning's headline in topicality, it is to explore in depth the human condition. In Africa he cannot perform this task unless he has a proper sense of history. (44)

And in "The Novelist as Teacher," written in 1965, he says:

> Here, then, is an adequate revolution for me to espouse—to help my society regain its belief in itself and put away the complexes of the years of the denigration and self-abasement. And it is essentially a question of education, in the best sense of that word. Here, I think, my aims and the deepest aspirations of my society meet. For no thinking African can escape the pain of the wound in our soul. . . . The writer cannot expect to be excused from the task of re-education and regeneration that must be done. In fact he should march right in front . . . I for one would not wish to be excused. I would be quite satisfied if my novels (especially the ones set in the past) did no more than teach my readers that their past—with all its imperfections—was not one long night of savagery from which the first Europeans acting on God's behalf delivered them. Perhaps what I write is applied art as distinct from pure. But who cares? Art is important but so is education of the kind I have in mind. And I don't see that the two need be mutually exclusive. (Achebe 1973)

The "unvarnished truth," "the clear vision," "the proper sense of history" ultimately evoke the very universal History to which Glissant would want to oppose the local histories of a creolized people in the Caribbean (*Caribbean Discourses,* 1981), a perspective elaborated into a generalized deconstruction of any cultural monadism in Jean-Loup Amselle (*Logiques Metisses,* 1990). For Sembène the only means to give unity and purpose to the "bouts de bois de Dieu," the "petits gens" for whom History was to ensure a glorious, triumphant destiny in some indefinite future moment, was to adhere to the conscientization that depended on an understanding of History. The argument that was to devolve from this was that whatever reasons a Europe might have had not to adhere to En-

lightenment ideals, Africa could not afford to abandon them,[11] given its state of underdevelopment and dependency—that is, the current state of poverty enforced upon it within the context of globalized trade conditions and IMF and World Bank controls (compare Manthia Diawara, *In Search of Africa*, 1998). The current conditions in Africa are no longer posited in terms of development theory, but rather are seen as the consequence of poverty and despotism (Mamdani 1996; and Mbembe 2001). It is not a question of dependency, but a state of economic and ultimately political impotency, both of which are largely due to market and international forces outside the control of individual African nations (Mbembe). Indeed, the freedoms inaugurated with the Enlightenment and its revolutions, now dismissed by the rising schools of postmodernism and postcolonialism, were viewed in Africa as having adumbrated the era of African independences. As a consequence, the old school of 1960s Sembène-style activism, or 1970s Bolekaja criticism, could not escape the critiques of Marxist historicism and determinism that emerged in the 1960s, the real price paid by Sembène's historicism.

The historicism that has prevailed in much of African literature and film has gone unexamined; history and time or temporality have been taken for granted. The assumption is that the empirical experience of time, and the rational construction of a linear diachrony, sufficed to evoke the needed category of history so as to provide the obligatory "context" for any text. That history is automatically there, automatically comprehensible, is grounded in the epistemological assumption that this knowledge of history and of temporality are naturally given. This is a classic ideological construction. Althusser's deconstruction of this naive view should form the basis for any assessment of the "price paid" for Sembène's ideological presentation.[12]

To begin, the chronology that measures an African historical frame, as in *Camp de Thiaroye, Emitai,* or *Ceddo,* or in the films that are the focus of this introduction, *Borom Sarret, Tauw,* and *Xala,* all mark their temporality by recognizable historical moments that fit into a familiar western historical frame: the onset of independence from colonialism (made explicit in the latter three films), the conjunction of European wars and African participation (the first two in the above list), or the Atlantic slave trade (*Ceddo*). We assign these historical markers their designated places in a chronological ordering that gives us what is "naturally" to be recognized as something like World History, or Universal History. This view of the constructedness of "nature" and "history" is presented not so as to deny their facticity or reality, but rather to ask what forms the basis for the frame into which they are set.

To give an idea of how this frame functions ideologically, we can offer alternative versions that provide a differential notion of a temporal frame. For instance, the day in the life of the cartman in *Borom Sarret* is clearly constructed around the rhythm of labor within a colonial economy, with the cartman's itinerary tied entirely to the patterns of work and repose, to the muezzin's calls to prayer that set off the segments of the day within a sequence of chronologically recognizable moments. The morning commencement of work, the afternoon

rest and then reprise of work, and the evening return—all fill out "the day in the life of" pattern. But what if the pattern had been generated by the tasks and relations with others viewed by the cartman's wife? What if the markers of time were not provided by the cartman's reflection on independence, but by hers on the need for companionship or clothes or food? It is not just that her notions of time or construction of "a day in the life" would be radically different, but that there is virtually nothing of her temporal experience of the day, or of their past life together, or of her own life, her relations, her obligations, and how she would set them into an account of the passage of time. When she resolutely goes off to get food at the end, no one has any idea where she is going, thus generating all kinds of speculation about the cartman's look as she departs. Her temporality, and story, are off-frame.

The appearance of the praisesinging griot in the middle of the cartman's day signals yet another one of the obstacles to the cartman's goal of making a living. He weakly gives in to the well-polished praises of the rotund griot, and becomes a victim of the kinds of "tradition" critiqued by Sembène. In the process of exposing this encounter as yet another weakness of the cartman, Sembène makes clear the illegitimacy of the griot's appeal—an appeal to a noble past that lends nothing to the cartman's struggle to survive. It is as though the proletariat worker of the present has not yet learned where his true class interests lie. More to my point, however, is the notion that an alternative chronology that might have marked significant moments in the past and that might have generated a different temporality from that delineated by colonialism, with its terminus in the "suns of independence," does not emerge as a competing version.[13] The "scientific" socialism that informs *Les Bouts de bois de Dieu* is equally present here, as in *Tauw* or *Xala*. In all of these works, the women's time is suspended as we follow the male protagonist; the women's moments are marked as significant inasmuch as they are punctuated by the men's appearance; the women's histories remain occluded, unarticulated, silent. Even the history in *Ceddo* might be viewed in this light, despite the important role of the princess, since she could be said to fit into the chronology established by the men as they set about to define the key moments of the acceptance of Islam into their culture.

This criticism of Sembène's first-wave feminism, then, goes far beyond a critique of strategies, to include his centering on a rationalism that provides a basis for the temporality, the construction of history, the erection of important markers, and the sense of a progressive structure. It is now essential to recognize the link that Derrida established in *Of Grammatology* (1967) between logocentrism, the binary logic that informs the rationalism at its core, and phallocentrism, its correlation to the conventionalized systems of gender domination. The turn to a particular, rational form of emplotment, which generates a story, a history, and a meaning, is marked at every moment by the exclusion of other stories, histories, temporalities, and meanings. In place of the real history that Sembène provides, or of stories whose meanings take on import in their relationship to the economic and social structures that he creates, the dismissed or ignored versions of the women, the griot, or the religious personality become

myths, legends, or, worse, dreams that deflect one from confronting the real problems of poverty and discrimination. They become "pie in the sky," the deluded embrace of opiates, as Sembène makes more explicit in the novel version of *Xala* (1974) when discussing Awa's fideism.

The issue at stake involves more than different points of view, different gendered positions or gendered experiences. It is a question of authority, that is, the establishment of a narrative as authoritative and authorized. African literature has moved around the edges of this issue for some time. For instance, the epic narratives of such heroes as Sundiata or Mwindo have typically been framed by commentaries or introductions, the point of which is to explain what "really happened." A recent egregious example of this framing can be seen in the publisher's gloss on Zoe Wicomb's brilliant *David's Story* (2001), where the Feminist Press deemed its audience incapable of dealing with the novel's polyphonic constructions and lack of straightforward narrative, and imposed a fifty-page historical overview of the Griqa as an afterword.[14] In somewhat less dramatic fashion, Elechi Amadi's account of a conflict over territory between two competing villages in *The Great Ponds* (1969) is similarly resolved in a "rational," "historical" fashion when he tacks on an ending establishing the fact that it was the Great Influenza Epidemic of 1918 that accounted for all the deaths in the novel, and not the work of the powerful sorcerers whose actions had been held as responsible by the narrator and the villagers. Similarly, the endings of *Things Fall Apart* (1958) and *Arrow of God* (1964) set up competing narratives, with the death of Okonkwo and the madness of Ezeulu presented so as to make visible European attempts to recuperate such events into European epistemological schemes: the workings of anthropological rationality or psychological rationality are posited as narratives that compete with the novel's narrator for authority. In Achebe's case the Eurocentric ratio does not prevail, as it does in the end with Amadi.

In a brilliant article on competing narratives developed during the colonial period in East Africa, Luise White demonstrates how popular African accounts tried to explain the relationships among emergency vehicles as fire engines and ambulances, blood drives, and the powerful constraints imposed on the populations by colonial authorities. The widespread urban myth–type stories that resulted were dubbed "wazimamoto" stories—motor-wizardry stories, or more precisely, vampire stories. "Stories about bloodsucking firemen, known in East Africa by variants of the Kiswahili term *wazimamoto,* the men who extinguish the fire (or heat, or light, as in brightness but not as in lamp), and in Central Africa as *banyama,* the men of the meat, or animals, as in game rangers or possibly hunters, cover a wide geographic range, from the East African coast to eastern Zaire to at least as far south as the Limpopo" (White 1997, 440). For White what is of central importance here is not simply presenting an African account with African voices, but what is at stake in the appeal to authenticity: "These vampires are described in a wide variety of oral accounts, and, as descriptions of things that never happened, should begin to subvert some of our

ideas about what constitutes authenticity" (438). She goes on to validate the narratives in which because "the images and idioms [were] produced by the subjects themselves" (438), and she further claims that the anxiety revealed in these stories attests to the tensions created under colonial rule, created with the introduction of poorly understood technologies and with the reconstitution of lines of power within society. What is of more interest to me, however, is the basis for the authority of any given narrative itself. White's key statement, citing Stoler, highlights this point: "Rewriting colonial histories means asking how the colonial experience created what Ann Stoler has called 'hierarchies of credibility'" (437).

The hierarchy that distributes authority to one narrative account, and that dismisses others, is recognizably joined to the colonial enterprise, one that set "history" against "myth." The latter is dismissed as fanciful, fantastic, fantasy—a product of desire, not knowledge. The former is empirical, scientific, rational, real—and therefore authentic. This all coalesces beautifully around the story of a fire engine used on an airport runway as a place for collecting blood—or is it the story of vampires, in the guise of police or volunteer firemen, taking unsuspecting Africans off the street and removing their blood or various body parts? These are two competing versions, with different hierarchies of credibility depending on the narrator and his or her audience. "In Dar es Salaam in 1947, according to a former superintendent of police, a blood transfusion service was established but had no transport of its own, and so fire engines carried blood donors to the hospital, giving rise to the rumor 'that the vehicles, usually with a European volunteer in charge, were collecting African males for their blood and that it was a plot by Europeans to render them impotent" (441).

Jean-Pierre Bekolo, and many others of the current generation of filmmakers, would seem to be most sensitive to this "hierarchy of credibility." *Aristotle's Plot* (1996) stages competing parodies of "truth" in accounting for the paradox that characters who die in one film appear to be alive in the sequels, while *Quartier Mozart* (1992) builds around the urban stories about strange men whose handshakes render men impotent, or others who are really women in the bodies of men. As the medium that brings us closest to the imaginary, to the mirror stage in which the specular is dominant, to the realm in which the viewing subject must relinquish a hold, if only temporarily, on the credibility of an authorized account of reality, film might best provide the site for us to understand how fantasy and desire are not simply distractions from truthful accounts, but inevitable factors in the ideological interpellation of any viewing audience. Especially as realist cinema depends upon the construction of a sense of what is normal or natural, it conforms to the patterns of ideological interpellation, it mimics the structures of credibility that are inevitably enmeshed in hierarchies of power. This is Althusser's point when he identifies the "confusion" around the concept of history as arising from the common assumption that there is a one-to-one mapping between experience and history: "as it is adopted and understood [history] is an uncriticized concept, a concept which, *like all 'obvious' concepts,*

threatens to have for theoretical content no more than the function that the existing or dominant ideology defines for it" (Althusser and Balibar 1970, 93; my emphasis).

There is a direct link between film and the construction of history and time. That link is made apparent in the ideological interpellations that we see not only in the way the subject "misrecognizes" himself or herself but also in the parallel situations that arise with the focusing on the protagonists and their encounters in each film, and with the interpellations of the audience. Most of all, what constructs a sense of the linear in film, what carries the diegesis forward, is editing, and it is there that it becomes most obvious how the work of constructing a film corresponds to the work of constructing an ideology. Sembène opted from the beginning, along with the "school" that he created, to embrace a form of social realism that harmonized with the socialist realism that was dominant in the Russia studios where he, Souleymane Cissé, Abderrahmane Sissako, Sarah Maldoror, and others first learned their filmmaking. The norm was continuity editing, as in commercial western filmmaking, and that meant not the kinds of editing that marked *Touki Bouki* (1973), or even the temporality of Oumarou Ganda's *L'Exile* (1980). Bekolo's jump-cuts in *Aristotle's Plot* are redolent more of Trinh T. Minh-ha's experimentation (*Reassemblage* [1982], *Surname Viet, Given Name Nam* [1989]) than Mikhail Kalatozov's *The Cranes Are Flying* (1957), a classic Soviet realist film made just at the time Sembène was developing his project of becoming a filmmaker.

Althusser's formulation of the way historical temporality is constructed might be taken word for word as a description of the way in which film editing creates its own sense of cinematic time, duration, and structure. He begins, as Robert Young notes, by acknowledging that "periodizations differ for different times, and that each time has its own rhythms" (Young 1990, 59), and continues that one must "think these differences in rhythm and punctuation in their foundation, in their type of articulation, displacement and torsion which harmonizes these different times with one another" (Althusser and Balibar 1970, 100). We can attend to the editing "rhythm," to the way in which events are punctuated, thus marking those moments toward which the emplotment moves. In addition to the length of the scenes, the cutting, and the camera motions, which contribute to rhythm and punctuation, the articulation—literally the ways in which language is spoken, enacted, and physically embodied—generates a strong sense of duration and locale, a chronotope that conveys the immediacy of historical presence. This is reflected in the well-known disparity in running time between the original Wolof language version of *Mandabi* (1968) and the French-language version (called *Le Mandat*) that was considerably shorter, the difference of fifteen minutes being attributed to the greater length of time needed for the Wolof "articulation."

If it is the editing that accounts for the film's temporality, we need to recognize that with each character, with each subplot and sequence, a variety of temporalities is generated. The resulting temporalities form a relationship with each other and, in classic realist films, generate a relationship of dominant and

subordinated temporalities—corresponding to dominant and subordinated histories and discourses. That this is resolved, through editing, into one story, one sense of the passage of time, one history, one plot, one diegesis, attests to the ideological work accomplished through the naturalization of constructed sequences. What would function to interrupt that work of naturalization is deprived of "presence," made invisible, pushed off-frame. Althusser makes the crucial observation that the western construction of history as having a "single continuous reference time" (Althusser and Balibar 1970, 105) is responsible for such common notions as "unevenness of development, of survivals, backwardness," and even, as Young notes, "the contemporary economic practice of 'underdevelopment'—notions that provide the very basis of Western ethnocentrism" (Young 1990, 59).

Now we can see the full price of the determinism that provides the explanations or resolutions of Sembène's films. It is the dismissal of the overdetermination that accounts for the construction of a dominant temporality as the basis for a meaningful history. In other words, it is the occlusion of the competing, differential, subordinated historical possibilities; the relegation of the marginal accounts to the status of the folkloric, the invisible, the silent. Althusser's comment about the presence of one historical frame necessarily displacing any other could be transposed directly into language concerning the actor's presence before the eye of the camera, or his or her image on the editing table, functioning to displace any other's presence. Althusser writes, "The presence of one level [of a historical account] is, so to speak, the absence of another, and this co-existence of a 'presence' and absences is simply the effect of the structure of the whole in its articulated decentricity" (Althusser and Balibar 1970, 104). The correspondence between this pattern and that of patriarchal ideological normalization could not be clearer.

As with historicism, so too with economism, and finally with phallocentrism. There is a direct link between a normalized temporality and the normalizing of correlative determinisms, including those in which gender and class are incorporated. The choices that generate a sense of time, of key punctuated moments, and a movement toward a meaningful conclusion bear on all the elements that constitute the film—and especially the realist film.

The construction of a dominant temporality is also made possible through reductionist constraints imposed on plot and character—with the reduction of overdeterminism to determinism. After all, if the passage through conflict requires a certain kind of class-based opposition, that would necessarily impose limits on the range of characters and their actions. Instead of the bourgeois western cinema grounded in introspective subjectivities increasingly preoccupied with the need to overcome the obstacles to their desires, Sembène's conscientized cinema requires an overcoming of the obstacles to the audience's knowledge—thus explaining the ease with which Sembène accepted the mantle of griot, spokesperson for History, or more accurately, for Truth, just as Achebe accepted and advocated for the role of writer as Teacher. Thus in *Borom Sarret*, the cart driver leads us to recognize the folly in accepting the assurances of the

Figure 0.2. *Xala:* A policeman's boot on a coin thrown to beggars.

nouveau riche passenger, who wears a suit, shows the cart driver his money, and assures him he has "connections" that will protect the cart driver from the risks of violating the law against having carts on the plateau—a law that ensures the boundaries between rich and poor.

This is reinforced when the cart driver enters the plateau, finding himself surrounded by tall buildings whose threatening aspect is generated by the low camera angles, and whose association with white bourgeois colonial society is made through the shift in the soundtrack from kora music to Mozart. When the inevitable occurs and the policeman stops the cartman (the words "borom sarret" mean "maître de charrette," or "master of the cart"), it is so that we can learn how gratuitously cruel the instrument of the ruling class can be: the policeman stands high over the cartman, his foot on the cartman's medal, the high-angle point-of-view shot ensuring the dominating economy of their relation. This shot is duplicated in the scene at the wedding reception in *Xala*, again involving a policeman stepping on the coins intended for the beggars and staring them down with an intimidating look.

Beggars, lumpenproletariat, and poor workers all learn their place so as to enable the viewing audience to appreciate fully the true nature of the corrupt comprador class that has hijacked independence. Yet as the endings of *Borom Sarret, Tauw, Xala, Ceddo, Emitai,* and indeed *Guelwaar, Faat Kine,* and *Moolade* all show, there will be a day of reckoning, and even more a real future toward which the protagonists in each of these films direct the viewers' hopes and certainties for change. The cartman's wife carries this function in Sembène's first film, while Kine's son does so in the more recent filmwork. And often, as in *Moolade, Emitai,* and *Faat Kine,* we can expect this driving force of history to be embodied in the forceful actions of the women whose refusal of patriarchy is equally presented as the motivating force that drives History forward.

The stark contrast between this, Sembène's first-stage feminism, and the feminist critiques that developed in the west with their second-stage and third-stage feminist movements, is striking. While Sembène constructs models from the forward-looking Rama in *Xala* to the images of female solidarity and resistance in *Emitai* or *Moolade,* these are figures who stand for the ideals of the new nation and who carry its emblem forward very much in the manner of "Liberty Leading the People." They become Women. Simultaneously they serve as models for their foil, Woman-as-Victim, as given in Tauw's mother, Rama's mother Awa, Niaye in *Véhi-Ciosane* (1965), or Dieyna in "La Noire de . . . ," and others. The problem is not that Sembène does not individualize or humanize the women, nor even that they are cast as figures in the service of an allegorical function. Sembène is too good at creating comic characters not to have them rise above these limitations—two fine examples being Dieng's two wives in *Mandabi,* as well as Faat Kine and Guelwaar's wife—all very powerfully constructed characters with wonderfully compelling qualities and presence. Rather the issue is Sembène's conception of the frame within which the Woman finds herself. Invariably we are presented with a given set of "women's issues," formally and rigidly defined, beginning with Sembène's earliest filmmaking to his latest work *Moolade.* By the 1970s he was clearly conceiving of women as caught in the struggle for equality within the rigors of a male dominated, heterosexual, sexist, masculinist economy. When the daughter is raped by her father in *Vehi Ciosane* (1965) and the men in the community conspire to hide the shame; when "Pres's" sister in *Faat Kine* is compelled to play second fiddle to her brother, and when Kine leaves the bank and the manager gives the equivalent of a wolf whistle in admiration for her "chassis";[15] and when the women are subjected to classic sexist abuse as in *Moolade,* we are placed within the tightly controlled dominion of a first-wave African feminist Agenda, one carefully established in the earliest critical writings on African women's literature, *Ngambika* (Davies and Graves 1990). The second wave, typified by the reconceptualization of the site of women's subjectivity as "migrating" (Davies 1994), eschews the underlying allegorical problematics of what constitutes an identity politics for the African Woman, and opens us to the ways language and location in terms of both space and temporality provide the contours for the constitutiveness of women as a category. In Davies's view, the subjectivity of the black woman turns on the key notion of a resistance, thus preserving the core engagements inherent in the first-wave movement.

Davies places us at the edge of the dilemma that Sembène poses for us, just as does Paul Gilroy in his attempt not to relinquish an effective black subject-position that is necessary for a collective activism grounded in race. The terms of resistance were so powerfully set by Sembène and his generation, it became almost impossible for any filmmaker or novelist not to take a politically engaged position. The few exceptions of such works that appeared in the 1970s and 1980s were treated as anomalous or dismissed by such critics as Boughedir as trivial entertainment or forms of overly indulgent subjectivism. Into the former category would fall Henri du Parc's *Bal Poussière* (1988), and in the latter Djibril

Diop Mambéty's *Touki Bouki* (1973). In similar fashion, one could say that Achebe buried the pulp writing of Cyprian Ekwensi, or that Mongo Beti and Ferdinand Oyono buried that tendency in Mbella Sonne Dipoko (*Because of Women* [1970], *Black and White in Love* [1972]). It was to take a full generation before Jean-Marie Teno would appear and redefine a political cinema in which the subjective space, and not the imperial domain of a determinist History, could provide the opening for the critiques of despotism and sexism; a generation before Jean-Pierre Bekolo would train his mocking gaze on "nos ancêtres," this time not "les Gauls" but "les pères africains"—among the foremost of whom was certainly to be placed Sembène, now crowned Père de Cinéma Africain in dozens of texts and websites.

So, in a sense as Sembène has become canonized, as decolonized African culture has moved from under the heavy weight of an anticolonial or antineocolonial exigency to one now defined as postcolonial, the controlling frames of historicism and class-based analysis have been increasingly discarded. If Mambéty was once an anomaly, one might now say that Bassek ba Kobhio, the heir to the earlier generation's politics, is now a throwback.

This study is not at all interested in proving that the new paradigm of postcolonialism is sufficient to account for current cinematic production, or that a new historicism is necessarily to be created so as to allow for the playful deconstructive aspects of Teno's, Bekolo's, Mambéty's, or for that matter Nacro's films. Neither is it sufficient to place the works of Tanella Boni or Véronique Tadjo into the framework of a second-wave African feminism to account for the distance in their writings from Emecheta's *Joys of Motherhood* or Nwapa's *Efuru*. Let the great narratives of compendia studies, beginning with Janheinz Jahn's *Muntu* (1958), remain with the past and with their critical approaches to African literature and cinema always designated as "emergent" or "neo-." Rather, my interest lies in those films that are amenable to the kinds of analysis that are concerned with the ways in which desire and fantasy play decisive roles in the ideological constructions of subjectivity and agency. Lyotard's criticisms of the grand narratives of historicism or any other progressivist program, be they grounded in class, gender, or economics, are not vitiated even when considering the conditions of production in Africa.

We are called to read the forces that account for modernism or postmodernism, or globalization, not from the perspective of a dominant western culture, as has been the case of Jameson or Lyotard, or Foucault and Said for that matter. But it would be foolish to presume that there is not, and has not been, a confluence of circumstances in Africa that has accounted for, and continues to account for, modernism and globalization. After all, Europe could not have had its versions of modernism without the African or colonial other to serve as its template for alterity, and globalization cannot have its outsourcing without having its Third World sweatshops and tax-free zones to exploit. This is a study of African cinema from within the zone, and especially from within the contact zone. A new space and time are required for the terms of modernism and globalization to be understood as the property of that zone. We will start the study with

the early critical approaches in the 1960s and 1970s, and ask how it will be possible to provide new readings of the anomalous cinema that is now so much at the cutting edge of Africa's changing visual cultures. In French the term "traveling" is used to express a tracking shot. This is a study of "traveling abroad," on the track of a cinema that is always out there.

1 Did We Get Off to the Wrong Start? Toward an Aesthetic of Surface versus Depth

The premise of this chapter is that it is time to revisit the beginnings of African filmmaking and the critical responses to which they gave rise. We may now ask what limitations these beginnings might have contained, what price was paid for the approaches then taken, and whether we are still caught in those limitations (if not traps) today.

I am identifying the commencement of African filmmaking with the first films by African directors, including Vieyra, Sembène, and Ganda. The time was the late 50s and early 60s, the time of the struggle for the end of colonialism and for independence. It was a time that defined its values around the works of Fanon, Memmi, Cabral; around the war in Algeria, which accounted for the great importance that came to be attached to *The Battle of Algiers* (1965) as a signature piece of revolutionary filmmaking; around Marxist analyses of class struggle and imperialism; around the solidarity of the black struggle. It was a period that laid the foundation for the battles against neocolonialism that saw the onset of the compromised new leadership that introduced one-party states, corruption, and rule by force, thus betraying the struggle. After Senghor ascended to the presidency of Senegal, other African leaders espoused a rhetoric of Negritude, black independence, or authenticity; such leaders as Mobutu in Zaire, Idi Amin, Amadu Ahidjo, or the Emperor Bokassa, who followed in the wake of Nkrumah, Lumumba, Azikiwe, and Ben Bella, and came to be regarded as tyrants.

The project of the early filmmakers was to expose the failures of their abusive authoritarianism. By the 1970s, when Sembène attacked neocolonialism, most famously in *Xala* (1974), others like Dikongué-Pipa, challenged a patriarchy associated with traditional society, as in *Muno Moto* (1975) or *Le Prix de la liberté* (1978). By then Negritude was viewed as passé or compromised. Civil rights rhetoric, likewise, belonged to the past, especially as the liberationist struggle continued and intensified in Guinea, Angola, and Mozambique, and as Mandela and Mbeki languished on Robbin Island.

The general feeling of the time was that we could not afford to indulge in sentimental, subjective explorations of individual sensibilities and personal relations, as in European New Wave cinema, while the larger questions of life or death import for the African community were at stake. *The Wretched of the Earth* (1961) provided the model for a threefold path of liberation, passing from

subjugation and assimilation or acculturation, through the subsequent, inadequate stages of compromised independence, to the final and necessarily violent achievement of independence. This structure served as the basis for much of the critique of the period. All that remained was for the scholars of film to schematize these values. This is what Ferid Boughedir (1976) and Teshome Gabriel (1982) did, and to a large extent these approaches were to mark the later work of others like Mbye Cham (1988), Françoise Pfaff (1984), and myself,[1] as well as those who came later in the 1990s like Manthia Diawara and Frank Ukadike.

So first, I want to offer a general critique of the approaches we took at that time, to show in some detail how the film criticism of the period was schematized and how it has often carried into the present, and finally to suggest a new direction that represents something of a break with the past. It is not a question of rejecting the earlier ideals we held, not a neoconservative turning, but of seeking to understand the limitations we imposed on our thinking, so that now we may move beyond them.

We thought we were on the cusp of a new age—the struggle for decolonization in the 1950s, national liberation and revolution in the 1960s, cultural authenticity in the 1970s—these were the bywords of the period. The corresponding model for filmmaking practice involved a validation of Third Cinema, vaguely affiliated with Third Worldism, with an emphasis on realism and its offshoots, neorealism and social realism. The final goal was to be an African socialism and an African cinematic aesthetic for a conscientized African audience.

This was, in fact, a grand narrative that lagged, like all grand narratives, behind its historical moment of change. Just as the goal for national liberation was the independent nation state, Africa was becoming a site for the struggle between the superpowers of the Cold War. Hardball politics marked the efforts to gain control over the national state, and through its structures, the national resources. The grand narrative of opposition to the nascent dictatorships was grounded in a progressivist, Enlightenment model that marked everything from the monadic vision of the state as an autonomous entity to that of the individual as an autonomous subject, and of the culture as equally monadic and autonomous. Thus dependency and inauthenticity, markers of neocolonialism, were generally conflated, and were represented in Sembène's figures of the mimic, the hybrid, the westernized bourgeoisie who, like Dieng's nephew in *Mandabi* (1968), El Hadj and the ruling Chamber of Commerce in *Xala* (1974), or Barthelemy in *Guelwaar* (1992), had sold out the people. This conflation of the European with the modern was in harmony with the reigning eurocentric values that validated modernism. After all, it was the proponents of modernism who assumed that the west had invented the notion of the modern, was the site of progressive change, and had created the modern nation over against the uncivilized natives' empires or kingdoms, or the village societies inhabited by Others. It was the west that had built its own ontology on the basis of the modern self, or Same, over against the traditionalist and backward Other, and that had claimed to have developed autonomously. "We," said this west, "invented the airplane, the car, the train, whereas 'They' had never invented anything,

and moreover, had never changed." Fanon had called it a dying colonialism, but in fact this modernism had developed as a bulwark to shore up its own moribund adherence to what was a dying nationalism. The Cold War represented a national struggle for domination by two superpowers, but also was the staging ground for the demolition of national monadism: it was global linkages, globalized economies, globalized cultural exchanges, globalized subjectivities that could not be stopped, just as they were not being perceived for what they were. By the time the Cold War ended, and the last major struggle for national independence was won in South Africa, the nation–state had become increasingly irrelevant, and NGOs, those innocuous appendages, along with the IMF, World Bank, and multinationals, had moved into the vacuum (Mbembe [2001][2]). There was *nothing* in our earlier models that could account for the weakening of the state, a disintegration that is becoming so generalized that even those states once regarded as bastions of African development, like Côte d'Ivoire, or of African stability, like Cameroon, have experienced chaotic changes and loss of control over national territory.

The construction of African film criticism around the categories that were developed by Boughedir and Gabriel depended upon modernist and nationalist models that continue to inform, prescribe, and limit our thinking. We can see this in Gabriel's three-stage Fanonian model for Third World films that leads from domination to liberation—a Hegelian model of progressivist development. The first phase he terms "unqualified assimilation," which he associates with a film industry that identified with the Hollywood model, and that sought to develop entertainment films. Films were "properties" intended for mass consumption, and served to secure commercial interests rather than the social needs of the people. The style of this phase "apes" Hollywood. The second stage he terms the remembrance phase. Here the industry has become indigenized, with the committed or engagé cinema of Senegal or Mozambique serving as his models. It is termed "remembrance" because of its focus on the validation of authentic African culture and history, and he cites such filmic themes as "the clash between rural and urban life, traditional versus modern values systems, folklore and mythology" (1995, 72).[3] The last phase in this dialectic is termed the "combative" phase, and here he describes filmmaking as a "public service institution." His wording is important: "The industry in this phase is not only owned by the nation and/or the government, it is also managed, operated and run for and by the people. It can also be called a cinema of mass participation. . . . " (73). As for its themes, he writes that they focus on the "lives and struggles of Third World peoples. This phase signals the *maturity* of the film-maker and is distinguishable from either Phase I or Phase II by its insistence on viewing film in its ideological ramifications" (73, my emphasis). The adherence to the ideals of progress and development are apparent in this progression from worst to best, with the term "mature" denoting a Hegelian notion of dialectical advancement.

Gabriel's three-phase theory was developed in the early 80s and it differs little from other, similar models of the period. Here, for instance, the dominant values expressed in Ferid Boughedir's oft-cited tendencies (1976, 404–14): 1.

The socio-political tendency, marked by the struggle against colonialism or neo-colonialism, against servile imitation or alienation. Its message is "réveil"—awakening conscientization. 2. The moralist tendency, with filmmakers who "criticize the negative aspects of their society," but without "analyzing" the political-economic causes, and propose no more of a solution than individual effort. The focus is on the individual rather than the society, and the spectator is left "untouched, unimplicated" (Boughedir 1976, 80). 3. The "self-expressive" tendency where the filmmaker seeks to express his or her personal universe using avant-garde techniques. Boughedir associates this with auteur cinema, and cites *Touki Bouki* as an example. 4. A subgroup of the "self-expressive" tendency by those he terms "the narcissistic intellectual." It concerns "those African directors who are 'alienated' by their contact with the West and take their personal problem to be that of the whole nation" (81). 5. The "cultural" tendency that aims to valorize traditional culture. A model here might be *Wend Kuuni* (1982) or, in his view, *Muno Moto* (1975). He states that "it is not a question of *idealizing folklore*," but of "restoring with the greatest possible authenticity" the life and thought of the African masses (80). 6. Lastly, the commercial tendency, one that crassly embraces pure entertainment values.[4]

Boughedir creates a hierarchy of value in this list of tendencies, with a line of progress clearly evident in the chronological ordering: first there is the Hollywood entertainment industry; then the solipsism or avant-gardism of the New Wave or experimental cineastes; the quasi-ethnographic apolitical work of the culturalists (let us remember that Jean Rouch's cinema vérité was contemporary with, and influenced, the French New Wave of the 1950s); and finally, the rise of Third Cinema, the highest stage, associated with the struggle for national independence.

More recent critical developments include Ukadike and Diawara's work. Ukadike does not offer such limited tendencies as Boughedir, whose work had been published two decades before Ukadike's, but he remains sympathetic to his approach, writing, "Ferid Boughedir identified some of the principal tendencies of African cinema in his thesis *Cinéma Africain et décolonisation* [1974] [*sic*], and the classification he proposes remains germane to this discussion. But since 1974 new directions and new developments have surfaced, and for this reason I will modify or expand on his classifications" (1994, 11). We also have Diawara, who has written about three narrative forms that he identifies as having emerged in the "evolution" from FESPACO '87 to FESPACO '89. These are not hierarchized. The three movements or tendencies, as he also terms them, are "social realist," "colonial confrontation," and "back to the sources." The first is a mixed genre based on "thematizing current sociocultural issues" (1992, 141). Examples he cites are films that draw upon "contemporary experiences" that oppose tradition to modernity, oral to written, village to city, and so on. The tendency spans different modes, including melodrama, satire, comedy, and includes popular as well as serious film. The other two tendencies are thematically defined genres whose titles are self-explanatory, and that represent efforts to deal with serious issues.

Diawara is careful to avoid prioritizing these three: "it is not . . . my intention to sort out which modes of representation are wrong," he writes, but "to attempt to evaluate each narrative movement in the context of its own modes of production" (1992, 141). He avoids Boughedir's and Gabriel's scorn of the commercial by taking seriously the popular, but follows both, and especially Gabriel, in seeking to show how African filmmaking techniques differ from those that dominate European/Hollywoodian filmmaking practice, as well as to identify those that employ dominant Hollywood techniques. The first two tendencies, he avers, "borrow just as much from Hollywood as they do from auteurist European and Third World cinema" (1992, 165), but he is careful not to assign lesser values because of these borrowings: "Taken as a whole it is clear that they reflect Africa in its quest for social and economic justice (social realist), identity (return to the source), and history (confrontation). Given the importance of each of these categories, it is counterproductive to look at form alone and posit it as the criterion for a developed cinema" (164–65). He goes on to show how dominant cinematic forms are borrowed in much of the work being done by African filmmakers, and concludes, "Just as it is misleading to fetishize form for the purpose of debunking some films, it is also dangerous to impute quality to a particular film because it is more realistic than others or because it is the only avant-garde film in African cinema" (165–66). Thus Diawara avoids the dogmatism of the earlier critics, yet remains largely within their critical and epistemological frame in giving definition to cinematic form.

The focus of Ukadike's work is to demystify the nefarious effects of western misrepresentations of Africa, and to follow through with the projects of Gabriel and Boughedir. He writes, "From the beginning, the major concern of African filmmakers has been to provide a more realistic image of Africa as opposed to the distorted artistic and ideological expressions of the dominant film medium. . . . The new black African cinema concerns itself with the role film can play in building African society" (1994, 3). He views the majority of African filmmakers as united by "their art and ideology" and cites the following Third Cinema trends: 1. to decolonize the mind; 2. to contribute to the development of radical consciousness; 3. to lead to a revolutionary transformation of society; and 4. to develop new film language with which to accomplish this task. His thesis is that black African filmmaking emerged "out of the excitement of nation-building and a quest for the revivification of Africa's lost cultural heritage and identity" (1994, 7), and in this he aligns himself with the above-cited Third Worldist critics.

The challenge of this study is to ask if this ironclad ideological commitment was embraced without cost—whether a political commitment to the struggle against colonialism or imperialism could be waged without asking questions about the premises upon which the struggle based its claims. The querying begins not with a reexamination of the anticolonial struggle itself, but with an approach that relies upon tendencies, thematically defined genres, that works by a process of exclusion and difference, while ignoring borderline cases. It fixes us on an approach to film as thematic text, privileging content and hermeneu-

tics. It depends on monadism and metaphysical presence requiring a bright line between African and European, and between categories that establish difference as a form of diversity, that is, difference without *différance.*

Modernism, too, depends on difference without *différance* since it rests on the opposition/difference between modern and nonmodern, that is, modern/ traditional, modern/passé, modern/primitive. This binary sets the "modern" of western, contemporary society on one side, and the "traditional" and "primitive" on the other, relegating those who are exotically different, that is, the Other, to a disadvantaged position. No system of categories can escape this trap since all the pigeonholed categories depend upon exclusions and, ultimately, a hierarchy of naturalized values. Further, as Gikandi has so brilliantly demonstrated in *Maps of Englishness* (1996), it is utterly meaningless to assign the invention and creation of modernism to the west, while implicitly adhering to some notion that an Africa, protected or isolated from the west, was authentically traditionalist. (This is implicitly shown in Diawara's film *Rouch in Reverse* [1995], as well as his more recent *Bamako Sigi Kan* [2002], where he revisits his youth in Bamako and evokes the earlier days of mid-twentieth century African modernist styles in photography, dance, and clothing.) The very notion of tradition is a concoction of modernism; the attempt to validate African authenticity, or traditional identity, is a reaction to western domination and is betrayed by its dependence on western epistemological tools, western categories of knowledge. It assumes that Africans were not the agents in the creation of modernism—not only in Europe, but in Africa as well. The two modernisms, European and African, although different, were born in dialogue with and in response to each other and to the times—that is, as Stoler has shown (Cooper and Stoler 1997), to colonial times, and to the times when Europe's own self-image, as well as its power, wealth, and especially its development of class-conscious values, and of what constituted the bourgeois class, depended enormously upon the non-European other. That other, as a sign of difference, was repeatedly reproduced for European eyes in such venues as World Fair expositions, exotic postcards, and safari adventures in the wild, giving us everything from Tarzan to Fu Man Chu, and on and on.

Difference without *différance,* in today's parlance "diversity" or "multiculturalism," depends upon a hermetically closed, fixed, monadic vision of identity— of cultural identity, and by extension, of social identity, with people bound to such fixed entities. What we might call history, the dynamic processes through which peoples have interacted with others, changed, and acted continually to choose between options that made sense to them and had value for them, is lost in this virtual universe of authentic, traditional, and uncontaminated peoples. And there is a reason for the construction of that vision. It is what I am calling the price we paid when we adhered to the exclusionary politics of film tendencies that I outlined above—and that was to buy into a model that depended for its foundations on the very epistemology that undergirded western modernist thought. Just as western modernism could not be separated from colonial mentalities and beliefs, so did colonialism depend on modernism to validate its

racial and class practices. Ann Stoler (1995) and Anne McClintock (1995) have shown how essential colonialism was to the European bourgeois construction of itself as a class, of its class values, framed with the colonial other as its point of reference. Similarly, there was a reason for the resentments that such modernism generated in Africa (compare Towa 1979; Mudimbe 1979), and they too depended upon the interplay of power linked to colonialism. The ideological constructs that sustained the west's sense of normalized superiority depended upon two features of history: the first, articulated by Hegel and subsequent European historians like Hugh Trevor-Roper, was that Africa never participated in history until the arrival of the Europeans. Even as more recent historians have dismissed these claims as ignorant and eurocentric, they have returned in the form of historicism, that is, the progressivist notion that history has been determined by processes of movement toward higher forms of civilization. This construct depends upon a unitary conception of that linear progress, the incorporation of something we should call History as an abstract and universal chronicle that somehow has arisen above the perspectives of those who write and research it. In other words, its values are implicit and naturalized—another clear marker of ideological fashioning. Needless to say, by this account we have not escaped from the dominance of European values but simply naturalized them, and the tragic efforts of Afrocentrists to claim originary rights to civilization merely confirms this replication of the European terms that constitute historicism.

I want to break now with a past that feels like a straitjacket, with its visions of films tied to categories, and categories tied to political agendas that are themselves unwitting servants to historicist, progressivist Enlightenment thought. The problems I have outlined above lie in the incapacity of the categories to be sustained without a reliance on questionable assumptions, and worst of all on a universalizing reductionism to which the films were subjected in order that they might be squeezed into each category. Lastly, the narrow, superficial notions of political values suggested in the literal readings of the films on which these categories depended exclude the understanding of Gramscian notions of hegemony[5] and especially the Althusserian concept of ideology.[6] Without the latter, revolutionary values and structures could not separate repressive state apparatuses from new forms of repression that they themselves would be responsible for putting into place. And their normalized values, unexamined in relationship to the state apparatuses as well as the material conditions, would replicate the social order, the accompanying subject and gender positions, and eventually the increasing emptiness of its rhetoric. As the Resolution of Third World Filmmakers Meeting in Algiers in 1973 made plain, it was class values alone, class struggle alone that determined whether a film, as a people's actions, was liberating or not. Four decades of feminist thought, beginning with the French feminists of the 1960s, and continuing with the feminism of women of color, have demonstrated that liberation without considerations of phallocentrism, of patriarchy, or of color, and now without also considerations of institutionalized heterosexist normalizing, reveal the limited, indeed repressive, no-

tions of liberation we held back in the 1960s. It is not inclusion that is at stake, but hegemony in the form of dominant social practice, and more especially, the dominant symbolic order that instantiates repressive values. And feminist thought is merely the wedge to dislodge the stabilizing beams of those dated narratives that repeat the same gestures of Authority that Mbembe (2001) so ably skewers in the person of today's ruling autocrats.

I want to break with the limited approach to a cinema of boxes by challenging what I feel is the essential foundation of the modernist approach, one that would have us interpret a film according to its underlying, hidden meaning, and that functions in accordance with values that are inextricably tied to varieties of realism. Realism and its progeny are built upon the normalizing function of the dominant symbolic order, and thus reinforce its values (Barthes 1953), even when those texts purport to challenge that order by advocating revolution. Most of all, realism is built upon an epistemology that posits the binary surface/depth and privileges depth. This is because if there is one approach to textual analysis on which modernism has typically depended, it is one in which the surface is understood to be of lesser importance—that is, superficial—while the underlying meaning or value is understood to be deep, profound, and meaningful.

This dichotomy of surface/depth has provided the basis for the modernist construction of high art versus popular or commercial art, a dichotomy whose lesser term we saw so disparagingly dismissed by Boughedir and Gabriel, and many others. It is a dichotomy we have seen Karin Barber break down in her classic work on popular culture in *Readings in African Popular Culture* (1997), where she has contested the increasingly meaningless division of high, popular, commercial, or traditional culture in Africa. It is a dichotomy we would want to demolish in films like the South African *Mapantsula* (1988), where Oliver Schmitz and Thomas Mogotlane brilliantly created a "gangster" musical so as to get a truly subversive, anti-apartheid film past the South African white censors. It is a dichotomy whose poles collapse in the face of not only western postmodern films like the German *Run Lola Run* (1998), but Asian ones like *Chungking Express* (1994), Caribbean films like the Cuban *The Elephant and the Bicycle* (1994), Latin American films like the Brazilian *How Tasty Is My Little Frenchman* (1971), as well as African films like the Cameroonian Bekolo's *Quartier Mozart* (1992).

The dichotomy collapses when we go back to the past as well. If serious purpose and the dominance of realism characterized Sembène's "revolutionary" films, still there were also moments of gross comic farce, as with Ibrahim Dieng's belching, toothpicking, and toe-pulling scenes in *Mandabi*, as well as the wedding guest's nosepicking at El Hadj's wedding in *Xala*. These subordinated "low comic" elements have become dominant in many instances, especially recently in the most widely made and distributed films in more and more African countries: video drama. To take but one example, that of the melodramatic *Thunderbolt* (2000, distributed by California Newsreel), we have a narrative that thematizes an issue often found in high culture films, the conflict between western and indigenous practices, which is given in terms of "magic" versus "medicine."

This is inserted into a drama where the role of the female protagonist is subjected to a range of feminist critiques, and where the political implications of the mixed Yoruba-Igbo marriage are open to a range of interpretations, none of which would necessarily correspond to the film's literal message.

So what would a new approach look like that would take us into a new topological reading? We begin with the topology of a surface in which its opposition to a depth would no longer be possible. It is a surface where the tracing of such difference could not be done because of a reading of continuous displacements, rather than a reading of symptom to cause; a surface of deferred meanings where meaning itself, like the projectionist's light, lies on the screen. In other words, a cinematic surface—one that can yield only cinematic truth, cinematic depth, cinematic reality.

Surface versus Depth

The "Egyptian" in us can be suppressed, but he can never be quite defeated. . . .
"[T]he Egyptian or the child in us remains stubbornly there . . . "

—E. H. Gombrich, *The Story of Art*

In the summer of 2002 I visited the Tate Modern museum in London for the first time, and revisited the modernist art of the twentieth century after a long hiatus. It was inspiring to return to works that had awakened feelings of excitement thirty or more years ago, but whose impact had to be given a rest before those feelings could be revived. As it so happened, it was the early-twentieth-century work of those artists who were struggling to break with representational or figural art that struck me the most, especially one painting, Picasso's *Naked Woman with Necklace*.

It is a late Picasso, dated 1968 (executed one day before his seventy-eighth birthday), and as exhibits in the past two decades have borne out, it reveals the older Picasso's preoccupation with a kind of brutal engagement with libidinal energies, with oversized phalluses and direct exposures of female genitalia, anuses, and breasts, demonstrating especially his uninhibited openness. The lines are boldly sketched, and the colors appear to be quickly applied to a few key regions of the woman's body, which rests upon a reddish carpet of some sort. She is strongly delineated, without fine details, and her private parts are rendered public in the form of well-defined circles, round-shaped and protruding like the conical tip of a lid to a pot: nipples like large rubber erasers; a belly button like the tip of a teakettle spout; an anus like the small mouthpiece of a fountain; and a vaginal opening like a broad cleft in a rough-hewn, bearded snout. The right nipple stands staunchly upright, the left confronts us relatively directly, like the unnuanced gaze of the nude woman. Below the area of her belly is the view of her buttocks and anus, bringing into direct view all that might lie behind her. She is presented to us frontally, and we can recognize the workings of a longstanding cubist perspective that has striven to eliminate the principles of perspective and depth that would have normally complemented a realist por-

Figure 1.1. Pablo Picasso, "Naked Woman with Necklace." ©2006 Estate of
Pablo Picasso / Artists Rights Society (ARS), New York

trait of an individual whose gaze and posture would have conveyed something
of her psychological state. She is a surface figure. Not superficial, but frontally
surface. A woman who is presented for the viewer's direct gaze, a figure whose
eyes, breasts, and nipples, whose vagina and anus, and even whose roughly out-
lined toes and fingers are equally and indiscriminately opened to viewing. An
old man's viewing in which bodily discharges are as much a feature of frankness
as is the display of the parts of the body.

In one sense, we can approach this figure from a purely design point of
view, and further reduce the components of her body and the surrounding ob-
jects into geometric shapes whose distribution forms harmonies and construc-
tions that barely acknowledge their roles as bodily appurtenances of the woman
whose face is gazing at us. Indeed the transposition, or mapping, of her backside
to the frontal perspective suggests this disassemblage and reassemblage. Her
face sits in a skewed manner atop her torso, almost a mask that returns our gaze,
but also flattened into a series of circles, ovals, and tilted planes. She is the left-
over of the Picasso genre, returned from an earlier stage of purity in the 1930s,
or earlier abstraction in the teens, to this late engagement with dark red femi-
ninity, deeroticized, but libidinously charged in her posture of open availability.

What captured my attention with this figure was the understanding that Pi-
casso had deployed the techniques of cubism, now in his own personalized and
particular manner, so as to enforce the full effect of the nude woman as an ob-
ject that is completely presented to the viewer on the surface, not as what we
might call the unified subject grounded in the depth of psychological realism.
In other terms, we might claim that her openness to the complete exploration

of her parts, no longer private, no longer hidden, no longer behind or under-neath or disguised or sublimated or represented in displacement—her complete and vulgar and heavily melodramatic openness—conveys a new understanding of surfaces, of the potentiality of the surface to ensure the artistic experience.

Further, I began to view all the paintings and sculptures in the museum in light of this sense of the adequacy and necessity to engage the surface as surface, in contrast to an art of an earlier period that had struggled to convey the quali-ties and subtleties of art through the validation of depth. I reconsidered our newfound interest in popular culture, in melodrama, in video dramas, in low art, in all that we have dismissed as cheap or meretricious or unworthy of seri-ous analysis or engagement as an extension of this validation of the surface. Simultaneously, following Lacan's analysis of the mirror stage, in which the sub-ject's construction of an ego position is dependent upon the misrecognition of the imago returned to the subject's gaze, I considered the notion of depth as an extension of this act of misrecognition. It is not surprising that the mode of fiction most closely associated with depth, selfhood, personality, and back-ground meaning is realism, while its displacement shifts into the mode of ro-mance. It is appropriate that we move from the split between surface and depth to a consideration of postcolonialism following the vector established by Pi-casso's painting. I want to unpack that vector slightly, and then trace its move-ment through Gikandi and Bhabha.

Three more paintings from Picasso will serve to establish the foundation for my claims. First we have the radical opposition between cubism and his early works before 1906 that culminated in his blue and then rose phases. An example of the latter can be seen in his 1905 *Girl in a Chemise*, a classic portrait of a young woman whose slender figure is revealed beneath a semitransparent shift. The mood is quiet, contemplative—almost somber. She is a figure with a mood, with a real dimensionality, an apparent personality. Yet the right arm terminates in a truncated fashion, and the right edge of her torso beneath her breast is etched in a strong dark line. She is on the cusp of a shift that will take place with powerful consequences the following year, 1906.

In contrast, twenty-five years later, Picasso presents in all its simplicity *Acro-bat*, a silently turned line figure of a man whose extended, contorted limbs are distributed in completely two-dimensional fashion. Mood, material substance, the "presence" of his being are now mapped completely onto the surface. The "Egyptian" to which Gombrich referred in our epigraph, the one who is wedded to conventional figures of representation, is compelled by Picasso to reconsti-tute the real along new lines, lines that moved through cubism's radical as-saults on figural conventions to recast the surface as the space for aesthetic engagement.

The painting that made that cubist announcement irresistible was the monu-mental *Les Demoiselles d'Avignon* of 1907. The significance of the break this work, and the accompanying pattern of works from around this period, repre-sents can be summed up in Helen Gardner's claim in *Art through the Ages* that the "breaking-up of smoothly continuous volumes into separate if interlocking

planes leads sharply away from Realism to a concept of design independent of nature" (1980, 817–18). Gardner's comment is based on Picasso's portrait of Gertrude Stein, rendered one year before *Demoiselles*. Similarly, Herbert Read in *The Philosophy of Modern Art* struggles to evoke the dissonance that marked the departure from realistic representation, conveyed through the increasingly flat, that is to say, unemotional figures that evolve from early analytical cubism to synthetic cubism. For Read, synthetic cubism is not "dependent upon the real object in the same sense as analytical cubism"; in its more radical departures from realism, synthetic cubism recasts the object by a "process of concretion: the object emerges from the canvas like the image of a lantern-slide in the process of focusing" (1953, 42). That lantern-slide, as we know, was one of the precursors of cinema, and it rendered in silhouettes the recast images of a reality whose "concretion" emerged not through the figure but the narration in which it was ensconced. It was given depth in its embrace of what Read called a "renunciation of the grosser sensations associated with a 'too brutal and descriptive reality,' but also a progressive refinement of sensuousness itself" (43). Read would identify that refinement as the essential feature of modernism, as the essence of modern art. But refinement could only have taken form in its difference and deferring of the effects related to "grosser sensations" and "brutal" reality. Only by grounding modernity in its relationship to the gross and brutal could its refined essence, its "profound," "subtle," and "sublimated" figures find their appropriate form. Picasso provided that difference in primitivism itself— employing the mask that no longer hides the dancing figure behind its moving features but now assumes that most charged of engagements with the surfaces of the material, that of the "primitive."

> In no other artist's career has primitivism played so pivotal and historically consequential a role as in Picasso's. It was critical (though in diminishing proportions) in three periods of redirection in his work: between his return from Gosol in 1906 and the resolution of his early Cubist style in winter 1908–09; during the formation—in the context of collage and construction sculpture—of Synthetic Cubism in 1912–13; and in the new directions of both his modeled and constructed sculpture in the early thirties. Overarching these particular interventions were primitivist instincts that represented an abiding strain in Picasso's psychology. They could only have been reinforced by the continuous presence of tribal objects in his studios from 1907 until his death. (Rubin 1984, 241)

Thus does William Rubin, the curator of the monumental 1984 Museum of Modern Art (MOMA) exhibition of "primitivism" in twentieth-century art, begin his essay on Picasso, delineating the "affinity" between "the Tribal and the Modern." For Rubin, Picasso's "primitivist" instincts, like synthetic cubism, are given "concretion" by their grounding in a Real to which he remains attached throughout his career, and Rubin identifies that Real with those same masks that give primitivism its newly acquired concretion as "tribal objects." In short, Rubin constructs a Picasso in the same manner that modernism constructed its notions of tribal traditions, and he lent depth to that construction of Picasso

Figure 1.2. Pablo Picasso, "Girl in a Chemise,"
1905. ©2006 Estate of Pablo Picasso / Artists
Rights Society (ARS), New York

Figure 1.3. Pablo Picasso, *Acrobat,* 1930.

Figure 1.4. Pablo Picasso, *Les Demoiselles d'Avignon,* 1907.

by evoking his "primitivist instincts." So deep does this association go, accord-ing to Rubin, so well grounded is the "affinity," Picasso must have had "Negro blood" in his veins to account for its realization in his "psychology." Thus does Rubin return us to the nineteenth-century colonial scientism of blood and in-stinct to establish the grounding for his postcolonial, late-modernist exhibition. "So deep, indeed, was this affinity perceived to be that it engendered a myth ascribing African blood to Picasso, presumably through Spanish-Moorish de-scent" (Rubin 1984, 241)—a notion Rubin ascribes to Picasso, who "seemed to be charmed by the idea" (1984, 334, note 3) when he repeated the assertion to Rubin.[7]

The continuing prominence of *Demoiselles* can be seen in the passing refer-ence to it Holland Cotter makes in his review of a recent exhibit of African masks mounted by the Museum of African Art, Long Island City, Queens. Cot-ter's comments attest to the distance art criticism has come since Rubin's major work on "primitivism," but it also reveals the continuing correspondence be-tween the concept and modernism. Cotter writes, "Once upon a time in the

West, all African masks fell into one stylistic category: primitive. Later they were sorted out by ethnic group, one style per group, as if each group were a sealed biosphere. Now it's obvious that the real story is one of overlap and exchange, of healthy impurity, with neighbors borrowing from one another, changing what they borrow, then altering the altered version, to further or differently enhance its value or just because change feels good" (Cotter 2002, B32). We can say that this vision of Cotter's corresponds to a postcolonial perspective, and as such attests to the impact of globalized economies more than to the influence of late capitalism. Cotter's citation of the earlier phase of primitivism (the exhibit in question dates to 1984!) corresponds to the high-modernist period of late capitalism, and yet, ironically, the major exhibit mounted by Rubin at MOMA took place in 1984—hardly the distant past, as Cotter's comment would lead one to surmise. Cotter's point about the shift to ethnic groups corresponds to a model of diversity or multiculturalism that marks the end of the nationalist phase of late capitalism. The most recent model corresponds to a globalized economy where overlap and exchange are presented along lines of free market capitalism[8] and its rationale ("just because change feels good") without any acknowledgment that the conditions of exchange are even more powerfully controlled than under colonialism, that globalization implies a greatly expanded disequilibrium in economies throughout the world.

In the article, Cotter comments on the role of *Demoiselles* in African art:

> There was, after all, a reason Picasso turned to African masks for his "Demoiselles d'Avignon." He was out to rattle chandeliers, to shake art up, to blow those complacent European minds. With the assistance of Africa he did so, in an unasked-for homage to this continent that demonstrated, you might say, the upside of exoticism.
>
> Anyway, it's great that that very painting is hanging at MoMA QNS, a short walk away from "Facing the Mask." Talk about transformative interaction: historically speaking these two museums were born to be neighbors, and now, for a while, they will be. (Cotter 2002, B32)

So what does *Demoiselles* tell us about this new infusion of the "primitive" in the modernist project of recasting reality, renouncing its grosser sensations, departing from Realism and its grounding in nature? The masks provide a new grounding, and we can see, from the trajectory that leads through the relatively abstracted versions of synthetic cubism, the thoroughly simplified form of the 1930 acrobat, and the final porno renditions of the nudes by the grizzled old man, that that renunciation has nothing to do with gross qualities, but with the illusion of material substantiality, what Derrida would call the metaphysics of presence. As this presence does not entirely lose its materiality, but transposes or maps it onto the surface, we can see how the angular planes that come to take the forms of African masks for Picasso are intended to evoke the rhythms and even exoticism available to the surface of a vision spliced at an angle to the Real. As the masks move the features of the prostitutes out of whack, they begin the process of revelation and reduction to surface presentation that is com-

pleted in the late works, such as in *Nude Woman with Necklace*. This is the defining moment in modern art: *Les Demoiselles d'Avignon* validates Gikandi's central claim in *Maps of Englishness* (1996) that modernism is the product of late colonialism—not through any direct tribal influence, any gross sensation felt in the vein, but through the shared experience of a late capitalist world that defined its modernity in terms of the brutal, the primitive, and the grosser expressions of alterity.

In *Maps of Englishness,* Gikandi argues that "colonialism was a project of power and control, of domination and racial exclusiveness that, nevertheless, provided the context in which *modern* identities were constituted" (1996, 9; my emphasis). Rather than reading colonialism as belonging to the past, with its effects located in an earlier era, he sees the continuing crises in Africa as being generated around issues arising during the colonial period—its valuations of race, of the natural, normative dominance of modern values, its definitions of self and other along lines of modern and primitive—as attestations of the "incompleteness" of the colonial project. "[T]he crisis of Englishness in the present period is symptomatic of the incomplete project of colonialism, for it calls attention to the fate of powerful cultural categories forced—by decolonization and the demise of empire—to exist outside the historical conditions that made them possible" (1996, 9).[9]

African cinema has to be understood as continuing, as Gikandi would claim about postcoloniality, the incomplete project of colonialism, which is still felt in issues concerning race, the normative dominance of so-called modern values, and eurocentric definitions of self and other along lines of modern and primitive, or modern and traditional. As the cultural productions of colonialism generated realism and romance, it is there that we would look to understand the basis for the limitations of earlier African film practices and criticism. Those cultural projects developed along lines that were similarly etched in the transposition of an aesthetic of depth to one of the surface, corresponding to the history of modernism's changes in the twentieth century, not because of a western influence or domination, but because of a shared experience of late imperialism and colonialism that inscribed its values in the cartographies of colonizer and colonized, that is, of self and other—a self that could only know itself in relationship to its other, and an other that could only know itself as alienated self. This is Gikandi's major point: rather than seeing western culture—Englishness in his case, or, correspondingly, in ours, African culture, Africanness, *Africanité*—as the products of discrete, autonomous, independent projects; rather than seeing *influences* of the one upon the other, like those conventionally associated with the masks in Picasso's studio as having influenced him, and as being visible in *Demoiselles,* we need to read that creation of self and other, the processes of alterity, as having been generated across the empire by the selfsame forces responsible for the ascendancy of modernism. By these forces I don't mean simply late capitalism alone, as though modernism were a superstructure of an economic system's base, but rather that the sensibility being generated through and around the economy of late capitalism was one that fashioned it-

self into the figure of the modern individual, and that the term "modern" was always positioned against its "primitive" other within the context established through the relations of late capitalism.

Where do notions of depth and surface come into play here? The emergence of modes of fiction during the rise of colonialism that are homologous to the production of the illusion of depth, particularly in the shape of realism and romance, provided the two defining boundaries of fiction and cinema in the nineteenth and twentieth centuries. If realist fiction was the product of the industrial age, with the novels of Zola, Norris, or Sinclair serving as examples, it was because it corresponded to an understanding of social issues embedded in the stories of psychologically complete individuals. The codes that were designed to certify the authenticity of the European coal miner or factory worker were the same as those deployed in the "scientific" codifications of the "primitive" others. Gikandi showed how the travel narratives of the nineteenth century were designed to convey the traveler's perspective along the lines provided by the moral vision of English culture, and it was that moral vision that translated into the need to describe the physical contours of the land and the people—to map onto them contours already prepared for the lens of the English reader: "Within the imperial project . . . the more important question concerns the hermeneutical codes *provided by the spaces of alterity,* spaces in which . . . ideas of culture, of biology, and human nature are being reconstituted" (Gikandi 1996, 100; my emphasis). As the terrain to be mapped, the bodies and landscape, were filled in by the travelers' narratives, what took shape was the imperial vision: "we can conclude that [Kingsley] reads the space of the other as nothing less than the stage on which the history of imperial possession is dramatically displayed" (100–101). That impulse to display was generated in the bourgeois project to reshape the vision of society and the bourgeoisie's new-found dominant place within it, and it was continued in the protest fiction of realist writers. It emerged during the imperial phase as an idealized, indeed utopian vision of Manichean proportions, resulting in romance and utopian fiction, appropriate for noble savages and their discoverers—what Gikandi calls "the triumph of the English spirit unencumbered by the disease of industrialism" (101).

Three things are needed by the artist to complete the canvas of classic realism and its offshoots: an appropriate sense of time, place, and one's subject position—and all three of these emerge with the totalizing forms generated by the "modern" sensibility when confronted by the need to render accurately the other: "a progressive temporality, a linear cartography, and a unified European subject" (Gikandi 1996, 161). These are seen in colonial and national modernity, with its notion of "a unified subject whose cogito comes to self-recognition and consciousness at its moment of reconciliation with the *imperium;* the idea of a unique subjectivity; the logic of historicism and the doctrine of progress; and, ultimately, the central integers of identity itself—land, belonging, home" (Gikandi 1996, 206). These were the dominant terms that defined the colonial culture—and as the pressures for decolonization called them into

question, as the violence of capitalism in deadly conflicts took shape in the twentieth century, so too did the crisis in time, place, and subjectivity give rise to twentieth-century modernism. We can trace the trajectory of eighteenth- through twentieth-century modernism along with the mapping of depth onto surface, which gradually transposed the illusion of depth to pure illusion, and finally the abstract denial of illusionism itself.

The broad features of this argument also appeared in Homi Bhabha's analysis of the stereotype, a figure created from the anxiety and crisis related to coloni- alism. Bhabha evokes the totalizing gesture needed to provide presence to the threatened colonial subjectivity. Following Said and Foucault, he identifies the colonial regime of truth that results in realism as employing a strategy of con- structing images of presence: the "language of personhood" comes into play as it is "invested with a visuality or visibility of depth" (1994, 49). This is the workings of the agency of depth, which gives visual meaning to the unified subject, on the one hand, and coherence within the economy of alterity on the other. However, colonialism functions contradictorily, generating both dis- avowal and desire simultaneously. This is what gives instability to its signs. Bhabha represents the tropes of fetishism that solve this instability and account for the stereotype as having two faces: that seen in the totalizing work of the *metaphor* associated with narcissism, whereby the "masking function" of meta- phor works out the narcissistic impulse; and the aggressive phase of the imagi- nary that is marked by *metonymy*, which corresponds to the figuration of lack. In other words, we have both acknowledgment and disavowal: the recognition of the colonial lack "which must then be concealed gives the stereotype both its fixity and its phantasmatic quality" (77).[10]

Bhabha's argument here is quite straightforward, and it will supply the link between what I am trying to establish between the notions of surface/depth and their relationship to modernity and colonialism, and to their production in Af- rican cinema. The link is supplied by the fetish and the stereotype, figures that provide Bhabha with the key to the economy of colonialist discourse, and that provide us with an understanding of postcolonial African cinema. Fetishism represents a divided or ambiguous mode of representation. On the one hand, it is a figuration of wholeness associated with the Lacanian notion of the Imagi- nary formed in the subject during the mirror phase.[11] The subject finds or rec- ognizes itself, as Bhabha notes, through identification with an image that on the one hand supplies its need for wholeness, and yet that is "simultaneously alien- ating and hence potentially confrontational" (77). The two emotional responses to these conflicting modes of identification are narcissism and aggression—the two poles of what JanMohamed (1983) identifies with colonial fiction. One the one hand, the subject "recognizes" itself in the reflection of itself as positive and whole, given in the form of the "imago"—the complete image—and on the other it experiences itself as a being of "bits and pieces," and disavows or rejects the image, seeing in it the aggressive figure that threatens it with "lack."[12] Co- lonial, and we would add modernist, discourse is built along similar lines as we see in the totalization of the "native;" the colonial other, on the one hand, pro-

vides the regime of wholeness that is fixed into the stereotype, and on the other hand functions to mask the aggressive processes for whose purposes that stereotype is constructed. The masking function is performed by the metaphor as it supplies that comfortable, totalized image associated with the narcissistic object-choice. But this must be "inscribed on a lack which must then be concealed," and this can be seen in the repetition of the image as metonymy, ultimately giving the stereotype its two qualities of "fixity and fantasy" (77), the two poles embodied in realism and romance. As the system of stereotyping is built on the work of a disavowal that is always under the threat of the revelation, the wholeness, the plenitude of the image, the completeness of the stereotype is only a form of masking over the fearful lack. Narcissism and aggressivity compete, as seen in the two poles of the representation, those of the noble savage and the dangerous, primitive native, producing the fetish, the stereotype. This split economy must be hidden for the work of disavowal to succeed. In terms of the stereotype, it is the production or constructiveness of the image that must be concealed, as it is in both the pseudoscientific discourse that attempts to explain the inferiority of the native, all the while never questioning the reasons for that assumption of inferiority, and in the popular colonialist notions of the true nature of the native. Bhabha cites Paul Abbot, who puts it succinctly in distinguishing between the kind of disavowal required for colonialist discrimination and the repression required for the successful production of the fetish: "What 'authorizes' discrimination . . . is the occlusion of the pre-construction or working-up of difference: 'this repression of production entails that the recognition of difference is procured in an innocence, as a 'nature'; recognition is contrived as primary cognition, spontaneous effect of the 'evidence of the visible'" (79–80).

That innocently recognized nature, as it thus appears to the unreflexive eye, is what must be produced not only in the stereotype, not only in the world created by colonialism, not only in the construction of alterity in modernism, but also, above all, in the realist novel or film, which is why we can say that as long as Sembène's films adhere to a realist mode *they continue the work of producing modernist values*. Bhabha provides the link between realism and colonial discourse: "[C]olonial discourse produces the colonized as a social reality which is at once an 'other' and yet entirely knowable and visible. *It resembles a form of narrative whereby the productivity and circulation of subjects and signs are bound in a reformed and recognizable totality. It employs a system of representation, a regime of truth, that is structurally similar to realism*" (70–71; my emphasis)—a regime of truth Bhabha likens to Said's notion of Orientalism, or which we would equate with its Africanist equivalent, colonialism.[13]

If realism does the work of industrial capitalism by providing the metaphors for presence and meaning, romance completes the equation of identity by providing metonymies of stereotypes (compare Gikandi 1996). Sembène gives us both, as the familiar Dakarois denizens along with stereotyped Europeans or Moors[14] depend upon a sense of wholeness or depth that provides the illusion

and imagos from which the subject constructs identity. The crisis of colonialism, then, was always there: always generated by the simultaneous construction and "recognition" of difference, and its disavowal, its fetishization, its stereotyping. *Différance* is built around the deconstruction of such metaphysics of presence, opening the way to a return to the surface. "What is profoundly unresolved, even erased, in the discourses of poststructuralism is that *perspective of depth* through which the authenticity of identity comes to be reflected in the glassy metaphorics of the mirror and its mimetic or realist narratives" (Bhabha 1994, 48). With the developments of late modernism and postmodernism, as surface contended with depth, the crises in time, place, and subject, gave rise to twentieth-century African modalities of modernism and postmodernism. African examples that reflect this aesthetic shift would include in earlier times the novels of Amos Tutuola, the painting of Twins 77 and the Oshogbo school he influenced, and more recently the novels and plays of Sony Labou Tansi or Ben Okri.

Strange how what seemed the world of colonialism past should inform the vision of a contemporary African cinema posted into the period of the independences. We can play out the division of the two phases of modernist representation, realism and romance, by tracing the role of fetishism in specific African films, and in so doing provide an analysis not only of the motivations that might have accounted for these choices but also, more importantly, of the ways in which these motivations relate to the broad economies of desire and discourse with which modernism, postmodernism, and postcolonialism have become associated.

Sembène's realism begins with premises not too far removed from those of the colonial traveler Kingsley, quoted by Gikandi as he remarks on the need to get past the surface of impressions to the truth. In travel, according to Kingsley, we see "but the outside of people, and as we know nothing of their inner history, and little, usually, of their antecedents, the pictures which we might sketch of them would be probably as untruthfully as rashly drawn" (Gikandi 1996, 99). Gikandi indicates the three key features of realism—progressive temporality, linear cartography, and unified or fully informed subjectivity. We can easily recognize their presence in the films of Sembène, as well as with many others influenced by this aesthetic. That is, the anticolonialist rhetoric he deployed depended upon the same enabling conditions responsible for the generation of colonial discourse, because both were made possible by the structure of value in late capitalism. Sembène's apparent progressivism has always been there, and from the time of *Les Bouts de bois de Dieu* (1960) has been presented in the familiar form of the dialectic of historical materialism, the class conflict transposed first into the colonial milieu and eventually into the world of neocolonial comprador capitalism. The linear cartography of home and the world comes to life as Sembène boldly strikes out in the direction of a Wolof language soundtrack in *Mandabi* (1968). The early tracking and crane shots that re-presented Dakar in *Tauw* (1970) and *Xala* (1974), down to his more recent film *Faat Kine*

(2000), situate us in a space whose logic is never disjunctive as the camera's point of view functions to re-familiarize rather than to de-familiarize us—to situate us in the familiar.

But most of all it is the distinctive, recognizable character-types who give the Real substance. It is they who charge and motivate the plots, move the narrative, deploy a pronounced ethnocentric discourse, marked in a Wolof that provides not only the diction but the gesticulation, articulation, and tempo for the speech and accompanying action. They inscribe "authenticity" on the films' ideological claims, and can do so only with the image of depth that teleological fiction demands. What this has generated has been what Sembène's collaborators and emulators hoped would be an "African" cinema: a genuine expression answering the needs of the people through a cinema of struggle and cultural representation, defined as serious and committed; defined, that is, as the only cinema that Africa could afford. The confusion that marked Djibril Diop Mambéty's *Touki Bouki* (1973), a film that appeared only slightly earlier than *Xala* (1974), signals how powerfully Sembène's cinema of depth displaced the possibility of an alternative cinema of surface. This is because his films, following the model of auteur cinema and the Third Worldist variant of Third Cinema fashioned in the 1960s and 70s, operated on the basis of conventional binaries: serious versus light, pedagogical versus entertaining, committed versus commercial cinema. Ferid Boughedir reinforced these valuations in his columns in *Jeune Afrique* and in his study *Le cinéma africain de A à Z* (1987), and the model was followed by Med Hondo, Mahama Johnson Traore, Souleymane Cissé, Haile Gerima, and most of the other serious, politically engaged filmmakers of the period.

Ironically, as poststructuralist critics were following Barthes in holding that realism was essentially a conservative mode that reinforced dominant social values,[15] Sembène paved the way for the model of African social realism, exemplified in *Xala* but also characteristic of his historical films *Emitai* (1971) and *Ceddo* (1976), and later *Camp de Thiaroye* (1987) and *Guelwaar* (1992). What is striking about *Faat Kine* (2000) is how the movement of realism has continued into the bourgeois milieu of Dakar, while fading into the melodramatic theatricality provided by romance—as we might have expected in the alternance between recognition and disavowal.

What this cinema displaced was the modernist move of mapping depth onto the surface: the break with 400 years of realist representation, as with Picasso's turn to cubism, which reduced three-dimensional illusionism to two dimensions; and a cinematic break with what Bhabha playfully terms the "glassy metaphorics of the mirror and its mimetic or realist narratives" (1994, 48). It displaced the possibilities for a cinema shooting with a distorted lens, one that would give visibility to the surface. Instead of resolving the crisis to which modernity attested, this would have been a cinema that heightened the contradictions or aporias in the real. Djibril Diop Mambéty took inspiration from Godard in his early films *Badou Boy* (1969) and *Contras City* (1968), predecessors to *Touki Bouki* (1973). Mambéty's play along the surface could not be mistaken for a cinema of lightness or commercialization in opposition to a *cinéma*

engagé; but neither was it a cinema of realism, of social am, ameliorism, or of progressivist temporality (Boughedir dubbed it exemplary of the self-expressive tendency). It was a cinema born of that auspicious year of French cultural and political change, 1968; the same year when Ouologuem published *Devoir de violence,* Picasso painted his *Nude Woman with Necklace,* and Mambéty directed his first film, *Contras City.* Bunuel and Godard broke with the bourgeois conventions of cinema, and Mambéty was the first African director to pursue the anti-bourgeois aesthetic in his praxis. It was to take another generation before Jean-Pierre Bekolo, with *Quartier Mozart* (1992) and especially his more recent *Aristotle's Plot* (1996), was to carry on the rebellion against the weight of an increasingly burdensome seriousness and the straightjacket of the "African aesthetic."

2 Sembène's *Xala*, the Fetish, and the Failed Trickster

Fetishes in Wax and Gold

We begin with *Xala* (1974), where everything would seem to begin. The opening shots give us the celebration of independence, the betrayal of that independence, the demand for women's place, the demand for cultural autonomy. Hidden behind the public facade of an African regime are the silent, ever-present white men in business suits, the metonymies of French power and control, instantaneous signs of neocolonialism. And hidden behind the walls and doors of the home are El Hadj's daughter Rama, who regards all polygamous men (like her father) as liars, and his third wife Ngone, whose marriage is yet to be consummated. All the concealments of dissonance and crisis eventually surface. The work of the fetish, which is to make the flow of desire possible—or, as in commodity fetishism, to make exchange for surplus value palatable—depends on concealment. But as these fetishes, and these concealments, are directly bound to the open displays of desire and to what threatens that desire, we can liken their working in this film more to discrimination or public fetishization, that is, stereotyping, which displaces the hidden work in the production of class. The maneuverings and repression of class dissent that at first takes place behind closed doors moves outward into the open, with unconcealed actions: the bribing and corruption of officials, the presence of beggars, the removal of beggars from Dakar's city streets to the barren landscape on the outskirts, and finally their invasion of El Hadj's home at the end, where the concluding ritual requires a public act of humiliation and disavowal.

Laura Mulvey (1991, 1994) has analyzed brilliantly how the double function of sexual and commodity fetishism works in *Xala*. The language of concealment and of revealing, of the burial of meaning or desire in an invisible depth that can be plumbed for meaning and brought to the surface, runs throughout Mulvey's reading of fetishism. We see this in the epigraph to her article citing Teshome Gabriel, who speaks of African cultural objects as being comprised of wax, "the obvious and superficial meaning," and gold, "embedded in the art work [which] offers the 'true' meaning, which may be inaccessible unless one understands the nuances of folk culture" (Mulvey 1994, 517). What interests me is how this figure of concealment, this sign of a depth premised on an act of concealment, and a surfacing of meaning can be read in terms of modernism's join to the discourse of colonialism, and more especially how we can review the image of depth mapped onto the surface without resorting to hermeneutics,

where the intrinsic grounding of meaning in the hidden depth is assumed as the basis for the value of the interpretation.

An agenda of depth has governed our readings for a century, from the Freudian to the Marxist to the culturalist, all of which find gold—hard, valuable, and replete with meaning—buried beneath the surface of the wax that needs to be melted off for the gold to be revealed. This is the language of reading fetishes as symptoms, the language of diagnosis. And yet we cannot be free from the need to understand the fetish not only as a metaphor that covers a lack, a constructed image of fullness, wholeness, integrity, and unity that essentializes people and cultures, but especially as a product of a process of production intended to hide the underlying, concealed forces, such as sexual desire or labor. How could we not do the work of exposing that constructedness; how could we not read the fetish back to the lack, or the stereotype back to the colonial structures of domination? What would be gained by turning to Picasso's acrobat or woman with a necklace, where the concealed parts are displayed as openly as racist, sexist prejudice? Mulvey (1994) gives us the classical claims for unearthing the buried features: the symptoms are "stamped onto the surface of the colonised's existence; the underlying structures mark the lives of the ruling elite as well as the people, and signs and symptoms signal an insistent return of the repressed" (519); the surface fetish functions like a "carapace," or a mask; "psychoanalysis traces the process [of displacement] backwards" (526); the fetish "keeps the truth, which the conscious mind represses, concealed" (527), whereas "sexuality . . . is the site of the symptom, the first sign of a return of the repressed" (527). When El Hadj fails to recognize the beggar, his relative, this signals his act of repression, his "forgetting" of the production of his and the beggar's class status (528); and Ngone (El Hadj's third wife) serves as the pivot between the two fetishistic systems, the economic and the sexual, functioning like the commodity to seduce the consumer and thus conceal the processes of its/her production as object (529). The surface, which appears to convey value, is a deception, a trompe l'oeil that conceals the social reality of production (531).

Following Mulvey, the agenda would then be fixed for us: we would have to reveal what is concealed, read wax as covering so as to uncover what is really gold—not the underlying value, but the underlying system of production of value. This is understood especially as the system that has produced the fetish objects, the fancy cars, the fancy women, and, by extension, both modernism and its stereotyped or totalized figures, its primitives and its moderns. But for me, reading wax is not an attempt to return to colonialism's coherent world; it begins as an act of resistance to the agenda that ignores the production of the agenda itself. It is a move of discomfort, not unlike that of Dirlik (1997) who characterizes postcolonialism as a movement produced by the effects of globalization. But even here, in this move of Mulvey and Dirlik, and we would add Althusser, there lies the danger of discarding the wax, because if we can locate the gold only after we are told that the gold is hidden beneath the wax, we not only dismiss the wax as symptom, as false or irrelevant, but also lose it. In fact,

we cannot ignore the presence of the fetish as fetish, the stereotype as stereotype; but simultaneously, as we read it as such, we also need to make that acrobatic leap of projection that Picasso made in displaying the surfaces of the nude woman's body, where the object is no longer read as symptom or fetish, but as surface in its own right—its own concretion. In fact, we will see this later in this chapter and also in chapter 5, which deals more with Žižek, as both sinthome and *l'objet a.*

What is there in film that keeps us from seeing the surface, from projecting depth onto surface rather than reading surface as carapace over depth? Techniques intended to emphasize the naturalness of action—character development, continuity editing, shot/reverse-shot, deep focus, and camera movement—all support the two essential ingredients of film: the fact that the frames move, while their individual images are hidden in the process, giving us the illusion of motion; and also that we see, as in a mirror, a reflection of reality that like the surface of the mirror conceals entirely its quality as surface. The mirror and the motion all say, "read me for depth"; if we freeze the motion and take a look at the mirror, say from the other side, we can restore something of the surface wax to its original imprint.[1] To begin this process, we must resist the act of discarding the fetish.

The fetish objects that appear in *Xala* are presented in the opening scene in which the African businessmen displace the French members of the Chamber of Commerce, removing their statues and other appurtenances of French rule. We soon hear the speech of the new African president of the Chamber of Commerce, who ends his peroration reclaiming the members' Africanity with an invitation to El Hadj's third wedding: "Notre modernité ne nous a pas fait perdre notre africanité." (Our modernity hasn't caused us to lose our Africanity.) These are the two poles of totalizing identities and stereotypes in the film, modernity and Africanity, and the fetish objects in *Xala* all bespeak one or the other in the two sites. We need to ask about the processes of disavowal unleashed in the skewering of the African comprador class. Since that class constitutes the symptom, the publicly displayed locus for the audience's disavowal of modernism, presented in the guise of neocolonialism, what is not displayed is the production of the reading of this class as a fetish or stereotyped object. Thus we arrive at the trap of a film that critiques neocolonialism as a form of western modernism while ignoring its own grounding in those very modernist, historicist, and realist values. We stay within the "glassy metaphorics of the mirror" (Bhabha 1994, 48), that is, the conventional strictures of realism, which means that as publicly displayed symptoms the fetish objects are ostensibly no longer able to conceal the hidden truth. Indeed, we see the French businessmen hand the African business leaders briefcases of money, revealing from the outset their role as purchased tools of the French. If the fetish is the seductive figure that conceals, here it must be that truth for which they stand, the truth that they are a compromised bourgeoisie whose processes of production as such are concealed. If we then refuse to read the images purely as symptoms, we begin to

reverse the lost wax technique and can return to the quality of images on the surface of the text without having to lose the wax.

Fetishes in *Xala* circulate around various objects and figures. The film begins with the replacement of French fetish objects by their African equivalents. The decoding of the symptomology, or the moment of recognition, occurs late in the film in the scene in which El Hadj is convoked to the Chamber of Commerce scene and says to the members that he and they are all *voleurs*—thieves—all servants of the white corporations. It is a form of misrecognition,[2] since the one who makes the denunciation is split from the one who is being denounced and bears the mark of disavowal (he is accusing them) and recognition (he is one of them). But as he is no longer technically one of them, and is standing apart as he makes the accusation, he both recognizes and disavows. Fetishism for Freud is a refusal to accept the castration of the mother's phallus, and is a projection of that forbidden desire onto a metonymy for the mother's phallus; exposure of the fetish, like that of stereotypes, needs to address the processes at work in producing the fetish or stereotype. Disavowal and recognition will continue until the work of substituting the fetish for the hidden desire, or the unseen labor to use Marx's model, is understood and revealed. The lack that is covered over, the *xala*, lies not just in the impotency of neocolonialism; it also lies in the process of production engaged as a symptom openly proclaiming itself as symptom, that is, which purports to expose all the fetishization, while itself hiding its own processes of producing its symbols of truth. We never actually arrive at the point where those processes are addressed (and if we did, we would still be looking outward, away from the site from which we were viewing those processes).

It seems clear that the lack signified by *xala* points to Lacan's *objet a*.[3] In place of that object, in place of the production of the fetish object, we see a metonymic displacement of fetish objects, so that El Hadj's failed penis becomes the metonymic link to all the substitute figures for phallic potency, joining Ngone to the objects given El Hadj by the marabout, to the beggar's walking stick, to his own erect body. Ultimately, the beggars treat him as the object of aggression (spitting on him, *disavowing* him) and of narcissistic desire (he now wears the bride's tiara—*recognized* as such in the beggars' eyes). In this realist film framed so as to aggressively denounce neocolonialism, the fetish comes to be read metonymically (not, as in Mulvey, metaphorically), corresponding to Bhabha's reading of metonymy as the trope linked to aggression in the splitting caused by fetishism, and with metaphor as the trope linked to narcissism. This is the "regime of visibility" (Bhabha 1994, 79), a regime Bhabha places under the heading of stereotyping, where the visibility is tied to the scopic, the fetishistic, and the Imaginary (79). My strategy for resisting this subordination to a reading thus determined by the twin poles of metonymy and metaphor, with the reading of the fetish as symptom, would be to stop the process, stop its movement, and freeze the frame. By freezing the frames we subvert the techniques of realism, forcing ourselves to return to those elements virtually impos-

sible to hold onto with the rapid change of twenty-four frames/second, that is, with the motion. Only then can we notice composition, lighting, color, balance, mise en scene, camera angle, and so on, at a given moment. We can't "see" the depth of character, feel the full emotion, round the scene into the feel of reality. But we can embark on the search for surface, on the track of the movement that leads to fantasy and desire, sites for new readings of African cinema. One of those readings, paradoxically, would be to see in *Xala* the workings of the failed trickster. This will lead us through the role of the fetish in *Xala* to the possibility of reading it not simply as a symptom, but in Lacanian terms, as a *sinthome*.[4]

The Failed Trickster

Robert Pelton (1980) begins his authoritative study of the West African trickster with these words:

> Loutish, lustful, puffed up with boasts and lies, ravenous for foolery and food, yet managing always to draw order from ordure, the trickster appears in the myths and folktales of nearly every traditional society.(1)

In a sense this description would seem to fit El Hadj Abdou Kader Beye, the unfortunately afflicted businessman of Sembène Ousmane's *Xala* (1974), especially if we interpret the ending, as Sembène would seem to be suggesting, as the moment of a passage from capitalist, neocolonial degradation to the assumption of authentic African manhood. On the other hand, we might reverse the terms, and view El Hadj's final ordeal as a descent into the ordure of the abject, the liminal space occupied of necessity by the trickster, from which he would not be able to emerge. We might term the first the classical Sembènist interpretation, or more simply, the trickster's comeuppance. The second represents a deconstructionist's view, in which the trickster's control over the process is only apparent, as the foundation for the final transcendental transformation is called into question.

Pelton's opposition of ordure and order is built upon a more fundamental Levi-Straussian concept, the "raw" and the "cooked," that is, nature and culture. In his interpretation of the trickster's role, Pelton emphasizes the ways in which the trickster negotiates society's need for disruption in order to ensure its ultimate health; the trickster enables society to deal with ordure so as to establish order. The trickster becomes an instrument of inoculation, the one who will save Africa from AIDS by transfiguring its infected penis into a magic wand of fertility. This trickster figure is Sembène Ousmane, the putative griot[5] whose adherence to the rebellious stance of the Ceddo or, more recently, the noble but impoverished Guelwaar, was intended to provide today's youth with the backbone necessary to stand up and be counted. Sembène is, as Jane Gallop has dubbed Lacan, the quintessential prick.[6] That is, he is the "subject who is supposed to know," who tells the audience what it needs to hear, and who restores virility to the depleted organs of regeneration. Why "prick"? Gallop dubbed Lacan a "prick" since his stance of psycho-provocateur, combined with an ar-

rogant attitude toward women, seemed to have been deliberately chosen to provoke challenges to the received attitudes of deference to the authority of the analyst, "le sujet supposé savoir." Now it is Sembène who has abandoned his initial clichéd vision of the griot as exploiter provided in *Borom Sarret* (1963), and he has fallen into the griot's trap of thinking himself a mouthpiece, of being the one who can define and then speak for all those diminished beings, who have long been the butt of his humor, as well as for the weak or oppressed in need of being conscientized: the semi-évolués, the neo-colonized, the women, the masses, and, most recently, the children. Established by broad acclamation as the father of African cinema, the griot of modern Africa, the voice of the people, there is little left in his recent films *Faat Kine* (2000) or *Moolade* (2004) of the comic but sympathetic Ibrahima Dieng of *Mandabi* (1968), whose eructations have been replaced by the displacements of the trickster's erections into signs and assertions of truth. Sembène has always assumed the power of ideological, and especially dogmatic Marxist, class-based truth to sway his audience; assumed the rightness of the savoir implied in the position of the author, the director; assumed with the narrative position of the camera the very role of "griot," spokesman—a role eschewed by Trinh T. Minh-ha and, in general, feminist film critics and filmmakers for whom "speaking for" has always been understood as the conventional role of the phallocentrist.[7] The struggle between the classical ideologues of the sixties and the feminists of the nineties could not be more clearly demarcated in this gap between the male director of *Faat Kine* (2000) and the female director of *Reassemblage* (1982).

The griot represents the failure of ideology's role in the transformation of Africa from colonialism to independence. If Sembène has raised his voice to criticize that failure, it is time we now move beyond the project begun with *Le Docker noir* (1956), nostalgic though we might be for its stirrings of feeling and sentiments of justice, and face the realities of Sembène's role today, that is, the role of El Hadj Abdou Kader Beye—not as the reformed capitalist, the restored *militant,* or the revitalized symbol of an emasculated Senegal, but as the failed trickster.[8] Only as such might it be possible to return once again to Sembène's work with the hope of turning a questionable order into creative ordure.

But to arrive at a place in which ordure, or abjection, might function so as to disrupt without necessarily leading to the restitution of order—to pass beyond the conventional patterns erected into logocentric structures—we must first explore the structuralist understanding of the trickster's role as established in Pelton's work. Pelton works from a Levi-Straussian model grounded thoroughly in binary oppositions, the most fundamental of which is nature/culture. The trickster represents, for him, the guardian of the space between the two, the border figure between inner and outer, the "limen." Pelton (1980) cites Eliade, Van Gennep, and Turner in evoking the liminal period created in "shamanic and initiatory transformations" (33) in numerous rituals, including especially those that permit the initiation "communitas" to be formed. Although the space and time of the initiation community would appear to be antithetical to that of the normal social order, its function is precisely to establish that order:

"This *communitas* . . . reveals the hidden depths of social order, its true center. Thus the movement outside, where life is lived 'betwixt and between,' is in fact a movement inside, a movement disclosing the inner cohesion of society even as it makes available to society those forces of contradiction and anomaly which ordinarily seem to lie outside its scope" (34). Like Mulvey, Pelton bases his argument on the binary inner/outer, where it is the inner, hidden depth that provides the truths, despite appearances. The trickster passes from one space to the other, inhabiting the in-between liminal space, and it is the "recreative power" of the liminal state for which the trickster is the agent and symbol. Pelton cites Turner, who states, "One dies *into* nature to be reborn *from* it" (35). To understand the meaning of this role, Pelton analyzes the stories about Ananse[9] that demonstrate his disrespect for the powers of the gods, for their sacredness itself, his breaking or inverting the social rules governing incest. Ananse has intercourse with his daughter-in-law or mother-in-law, ultimately not to defy order, but to reestablish a "new ordering" of the limits of the sacred and the social.[10] Inevitably his ordering will turn on the domestication of nature—of the earth, of the creative forces of life, and most of all, of "the force that males persist in seeing as the vastest, most threatening, most essential irruption of nature into culture—woman herself" (40). Woman here is a metonymy for female sexuality, and it is the lines delineated by that sexuality and transformed by the operations of the phallus that determine the orderings of society—creating "the lines of force that bind society together" (40). Implicit in the notion of society, of center and periphery, of inner and outer, of nature and culture, is the logocentric principle or ordering, that is, the principle that requires presence for meaning to be established. And as that logos is built upon the conventions of the heterosexual binary, it is phallocentric.

"Phallocentrism" has come to stand for many things: male centeredness; masculinism; sexism; heterosexism; the association of authority with male power; and eventually, less popularly, when theorized, that set of values conventionally based on the dominance of the first term in the binary male/female.[11] For Lacan the term "phallus" varies in its meaning depending on whether it is the imaginary or the symbolic phallus. For our purposes the simplest sets of usages involve the association of the term with the object of desire, to begin with, and secondarily, after the effects of the threat of castration are experienced, the association of the term with the signifier of signifiers—the object and mechanism on which speech and the act of signification depends.[12] What is of interest to us is the centrality of the phallus in the processes of the subject entering into language use, the phallus being the object of desire for which each signifier becomes, in a sense, a substitute, a displaced object. In the "perversion" of this process the effects of castration are denied by the displacement of the desire for the phallus onto a less threatening object, that is, a fetish. Before coming to *Xala* as the fetishist's dream we need to establish one more aspect of the trickster's role, that of the mediation based on his phallus: the trickster as phallus, the trickster as linguist. For this we turn to Legba.

Pelton first presents Legba, the Fon trickster god, as Mawu's mouthpiece. He knows all the languages of Mawu-Lisa, the High Goddess of the Fon; he speaks in place of his brothers who are each given a realm of creation over which to rule; he mediates between the others and Mawu, between the sacred and the human, and, ultimately, between those on the outside of a threshold and those on the inside. For Pelton this is where the Fon understanding of reality leads them not to anomy, but to order, to a centered structure: "Legba's mediation discloses the underlying connection between the transcendent center of reality and the human matrix of life, the family" (1980, 73). The nature of that connection may be figured as sexual, as in a copulative joining in which the tongue of language is expressed with the sexual organs. This marks the very language used to describe speech itself—a language characterized by such terms as "copula," "intimate," and even "limen," understood as a sort of hymen. The ruler of this linguistic space, the one who is also ruler of the crossroads, penetrates both inner and outer spaces without occupying them; turns the hymen from a barrier into a threshold that permits intercourse between two spaces. As a result, Legba becomes the guardian of the entrances to the household, just as he is the guardian of the word:

> Legba is the divine linguist—the master of their unique dialectic, the copula in each sentence, and thus the embodiment of every limen. If the threshold has become his special place, and if he is intimately associated with the crossroads and the market, it is because he is preeminently a being of the boundaries. He has sexual relations with any woman he chooses because those boundaries—physical, social, religious, and even metaphysical—dissolve and reform in his presence. . . . [The Fon] realize that he cannot live inside their houses or reign over their kingdom; his power to open passages and shut them will serve human life, and not debauch it, provided that he not be allowed to assume control over its center. (Pelton 1980, 88)

> As both initiate and initiator, Legba puts the power of sex at the disposal of the human community. With drums and phallic dance, he ritualizes sex. That is, he takes it out of the arcane and dreadful realm of the potential and fixes it firmly in the center of social life by the use of symbolic gestures, actions, and music. By making sex ritually public, he makes it socially creative. Thus Legba's dance is repeated each time that novices are initiated into the cult of Mawu. (Pelton 1980, 92)

As with Ananse, the conjuncture of a metaphysics of the center and phallocentrism is made clear: "The ritual domesticates the power of female sexuality even as it sets free the power of male sexuality. Sex no longer threatens to introduce chaos into human order because it has become true intercourse" (Pelton 1980, 92).

Legba's foolish insistence upon sexuality, his public displays and acts turn into a principle of life and society: "He is allowed to penetrate every woman so that order can be continually enlarged. Furthermore . . . , in becoming the personal guardian of each man and woman, Legba penetrates human conscious-

ness itself. He reveals that most hidden and dangerous limen of all—the one inside each person. His ubiquity is synonymous with human life because he is identified with the inmost processes of that life" (Pelton 1980, 92).

The play of the phallus becomes the trickster's dance: the play of the signifier along the endless chain of signification; the play of the displaced desire onto the object that signifies that desire; the play of repression and supplement refigured as the ordering process whereby culture supplants nature. Mawu-Lisa chooses her daughter or son for her cult, to become *vodunsi*, "wives of the deity," their transformation to be consecrated by Legba. Legba, the embodied penis, enters the dance through the body of a young girl in this ritual, dressing her in a purple raffia skirt and a purple straw hat. Herskovits describes her role. She danced to the drums:

> When she reached the drummer, she put her hand under the fringe of raffia about her waist . . . , and brought out a wooden phallus. . . . This was apparently attached in such a way that it would remain in the horizontal position of the erect male organ, and as she danced . . . toward a large tree where many women were sitting watching the ceremony, . . . they ran from her shrieking with laughter; and they were made the butt of many jokes by the spectators. (Quoted in Pelton 1980, 101)

This is the dance of the phallus unveiled. For Lacan, the uncovering of the phallus only engenders another masking of its presence. What is striking here is the extent to which this is thematized, the extent to which the act of revealing the hidden organ engages the entire community in its act, both extending the limen to include the entire community and delineating the trickster as the figure of that liminality. "The capturing of the initiates by Mawu-Lisa is equivalent to a sexual possession, yet that possession is not complete until Legba possesses the whole people on behalf of the deity. . . . [Legba's] penis becomes a moving limen through which Mawu-Lisa passes into both initiates and society, the initiates pass from outside to inside, and 'outside' itself becomes 'inside'" (Pelton 1980, 102).

The sign of the limen is the penis: Legba's role is both to enable the passage from inside to outside, and more, to be the instrument of passage, the hidden phallus that functions to establish the reign of a hidden center by revealing the unrevealed organ responsible for its implementation: "It is Legba's penis which symbolizes, both ordinarily and most ceremoniously, the bond between the divine and the human worlds. He is a living copula, and his phallus symbolizes his being, the limen marking the real distinction between outside and inside, the wild and the ordered, even as it ensures safe passage between them" (Pelton 1980, 108–109).

What Pelton misses, in his careful elaboration of the Fon schematic design of limen, inside, and outside, is the function played by the center at every turn, with every binary pair binding up the act of interpretation into the opposition of nature and culture, and reducing the play to a purposeful teleology. Despite the pleasure he takes in the complexity and apparent ambiguity of the figure of the trickster, this comes to an end with the vision of the spiritual, sacred, or

metaphysical center on which his vision of life rests. This drives the interpretative act, leading him into the familiar pattern described by Derrida as a metaphysics of presence:

> There are thus two interpretations of interpretation, of structure, of sign, of play. The one seeks to decipher, dreams of deciphering a truth or an origin which escapes play and the order of the sign, and which lives the necessity of interpretation as an exile. The other, which is no longer turned toward the origin, affirms play and tries to pass beyond man and humanism, the name of man being the name of that being who, through the history of metaphysics or of ontotheology . . . has dreams of full presence, the reassuring foundation, the origin and the end of play. (Derrida, 1978, 292)

Like Pelton, as we shall see, Sembène's play is subordinated, *always,* to the first of these acts of interpretation, one whose dependency upon the grounding of a center and whose alienation are subordinated to an ordered epistemology.

*　*　*

What are we to make of El Hadj's xala? At first blush we understand it to symbolize the failures of Senegalese society to realize the dream of independence. This is made painfully clear with the opening shots signifying the passage from colonialism to independent African rule. The passage was compromised at the outset, as we can see with the scene in which the silent Frenchmen in business suits buy off the newly established members of the Chamber of Commerce, a thinly disguised attack upon Senghor and his administration. As El Hadj announces his marriage at the same opening scene in which the African businessmen occupy the council's chambers, the parallel between the state of affairs in the newly independent country and his own marital state of affairs is established. His xala signals the impotency of the neocolonial state. The film quickly establishes in the scenes at his two households and at the wedding the extent to which the impotency has extended its reach throughout most of the society whose members are corrupted by materialist values and dependency upon European culture. The work of resistance is located in the few who attempt to adhere to more authentic values, be they Wolof or peasant. If the function of the trickster is to enable the passage between worlds, there would seem to be little space for him to occupy in this film, centered as it is on its certainties.

The safest place for the western critic to occupy in reviewing this celebrated African classic would be to retreat into the space created by Sembène's truths; that is, to identify explicitly the ways in which the corrupted materialism corresponds to Marxist notions of commodity fetishism developed under capitalism; and further, how the third wife, rendered speechless and objectified before the lens of the camera, figures the fetishism that accompanies the male gaze.[13] All this is to leave aside the relationship between Sembène and El Hadj, a relationship seemingly denied by the filmmaker's apparent distance from the negative character he created. Put differently, all this is to leave untouched the role of the phallus as it appears in the film. The resurrection of this film from the ashes of yesterday's ideological certainties, however, depends on pulling out

El Hadj's phallus from beneath the surfaces, an action Sembène himself does not shy away from doing as literally as possible.[14] As the film's critics have often looked toward the condition of El Hadj's three wives, performing a political feminist critique, they have overlooked the possibilities of a liminality that the film desperately attempts to deny, all the while asserting its vital force. El Hadj is a failed trickster, but first we must see where he has hidden his phallus.

The most striking scene of liminal dislocation in the film occurs when El Hadj is riding an elevator, on his way to see his "cuz," a banking official from whom El Hadj is to request a loan. El Hadj has just left the president's office where he has been complaining about his convocation to a special meeting of the Chamber of Commerce—a meeting called to discuss the problems occasioned by El Hadj's bank overdrafts. Up to this point El Hadj has tried everything to rid himself of his xala, and finally has succeeded with the help of his chauffeur Modu's village marabout. However, he has paid Serigne Mada with a check that will bounce, ignoring the warning that he was given, "What one hand does, another can undo." In a sense El Hadj is riding the triumphant edge of a curve since he has managed to rid himself of the xala, and now can devote himself to his business affairs. On the other hand, though the xala is gone, he discovers his new wife Ngone is not available since she has her period, and now that he has spent his money on his third wedding and on the marabouts, his shop is empty. His major customer, Ahmed Fall, a Moor, has come to the shop looking for supplies, and when El Hadj attempts to hit him up for a loan he refuses. "We Moors are traders, not moneylenders," he tells El Hadj, while a policeman brings the president's convocation to El Hadj. Simultaneously the camera alerts us to the return of the beggars whom El Hadj has had ejected from the city, and the refrain of the beggars' playing is heard all the more insistently. The moment that El Hadj has been so desperately working for, the return of his manhood, corresponds to the moment in which are set in motion all these markers of his failure. Every scene that follows his departure from Serigne Mada marks his decline, without his knowing it.

Thus we are prepared for what follows his departure from the president's office, his descent down the elevator and the questionable reception at the bank. He expects the president to be calling the bank on his behalf, and as he departs the president's office, the president is on the phone to the bank. As he arrives, the *sous-directeur* (assistant director) is still speaking with the president, and has been alerted to El Hadj's impending visit. Either the president has lost his power to control the banker, just as we later learn at the Chamber meeting that all the members of the Chamber are being denied loans because of El Hadj, or they have conspired to eject El Hadj from their group, and the scene at the bank would then be more or less a setup that allows the president to pass the buck. In any event, it is clear by the time El Hadj leaves the bank that he will be denied his loan, and his downfall at the subsequent Chamber meeting is felt by the film's spectator as inevitable.

Following this construction we can interpret the scene in the elevator as the moment of El Hadj's fall: the president has dropped him, and although he

doesn't know it, although he thinks his xala is cured, although he now believes the president will ensure that he will obtain his loan, just the opposite is taking place on the phone. He is falling, without knowing it, as the message passes from the president to the banker. That moment of falling, like the passage from erection to flaccidity, is presented in the form of a misrecognition: thinking his phallus has made him a man again, made him whole, made him strong and erect, he constructs himself as an *homme d'affaires*, a man of business, with portfolio, business project, suit and tie, and smiling confidence. He tells his "cuz" at the bank to leave the air-conditioning on. Indeed, he cannot sleep without it. He is "modern."

However, this "modernity" is taken by some as the very sign of his in-betweenness, not his arrival at the terminus of the passage to an identity. For the Badyen, his new bride's aunt, his impotency is due to this very aspiration to be a toubab, a white-black man who is "neither fish nor fowl." For her his in-betweenness explains his impotency, gains him no credit or authority. She leaves him with Ngone, a woman that "would give any man an erection," and returns to find the sheets as she had left them. Like the trickster, he passes in and out of all the chambers of home and the world: from one wife to another, from Dakar's center, to the wealthy neighborhoods to the distant village, speaking Wolof and French. If he is a businessman, he is so in the disguise of the trickster whose passage in and out of these spaces, these tongues, these situations, is predicated on the assumption that he can outfox the opponent, and in so doing make passage fertile. Now he is caught in the moving space in between the president's office and the street below.

The descent down the elevator takes a full seventeen seconds, an enormous expenditure of cinematic time at a crucial moment in the film. In retrospect it is clear that it is a synecdoche of El Hadj's fall, although the irony of his unawareness is not yet fully apparent. His entrance into the elevator is seen through a mirror on the wall of the elevator, and the shot is set up so that we see half of his torso and head from the rear, reflected in the mirror, while simultaneously we see directly the front of his left shoulder in front of the mirror. He stands thus doubly split, like Bhabha's mimic man:[15] a partial being, bits and pieces of the man, divided against himself at the moment he thinks himself cured, whole. Sembène's portrayal of the fall, ticked off floor by floor, framed by the scene of the president calling and, on the other end, the banker receiving the message of denial, is intended to mark the trajectory of the narrative and to underscore the irony of the African protagonist thinking he can make himself whole through manipulating the corrupt practices of Senegal's new capitalist regime. But Sembène would have this portrayal of El Hadj present the dislocation of the African man as an image that is, itself, undivided in its vision of the truth. The camera shot tricks the ideology, as the trick mirror shot conveys more than a fall in fortunes, a fall in the constructedness of identity. We see a view of El Hadj that he could not see himself were he to look in the mirror, and it is more of him than what the camera sees from the front. The mirror view is partial, giving us the only view of his head—mostly the back and partially the side—along with

Figure 2.1. *Xala:* Mirror reflection of El Hadj descending in an elevator.

floors as he descends. The effect of the juxtaposition of the mirrored image and the real is to create a pure double, with a line between them—the line formed by the edge of the mirror. This doubled image, belonging not entirely to either the space of reflected or of mimetic reality, captures as best it can the liminal space of the trickster whose real visage does not belong to either realm but rather lies in between the two. It is no coincidence that El Hadj thinks he has cadged the president, as he did the marabout, and will shortly attempt to do to the banker, and that at that moment the phone message is transmitting the message that will outtrick him.

He cannot talk his way out of this situation. To understand his failure we have to return to another of the trickster's functions, his role as the translator, and specifically the one who translates what is hidden or uncomprehended, effecting the communication between those who cannot understand each other. The key to the model, to begin with, will be the act of revealing the hidden, and then, secondly, that of transforming and translating the meaning of what is hidden—Legba's true role as the linguist.

The nature of the phallus in Lacanian analysis is that it is always veiled, that even in the act of unveiling it, it remains all the more hidden by virtue of its apparent visibility. What is veiled and then revealed in *Xala* shifts from the sexual to the hidden history of expropriation, the "real history" that lies buried in the consciousness of the oppressed and that is expressed only at the end in their act of spitting on El Hadj.

El Hadj's xala is hidden. He is unaware that he is afflicted. Early in the film, he laughs and assures the president and the minister that his two wives were virgins, and that so is his third, and that he needs no aphrodisiac or magical

substances to achieve satisfaction with Ngone. He believes, like the other members of the Chamber of Commerce, that he is in on all the real secrets: he has opened his briefcase, and the covert French bribery is exposed to all the members and to the camera. He believes himself safe in his financial dealings, his secret, illegal sale of the rice subsidy. Whatever the secrets of his personal history, his business affairs, his physical condition, he believes that he is possessed of whatever knowledge and power he needs. That is why he so confidently turns the Badyen down when she requests him to sit on the mortar and to wear a caftan; why he laughs at the offers to ensure his sexual potency. He begins having turned the trick on every other opponent, including the most powerful of all, the colonialists, and has no reason to suspect that he is now in another person's grip.

The passage from hidden to open requires the movement from inner to outer space. El Hadj is presented as easily making that movement, at least until the revelation of his xala. He joins the ranks of the few who can enter into the prestigious Chamber of Commerce, and once inside, joins those who are within the inner circle of those needing to be bribed. Similarly, he passes from the public street, through the garden and corridors of the house to the inner sanctuary of the bedroom where the intimate act validating his manhood is to be performed. The outward appearance of the fetish, as Mulvey points out, is both a symptom and a disguise that calls attention to the act of putting on the disguise. Similarly the revelation of the secrets of the inner chambers of both financial and sexual commerce presents to the camera's eye, to the audience, the inner workings and symptomology of neocolonialism, the hypocrisy of the leadership's nationalist and socialist rhetoric, and, alternatively, the vacuity of the masculinist boasts of that leadership. The symptom then, corruption, lies exposed and explained through the revelatory recordings of the camera's eye and ear that capture its own obsessive character; the disguised phallus remains all the more hidden as the new symptom, the xala itself, makes its appearance.

Much of the motion after the wedding scene involves traveling to the village from the city, and then traveling back. Again there is an outer life that is carried on in Dakar, and an inner mystery that drives the symptom of failure and that is to be discovered in the village. The removal of the *déchets humains* (human rubbish), the beggars and handicapped, from the streets of Dakar to the more distant barren regions surrounding the city, is due to El Hadj's complaints. Similarly, all he needs to do to arrive at the proper village is to get into his Mercedes and have his chauffeur take him there. El Hadj cures the city of its "déchets," and his body of the appearance of a xala. Its hidden sources remain unchanged; the beggars return, his xala will return. Just as the trickster normally successfully negotiates the passage, so too El Hadj thinks he has made the run from village poverty to city wealth without having to pay the price. He has taken a third wife, the sign of his wealth, and joined the Chamber of Commerce, his sign of power. Yet the secrets return, like the repressed, to attach themselves to yet another fetish. The xala will always affect his penis, although he remains mystified as to its origins, and to his true enemy.

Sembène's Xala, *the Fetish, and the Failed Trickster* 57

Between the scene with Serigne Mada who has removed El Hadj's xala, and El Hadj's fall from power and wealth with the expulsion from the Chamber of Commerce (and the eventual reinstatement of his xala), El Hadj meets with Ahmed Fall and seeks to obtain a loan from him. In their exchange we learn the secret of their shared corruption: El Hadj has sold him under the table his quota of rice from the National Food Board, rice intended to feed those villagers starving from the drought; and with this money, has taken his third wife (money for an expensive house, a wedding, and a car as wedding gift). El Hadj has transformed the gift of food and life, with the help of the subtle, sly, conniving "Narr."[16]

The sequence of shots that follows provides external echoes of the inner moral fall exposed in this scene. And it sets up the final return of the repressed, secret history, for after El Hadj has been stripped of his second and third wives, his business, his Mercedes, his place in the Chamber of Commerce, and finally, again, his manhood, there is little work left for the xala to perform, little truth left for it to signify except for the revelation of its own working. Sembène marks the passage to this last stage by a sequence of three shots—three images that link power to the phallic economy. In the first shot El Hadj has just lost his shop and car, and has had his xala restored by Serigne Mada. He is walking down the street with Modu, dejected and depleted, while the camera fixes on the wooden stool in Modu's hand. The stool had earlier served for the chauffeur as he awaited his master: it stands in total opposition to the expensive machine he drove, and to the luxurious furniture and trappings of the second and third wives' houses. The camera then draws back, revealing in the distance the rising form of the Grand Mosqué of Dakar, standing erect between the two men. This is another moment of transition, another passage from apparent defeat to latent rebirth. Gorgui, the principal beggar, has told Modu that he can cure El Hadj if he will obey him, and as El Hadj and Modu are walking off, the mosque between them, the head of Gorgui's walking stick appears against the sky, round, firm, and in the image of a penile-shaped head, definitely phallic in form and position. The last secret stands ready to be revealed.

Sembène is about to take us as far as he can. For him, the motive of history drives the currents of our lives, and that motive is neither sacred nor formed by individual volition: it is class interest. El Hadj's crimes were crimes of the family: he betrayed his half-brother Gorgui, stole the clan's inheritance, condemned his family to death or devastation, and established the pattern of crimes that was to be repeated again when a villager observing a car accident was robbed by a Mr. Thieli,[17] the very man who replaces El Hadj on the Chamber of Commerce. If capitalist theft will ultimately turn against the thief, then history itself, and its passage through time, will function like the workings of the trickster. The origins of the theft remain bound in the hidden history of the family, where greed for private ownership made its first appearance, only to be turned quickly to the family secret, the ghost in the closet.

"What I've become is your fault," says the beggar Gorgui. What all the dispossessed have become is the fault of all the wealthy men whose train of honk-

Figure 2.2. *Xala:* The beggar Gorgui's walking stick.

ing cars is seen at the film's beginning as they are headed to the parodic scenes at the wedding. Starting with a thief's arriviste celebration at the beginning, the film ends with his comeuppance, the beggars' revenge, the return of abjection.

El Hadj is exposed to the spittle as his sordid history is unfolded before the eyes and ears of his family, of the camera—of an audience intended to understand that this private truth has a public meaning. And that meaning, beyond the film's dogmatic agenda, must be sought in the last quality of the trickster, the transformative powers of his acts of translation, the final arena of El Hadj's failure.

"Xala" is, after all, a Wolof word. The subtitle of the English version renders it as "the curse," a comic mistranslation of something much closer to impotency. How we translate "xala" might depend on the audience we wish to address (one French translation gives it as *impuissance temporaire* [in English, "temporary impotency"], without any indication of a curse or spell). Translation involves the great passage of meaning and power, which explains why Hampaté Bâ represented Wangrin, the eponymous trickster hero of Bâ's great bio-novel, as powerful and wealthy because of his ability to exploit his position as official translator. Being a translator not only puts one in close proximity to power, it allows the translator to supplant the power of the authority by feigning subordination while still controlling the communication. The lines of power that seem to pass through the translator are only apparently direct: translation is yet another form of displacement, of exposing so as the better to conceal, and by concealing continuing the work of power.

This is why El Hadj gets so upset when his daughter Rama refuses to respond to him in French. He has had his xala removed and has returned to his seat of power as CEO of his business. He opens a bottle of imported French water,

Evian, and offers this, his favorite drink, to his daughter, as he will offer her money. He assures her he will return to Adja and take care of her needs as well. He is as important as he can make himself, and it all depends upon his expressing himself in the French idiom. For Sembène's audience he represents the failures of assimilation—a mockery of the Senghorian ideal at a time when Senghor was stressing the importance of French in Senegalese education. Although he still speaks Wolof when need be, it is his less prestigious self that emerges at such times—the villager, not the *patron*. The parody of the *évolué* is what we see and hear; the maladroit figure of the man in the suit, sweating on the cart, being taken to Modu's village, out of sorts with his own origins.

Sembène is a great advocate of originary thinking: from *Ceddo* to *Emitai* to *Guelwaar* we are repeatedly told that there is an African base that underlies all the superficial differences imposed on the Senegalese, and that we can return to that base if only we shed the foreign influences brought by the Narrs, the toubabs, and, most recently, the IMF and World Bank and their foreign donors. In the case of El Hadj, who slaps his daughter down when she challenges the right of Senegalese men to be polygamists, he claims that they fought the colonialists and threw them out so that they could maintain their traditional rights, polygamy included: "Le polygamie c'est notre patrimoine religieux" (polygamy is our religious patrimony). Yet the rights of the wives to their *moomé*—their allotted period of time to have their husbands with them—are ignored by these same patriots. Sembène sees no contradiction here in espousing an "untraditional" feminist agenda along with a nativist program, as is implicit in his hostility to foreign cultural assimilation, the most nefarious effect of neocolonialism. He is confident that he can negotiate feminism and cultural nationalism on the basis of the people's rights. The negotiation is between two truths, two centers: the truth of the Wolof, best conveyed in the glamorized resistances of the Ceddo; and the beggars and peasants combined into the truth of the proletariat —two grand narratives of liberation, pan-Africanism and Marxism. At times this places Sembène in an awkward position vis-à-vis his audience: women who don't always or necessarily feel as deprived or oppressed as they are made to appear in his films; Muslims who don't feel themselves to have been the dupes of foreign proselytizers or drugged by dreams of pie in the sky so as to cope with earthly miseries. Yet Sembène does not perform the role of the mouthpiece as a function of public opinion: he is the interpreter *for* the people; closer to Guelwaar lecturing the audience at the stadium in Thiès; closer to Wangrin who decides what the message will be that he is interpreting, not simply content to parrot another's line.

This is why the scene at El Hadj's convocation to the Chamber of Commerce is so interesting. He has already fallen, as we have seen in the scene in the elevator. He doesn't know whether he will receive the bank loan, but being put off for a few days by the banker is probably enough of a clue. He had thought the president was still supporting him, but no doubt was able to figure out that if he hadn't received the loan after the intervention of the president, he probably did not still have his support, and that the convocation was to be what he feared, a

lynching. There is nothing about El Hadj Abdou Kader Beye from the beginning of the film that would lead us to think he could speak either of the two central truths so dear to Sembène, nothing except his own seemingly self-serving references to his role in the struggle for independence. And even there, little in Senegalese history would suggest that one of the early comprador businessmen would have known anything about the truths of resistance.

So it is all the more surprising that both truths come to be spoken at the convocation. Accused of corruption and malfeasance, of endangering the positions of the other members of the Chamber, El Hadj defends himself by accusing all the others of having done the same things. More importantly, he accuses them, and himself, of being miserable middlemen, "minables commissionnaires," and worse, tools of the colonialists who are stronger than ever. The full indictment is rehearsed in the novel's version: "We are nothing better than crabs in a basket. We want the ex-occupier's place? We have it. This Chamber is the proof. Yet what change is there in general or in particular? The colonialist is stronger, more powerful than ever before, hidden inside us, here in this very place" (*Xala*, Sembène 1973, 93).

This is the point at which "truth" displays its trickster function. Like Wangrin, El Hadj plays the chords of the truth when it serves his interest to do so, and the truth he claims, the trickster's truth, is that the authentic being of the African ruling class has been compromised from the outset. The battle with Senghor's Francophile and pro-western policies and views is only the surface of the struggle Sembène engages here: it is his belief that this is the struggle for the soul of his people, for their African identity. That is why El Hadj's demand that he speak in Wolof, and the ironic refusal he receives, marks the second, crucial pole of Sembène's truth claims: a Senegalese truth, a Wolof truth, in fact, it cannot be articulated in the foreign dress of the Other, much less the language of the colonizers. "Chacun de nous est un salaud" (each one of us is a bastard), he proclaims lamely in French (an irony highlighted in the film and lost in the novel, which was written, after all, in French), bringing into the open the sentiments cultivated by the narrator, the invisible camera, throughout the entire film: El Hadj transforms himself into the mouthpiece for the director's camera and his silent, implied presence.

The presence of truth's central vision need only be fully exposed for the interpreter's role of spokesman to be completed. That is the function of the final scene: El Hadj is to be transformed into his true self; his bourgeois, corrupt clothes are to be discarded, and the beneficial reinsertion into the community to be effected. For the west, spit conveys scorn and denigration; for the marabout, in tale after tale, saliva is the concrete means by which the parole and baraka of the holy man is to be transferred to the petitioner.

From the beginning of *Xala* we have been informed what to believe about the wealthy ruling class, and about the selling of women in Senegalese society. We are informed, more explicitly in the novel, what functions the different people have: the term "Badyen," for example, is translated, parenthetically, as

"the bride's aunt and her father's sister" (5); her position as double widow is patiently explained ("The traditionalists held that she must have her fill of deaths: a third victim. So no man would marry her for fear of being this victim"). And the narrator continues, the social interpreter par excellence: "This is a society in which very few women overcome this kind of reputation" (35). At times this kind of information is placed awkwardly into the mouths of the characters. Adja tells her daughter, "Without a man's help a woman has to fall back on prostitution to live and bring up her children. This is the way our country wants it. It is the lot of all our women" (38–39). This is the thinly disguised voice of the implied author. The conventional distance between the audience and the author is reduced in the film with less overt moments of translation. But the implied author's interpretation functions, like the inner truths, to enlighten and motivate the viewers. The trickster then, turned truth-sayer, plays the images before the eyes of the audience to win them over, and if the act of self-exposure will better conceal this goal, then it will be deployed as well. This is what happens when Kebe, El Hadj's greatest antagonist on the Chamber of Commerce, uses the term "trickery" to describe El Hadj's former actions as militant: "El Hadj thinks he is still living in colonial times. Those days when he harangued the crowds with his trickery are over, well and truly over. We are independent now. We are the ones who govern. You collaborate with the regime that's in power. So stop all this empty, stupid talk about foreign control" (92). In exposing El Hadj as a trickster, Kebe's accusation of empty talk has to be turned against himself, as the trickster's discourse is one that always hides in the act of disclosure.

At every point at which we try to fix the truth of the accusation, Sembène's own role returns, as in this scene, to a moment in which we can expect an articulation of the truth. At first it was with Sembène assuming the role of the griot; then that of the trickster, as one whose interpretations of neocolonial tricks enable us to pass from ignorance to consciousness. In the end, he might just as profitably might have been called the *seer-katt* or seer. We are informed what *seer-katt* means in the novel, when El Hadj thinks he is consulting with a traditional healer ("I am not a *facc-katt*—a healer—but a *seer-katt*. My job is to 'see'" [54]). In all cases, like Legba, the porter of phallic tricks, he is an interpreter, the mediator of truth. What remains unrevealed is the common appeal of griot, trickster, *seer-katt* to a difference grounded in the assumption that the truth can be known and spoken for those who are deceived. This is the difference Derrida deconstructs in his analysis of Levi-Strauss's notion of the engineer as the constructor of systems, and the *bricoleur,* the one who fashions things out of the materials at hand.[18] If the engineer is different from the *bricoleur* in the same way that the narrator differs from the trickster, then we can conclude that just as the trickster plays on the registers of a hidden phallus, so does the narrator, unbeknownst to himself, fall victim to the very play he thought to deploy for his own purposes.

The phallus that appears at the end of *Xala* is that of the "authentic African man"—it is, in fact, authenticity itself, the original history, underneath

Figure 2.3. *Xala:* Final scene of El Hadj's humiliation.

whose subsequent clothing lies the original center. When Legba pulls out that wooden phallus and the women run off screaming with laughter, it is because there is nothing funnier than a disguised phallus that pretends, or purports, to reveal its workings, especially when it is done in the service of the trickster's concupiscence.

Let us consider the figure of El Hadj Abdou Kader Beye in the final scene, standing in the center of the room, unclothed and covered with spittle, frozen in the last frames while the sounds of the spitting continue—the complete image of abjection, or ordure. We understand this is supposed to be the true ritual of restoration of manhood, and presumably of integrity, of the reestablishment of community and even family ties. He is no longer the prick, object of the camera's scorn, but now the figure of passage, the trickster who has made himself into the sign of the limen, the wooden phallus. As he stands thus all the more revealed, our eyes are turned inevitably from the unseen presence of the camera to the disgusting sight and sounds that compound his image. The unseen phallus of the center, its lens aimed at the targeted, disguised wooden phallus, elicits our repulsion, as Legba's wooden phallus did the laughter and screams. But we can choose to join this image with that of El Hadj doubled in the elevator so as to trick the trickster's trope,[19] and thus return the workings of phallocentrism against itself.

From Symptom to Sinthome

The ending of *Xala* remains the great controversial scene of the film, not only because it is disgusting, "abject," difficult for the spectators to "swallow,"

but because it is enigmatic, because its enigmatic quality translates with difficulty the symbolic, ritualistic meaning so obviously accessible to the beggars. In other words, we have a Lacanian "passage to the act" that exceeds the patterns of interpretation of symbolism.

Lacan designates a number of terms to signify that which exceeds the symbolic or the possibilities of interpretation. "L'objet petit a," or the object a, designates an irreducible "foreignness" (Lacan 1977; discussed by Žižek 1999, 30; Žižek 1991, 8), one we will associate increasingly with the dimension of displaced desire or fantasy. And for Lacan, the Real remains inaccessible, and the encounter with it, designated as "jouissance," is irreducible. For our purposes here, the phallus associated with the fetish in *Xala* is best identified as the *sinthome*, the point of support for the subject that cannot be accounted for in those specific attempts to recognize oneself through one's narcissistic or antagonistic sentiments. The reaching beyond the concrete, while adhering to what is closest to the subject's sense of itself, is evoked in the terms "passage to the act" which exceed acting out. There are two key glosses on sinthome and "passage to the act" that will open our reading of *Xala* to that dimension of the surface, of the immediately accessible plane of pure phenomenal interaction, that resists interpretation. For the term "sinthome," what Žižek calls the "point which functions as the ultimate support of the subject's consistency," we have a definition of that point by what it is not: it is "neither symptom (the coded message in which the subject receives from the Other its own message in reverse form, the truth of its desire) nor fantasy (the imaginary scenario which, with its fascinating presence, screens off the lack in the Other, the radical inconsistency of the symbolic order)" (1999, 30). Sembène's films have suffered excessively from decades of "decoding."

Like a Lacanian analysis, *Xala* tries to bring us to a moment at which we will have achieved a passage toward some kind of final understanding, one that enables us to deal with ourselves, our blockages, our limits in our relations between ourselves and others, so that we can function with some sense of completion, if not satisfaction. Conventionally, this is what Sembène seeks in terms of conscientization. But the limits to such a passage are set by the relationship between the inaccessible, as in the Real, and the constructed, as in the symbolic order. In his work, Lacan moves increasingly to the point where he seeks to have us recognize and even accept our experience of all that is impossible, inaccessible—the sinthome, jouissance, and this can be accomplished only by a recognition of the limits of our satisfaction with interpreting that which is symbolizable. Acting out is directly associated with the symbolic, whereas the "passage to the act" involves the suspension of the ties to that which makes the symbolic possible, that is, the tie to the Other. Žižek ties the knot to this reaching beyond by claiming that the passage to the act entails identification with the sinthome.

It is rather much to state so explicitly that the final scene of *Xala* is an evocation of the sinthome, but it is not too much to say that it reaches for that identification, that it passes, as much as film can, to that moment of identifica-

tion with one's "pathological singularity" as that which guarantees our consistency as subjects (Žižek 1999, 32), as the screen freezes on the frame of El Hadj covered with spit, and then goes dark as the sound of spitting continues. Off-frame we experience the sinthome of pathological repulsion.

Every claim one could make about that scene—every interpretive gesture, every reading in terms of class, authenticity, subjective insight, transformative creativity, or the trickster's creative immersion in ordure—takes us from the immediacy of our responses to the satisfaction of some accounting. My call for greater fidelity to the surface cannot eliminate that detachment from the moment, even as I reach for the least symbolic of accounts with the passage to the act. But it is enough for now to realize the gain in resisting the totalization of such closed interpretations that rest in the peace of a truth. "The *passage à l'acte* so to speak suspends the dimension of truth [since] truth has the structure of a (symbolic) fiction" (Žižek 1999, 33).

In the end, this is why we have to reject the finality of Mulvey's reading of *Xala*. We cannot pass to the act in our reading of the film; but we can resist those readings, those comprehensible forms of acting out, of interpreting and closing the book, that leave us assured that the encounter with the surface need not be sustained for us to achieve understanding. Traveling along the track of *Xala* will take us beyond that end point if our goal is not simply to mine it for the gold.

3 Cameroonian Cinema: Ba Kobhio, Teno, and the Technologies of Power

Foucault and Mbembe

Foucault is an obsessive. *Discipline and Punish* (1995) begins with the exaggerated, tortured, baroque, violent description of the drawing and quartering of the eighteenth-century regicide Damiens. We cannot read the rest of the book without the horrific images of his long, drawn-out, inhumane death remaining before our eyes, coloring our reactions. And this is not so that we will shun with abhorrence the period that tolerated such punishments and its underlying values. By the end of the book, by the time we have passed through the cusp of the end of the old regime and into the modern period, whose advent we are to associate with the end of the eighteenth century and the beginning of the nineteenth, we are given to understand that the discipline, with its modern methods, that replaced the earlier forms of punishment was in some way more totalitarian, more insidious for all its humanitarian veneer.

The association of the image of the tortured corpse of Damiens, that is, of his remaining limbs and torso, and the despotic system of power that exercised its violence on Damiens's body, remains inscribed on the power-knowledge that is translated into physical form, and thence to the music, art, architecture, and infrastructure of the dying age of royal rule. The images of punishment disappear from public view with the passing of the monarchy and the rise of the republic and its social contract; the all-seeing eye, internalized and yet ubiquitous, the diffusion and extension of authority, and most of all the replacement of an ethic of punishment by one of cure—that is, the replacement of punishment by disciplinary control—all come to define the drearier times of the modern period with its systems of social organization, from the prison to the school. Foucault joins the bloody images of Damiens to this argument in the desperate attempt to unyoke the normalizing functions that undergird the disciplinary society. As if only the abnormal, and especially its obsessive features, could serve that role of subversion.

It is with this conception of Foucault that we shall approach the recent efforts of Cameroonian filmmakers to oppose the authoritarianism of the postcolonial period. In particular, it is through this optic that we shall view the works of Bassek Ba Kobhio and Jean-Marie Teno, whose *Sango Malo* (1991) and *Chef* (1999), respectively, fall into the category of reform or protest films. The protest

is against the effects of neocolonial authoritarianism; the despots they target are Ahmadou Ahidjo and Paul Biya, and by extension the minions they came to depend upon and reward within the postcolonial state, that is, within the system Mahmood Mamdani (1996) defined as "decentralized despotism," and that Achille Mbembe (2001) associated with the autocracy of the postcolony. The challenge for this chapter is to "go a piece of the road" with Ba Kobhio and Teno, while simultaneously asking whether they are not, in the end, falling unintentionally into the trap of acceding to the very forms of disciplinary power against which Foucault wrote *Discipline and Punish*. Finally, we will explore Teno's major opus *Afrique, je te plumerai* (1992) under the optic of postmodernism and the simulacrum.

For Alain Nganang (2003) there is little question about the enlightenment goals of Teno's project (which I find basically the same as Ba Kobhio's). Thus, whereas Foucault's immersion in the macabre details of eighteenth-century torture and punishment is neither sadomasochistic nor nostalgic, but rather shocking, Teno's immersion in the slime of the corrupt Cameroonian universe is in the service of a liberationist philosophy: "Si les films de Teno insistent sur les odeurs nauséabondes des quartiers populaires, sur la pourriture des poubelles de Yaounde, sur la mort dans les prisons de New Bell, c'est pour en extraire des moments de lumière, pour mettre en evidence des poches de renaissance, des signes positives, des gestes ultimes de creation" (Nganang 2003, 211). [If the films of Teno stress the nauseating odors of popular quarters, the filth of Yaounde's garbage cans, death in New Bell's prisons, it is to draw light from those moments, to bring forward pockets of rebirth, positive signs, the ultimate gestures of creation.] Nganang easily joins the familiar discourse of an engaged politics that has defined serious African literature and cinema since the 1950s, that is, from its inception with the anticolonial struggle, to its continuation in the more recent opposition to neocolonialism. What the earlier, straightforward notions of liberationist struggle lacked can now be better understood in the present period of globalization, and that is the limitations of a protest against an apparently totalizing authority that has lost what it never really possessed, that is, total power. Here is Nganang's rendition of this ethic of resistance: "La reference de Teno au Cameroun et à ses plaies est aussi une métaphore de l'Afrique post-coloniale étranglée par des puissances citadines, une Afrique sombrant dans le bidonville, la puanteur et la violence, une Afrique violentée tous les jours par des pouvoirs inconscients et mégalomanes ainsi que par une doctrine de la 'modernité' qui n'est que la fille du colonialisme" (210–22). [Teno's reference to Cameroon and its wounds is also a metaphor for postcolonial Africa, strangled by urban forces, an Africa foundering in its slums, reeking odors and violence, an Africa raped every day by unthinking and megalomaniac powers as well as by a doctrine of "modernity" which is nothing but the scion of colonialism.] In short, the politics of resistance are built on the familiar Manichean dualism that excludes Africans and Europeans from the realm of the other, and that reimposes the European modernist vision of a modern dominant Europe and a victimized, passive, traditional, authentic Africa, a notion effec-

tively dismantled by Simon Gikandi in *Maps of Englishness* (1996). For Gikandi, modernism was produced both in Europe and in Africa—if not in concert, still in conjunction with the forces of colonialism; if not as an act of collaboration, still in relatively collaborative fashion. Africans participated not only in the fashioning and elaboration of colonial rule, but also in the constructions of modernism that were to become dominant not only in African urban centers,[1] but also in Europe.

However, it is not Gikandi to whom we shall turn for the ethical imperatives in Cameroonian cinema, as portrayed in *Sango Malo* and *Chef,* but to Mbembe, whose violet prose in evoking the autocrat of the postcolony shares much of Foucault's flavor. Mbembe turns to hilarious cartoons of the *Messager* to evoke the debased images of the autocrat. We will then ask how to read those images against those of Ba Kobhio and Teno, and what normalizing disciplines are engaged in those readings.

<p style="text-align:center">* * *</p>

Foucault begins *Discipline and Punish* with four central principles:

> —that punishment is not merely repressive, not even necessarily a punitive mechanism per se, but rather as a complex social function whose effects are "positive," that is, that produce as much as they limit. For instance, the penal system produces criminals and criminality, whereas a normative understanding of the penal system is that it is a mechanism whose goal is to stop criminality, and to limit the ability of criminals to harm honest citizens;
>
> —that punitive methods are techniques of power, punishment a political tactic (23);
>
> —that power develops its own "technologies," and through them its knowledge: both the penal system and humanistic knowledge are products of these technologies; both are knowledge in the service of a common technology of power;
>
> —that by operating upon the body, the technology of power is productive not only of a disciplined body, but of a disciplined soul. That is, the material workings of the technology of power are written on a physical surface that functions so as to produce the notion of a particular interiority—the spirit, the soul—whose reformation depends upon the effects of the actions taken upon the body (24). Thus, the oft-stated goal of modern penology is rehabilitation, not merely punishment.

The technologies of power, the inscriptions of those technologies on the body, and most of all, the creation of disciplines of knowledge that produce the criminal, the insane man, the politically marginal figure, are all integrated systems. If we assume this inverted manner of approaching power and knowledge, and seek what is produced by the exercise of power, instead of what is limited or constrained by it, we can better situate our inquiry within the specific context of postindependence Cameroon. The postcolony, ignored as such by Foucault, can profitably be subjected to a Foucauldian analysis not by asking what western epistemes have functioned to produce knowledge about Africa—not, that is, by exploring the blank darkness metaphor to ask what has produced Africa—but rather by inverting the paradigm, much as Gikandi has sought to do, and ask what Africa has produced. We are concerned not with a production that springs

from the soul, and is written on the body, but rather that springs from what is inscribed on the body, and has the effect of producing the "soul," the "African soul." This approach requires continual resistance because the decades of truisms built around the struggle against colonial oppression have themselves created such a weight of normalized knowledge that it has become almost impossible to return to a position of contested inquiry. That is why Gikandi's challenge to the received notions of a colonized Africa passively receiving Europe's modernism is so vital.

Foucault is just naturally perverse about normalized knowledge as it is seen to be the product of disciplines; his construction of the premodern royal sovereign and the modern state as antitheses provides us with an approach that will permit us to laugh at the satiric comic treatment of the oppressive autocrat whom the writer in *Le Messager* termed "Popaul" (Mbembe 2001, 150), and at the same time to develop a critique of the disciplinary assumptions of normalcy upon which Ba Kobhio and Teno build their attacks on autocracy. Mbembe's prose exudes flesh in his description of the autocrat, building a portrait of affect and gross indulgence that far exceeds the actual image itself:

> The autocrat is lying down, on his side. But not quite. Crushed up against the pillow, his right cheek is totally invisible. Of his eye on that side, practically nothing can be seen, only a hint of an eyebrow quickly lost in a wide forehead, slightly scowling, as well as one side (and half the other) of a mustache, split by a short cleft beneath a nose not snub enough. The autocrat is close-shaved. From this third of a face convoluted and variegated, just where the hair and the far cheek meet, the left ear emerges abruptly—sticking up, as if on watch, like the leaf of a kapok tree. The cheek itself droops, like a cluster of grapes—or, we might say, a bag full of wine, milk, and fat all at once. The whole lower body is wrapped in a thick blanket. This clings so closely to the form's rough lines that it clearly hints at where the flesh sticks out, where it protrudes, and where it curves—in short, its excess. (149)

In the last frame, the autocrat has woken from his nightmare. He sits up, and exposes his body to the full view of the satirist. We see a small, sweating figure contained within the frame of the cartoon, but are introduced by Mbembe to a larger-than-life image of abusive obesity, of obscenity: "Podgy pectorals overhang a misshapen abdomen. His guts, all the more conspicuous because so gross, suggest not only gluttony but all sorts of ordinary details (secretions, breath, excretions, odors, vapors, exhalations, wastes)" (153). Mbembe goes on to describe the invisible penis, completing the exposure of the dictator's symbolic order of power. He ends with the revelation: "Not so long ago he was called Ahmadou Ahidjo. Today his name is Paul Biya" (153).

The autocrat, whose portrait and voice permeate the public space and private homes—accompanying radio broadcasts, adorning walls of shops or homes, dominating the official media outlets with his presence—functions like the figure of royalty whose authority in the past marked the public space in equally visible and impressive fashion, with castles or palaces, on the one hand, and with newly inscribed orders of knowledge on the other. The munificence of Versailles

Figure 3.1. Cartoon of Popaul dreaming, in *Le Messager*.

Figure 3.2. Cartoon of Popaul troubled at night, in *Le Messager*.

and the Royal Academies that were created under Louis XIV could be associated with the presidential palace in Dakar, or Yaounde, with the inevitable appropriation of the university systems, and especially the penal system, which could not be dissociated from the requirement to make the power of autocracy visible. In Cameroon, Ahidjo's predecessor in the post of prime minister, Andre-Marie Mbida, was imprisoned under appalling conditions at Tcholliré, in a "cachot," a cell without light from which he emerged blinded after years of isolation in darkness. The deployment of a brutal police force was also intended to intimidate, not to impose a disciplinary order; to stamp the fearful image of its authority on the populace, not to institute a new order of knowledge. Elsewhere, in neighboring Nigeria, the popular executions of thieves on the beach in Lagos in the 1970s recall the violent disposition of the regicides in eighteenth-century royalist France, whereas the sign of disciplinary executions is their total seclusion from the public eye. More recent accounts of the brutal exactions of militias in Liberia and Sierra Leone, East Congo, and Darfur, indicate the proliferation of this model under conditions marked by the weakness or absence of the nation-state and its disciplines.

The visible field of knowledge produced by this autocracy is refracted through the lens of the satirist and polemicist Achille Mbembe, whose excessive prose style defines his subject along with his own critical positionality. What we see is less the knowledge produced by autocracy than that of critique, and this within the scope of contestation defined by the critic. Power and knowledge are inevitably contested spaces. Foucault describes them as exerting pressure on those who lack it, investing them through and through (27). Rather than a dialectical struggle between competing classes, Foucault describes power-knowledge as relations that "go right down to the depths of society" (1995, 27). In other words, they inform the visible, physical manifestations of the social actors through which are to be read the inscriptions on the ostensible inner being, and it is through them that the social structure is constituted. Foucault's term for that which ties the body to these relations is "technology"—a material practice through which power-knowledge is made to function: "One would be concerned with the 'body politic,' as a set of material elements and techniques that serve as weapons, relays, communication routes and supports for the power and knowledge relations that invest human bodies and subjugate them by turning them into objects of knowledge" (28). *Sango Malo* (1991) offers a perfect model for the struggle between autocratic and disciplinary forms of power and knowledge.

The Advent of the Panopticon:
From Ahidjo to *Sango Malo*

Bassek Ba Kobhio and Jean-Marie Teno are both concerned with such oppositional situations, as is Mbembe with his cartoon about the autocrat and the assembly of the "people." What is visibly exposed in gross details is the abu-

sive nature of the chief, the despot; what goes unexamined are those techniques that support the power-knowledge relations of modernity on which the film-makers build their critique. What remains to be seen is how these are con-structed as "technologies."

The technologies of power and knowledge are inscribed into *Sango Malo* with the arrival of the teacher, Bernard Malo, in the village of Lebamzip. He has just graduated from the university with a teaching degree, and has been as-signed to the village school. As he arrives, the director of the school is teach-ing what is to become Malo's class. The first image we have of the director's authority is of a classroom of students singing the national anthem and then repeating the director's words, "sit—stand—sit" and so on, as they obediently stand and sit. Meanwhile another student is being punished at the front of the room by having to touch one of his toes, bending over while the others repeat the director's instructions. The "discipline" of this old-fashioned figure of au-thority is instantly placed into the familiar mocked space marking French as-similation: he has the children recite a poem entitled "Jours d'hiver" (winter days). Malo arrives alone and on foot, and after being installed at the school quickly encounters the familiar features of the village: the greedy shopkeeper, the village drunk, the obtuse, overweening, patriarchal village chef, and so on. There is also the shopkeeper's assistant, whose two drinking friends always manage to con him into putting more drinks on the tab for them. That's as close as we get to a trickster in this serious drama, whose point is to locate the key issues of contestation between the authoritarian features of the old patriarchal order, and the new African modernism brought into town by Malo. In short, we have something of Wole Soyinka's *The Lion and the Jewel* (1963), without the benefit of Soyinka's irony, without the "lion's" sexual power or his tricks.

What the trickster would bring is something closer to the vagabond truth of what Foucault calls "the plague," that is, indiscipline, mixture: "Against the plague, which is mixture, discipline brings into play its power, which is one of analysis" (1995, 197). This discipline is what Malo imports into the village: in place of the shop owned by the exploitative, fat, mocked *chaud gar* ("hot shot") of a shopkeeper, he institutes a cooperative; in place of meaningless school dis-cipline he institutes a pragmatic curriculum of farming, carpentry, and similar physical practices. If the director's conventional curriculum was aimed at the "talented tenth," Malo's practical revolution brings in a familiar land-grant cur-riculum à la Booker T. Washington. And at every single point of village life there is an equivalent issue of old, authoritarian, or useless traditionalism set over against the correct, modern version he comes to impose. Under his direction, even the *bois sacrée* is to become the new farmland for the cooperative. Eventu-ally Malo's own absolutism does him in, alienating him from the very villag-ers he came to save. And in the process, he pays a high price: he loses his posi-tion in the school system; his father-in-law commits suicide in shame over his daughter's marriage to Malo without a dowry or festivities; and in the end the chief succeeds in having him arrested and carted off.

But we get the point. His defeat is only temporary and ostensible; the real

triumph is realized by the conscientization of the audience, as well as that of the villagers, thanks to Malo's willingness to go so far as to be sacrificed for the greater good. The real discipline of modernity prevails: not the false modernity of a glitzy eurocentric sort, but the reformist's version of a valid African modernism to be installed by those who have shaken off the deference to authority and tradition.[2] In short, the authenticity of the new discipline, the normalcy of the new discipline, and, inevitably, the power of this new pedagogy, the new science, prevails without any serious contestation.

In many African traditions, the element of disorder is represented by the trickster. For Djibril Diop Mambéty, it might be a vulture or a hyena, or it might be a wild child on a motorcycle. For Hampaté Ba, it was Wangrin, and for Soyinka Jero. The Foucauldian terms used to convey disorder, dis-ease, are the plague and, concomitantly the leper, the figure of exclusion. In *Sango Malo* we have a drunk, two con artists in a bar, a fat shopkeeper, and so on; but the prevailing gesture is not vagabondage but recuperation. The drunk is saved; the capitalist, exploitative shopkeeper is defeated; the paternal position is appropriated by Malo who impregnates his wife, the "modern-thinking" schoolteacher who takes his place. The new order is anticipated, prepared for, installed. We have thrust before our eyes the inevitability of its truth, especially as a normalized set of values. And the more this is the case, the more the film insists upon its modernist norms at every turn, and provides every question with an obvious answer, the more the disciplinary mechanism that has set up this procedure is both *exposed* and *dissembled.* This is because the actual hidden mechanism that drives the disciplinary values of the film is not the overt pedagogical program of Malo, but the cinematic apparatus that highlights his presence. His visibility, eventually his sacrifice, is stressed all the more insistently as the operations of the cinematic apparatus are obscured.

The camera functions in conjunction with the procedures that direct the audience's gaze. It is not only a racialized, acculturated, or gendered gaze that is inscribed in its look: it is productive of a space in which a normalized knowledge is installed with enormously more authority and force than that imposed by the worst excesses of the autocrat, the despot who is, after all, reduced to the image of a *chaud gar* ("hot shot") patriarch whose fat belly and bloated verbiage are all the more easily dismantled. Foucault's description of the Panopticon workings of discipline might evoke the image of a post-Enlightenment Europe in which the prisonhouse of the school, hospital, penal system, and, eventually, the entire social apparatus appear totalitarian. But the African cinematic apparatus begun in the 1960s with the reformist or revolutionary agendas of the disciplinarians of a didactic cinema met little or no resistance from those who were drawn into its gaze. *Sango Malo* is their heir, and Lebamzip the model for its knowledge—a space corresponding point by point to Foucault's disciplinary mechanism:

> This enclosed segmented space, observed at every point in which the individuals are inserted in a fixed place, in which the slightest movements are supervised, in

which all events are recorded, in which an uninterrupted work of writing links the center and the periphery, in which power is exercised without division, according to a continuous hierarchical figure, in which each individual is constantly located, examined and distributed among the living beings, the sick and the dead—all this constitutes a compact model of the disciplinary mechanism. (1995, 197)

What we can recognize in the above description might well be called the cinema hall of contemporary African cinema, and more precisely its technology. This is not a product of some sort of thoughtless imitation of European values. This apparatus has a history that is particular to the African experience, and this is precisely what colonialism, neocolonialism, and now globalization have brought.[3] If Mbembe deploys an excessive logorrhea in his vision of the autocrat now subordinated to the rationalized global order imposed by the corporate interests and the NGOs, Ba Kobhio makes use of a cooler, unobtrusive apparatus: the presence of the technology of his cinematic mechanism is never betrayed. It functions ideologically, that is, normatively; in generic terms, as a form of realism.[4] The autocrat—here the chef, in all his apparitions—is the true plague, the true leper. Not the tame drunk; not the obviously exploitative shopkeeper, but the autocratic chef, and behind him first the *sous-prefet* and then the *grand chef d'état*. The *chefferie* of autocracy figures both disorder and exclusion, because they are set off from the normalcy instantiated by the cinematic apparatus. It takes only this slight shift to read Foucault's evocation of those two figures of sickness as victims of an inevitable process of normalization:

> In order to make rights and laws function according to pure theory, the jurists place themselves in imagination in the *state of nature*; in order to see perfect disciplines function, rulers dreamt of the *state of plague*. Underlying disciplinary projects the image of the plague stands for all forms of confusion and disorder; just as the image of the leper, cut off from all human contact, underlies projects of exclusion. (1995, 198–99; my emphasis)

The coming together of plague and leper, for Foucault, was a result of "disciplinary partitioning":

> We see them coming slowly together, and it is the peculiarity of the nineteenth century that it applied to the space of exclusion of which the leper was the symbolic inhabitant (beggars, vagabonds, madmen and the disorderly formed the real population) the technique of power proper to disciplinary partitioning. (1995, 199)

Once these disciplinary forms are installed, the logical outcomes are predictable, just as the treatment of disease is predetermined: analyze the sickness, cure the diseased, if necessary amputate the diseased parts or isolate the contagious. In short, the treatment is predetermined by the assumptions of knowledge, the dictates of its power.

We are in the grips of that cinematic apparatus, that is, one that aims to cure, that partitions and assigns meaning to power, as we direct our gaze to those green hills, that red earth, those naturalized villagers—and especially that por-

trait of a distant power whose authority we are called to displace, in *Sango Malo*, as well as in Teno's *Chef.* We are all the more ensconced within the beams of the Panopticon, caught in the gaze that is felt to be our own as it carries out its invisible and verifiable function, in the service of our own *highly visible* and *unverifiable* knowledge-power: "Hence the major effect of the Panopticon: to induce in the inmate a state of conscious and permanent visibility that assures the automatic functioning of power" (1995, 201). In the imaging of local despotism cinema shares with the Panopticon the combination of a controlled viewing space, the invisible presence of the camera, and the need for the audience to follow and construct the images presented before their eyes; in other words, to gaze as both subjects and objects. The historical investments that situate that gaze are what make the village scene the product of a colonial past—the dead whose bones are continually protruding in the skeletal disposition of the village landscape, the *bois sacrée* (sacred wood)—and a postcolonial present, the living whose visibility is made to carry the burden of an invisible ideological functioning. The more conscious and permanent the visibility of the apparatus of despotism, the more generalized, normalized, and irresistible the force of the cinematic mechanism—and the more self-evident the nature of its epistemological assumptions. The cannons of the conqueror have been replaced by the cinematic apparatus, just as the Third Cinema camera-as-gun shooting twenty-four frames a second has been replaced by the technology of postcolonial realist protest cinema. "The Panopticon is a machine for dissociating the see/being seen dyad: in the peripheric ring, one is totally seen, without ever seeing; in the central tower, one sees everything without ever being seen" (1995, 201–202). In the cinematic hall, one sees and is totally seen as the image inside the mechanism becomes the mechanism within the conscious vision of the viewer.

In the process of resisting the grosser movements of dictatorship, its imprisonments, torturing, and militant mechanisms of control—or in this case, the beating and arrest of Malo toward the end of the film—we absorb a post-Enlightenment discipline that places us in line with Foucault's trajectory of the seventeenth- and eighteenth-century transition from the one extreme of "discipline-blockade" to the "discipline-mechanism." This is the passage from the autocracy of Ahidjo to the discipline of the new order instituted in Lebam-zip by the well-meaning, serious Malo:

> At one extreme, the discipline blockade, the enclosed institution, established on the edges of society, turning inwards towards negative functions: arresting evil, breaking communications, suspending time. At the other extreme, with Panopticism, is the discipline-mechanism: a functional mechanism that must improve the exercise of power by making it lighter, more rapid, more effective, a design of subtle coercion for a society to come. The movement from one project to the other, from a schema of exceptional discipline to one of a generalized surveillance, rests on a historical transformation: the gradual extension of the mechanisms of discipline throughout the seventeenth and eighteenth centuries, their spread throughout the whole social body, the formation of what might be called in general the disciplinary society. (1995, 209)

The discipline blockade for Ahidjo was Tcholliré; the new discipline mechanism in *Sango Malo* may be expressed as the new school, the pedagogy for the people, but its unexpressed mechanism is the cinematic apparatus.

Sango Malo is made to work for the project of liberation; it is in the service of a new society grounded in nonpatriarchal liberties. But as Foucault reminds us, "The 'Enlightenment,' which discovered the liberties, also invented the disciplines" (1995, 222). In an age of ever-increasing conflict and genocide, it might appear unethical to argue against a project of this film's sort when the only alternative would seem to be retrograde authoritarianism. But the vision of Djibril Diop Mambéty reminds us that the liberties that are imported into the African community in the age of the hyenas can impose a rigorous harrowing on the red earth whose flattened vistas can be extended indefinitely into a uniform future. And it is there that we might be wishing for something apparently retrograde: not necessarily in the guise of the chef or the *guide providentiel,* but more like a small man with one leg shorter than another, standing at a crossroads at dawn, ready to trip us up.

Jean-Marie Teno's *Chef:* Who Stands at the Crossroad?

Shortly after the opening scenes of *Chef* (1999) dealing with the celebration of the *chefferie* of Bandjoun, Teno records a crowd's interpellation of a young thief on the last day of the festival. The celebration had crowned the inauguration of a statue of Kamga Joseph II, the ruler who saw the invasion of the colonialists as the opportunity to modernize his state. Now, as Teno's ironic commentary has it, his golden statue stands exposed to the elements, facing beer and cigarette advertisements on billboards. The crowds dance, the male elders sing his praises; the chef is visibly moved. He extends his protective hands to his supporters, guarantees his benevolent reign will be with them.

The next morning the intersection is cold, misty, empty. Teno has gone for capturing the feel of the after-celebration at a deserted place, but instead encounters a crowd. It is there that the drama of the Panopticon's eye is brought to light with the ambiguities of Teno's role as committed filmmaker.

We see a sixteen-year-old boy held by the crowd. We see him threatened, hit. We see his closed face. We see his body as he is stripped. We see all this, which the camera captures, and which the narrator's voice describes at the same time. The narrator who identifies himself as the grandnephew of the chief of Bandjoun is manifestly our filmmaker Jean-Marie Teno. From other films, if not from personal encounters, one can recognize the voice to be that of Teno, though he never directly identifies himself. He is the one who speaks to us, while we see what the camera is showing.

Thus it is all the more bizarre that he speaks the following words at the beginning of the film: "Toi qui fait des images, ne manque pas ce weekend au chefferie. Ca va chauffer." (You who make images, don't miss this weekend at the chef's celebration. It's going to really be something.) Soon after, we learn

the words were addressed to Teno by a friend at Douala who was informing him about the celebration at Bandjoun. We are thus made aware of the presence, and personal investment, of the one *who speaks to us without ever being seen.*

When he uncovers the events in the early morning, at the crossroad, for a while the individuals who are there speak without any narrative intervention. We are brought into the episode by the immediacy of the camera's gaze, as if there were no mediating presence. However, that immediacy is broken first by Teno's voice, as he increasingly excoriates the authoritarian and cruel nature of what he terms "popular justice," and then by the interruption in the filming that occurs when a large man gives the boy a powerful blow to the head. Warned that expedient village justice might well mean death, Teno states that he then stopped filming to intervene. The screen goes black. Then the images return, and we see the boy still there, about to be led off by the crowd, first to the neighborhood *chef de quartier,* and then to the police station where those with the "right" to beat the thief will deal with him. The others observe his "human rights" by refraining from meting out expedient justice.

Where is Jean-Marie Teno in all this? In a sense, his presence is made clear by his voice, by his act of calling attention to the act of filming, by his personal references to his own position as grandnephew to the chief and later as investigator of the authoritarian practices within the culture and society—the true subject of this film. The problem of his status, his identity, would then seem to have been solved.

However, there is a difference between a visibly evoked subject and the position of the one who is evoking that visibly evoked subject. That is, there is a difference between the subject of the enunciation and that of the *énoncé.* In this case, when Teno states that a friend had told him about the festival, he brings the presence of the subject of the enunciation into line with that of the *énoncé.* He is the one filming; he is the one being addressed by his friend, and thus is the one about whom the conversation turns. However, the one who sets up this narration, who sets up the filming of the scene, who describes what the narrator-filmmaker is doing when he stops filming to intervene on behalf of the youth, remains one step behind the subject of the enunciation, invisible both to the camera and to the diegesis created for and by the camera.[5]

The Teno-narrator who becomes present to us is a guide, in fact, the "native guide" whose return home provides us with such insider information as the names of the dances that we are about to view, the *mwouop,* the *mugo,* and especially the *tso,* which "has not been seen since 1975." As his presence becomes more visible, as we see the costumed dancers indeed pass before our eyes, and as the voice now identified as the one who "likes to make images" addresses us, we increasingly lose track of the fact that those images, that voice, are themselves produced for our consumption. In other words, the more the presence of the autodiegetic narrator is evoked, and the more the images he describes are made visible, the more the process of naturalizing the scene, and of extracting its natural meaning, functions unperceived. This is the process of normalization

to which Foucault referred, especially in connection with the Panopticon as the device of observation, of knowledge-production, of ubiquitous presence—of the normalization of truth.

We thought the presence of the Teno-narrator would empower our role as observers since his point of view would not be passed off as an objective reality. The opposite occurred: the more his subjectivity came forward, the more hidden was the extradiegetic action of the cinematic apparatus, the more ostensibly natural its acts of construction of truth and reality. We have here the subject of the Panopticon as the eye that sees, as the source of knowledge, becomes a visible presence highlighted as the I of the enunciation and the I of the énoncé, and at the same time the invisible I of the cinematic apparatus. This is the technique of power of the cinematic apparatus, and in this case, the technology of a cinema of contestation for power with the system of chefs. That latter system is described as a large *chefferie* constitutive of Cameroonian society in all its manifestations, and at all levels: the village society, the village justice, the husband as chef over his wife, the nation's chef d'etat who imprisons or liberates prisoners at his arbitrary will. The stronger the filmmaker's movement of contestation, and the more moving his stories of patriarchal power that run through society, the more we are drawn into the diegesis and follow along the path naturally cleared for us by the workings of the camera. The functioning of the technique that performs this work remains always situated outside the diegesis, outside our ken.

The honesty of Teno in admitting the awkwardness of his position as relative to the chef of Bandjoun whose power is being celebrated, and who rules over the festival with evident self-satisfaction, functions to control our gaze by turning it onto Teno, his world, his presence. The workings of a subjectivized Panopticon are not deceptive, or cruel, or oppressive in and of themselves. But they cannot avoid the one inevitable trait of the discipline, and that is the disciplinary normalizing of truth. And as such, they harmonize perfectly with the governing humanistic ideology of the Enlightenment.

As the film continues after the opening scene at Bandjoun, a series of feminist talking-heads evoke the unjust relations between men and women, stressing the fact that the men have advantages and privileges over the women. The final judgment they pronounce is that the men are the chefs and the women slaves: the former have the right to decide such things as where the couple will reside; the latter are obliged by law to obey. Similarly, when Teno cum narrator turns actor and intervenes to save the youth from the vengeance of the crowd, he recounts to his film audience that this scene offers an instance of a "justice *inhumaine*," a cruel practice tolerated under a corrupt system. And when the last half of the film leads us to focus on the unjust imprisonment of Pius Njawe, again it is to bring to light the *inhuman*, degrading, bestial conditions under which prisoners are held in Newbell Prison in Douala. This is the language of the reformers; of the humanist modernism brought by the Enlightenment.

The popular eighteenth-century broadsheets about which Foucault wrote might have as their African equivalent something like market literature, or con-

temporary popular videos. They are the counterpart of what Teno terms "popular justice," that is, the quick, dirty, physically retributive and abusive justice of the mob. It is ugly; it is inscribed on the head and naked skin of the thief, as was the case with Damiens. In contrast with the retrograde *chefferie* under which all of Cameroon lives, according to Teno, true justice must stand in opposition. If the Enlightenment brought discipline, it did so in the name of natural, universal, uncorrupted justice. Perhaps the price for the latter is paid by the elevation of the former.

But justice is not evoked in this film in the form of a grand institution, with neoclassical shapes and an indomitable woman holding aloft a symbol of equal weights. Instead, it is in the more pathetic figure of "Justice N." to whom the film is dedicated. We learn that Justice N. is Justice Njawe, the daughter that Pius Njawe's wife lost when she was beaten outside the prison where he was being held while she was in her ninth month of pregnancy. We are shown that Pius Njawe, imprisoned for reporting that the head of state might have been ill, learned, during his year of imprisonment, of the absolutely horrendous conditions under which the prisoners were detained, and of the absolute corruption of the judicial system that held them in thrall. We also learn of Njawe's determination to create a foundation on the prisoners' behalf, on his release, one dedicated to the amelioration of the prisoners' dire conditions. The name of the foundation is Justice Njawe Foundation.

Njawe's words about the judicial and penal system echo those of Foucault when Njawe states, "J'ai appris que le prison, c'est l'affaire des pauvres" (I learned that prison is the affair of poor people), and that the legal system consists of nothing so much as a bartering over bribes at all levels. Whereas Foucault evoked this class difference in terms of the modern penal system, the disciplinary system that defines crimes for the poor in one way, and those for the wealthy in another, Njawe refers us to a predisciplinary system of injustice, one in which it would seem that only reform, if not revolution, can address its ills.

The great cry of *Chef* is "Qui est le chef?" The film answers this question for us, over and over, and ends with a powerful appeal to right the wrongs experienced by Pius Njawe, and more generally by all the people of Cameroon forced to live under "démocratie apaisé," another name for dictatorship. We are provided with these answers; we are disciplined in the process of accepting them. However, most of all, we are not left with any alternative to Justice N.

Afrique, *Alouette—A Bird's-Eye View*

Afrique, je te plumerai (1992) is cast in the mold of the docu-memoir, where Teno presents us with both the history of Cameroon's passage from colony to neocolony, and with his own passage from child-consumer of the colonial texts (Indian films, action comic books, colonial histories) to the conscientized producer of knowledge/film. His investigations of Cameroon's colonial past are intended to bring to light the failures to achieve real independence.

The wonderfully ironic tone he deploys, and the reenacted scenes with figures representing authority (as with the Cameroonian TV executive), or those who can remember the events in Cameroon's past struggle for independence (like Ernest Moumie's father), serve his double project of demystification and resistance. The title conveys both qualities: the exposure of the past oppression by the French, and the present plucking of the continent by the former masters. Only the narrator's own voice goes unaccounted for: we see what he wants us to criticize, but not the actions of construction, much less misrecognition, that make the critique possible.

On the surface, *Afrique je te plumerai* falls into all the traps of African *engagé* cinema. They operate in the techniques of cinematic *témoignage* that put before our eyes the images of truth, of reality. Interviews, or better, archival footage from the colonial period enable us to hear the old voiceover of colonial films with their unabashed European, imperialist biases, and to witness directly how films of past colonialists presented colonialism to themselves, so that we, with our contemporary eyes and ears, can be distanced from them. However, nothing in *Afrique* turns the filmmaker's gaze back on himself, or on his practice—on his act of gazing at us, at his own "technology." This leaves his point of view, our assumed shared point of view, normalized. The mediation is made invisible—at degree zero: the historians or activist talking-heads are presented as direct transmitters of truth, eyewitnesses, givers of accounts that finally reveal reality as seen through the eyes of Africans, and thus counter the biased accounts of the colonialists. The space of a hybridity grounded in difference, where the ambiguity of the colonial discourse renders uncertain or contradictory its subject position, cannot be established here where the very act of filming, the cinematic articulation, is as transparent as the image of the unseen Jean-Marie Teno whose narration provides the voiceover.

Afrique is not a child of the Sembène *engagé* film as say *Le Grand Blanc de Lambaréné* (1995) or *Sango Malo* (1991) might be: as a nonfiction account it attempts to provide its message directly. Sembène believed that even the most didactic message should be housed in an entertaining fictional form. Teno is closer to Achebe cum pedagogue here and in *Chef* in that he openly embraces the role of filmmaker as educator[6] and militant; he clearly made this film so as to respond to all those French, and even German, films he excavated from the colonial archive that so openly, naively (to our sensibilities), and directly vouchsafed the values of the colonial project. *Afrique* offers a response to racism, to the historical abuses of colonialism and to the rhetoric of the civilizing mission, as well as to its continuation into the postindependence period with the regimes of Ahidjo and Biya.

Afrique, then, is on one level a reconstituted history of Cameroon, the "true" history, first obscured by the colonialists and then by the subsequent puppet neocolonialist regimes. It is positioned as a regime of truth in response to past regimes of lies; it offers an enlightened view of the revolutionary, resistant, progressive past, an African view by an "indigène," as Teno calls himself—a native tour by a native guide who sets out the images, stories, interviews, and footage

of a Cameroon that is so familiar it is as if it has been presented forever this way by the mainstream African voices since Oyono and Beti in the 1950s. In other words, although positioned as a new response, it is really an old story. One might cite, as one of many examples, Mongo Beti's *Main basse sur le Cameroun* as a kind of ghost whose vision of Cameroon haunts this film.[7]

To the extent to which we can fit *Afrique* into a pedagogical scheme, we can identify its strengths and its limitations. Its truth claims are the first place we would turn to evaluate its success as an educational project. Its strength as a historical reconstruction depends on the rallying of facts, its rhetoric, on which the ultimate message of liberation depends. The voiceover narrator leaves no doubt as to his intention: "un homme qui prend la parole est ainsi un homme libre" (a man who speaks out is a free man). There is no wiggle room for questions about what is involved in seizing the word, in speaking out, or in being a free man. Nor is there room for uncertainty about the economy of truth on which the certainties involved in speaking out and freedom are based. Speaking out is defined by the notion of giving an African voice where previously there had been only European or assimilated, imitative voices;[8] and now speaking out is set against the silencing of the opposition press embodied in Pius Njawe's *Le Messager,* the open letter of Celestin Monga, and all the testimonials recorded in the film, in the teeth of the Biya regime's censorship (seen as a continuation of those of Ahidjo, and before him the colonialists).[9] Freedom is defined by opposition to the forced labor, the virtual imprisonment and enslavement of Cameroonians by the German and French colonialists, and by the actual imprisonment, beatings, and slaughter of the opposition carried out by the same historical forces of neocolonialism, Ahidjo and Biya. Freedom is thus defined by acts of resistance, by the struggle against oppressive regimes. This is the burden of Mbembe's study of the postcolony—of which Cameroon is his model.[10]

Under these conditions, it would almost seem as though the right to question the fundamental assumptions of the film is always already foreclosed by the horrors of history. To assert that history is not a given but a construction distracts us from the objective of the film, which is to learn the history, speak out, and become free. The only space that the film leaves for the viewer is in considering the verisimilitude of the facts it presents. Was that data correct? Was Moumié assassinated by French agents in Switzerland as his father claimed?[11] The range of the viewers' responses is limited to corroboration, not interpretation, much less contestation. The film demands adherence, not dialogic engagement.

These judgments might appear severe, and indeed they don't go far enough in challenging the assumptions that might be taxed with an uncritical espousal of Enlightenment values of pedagogy, truth, and freedom. One might argue Teno adheres unwittingly to a system of values whose cultural and social history account for ideologies of "civilization" with which colonialism rationalized the conquest and rule of Cameroon and its other African colonies. But *Afrique* does more than advance a liberal humanist agenda: it is complicated by its own technologies of postcolonial cinema that expand the potentialities for reading beyond those of the closed classic-realist text. Its very elements of pastiche, irony,

and self-reflexivity strain at the leash of didacticism. Like the cartoons in *Le Messager*, it pushes to the limits of the frame.[12]

It might be possible to approach these limits through the mimetic fashioning of gender[13]—the imitativeness that highlights performance,[14] introducing a feminist challenge to the dominant logocentric nature of the Message film. We can access this challenge through the irony that governs the narration, especially with the role of Marie (presented as Teno's girlfriend). But Marie points us to more than ironic disenchantment and the playfulness of the sign in revolt against the dominant signifying order. In the scenes in which Marie appears, the clear-cut divisions of the binary that underlie the struggle, the revolt, the Movement, become blurred, and we become convinced that her and Teno's investigation is a mere ruse, a simulacrum of a real commission of inquiry. It is rather "as though"—as though Marie's demeanor, her questions, were a cover.

For instance, as she asks the administrator in charge of the library at the Centre Culturel Français about his library's holdings, he quickly interprets her indirect questions and states, "I think what you really want to know is how many African authors we have." Similarly, the staged scenes, like the one at the national television station where Teno is simulating a request to air a program on Cameroonian television, are intended not to deceive, but to highlight with humor the ironies of the situation in which western imported shows dominate the airways. The pretense of Teno presenting a manuscript to SOPECAM, the government publishing house, is likewise intended to inform us that the paucity of national texts on history, literature, or other subjects is not due to the absence of means to publish such books, or to a shortage of Cameroonian scholars, but to the relative monopoly the foreign press still enjoys in the publication of texts required for schools, as the decisions to require texts lies in the hands of venal government ministers.

The protest, then, is real, but Teno's presentation of the protest is simulated, and it is the simulation that masks the real interviews, the real footage, the real photos—in short, the entire apparatus of representation of the real—much as that representation is intended to both mask its role as re-presentation and convince the audience of its unmediated view onto reality. This is the simulation of the Panopticon, where the viewing audience is placed within the tower of observation, and given the image of the truth that appears before the lens. And the truth is thus presented as non-imaged, non-constructed, non-mediated—that is, natural.

"Alouette, gentille alouette" is the refrain that haunts the film. It is the real song "Alouette" distanced by the irony of disavowal. The memory of Teno's grandfather's account of colonialism and independence, the true oral tradition, is already framed by this ironic distance from its outset. The grandfather's oral tale, recounted by Teno, is about *alouettes*—larks—the alouettes of the song whose altered refrain provides the film with its title. It is a refrain to which the film often returns, usually with the visual or narrative evocation of children, and thus it highlights the pedagogical function of the narration. The position-

ing of the grandfather's tale is central to the narrative, although it is presented without much fanfare.

To begin, the tale is preceded by a long sequence dealing with the role of the book in Cameroon.[15] The scenes flow smoothly along with Teno's reflections and memories: he sees, among the books on the ground, *bandes dessinées* (extended comic book stories—graphic novelettes), which remind him of his youth. We follow his memories and associations to the action, scenes, animals that roared, the close-up kiss of a glamorous white couple, and a white adventurer-explorer who comes across the "natives," then throws one up against a wall and commands, "Tu connais notre langue! Réponds!" (You know our language! Answer!) The chain of associations continues. We enter a classroom where the teacher commands the students, "Sit! Stand! Sit!" and so on, a scene right out of *Sango Malo*. Then, with the children, we escape to the neighborhood movie theater and watch while the beautiful Mangala, the Indian singer, dances seductively for us. Who would not have dreamed, Teno recalls, to have her for one's wife? We are in full alienation: French, Indian, anything-but-African culture—all this in preparation for the grandfather's sad account of betrayal—alouette. First came the Europeans, missionaries, educators, purveyors of civilization. Then, with independence, their successors to the colonial rulers.

The ground is primed for the response to this, the conquerors' version of history, to the child's miseducation—a history for the children raised in the colonial school, and that Teno calls a history "non-assumée où la trahison, la fourberie et la censure semblent être les valeurs reines" (not assumed where the betrayal, the duplicity and censorship seem to be the reigning values). This long setting of the stage for the alouette tale then comes to an end as the dialogical response is provided: "Alors que la tradition orale pourvoie des histories magnifiques des héros dont la probité et le sens du bien collectif étaient exemplaires" (Whereas the oral tradition provides magnificent stories of heroes whose integrity and sense of collective well-bring were exemplary).

The story that follows scarcely resembles an oral tale, any more than the above description of brave, collective heroes resembles much in the oral tradition. The dialogic pattern on which the film depends demands a revision of the oral tradition along the lines that would conform to the discipline and the Panopticon—leaving no room for the trickster, much less the greedy, foolish, or bumbling characters found in tales. Also absent is the sense of a space and a time outside the historical, normalized realm of ordinary life. Instead, this grandfatherly account resembles most closely something like Birago Diop's semi-allegorical tale "Maman Caiman" or even more closely Kofi Awoonor's poem "The Weaver Bird."[16] Here the alouettes suffer at the hands of a foreign group of hunters, those of "another race" who also abuse the hospitality of the natives, take over their prosperous lands, forcing them to work for the hunters. When the hunters leave, they put in place false leaders. It is a "tale" that has nothing of the qualities of orature besides the moral. Teno introduces it as a story his grandfather would often recount to him. After describing the hard-

ships of colonialism, the tale ends with the departure of the foreigners and the beginnings of Cameroon's sad postindependent period:[17]

> Un jour les chasseurs repartent chez eux. En partant ils installent au village un nouveau chef. C'était un chef comme voulaient les chasseurs. Certains disent même que c'est un chasseur-sorcier qui est très vieux, voyant venir la mort, avait trouvé la force de sortir de son envelope terrestre. Il s'est précipité dans la pre- mière case et s'était introduit dans le corps d'un petit alouette qui venait de naître. Depuis ce jour-là, il y avait dans ce village une race d'alouettes très bizarre qui n'avaient aucun respect pour leurs frères qu'ils traitaient comme des esclaves. Qui acceptaient même de stocker dans leurs villages les déchets toxiques que d'autres villages ne voulaient pas.

> [One day the hunters leave for their homes. In leaving, they install a new chief in the village. It was a chief of the sort desired by the hunters. Some even said that it is a hunter-sorcerer who is very old, and having seen death come found the strength to leave his earthly frame. He threw himself on the first hut and was in- corporated into the body of a small lark that was just then being born. Since that day, in that village there has been a race of larks that is very strange, who have no respect for their brothers whom they treat like slaves. They even accepted storing in their village toxic waste that no other villages wanted.]

With the visual images shifting from a child climbing through the fields to those of fierce looking Bamoun masks, Teno concludes: "Cette histoire triste mon grand-père me racontait souvent pour m'expliquer l'indépendance" (This sad story my grandfather told me often in order to explain independence to me).

The simulacrum—defined by Jameson as a copy without an original—marks the recounting of this allegorical tale. It completes the logic of the film, but leaves an aporia in its trajectory. That is in the relationship between the series of historical simulacra, the recreated scenes, the reconstituted memories, the footage to which sound effects are added, and the juxtapositions of pertinent scenes that function to comment on each other like narrative lines in a plot already defined at the outset as one of betrayal. This strategy of simulation can- not stop the infiltration of its logic into the ideology of its representations: rep- resentation and ironic similitude become simulacra of each other, setting up an echo chamber. The repetition of the motif of "alouette," which is the ironic response to assimilation along with the evocation of a childhood song, a child- hood memory, creates this echo. "Ah, l'enfance" (ah, childhood), Teno intones, bringing us back to the youthful scenes of reading comics and watching Hindu romances. At the end of this sequence delineating the past, with his passage to adulthood and the country's passage from colonialism to independence, comes maturity; and ironically independence is evoked with the footage of colonial soldiers beating a man.[18]

This demystification of colonialist rhetoric is far from new. Teno wished to extend the technique to the mystifications that carried over into more recent Cameroonian history. Thus the tragedy of Lumumba in the Congo is shown as having its counterpart in Cameroon where the images of the leaders of the UPC, Ruben Um Nyobé, Ernest Ouandié, and Felix Moumié, are presented as

anticolonial figures of resistance at various points, in contrast with Ahidjo, who was installed in power by the French, and Biya, Ahidjo's successor.

"Alouette" is the childhood song par excellence, associated with the sweetness of French civilization. One of the voiceover narrators of an early French documentary comments that other colonialists rule by force, but "we French" alone intend to win the soul of our colonial subjects. He found touching that even the Cameroonians, who were technically not part of the French colonial empire (Cameroon was a mandated territory ceded to the French after World War I, and not a colony like French Equatorial Africa), identified themselves as "Français."[19] "Alouette" is this facet of the technology of colonialism identified with the earlier term "évolué" and the policies of assimilation, rather than association. Like the Hindu romances, it is part of the foreign cultural presence in Africa whose face is most innocent, and most seductive. Who would not want an Indian girlfriend like Mangala, says Teno, the Indian nightingale whose high-pitched singing and curvy dancing fascinated the children. And who could find fault with "Alouette," the implication would be, a song about being plucked that really isn't a threat at all: Alouette, gentille alouette.

Thus we find ironic that the grandfather's tale, Teno's one tie to the authentic village tradition, the oral tradition, the village artisanship, the heritage uncontaminated by colonial influences and propaganda, is a tale about a country of alouettes. We recognize that it is an allegory about the colonial takeover of Africa, about the false premises on which the takeover was based, and which provided the conditions that enable Ahidjo, the French puppet, rather than Um Nyobé, Ouandié, and Moumié, the authentic Cameroonian national leaders, to assume power on independence—that there was no real passage to independence, just as there was no real civilizing mission. "Alouette" carries all this weight of demystification, rebellion, resistance, and struggle.

It is the response to the French—"alouette" sung back. As such, it is of a piece with Marie's ironic response to De Gaulle's pompous pronouncement to "his" Africans at Brazzaville, where he made the famous declaration that he intended to provide African colonial subjects with their rights, such as the right to organize. "We're still waiting for that," responds one of the interviewees, an old-time organizer. Demystification is performed by the ironic, smiling simulation of Marie, who raises her arms and intones like De Gaulle, "Je vous comprends."

So how does the technology of cinema on which the demystification of this film depends negotiate the space to which it accords the truth? How does it sustain the regimen of the binary truth/falsehood in the course of filming Marie's winks and parodying, her playacting as investigative reporter, her few hours of walking us through the markets and offices of Yaounde, through the quips and gazing of the "chaud gars" (hot studs) who rumble, "C'est quoi ça" (that, that's what?) as they stare alternatively at her and at the camera. How do we negotiate the space of this camera whose role is equally to play at, to wink, to see what it is staging, piecing together as pastiche, mocking.[20] "Alouette" becomes more than a refrain. It becomes the locus of the camera's own attitude or expression, one that pieces together an image of the truth as a performed, silly, ironic, hu-

morous gaze: history as a comic act—such as the one performed by Essindi that concludes the film.

We can call this reality a "témoignage," as does Teno early in the film: a revealing or revelation of "réalité," in contrast with the deforming of reality by the French. But we can also call it a virtual reality, one that is set up by its very technique of pastiche-effects.

The message of *Afrique* is recognizably one that was developed in opposition to colonialism and neocolonialism from the fifties to the seventies—that is, from Oyono's two classic anticolonial novels, *Une vie de boy* (1956) and *Le vieux nègre et la médaille* (1956) to Sembène's antineocolonial films *Mandabi* (1968) and *Xala* (1974). But the technique and ruling sensibility are marked by the passage from parody (as in *Vieux nègre* or *Mandabi*) to pastiche, where the classic realist closures of form and meaning of the earlier generations have now entered into contestation with the sly mimicry, the open structure, with its winks and nods accompanying the serious or seemingly serious deliverance of the Message—what I would call the simulation of the Message. On one level that simulation-effect occurs because of the self-referentiality of irony, again that wink. For instance, in Essindi's comic song routine, his statement that he would pay to see a film only when it is made by an African in Africa is averred as he performs in front of Teno's camera.

Jameson would view this passage from parody to pastiche as concomitant with the succession of postmodernism following modernism. But he concludes his famous piece on "Postmodernism and Consumer Society" with the concession that there might be many postmodernisms, and here I would argue that the conjunction of Teno's serio-simulacra message and simulacra-seria form create a pomo postcolonialism that opens up the possibilities to which Jameson alluded. I would want to emphasize here, and in what follows, that Jameson's famously misguided reading of the postcolonial text as allegorical should be rejected. I prefer to follow Gikandi in seeing this African cultural development not as imitative or reductively political, but precisely as Teno would have it: the expression of an African sensibility that not only is in tune with its times but also is actively constitutive of those times.[21]

Afrique: *The Postcolonial Postmodern*

The times we are considering are measured by the step-function discontinuities of the present—one might say the openly discontinuous editing style of the present moment.[22] This is the style that accords with pastiche, especially as Jameson defines it as "blank irony" (1991, 16). This reference might appear somewhat strange as Jameson describes that blank irony as a "neutral practice" of mimicry, and without parody's "ulterior motive," whereas we know exactly what the point of this parody is. The Message is never in doubt. But that is true on only one level, what we might call the film's diegetical level, or its normative, literal level. It is the level where the point of comparison between the betrayal

of the people and fidelity to the people can be established—the point where Mbembe (2001) establishes the site of opposition to autocracy, and Mamdani (1996) the basis for the term "despotism." But that point, the infinite or vanishing point of perspective, can hold only so long as the opposing terms of the contradiction can be sustained. The more the positive pole, the pole of *authenticité*, is defined in terms of its negative opposite or its negation, the more difficult it is to sustain their difference, to sustain their impermeability to each other. Thus, the grandfather's use of "pays d'alouettes" to define the precolonial African community slips, jostling the binary each time that musical refrain returns as the ironic trope of disavowal. The validation of Sultan Njoye's invention of Shu-Mom or Bamoun writing similarly inscribes the European (not to mention Arabic) validation of literacy as the sign of progress and civilization as defined in eurocentric terms. The suppression of figures like the trickster, or of sly mimicry as a sign of the ambiguity of colonial discourse, equally complicates the purity of the film's dialectical oppositionality. Ditto with the appearance of the Bamoun masks and the artisans as the point in the grandfather's tale where he evokes the appearance of the old white as *chasseur-sorcier* and the failures of independence. The parody may not be blank when set against the overt declarations of fidelity to reality, but the real is continuously referenced by parodic repetitions and slips with the knowing gestures and winks that refer us back to the presence of the camera and its unacknowledged ideological work, its technology and discipline. First let us take care of the comprador regime, the film seems to be saying, and then we can worry about the problems caused by postmodernism or Panopticonist disciplines. But as both turns—the modern reformist's commitment to struggle and the postmodernist's open-ended gestures—are joined, the effect is to decenter the normative base against which the traditional parody would be framed, that "latent feeling that there exists something *normal* compared to which what is being imitated is rather comic" (Jameson 1991, 16). The Message becomes the simulacrum. This is Mbembe's point in establishing the relationship between the rulers and the ruled as a simulacra, and the rendering of the real in magical terms. He writes, "[P]eculiar to the postcolony is the way the relationship between rulers and ruled is forged through a specific practice: simulacrum. This explains why dictators can sleep at night lulled by roads of adulation and support only to wake up to find their golden calves smashed and their tablets of law overturned. The applauding crowds of yesterday have become today a cursing, abusive mob. That is, people whose identities have been partly confiscated have been able, precisely because there was this simulacrum, to glue back together their fragmented identities" (2001, 111). He goes on to call this practice magical, in a somewhat Fanonian sense that it fails to address itself to the fundamental bases of power, and therefore "simply produces a situation of disempowerment for both ruled and rulers" (111). The description fits *Afrique*, whose comic work succeeds in evoking a laugh, often bitter, without being able to solidify the normativity of the real, without escaping the sense that the real it attempts to capture in the archival footage and the interviews, the tracking shots through the various cultural cen-

ters, government buildings, and city streets constitute a pastiche of the cinematic reality—the ciné-real or Pravda (meaning "truth") that had motivated the filmmaker's search for truth from the beginning of cinema.

Pastiche for Jameson is the postmodern substitution for stylistic innovation, where "all that is left is to imitate dead styles, to speak through the masks and with the voices of the styles in the imaginary museum" (1991, 18). As Teno reconstructs his own past in scenes of a childhood shot in black and white, juxtaposed with sepia archival footage, it would seem that his pastiche builds strongly on an ironic, parodic tone. Yet those scenes are too tied to the desire to condemn the colonial mission in which his upbringing was enmeshed to permit us the relief of a simple sarcastic laugh. Again this conforms to Jameson's notion that the past here is not one to which the film can return in its totality; it cannot be recaptured as much as imitated despite the recovery of the colonial footage. The postmodern's film's nostalgia (or retro-mode), for Jameson, "does not reinvent a picture of the past in its lived totality; rather, by reinventing the feel and shape of characteristic art objects of an older period . . . , it seeks to re-awaken a sense of the past associated with those objects" (19). We see an exhibit about De Gaulle in Africa, see the footage of him declaiming in Brazzaville, and then see Marie raising her arms in ironic imitation. The "reality" becomes one that is resurrected in Marie's terms, not De Gaulle's, thus fitting perfectly Jameson's statement that "for whatever peculiar reasons, we seem condemned to seek the historical past through our own pop images and stereotypes about that past, which remains forever out of reach" (20).

For the Message to be seen and understood, the space of the anticolonial film, and its heir here in *Afrique,* must be represented with the laws of classical perspective, that is, with a vanishing point toward which all parallel lines must move. The "perceptual equipment," as Jameson calls it, had to have been forged in the Renaissance for this form of representation to be comprehensible. Baudrillard refers to this as the objective space of the Renaissance (1983, 52), a space over which we are able to exercise control, where the lines between the real and the imaginary are clear; a world defined by unequivocal objects; a universe closed by meaning.[23] In contrast, Jameson evokes the hyperreality of postmodernism where we have yet to have developed the requisite perceptual equipment. But the notions of high modernism and postmodernism within which Jameson operates are themselves enclosed by a western, urban landscape, one in which the characteristic architectural model for postmodernism would be a commercially driven, indefinite space that resists closure, harmony, composure, coherence, and complete comprehension. He might have chosen Disneyland or Las Vegas for his model, but instead picked the Bonaventure Hotel—the kind of multiplex monster caravanserai that seems to have become the inevitable choice for all large conferences and conventions. He marvels at the winding corridors and pathways through the Bonaventure, where one loses one's sense of where one is; where the discovery of a particular shop one day can never be replicated the following day; where elevators shoot up to enormous heights, with vistas looking down vertiginously into lobbies seething with people, or out

to cityscapes receding for miles into the bleak urban landscape, leaving us totally at sea. Narratives of motion are here translated into endless passageways, "emblems of movement proper" (1991, 23). The decentered subject has found here his or her own space: that of the narrative of virtual reality.

How distant this postmodernist landscape might seem to be from the African landscape where modernist buildings do indeed appear on the horizon, but never to the extent of decentering the viewing subject, nor of evoking "a transportation machine [that] becomes the allegorical signifier of that older promenade we are no longer allowed to conduct on our own" (23). Jameson would have it that this new commercial space constitutes an entire world unto itself, especially as the multiple entrances and exits replace the coherent structures of conventional buildings with recognizable entrances and rational order that enable us to view and make sense of them relative to their surrounding space. Rather, the Bonaventure "aspires to being a total space, a complete world, a kind of miniature city" (22).

Jameson chooses this hotel as his example of postmodernist space because it unsettles our conventional ways of perceiving space, of being in space. The absence of clear boundaries and the techniques of decentering conform to the new indiscipline of the "permanent present"—to the eschewing of clarity, closure, and enclosure. But they are not entirely foreign to the African experience of space, one that is generated in the urban landscape of most African cities where the Cartesian structures of the European neighborhoods are set off from the non-Cartesian space of the African quartier. Perhaps most tellingly, it is the African market, in contrast with the European supermarket, that provides us with the greatest simulacrum of the postmodern locus of space. Like the Bonaventure, there is no single, or frequently even central, entrance to the market. The alleyways there (or in the medinas of North African cities) are passages of motion, of sometimes swirling atoms of movement, as buyers and voyeurs jostle and push to get through to a shop whose location they might have remarked on a first or second occasion, but that doesn't become familiar until repeatedly visited. Jameson evokes the spectacle and excitement of the large convention hotel. But that is usually a temporary experience for the traveler whose stay is relatively short. The market is infinitely more interactive, one might say hyperactive, as the sellers call or reach out to the buyers, and as the line between the visitor and the buyer is nonexistent. Down in the lobby of the large Hyatt hotel one might experience that sense of "constant busyness [that] gives the feeling that emptiness here is absolutely packed, that it is an element within which you yourself are immersed, without any of that distance that formerly enables the perception of perspective or volume"; this a "hyperspace," Jameson intones, in his enthusiasm over its bewildering effects (1991, 24). But the market is an extension of this experience that cannot quite be captured in the postmodern narrative or action film that depends upon the subordination of the viewer to its perspective. Rather, it is the West African market that, at its height of trade and motion, brings us closest to the kaleidoscopic vision that Jameson strives to evoke in the Bonaventure. In the end, the ambiance of the hotel would seem a

poor contender in comparison with the space of the market where it is not only motion, but sound, odors, and an infinitude of interactions that give definition to its experience.[24] This specifically African sense of space is characteristic of the cinematic real that is created in the pastiche-effect of *Afrique,* as we can best see in its use of "traveling" shots, that is, tracking shots that carry us with Marie into the clothing and book markets in downtown Yaounde.

Yaounde's market is not one of the famous, great markets of West Africa, such as one finds in Kumasi or even Dakar.[25] But it serves equally well in defining the contradiction that I would wish to identify between the film's reformist Message, and its pastiched reality effect best captured by its tracking shots through the market. To appreciate the contrast I have in mind, we need to consider further Jameson's model. Jameson would seem to be almost out of touch with contemporary youth—or, in Teno's and Bekolo's terms, the *chauds gars* of the quartiers—as he describes the confusion that accompanies our attempt to maneuver through postmodern hyperspace (or is that Jameson simply is not one of the generation of those who grew up with video games?):

> So I come finally to my principal point here, that this latest mutation in space—postmodern hyperspace—has finally succeeded in transcending the capacities of the individual human body to locate itself, to organize its immediate surroundings perceptually, and cognitively to map its position in a mappable external world. And I have already suggested that this alarming disjuncture point between the body and its built environment—which is to the initial bewilderment of the older modernism as the velocities of spacecraft are to those of the automobile—can itself stand as the symbol and analog of that even sharper dilemma which is the incapacity of our minds, at least at present, to map the great global multinational and decentered communicational network in which we find ourselves caught as individual subjects. (1991, 25)

For Jameson, the older universe of classical thought and art was "oppositional" (1991, 27); it conformed to the high capitalist world formed in the nineteenth century. Teno's oppositional thought is equally retro—even as it evokes one dimension of the struggle of African societies to establish their own autonomy. This is the struggle that was once defined in terms of national liberation. But this doesn't take into account the effects of globalization, effects that are now becoming dominant at the expense of the autonomy of the nation-state. And despite his literalism, Teno cannot stop himself from tracking us into the heart of the market where he locates what he calls the cemetery of the book. In fact, Marie's presence sets the limits to that judgment as she is the instrument through which the cinematic tracking functions to construct its cinematic real.

We can define the real as the virtual space wherein Baudrillard proclaims the end of the panoptic system (1983, 52), that is, the end of that objective, linear, perspectival space in which objective reality is defined; where

> it becomes impossible to locate an instance of the model, of power, of the gaze of the medium itself, since *you* are always on the other side. No more subject, focal point, center or periphery: but pure flexion or circular inflection. No more violence

or surveillance: only "information," secret virulence, chain reaction, slow implosion and simulacra of spaces where the real-effect again comes into play.

We are witnessing the end of perspective and panoptic space (which remains a moral hypothesis, bound up with every classical analysis of the "objective" essence of power, and hence the *very abolition of the spectacular*). (1983, 53–54)

At the heart of downtown Yaounde, a large circular building in the form of a stadium houses the central market. But spread out along the adjacent streets, extending toward the main cathedral, post office, and supermarket, the street market continues, spilling over the sidewalks. As Teno's voiceover drones on about the violence in society matching the threat to the continuation of the culture, Marie enters into the lane where the sellers of clothes are located. She fingers a blouse, and the shopkeeper approaches her, ignoring the camera or the notion that she might be merely a virtual buyer, and begs her to say how much she would pay. She smiles and says, "attends, j'arrive" (wait, I am coming), and moves on despite his protestations. There is a pause in the voiceover. A voice protests, *what the fuck is this bottleneck here?* And we recall as the film crew enters the area of the stalls, the first voices asks, "ca veut dire que quoi, c'est quoi ça?" (that means what, what's that?). The presence of the camera and crew is evoked in these background noises, bits and pieces of protest that are not given the dignity of subtitles. And without them, the subsequent voiceover would make less sense since Teno states (with subtitles to translate) that the violence in the street, just verbal now, creates tension everywhere. Teno continues with banal observations about a society that suffers from the failure of development, a refusal on the part of those capable of ameliorating the situation to act, as if the expiation for this situation were the price now paid by the people. But our eyes are filled by images of brightly colored towels, with multicolored parasols in the sunlight, and Marie marching on, the light, colors, and sounds surrounding her.

This is not the kind of confused tension generated by a *Matrix* hyperreality. It is rather a polyrhythm of voices, the dominant voiceover pasted on to the inevitable flow of chatter, calls, laughter; the images spilling into a street and market without any regularity or fixed borders. Marie is lost from view as the camera's eye wanders. Teno is talking about books, an "exemple accablant" (overwhelming example), and we understanding he is talking about the unequal market forces that are deforming the national culture, despite an abundance of university graduates and intellectuals. Our eyes catch sight of stall covers, a man perusing a book while another looks on, the backs of two men in suits, open crates. A market—an open, higgledy-piggledy space—the edge of a zigzag red stripe set against the green and white of a parasol. Then children appear, and Marie holds up a French history book, the seller trying to talk her into buying it. Teno ignores her presence, trains the camera solely on the books, talks of the death of national literature, the graveyard of national culture, thought, and the people. While he speaks of this organized death, a perambulatory seller with his candy on a tray passes before the camera staring boldly into it. The death of

Figure 3.3. *Afrique je te plumerai:* Marché scene in Yaounde (a bit touched up!).

collective memory that Teno laments seems infinitely distant. A man considers a small book while Teno recites the Chinese proverb about the necessity of remembering the past. Then Teno breaks his rhythm, admits that for him these secondhand book markets constitute "un lieu magique" (a magical place), the sellers "vendeurs de savoir" (sellers of knowledge). The Message disappears momentarily as the camera now pans the books spread out on the ground, stopping on the *bandes dessinées. The lion on the cover roars.* Teno reenters his childhood. Only at the end of this chain of reflections will we return to alouette. The power and control over knowledge seem to have slipped—the Panopticon view flickers in and out. The camera travels on, its track distracted by the memories, snared in the light and color. Marie stands to the side, looking at a book.

So what does *Afrique* produce? If it is a cine-postmodernism, it is with a pastiche not quite as detailed by Jameson; a nostalgia not quite so comfortably in the retro mode as Jameson would have it; and most of all a space not produced by the technological cultural order that would find the simulacrum of itself in the Bonaventure. Yet the retro mode, the pastiche of blank irony, the movement and space of the postmodern constructed environment *all depend on their constructions of the Other space, Other past, Other memories of colonialism, struggle, postcolonialism, and independence, for their own self-absorbed formulations to hold.* Africa's participation in western constructions of itself does not stop with postmodernism any more than it was excluded from constructions of modernism; and doesn't Jameson say, after all, that postmodernism is in many ways a continuation of modernism?

What *Afrique* forces us to come to terms with, paradoxically, is the remystification of power in a globalized economy—paradoxically, since it is the goal of the Message to lay bare the lineaments of power neatly distributed along the binary axis of the west and the rest. But the loss of that binary, the resurrection of the évolué into the hybrid whose difference splits the colonial site of discourse,[26] entails not only the transformation of the Panopticon to the simulacra of power but also the recirculation of the gaze in the schemata of virtual reality. In the moment that the footage reveals Biya's power, its foundation slips into a

cinematic simulation of power, one that is elided with the very forces that are located elsewhere, and whose terms of enforcement would seem to be equally nebulous. We can't quite locate the source of Biya's power, of French power, of western power, of corporate power, as long as they depend upon a force that is exerted more in its appearance than in its substance. And as the substance is evoked in the terms of its appearance, it would seem to slip away from the fixity to which the binary sought to attach it. Baudrillard moves from the confusions that generate a circular discourse of this sort to the circularity of power: "Thus there is no longer any instance of power, any transmitting authority—power is something that circulates and whose source can no longer be located, a cycle in which the position of dominator and the dominated interchange in an endless reversion which is also the end of power in its classical definition. The circularisation of power, knowledge, and discourse brings every localization of instances and poles to an end" (1983, 77).

This might be seen as an example in which an instance of oppression faced by Africans is neatly dodged through a theoretical move that makes sense only within the European frame. But the circularity that accounts for the shifting of the locus of power is not local or purely discursive: it is political, and it follows the dominant patterns that have arisen in the past two hundred years—patterns in which "the people" or "shareholders" have become the rhetorical locus of political authority. Thus, states Baudrillard, "it is impossible to ask, 'From what position do you speak? How do you know? From where do you get the power?'" (1983, 77–78). The answer "from you" he terms "a gigantic circonvolution, circumlocution of the spoken word" since the deferral of an answer, as with the answer "the people," or "the stockholders," or "public opinion," serves as a defense against the localizing of power in responsible figures. The "people" are now the substitute for what was once "God," and this is the ultimate marker of the "democratic simulacrum," with its "substitution of power as *representation* for power as *emanation*" (78).

This is the dilemma, and agony, of *Afrique*. It can identify its opponents in binary terms, but can't account any better for the manipulations, limitations, and control that the discipline of knowledge entails and on which Teno's own identification rests; can't account for the manipulations not only in Teno's own discourse, but especially in his deployment of the technology of his cinematic practice, its normalization in what returns us to a Panopticon's gaze. Yet that objective space doesn't hold. What enables the manipulations, the play of virtual reality in which viewer and viewed are no longer held at a distance like actor and spectator, is the simulacra of power—along with those of knowledge and discourse. Teno cannot come to terms with this, no matter how hard he tries to fix the poles of the power/knowledge binary with the use of archival footage, interviews, and declarative pronouncements from a subject supposed to know. Yet in the very attempt, joining to the mock cine-vérité that he constructs, something similar to but not quite the same as Baudrillard's simulacra of power, a circularity of power, emerges. The circulation of power in the age of postmodern globalization does not look the same in the south as it does in the north.

And if that circularity is not complete without the dissolution of south into north and north into south, there would still seem to remain those traces of the real that mark the effects of the simulacrum.

This we can best appreciate in what might be Teno's response to Baudrillard's sweeping claim that "everywhere, in whatever political, biological, psychological, media domain, where the distinction between poles can no longer be maintained, one enters into simulation, and hence into absolute manipulation—not passivity, but the non-distinction of active and passive" (77–78). We can reach for that response through a Djibril Diop moment.

In *Hyenas* (1992), Gana remarks that we are entering into the era of hyenas—the sign of the triumph of the globalized economy. But awareness of the production of that cinematic moment gives us just the distance necessary to glimpse ourselves, and thus to avoid being totally enveloped in the world without borders, poles, and distinctions. Ironically, this simulation of cinema might be the one sign of our reticence to embrace fully the virtually real, to resist absolute manipulation. If this is so, it would not be in the reality effects Teno so painstakingly constructs that I would look any more for that resistance—the logocentric order on which they depend would deconstruct such an option. Instead, I would return to the moment when Marie enters the market, and before Teno insists on returning us to his reconstructed memories of an indoctrinated childhood; the moment of distraction in a space that is precariously perched on the edge of the city's gridwork, between the official market, the African cathedral, and the French supermarket, where unknown voices grumble about the blockage of the passageway, where Marie pauses and the camera catches glimpses of a cacophony of colors, light, and, just for a moment, undirected life.

4 From Jalopy to Goddess: *Quartier Mozart, Faat Kine,* and *Divine carcasse*

When Europeans think about travel, about theorizing travel, about travel plans, about travel brochures, about travel needs; about packing, about the tickets, about reservations, about taking medication, about car rentals, about restaurant recommendations, about risks they need to know about; about passports and visas, about traveler's checks or ATM cards and credit cards, about cash—about all the appurtenances of travel—it is *toubab* travel. Not travel driven by hard need. It is luxurious, pleasure travel; insulated travel; relaxed travel. This kind of travel is served by others, often others who are not European. It is travel for the rich, even when on the cheap. Sightseeing. Safari pleasures.

When Africans travel, it is different. Travel is usually driven by need, by hardship, by opportunity, by desperation. For family reasons. Due to luck—ill or good. But always in quest of that chance. It is not a gastronomical adventure; not a sex adventure; not a shopping spree. It might be a question of survival, work, a degree, or a matter of return: returning home to visit for a fortnight, returning home for retirement, or returning to the final resting place. It need not be dramatic, but it often takes many suitcases and boxes, packaging tape, and waiting on long lines. It is work, not fun.

I know there are rich Africans who travel in terms of the European model above; that there are poor Europeans who are hard-pressed for work, and look for it abroad; that there are Bosnian and Kurdish refugees, Afghani refugees, Albanian refugees whose travel is driven by need and compulsion. Those in-between travelers can deconstruct the binary of European–African, but they cannot change the paradigm for millions.

They cannot change the movies, since movies are a form of traveling. We can view movies as performing the hard work of traveling, or as providing the fun, sightseeing pleasures of a vacation abroad. We can view movies as the work and business of moving a jalopy across a hard landscape, or of driving a new Land Rover equipped with GPS, guide, and air conditioning across the exciting plains of East Africa, the colorful desert, and so on. There is the work of the coyote and of the travel agent. There are coyote films that carry us across the borders illegally; the hardened nomads for whom the customs agents and police are obstacles; the copyright infringement flicks, copied quick and dirty; porno films of child sex in Thailand; those with dead bodies for the titillation of the deca-

dent; and more. And there is always the comfortable ride on the Harry Potter expresses.

This chapter wants to ask what happens when you get in a jalopy that winds up being worshipped as a goddess. What happens to the native guide at the border, to the semiotic, deconstructionist, postmodern, and postcolonial guides, when we begin the trip on the pirate ship of the video, the pop film, the post–Third Worldist soaps, the melodramas. And also, since looking goes both ways, what happens when the ship of revolution takes on gold plating, and the carcass passes from dead hull to first-class chassis? What happens to the dirty sex, to the private gaze, to the gaudy and the meretricious? What happens in *Quartier Mozart* (1992), *Faat Kine* (2000), *Visages de femmes* (1985), *Bal Poussière* (1988), *La Vie est belle* (1987), and in other films that tread the line between high culture and popular entertainment? These are starter questions, on a trip without the critical apparatus designed to plumb the depths of meaning.

One place to begin is with some notion of popular culture linked to the chain of images that are spectacular, that knock out the eyes of the sightseer or wound the kind traveler's sensibilities; and those that do the opposite, that flatly place you there, perhaps inside a car that runs through the streets at night, in the darkness that never erupts into a baroque lighting. In Kiarostami's *Ten* (2002), *Taste of Cherry* (1997), *And Life Goes On* (1991), one has to move through traffic made difficult due to the recent earthquakes. It is aftermath traffic, not emergency traffic, although ambulances still have to get through. Ndebele (2002) signals the shift in South African writing from the early protest literature that cried out for attention, for action, for Death and Drama. He cites Brutus:

The sounds begin again;
the siren in the night
the thunder at the door
the shriek of nerves in pain.[1] (136)

Ndebele writes:

The spectacular documents; it indicts implicitly; it is demonstrative, preferring exteriority to interiority; it keeps the larger issues of society in our minds, obliterating the details; it provokes identification through recognition and feeling rather than through observation and analytic thought; it calls for emotion rather than conviction; it establishes a vast sense of presence without offering intimate knowledge; it confirms without necessarily offering a challenge. It is the literature of the powerless identifying the key factor responsible for their powerlessness. Nothing beyond this can be expected of it. (2002, 137)

Sembène Ousmane moved in the direction of conscientization in his work, moving away from whatever complexities *Les Bouts de bois de dieu* (1960) might have offered for the dialectic of colonial oppression to the directness of neo-colonial ideological polemic in *Borom Sarret* (1963), *Tauw* (1970), *Xala* (1974), and most of his film work since. He opted for direct action, a cinema of the

oppressed for their enlightenment; a cinema of recognition. A pro and con cinema. Between the two, the space of wire fences, barbed wire, guns:

> A small riot-van, a Land Rover, its windows and spot light screened with thick wire mesh, had been pulled up half-way across the road, and a dusty automobile parked opposite to it, forming a barrier with just a car-wide space between them. A policeman in khaki shirt, trousers and flat cap leaned against the front fender of the automobile and held a Sten-gun across his thighs. (Alex La Guma, "Coffee for the Road," cited in Ndebele 2002, 135–36)

The "vast sense of presence" here is essentially phenomenal in the sense of a display placed before our eyes. It is there at the end of *Camp de Thiaroye* (1988) when the silent hulking figures of the tanks pull up on the perimeter of the camp, and train their guns on the soldiers within. We are on the watchtower with the traumatized Pays who can see and grunt with fear, but not deliver the warning, not in time, not in words. It is dramatized over and over: the policeman who steps on Borom Sarret's medal; the tall soldier who places his boot over the coin El Hadj Abdou Kader Beye throws to the beggars at his wedding celebration; the Ceddo's challenge to combat; the shaven heads, the defiant princess. It is all extraordinary, spectacular, and instructive. Popular, in the sense that high culture has understood its opposite mode as being. Thus, for Ndebele the necessity to go beyond it: "The significance of these stories for me is that they point the way in which South African literature might possibly develop. By rediscovering the ordinary, the stories remind us necessarily that the problems of the South African formulation are complex and all-embracing; that they cannot be reduced to a single, simple formulation" (2002, 139).

We can hear in Ndebele's embrace of the ordinary, as with Kiarostami's of the quiet, the chosen mode of high culture: an ordinary that inevitably covers complexity, one in which it would not be unusual to find the ironic signifiers indicating the superficiality of the real in favor of the repressed, displaced, condensed, or overdetermined drives, from the emerging depth whose trace is inscribed on the symbolic. My challenge is to rest on the surface, without succumbing to the hermeneutic impulse to read through to that which is "complex and richer" (Ndebele 2002, 140); without accepting the notion that there is an ordinary that is "the very antithesis of spectacle" (138). Rather, it is to claim that there is always such an ordinary along with the spectacle, especially in cinema that cannot present itself without the specularity of the visual, and the simplicity of the surface. The topology of the cinematic is like the road, the vehicles and their motion. It is a peep show lit by a magic lantern that lights up the road, where we are called upon to recognize what Ndebele wants to go beyond, "the spectacular rendering of a familiar oppressive reality" (136). So we're off to see the wizard. And where better to locate the spectacular than in the figure of the vampire.

Catherine Belsey (1980) identifies the three aspects of classic realism in the novel as illusionism, a hierarchy of discourses, and a closure that presupposes a preexistent order that is disrupted with the early introduction of the problem

in the narrative, and that comes to a final resolution with the restoration of order (70). This classic configuration of knowledge is conveyed through authorized narrators and disciplined figures. All this stands in opposition to vampire literature, where headlights glare in the blood-sucking prose. Vampires suck blood, at night, in places hidden from the eyes. During the colonial period, such places came to be associated with fire engines, ambulances, and emergency vehicles, and the sites associated with them, where the specialized work of colonial figures like doctors or nurses was performed, where they might practice their ghastly tasks. These were the sites of fearful power, and Luise White has written about the vehiculing of that power in cars that were "out of place" (1997, 441–42).

Cars that are out of place are either poorly parked, have crossed the line, or possibly have broken down. Such banal occurrences might not seem to be subversive, but the skin of the symbolic is susceptible to the fetishist's oddest choices: A fire engine "stationed by the small airstrip" where it was used for a blood drive during World War II; vehicles without windows, colored red, bearing crosses, without lights; medical trucks, equipped with rubber pumps and tubes; a "courting couple" seen in the back seat of a car in an isolated spot.

The attributes of colonial modernity, inseparable from notions of power and complexity, with a surface that hides as much as it indicates another set of meanings, the confusion of disorder and conquest—here the masks of colonialism were read into the streets and cars that drove through the city streets and countryside. These became the sites of speculation, bringing fear of the specular, and of knowledge applied in extremis: "The presentation of cars in stories, even stories about vampires, reveals popular ideas about the interaction between culture and technology, between bodies and machines" (White 1997, 443). For the anthropologist, this is the place where folklore is created, where vehicles serve "for older symbols and associations and where their material value is at least equal to their symbolic value" (443).

For the traveler, however, the issue is not folklore, but where one might go to catch a ride. Nothing ever matters, when you are on the road, as much as getting there. This too comes with the stories: "That vehicles could be controlled, modified, and transformed may have reflected the imagined powers of their manufacturers or the real needs of their owners. Cars can take people away; motoring and roads are, by definition, ways of erasing boundaries and reclassifying space: *roads are someone's order and someone else's disorder*" (White 1997, 443, my emphasis).

As the cars occupied zones of intermediary space, boundaries became blurred: a *vanette* behind a governor's car, fire engines on an air strip, the darkened car where the couple was making love: these "implied the contradiction of orderly relations: they were parked in confusing spaces that blurred boundaries" (443). The people who worked in these strange places were termed, variously, *bazimyomwoto* or *banyama*, men who extinguish fire, men who eat meat; men who take blood or drive red cars in which blood was involved (440–41); men to be feared. Men about whom stories came to be told because of the undisclosed

purposes of their association with vehicles that occupied obscure places. These were places where obscure work was carried out (444); places of secrecy, scrutiny, and speculation (445); places where gender and potency could be refashioned due to the uncertain relationship between men and machines; in other words, places of transformation (447–48). With such a car we would expect Mama Thécla to perform her nighttime magic in the quartier. So what do the cars, and the traveling, in the African film tell us? We can look for some indications in *Quartier Mozart* (1992) and *Faat Kine* (2000).

Moving in the *Quartier*

In *Quartier Mozart* the car is static and first appears at the site where a young, curious, snappy, brash young girl, Chef de Quartier, is transformed into Montype, the quartier stud. Chef de Quartier undergoes this magical transformation to Montype when the sorceress Mama Thécla decides to "open" Chef de Quartier's eyes to the sexual secrets of Quartier Mozart. Montype seduces Samedi, the snobby daughter of the chief of police who has turned down all the other neighborhood suitors. But the intrigues of the other neighborhood young men, and the threats of the police chief Chien Méchant, suffice to drive the couple apart and result in Montype's transformation back into Chef de Quartier at the end.

As the title indicates, it is the quartier, the "hood," that is the real subject of the film; and like a good 'hood film, it is the comic side of male chauvinism that is exposed in broad slapstick humor. However, unlike the hood movies that feature flashy, brash sports cars or pickups, *Quartier Mozart* features the last remains of the car, its carcass. It is at one of those sites of an unmoving pickup that Chef de Quartier first undergoes her transformation into Montype. It is at night, and in the gloom and fog of a magical setting we see her emerge from the cabin as a handsome young man wearing only underpants. S/he clads himself in clothes filched off a clothesline and enters into the world of young studs, including their competition for Samedi. It is during his courtship that the next "magical" encounter involving a car occurs. We see Montype confront Chef de Quartier as she is flushed out of the back seat of the car by Atanga where she has been playing with the police chief's young son Envoi Spécial.

Lastly, not a car but a train is the site where Panka, the transformed version of the sorceress Mama Thécla, makes his appearance as he arrives in the city with a reputation for making men's penises disappear when he shakes their hands.

The city has its own flavor of magic. Traveling there carries one to the regions where a handshake shrinks a penis, where cars enclose the witch's gaze, and where there may be transgendered rematerializations. This is the field of the unreal, the undead, the ridiculous, where one hears slightly hysterical laughter because it is a space of the familiar unknown, the family haunt—the uncanny.

The stationary car, the mere shell of a body, accommodates the magical transformation while itself remaining in place, unmoving—a neighborhood fixture. Close by, the young men in the shop owned by Bon Pour les Morts play

Figure 4.1. Stationary hulk of a car in *Quartier Mozart*.

checkers and comment on black Americans and their relationship to Africans. Their repartee carries them far from their dusty streets to the movie screens and magazines that feature American, French, or Monacan celebrities about whom they make salacious jokes. They are all too conscious of the distance that separates them from that other world. They move across cultural, linguistic, and social boundaries, all the while staying inside the shop. Just as the car doesn't move—it's a dusty hulk sitting alongside a road without traffic—so too the shop, the quartier, is materially and economically a nonstarter, its owner marked by his sobriquet, Bon Pour les Morts, that is, someone who won't make any loans, as well as someone who is impotent.

The young men want to have sex, want to laugh about sex, want to get the local young women into their beds by hook or by crook. They want to seduce by virtue of their coolness—Atanga introduces himself as "Bonbon des jeunes filles" (candy for girls)—and the magically transformed Chef de Quartier is known simply by the sobriquet Montype ("my guy"). Every joke in the quartier works at the divisions between male and female. No serious, tragic vision of love can survive the rapid-fire ironies of Atanga or Chef de Quartier. When love threatens to make an appearance, when it does actually get its start in Montype's date with Samedi, the film shifts modes to a comic-book style and then rapidly permutates through five different musical styles in a brilliant tour de farce as bystanders ask, what's with those two?

Bekolo wants us to move at a rapid-fire pace through these scenes in which the question of dealing with modernity in a postcolonial, global age can best be posed, as at the site of a wrecked hulk of a car. It is there that we can begin to glimpse the answer to two crucial questions: How is the traveler to be gendered

Figure 4.2. *Quartier Mozart:* "Those two there, where do they think they are?"

in this new age—when the gendering may be seen as a signifier of the subject's position vis-à-vis patriarchy? And how can we position the traveler and the car within the matrix of change, of the transformative logic of the present moment, the time of the "failed project of colonialism." What *Quartier Mozart* answers is that phallocentric male gender roles in the quartier are like those of laughable penises that might disappear at any moment—shrinking bangalas, mad dogs, mes types, bonbons des jeunes filles. These names are repeated like good jokes until the joke sticks, played out by the adaptation to the attributes of the transformed economics of postcolonialism, that is, to a globalized world magically shrunk down, in the Cameroonian quartier, to the size of a wrecked car body. The magical transformation of Chef de Quartier into Montype thus encompasses the quartier's appropriation of the modern processes of transformation, the reterritorialization of white man's magic into black magic. The car, the road, the sidewalk, even the wall to Chien Méchant's yard where Atanga and Montype piss, all are the markers of that failed project of colonialism in which the rewriting of modernism is continually being performed—and by whom better than by the young people of the Quartier, whose driving impulses are continually shaped by the need to dress up, to perform both linguistically and sexually for the opposite sex, whatever that might be?[2]

Kine on the Move

How different are the boundaries in *Faat Kine*. There the cars move down roads that are paved, and have lights. Dakar in a bourgeois urban mode.

We still have the *cars rapides,* the trucks that spew out black fumes: the noise and dirt of a Senegalese city. But more to the point, there are rules about parking, horns that actually command and call out for work. There is order, boundaries, doors that lead to success or that shut out the failures. Borders, edges, balconies, spaces are well lit and well defined in the present moment—all in contrast with the darkened, ugly, even brutal and cave-like mise en scenes set in the past. The present is now the age of the women; the past remains under the Law of the Father. The road and its traffic serve Faat Kine, the owner of a gas station, and she is ready to make use of its profits to fly off with her women friends around the world. Yet the freedom to move is not so easy.

Faat Kine (2000) deals with the "liberated woman." Kine is the owner of a gas station and is first seen driving her kids to school. They are worried about passing their exams, while she has to deal with her ex-lovers and her friends' problems, as well as her business. In short, we are in the world of sentiment, of the romance in family drama—and far from the rhetoric of national liberation or anti-neocolonialism. Eventually Kine hooks up with Jean, a new lover, thanks to her kids' maneuvering, and is seen at the end wiggling her toes in pleasure as the new couple settles in for romance.

En route to this happy ending, we learn that Kine has known real hardship in the past. Her father had thrown her out when he discovered she was pregnant, and we learn that the father of her baby was her teacher who promptly abandoned her when she informed him of the pregnancy. However, her misery is attenuated by the support she receives from her mother and her female friends, as well as by Bob, a man who poses as a successful businessman, seduces her, and eventually fleeces her and flees. Through hard work and determination she establishes herself as a successful gas station owner, balancing her world of family and business like the modern working mom, the image of the successful woman of today.

Her world, too, is one of cars. At one point, Kine has a car locked up. It belongs to a briefly appearing, obnoxious mixed couple consisting of a white man whose Senegalese girlfriend has tried to pass off a counterfeit bill. If they represent the retrograde elements of neocolonial class and race values, still the way forward is not so clear. Sembène has dismissed the burden of dealing with neocolonialism; he has elevated to iconic status the old heroes of African independence, like Mandela and Nkrumah, thus relegating them to the past, along with their revolutionary rhetoric and impulse. The next generation will be led by Kine's son, who is called "Presi" (short for "president"), not "Comrade." Meanwhile Faat Kine has stepped out of the tragic and political scenarios of *Véhi Ciosane* (1965), *La Noire de . . .* (1966), or *Xala* (1974), where the women are both abused by or in revolt against the patriarchy; she miraculously enters the world of flat-out melodrama, spectacular in her mode sans gêne as she removes her bra, kicks back, and takes a glass of ice water from the maid.

She drives! She drives! A veritable soccer mom. Kids to school, off to the bank, back to work, off to a date, home to grandma and the kids; parking in the garage; blowing her horn at the car that blocks her in a parking spot down-

town. She honks, pulling out a large, ridiculous horn to call her workers. She is the mistress of the watering hole where cars must come to drink; where her ex-husband and lover come to beg favors of her, and where she blithely dismisses them both. Her servant, a hulk of a man, comes at her beck and call; her word is enough to stop or to start the cars, the gas tanker, the paraplegic's cart. She has become a Mami Wata of the soaps. And if we can borrow a bit further from the northern Igbo, it is the Mami Wata whose children are marked by their in-betweenness—what once was called *ogbaanje*,[3] but now is cast in the figuration of the modern young woman who resolves her restless urge to move by seeking a college degree abroad.

How Mami Wata Kine has become! The maiden who destroys her suitors. The miraculous source of wealth; the new woman, mermaid, goddess. From jalopy to goddess. From despised daughter, impregnated student, beaten, expelled, and humiliated. Yet also the one in between: daughter of the old ways where the father's whip ruled, where mothers and daughters suffered and trembled, but now mother of two successful high-school grads, flourishing patronne of a service station. From tragic mulatto to magic mulatto: culturally metissée. Not racially mixed, but in a sense occupying the exactly same position. Thus, she is like Mami Wata, who is, according to Ogunyemi (1996), "a fortunate Midas whose intervention meant economic progress for her 'native' half of the family" (30); she also represents the emergence of the biracial girl as "the epitome of beauty and bringer of the good things of life" (30). In Nigeria it was Osun turned mulatto. In Dakar, it is villageoise turned city slicker—with the two key attributes linked to the goddess, beauty and wealth. Thus in the list of Mami Wata's attributes, "Beautiful, single, rich, independent, powerful, and childless" (32), all but one are characteristic of Faat Kine. Kine is not childless, but as her children are grown and on the verge of becoming independent, and especially as Presi positions himself as Kine's brother, not her son—indeed names himself as such since his birth certificate wasn't signed by his father—Kine is restored to Osun's position as the mother of wealth for all: "Anybody willing to follow her rules can become her child" (33); and, simultaneously, any man who dares to cross her will suffer the consequences, as her first two husbands learned to their dismay.

How ironic it is then that this newly born woman of wealth finds herself so often located at points of blockage, in contrast to her situation as a daughter. In the scenes from her past, travelers were not subjugated to obstacles: she was free to travel, to attend college, to take a train to her market. Her abusive lovers, Professor Gueye and Bob, freely abandoned her and even traveled abroad. In the age of patriarchy travel seems not to be impeded, especially for the men; freedom of motion was implied in their domination of the public space, the byways or pathways of flight.

In her present life, however, travel is marked by blockages from the start. The first images of the film show a line of women crossing the Place de l'Independence as Kine waits at a red light, stopped. This is a clear reminder of the earliest images of Sembène's films: in *Borom Sarret* (1963) the cartman waits, with his

horse, at a light, commenting bitterly on the red lights of independence; in *Tauw* (1970) the couple stopped at a traffic light where children come to beg comment bitterly on the failures of independence after ten years have passed. In *Faat Kine* there is much talk of travel abroad, but Kine's daughter Aby is talked out of it; and Kine and her friends only talk and don't actually fly off. It is Presi, the son, who convinces Aby to accept remaining on in Senegal for her university education. Where are the home and the world now for the women, the travelers? The women are free to travel, but when Kine drives to downtown Dakar, we see her blocked in by Jean, and even after honking she finds her new boyfriend and old husband are chatting, keeping her trapped in her parking spot.

The blockages in the present are matched by male impotency, with the penis going from noon to six-thirty, in the words of one of Kine's female friends. She recounts the recent scene where her new husband begins to have sex with her; as she pulls out a condom, there is a rapid deflation. This is the impotency of the male under the reign of Mami Wata. Other male figures include the handicapped man who tries to assert his male prerogative over his woman, and resorts to killing her and her lover with a knife. He acts out, but instead of success, instead of the assertion of his male prerogatives, as had been the case with Kine's father, finds himself criminalized and arrested. The apparent triumph of the women is matched by the decline in the status of the men, figured in the tropes of blockage of movement, until the ending. The situation is then remedied with the restoration of order that brings the return of the woman to the home, and the reinscription of the conventional male-female couple with Kine's acceptance of Jean. The apparent reign of the woman is temporary, and is reversed at the end with the ascendancy of Presi, whose first plan, on graduation, is to travel throughout Senegal with his male friends, the future leaders of the country. His sister remains at the wayside, discarded from the camera's attention. Thus the subtext showing the blockage of the women along with the male impotency phallocentrically contradicts the central narrative of the Mami Wata reign.

From jalopy to goddess, from the wreck in *Quartier Mozart* to Kine's chassis, which she describes as "haut de gamme, pas pour le transport commun" (top of the line, not for common traveling): we are a long way from *Borom Sarret*'s sarret, his cart. The space that is occupied by the popular, whether quartier comedy or urban soap, is marked by the same mystery or uncertainty attributed to transformation on the cusp of the modern. That's why the vampire, the witch Mama Thécla, and the Mami Wata gas station owner, are all linked to the contemporary vehicles of transportation, of prestige and power, the car. And what vehicles their travel are the broader gestures of laughter and tears that bespeak not refinement or introspection, nor revolutionary ardor, but the more visible play along the surface of performance. There, on the city's streets, it has become possible to "erase boundaries and reclassify space"—especially in an age in which the most visible and threatened boundaries have become markers of gender identity. The politics of the popular, then, can be seen in the ghoulish or contradictory representations in the romance of gendered transformations, the

site where wealth or death might await the adventurous traveler. Where one can experience it all. Out of place.

Divine carcasse, 1998. Dominique Loreau[4]

Derrida deconstructs Levi-Strauss's notion of bricolage in *Writing and Difference* (1978) by demonstrating the difficulties in sustaining the difference between the engineer and the bricoleur. For our similar purposes, we can examine the notion of filmmaking in Africa, so well described by Sembène as "mégotage"[5] in terms of the erasable differences between western and African filmmaking, or more generally between the authorized systems at work in both structures of filmmaking and the playful violations that distinguish bricolage/mégotage.

I want to deploy a vehicle that crosses the boundaries set up by the notion of mégotage, that is, a putting together of a whole, say a film, out of a bit here, a bit there, rather than following the official systematic way that conventionally is driven by studios and their high finances. The vehicle that enables me to pass from one system to the other will be a car, an appropriate object for this reflection since, as is well known, without bricolage, sooner or later, no car could continue to run in "real" Africa—that is, the Africa that exists outside the few islands of urban wealth. The issue at stake here is not to set the eurocentric "norm" or "authorized" version over against an unauthorized, subordinated, or subaltern African other. It is rather to ask two questions: first, what is the status of a discourse that posits as the basis for its analysis terms like "myth" or "reality" without asking about the foundation on which the terms of the analysis rest. It is not a question here of the terms per se, of their weight as a function of differential cultures or of dominant versus subordinated cultures—this is the question posed by orientalism and colonial discourse analysis. Rather, it is to ask what more fundamental questions about centeredness or presence are built into the framing of the question of an authorized discourse. In the end this cannot be separated from questions of cultural framing or historical framing, but the answers sought go beyond simply justifying one culture over against another to get at the ratification of what the engineer or the bricoleur bring to the act of generating a discourse, a film, a history, and not whose history is being constructed. It is about how the history is being pieced together, and what assumptions generate historicism,[6] not just what is "in" history. In parallel fashion, it is what is at stake in the construction of a film's linearity, what goes unaccounted for and is repressed as a film's diegesis is constructed, edited, framed, shot, and presented, and not who is standing in front of the camera and who gets to speak. It is, in another vein, how the desire whose words we hear has gone through a displacement; and especially how the act of turning back to the source of the displacement leads, through the engineer, to one kind of explanation, one kind of source; and how, by going in another direction, another genealogy might be constructed so as to refute any originary thinking, any teleological thinking, or, as Derrida would have it, any presence.[7] Simultaneously, it would

involve an understanding of what supplements and exclusions were required so as to construct that presence.

The second question is how the passage from engineer to bricoleur can be made; how the mégotage involves movement, passage, transition, domestication, incorporation, ingestion, and finally expression. In short, how the trickster model of an African version of the playmaker effects the transformations needed to pass from one state to another. The state might take the form of something like a European episteme passing to an African; an aesthetic convention like studio photography transforming its modeling of the camera's subjects from one kind of object to another, from one style and reception to another, from exotic postcards to home picture albums. Or the state might entail the transition of one kind of vehicle to another. As Luise White (1997) has shown, the transition might involve something like ambulances or fire engines becoming mysterious closed containers for vampiric bloodsucking activities; or it might involve the generation of common stories about Europeans and their African workers engaging in vampirism or body-part dealings. It might involve the mysteries surrounding corpses, or diseases, with radically different understandings being generated by Africans and by Europeans; it might involve churches and their sacraments being understood within one epistemological frame as threatening, and within another as offering a saving grace—as in cannibalism versus salvation.

In the case of *Divine carcasse* (1998), it will involve a family car becoming a god as it passes through different hands, in different places and different times. It will suggest a chronology and an understanding that can be set against a different temporality and epistemology. In the end, one man's car will be another man's god; one person's cave will be another's prison of darkness; one reading of the shadows on the cave wall will trace a version of reality which another will find to be a delusion. And in caressing these understandings, passages, and transformations, we will have to be attentive to the key question posed by all acts of movement and passage: how do we read desire as working to effect the normalizing understanding of reality that gels into an ideology, that is, that compels the attention, that interpellates the viewer, that asserts a norm. Without this querying of desire, we remain within a historicist frame that insists upon a *ratio* grounded in class, economics, or culture. With the querying of desire we insist upon the relationship between change and transformation, and an act of displacement that cannot be traced back to an original drive or impulse. Refusing the grand schema of an Oedipal complex, we nonetheless retain the fractious patterns of desire and repression as accounting for transformational movement. Put in other terms, it is bricolage or history without a point of reference or origin that would account for the structure of the myth or reality. It is also a car that moves without an accounting for its motion, motion or change being the one property that gives us the signification of the car. And it will also be, mutatis mutandis, an account of the figure for that transformational status that is grounded in the location in which the car cum god finds its place, that is, the land of the Fon where Legba the trickster can be found lurking around

the edges of all forms of nasty desire; he does and undoes as a function of his role in the game. Legba, still a product of something like history; no less a god than Gu; no less a figure of the play of desire and change than the humans whose lives he affects. Guardian of the threshold, figure of phallic penetration and transformation: trickster Legba.

The idea here is to integrate this figure of Legba, or the car—that is the car, the trickster, the trickster-car—into the logic of the supplement, to refuse its grounding in one culture or another, or in the fixity of a definitive passage from one center to another. The supplement moves into the void of the center, and exceeds it because it is also a form of substitute for that which has no original version: "One cannot determine the center and exhaust totalization because the sign which replaces the center, which supplements it, taking the center's place in its absence—this sign is added, occurs as a surplus, as a supplement. The movement of signification adds something, which results in the fact that there is always more, but this addition is a floating one because it comes to perform a vicarious function, to supplement a lack on the part of the signified" (Derrida 1978, 289). I want to see the car in *Divine carcasse,* and, even more broadly, to see the cars in *Quartier Mozart* (1992) and *Aristotle's Plot* (1996) as performing vicarious functions that supplement a lack, that figure into the economy of desire that is always acting through displacement, vicariously, without stopping or being grounded. A "floating" function. Thus, the car does not come home to rest, at the end of *Carcasse;* it is always the chassis of the car, the wreck where children play at "doctor," or where magical gender transformations occur; always there on the road, moving us along with the camera's gaze infatuated with its movements. And, at the same time, it accounts for the accidents in the dawn, the impaled sacrifice, the face of one's death, and finally the revelations of a god.[8] The "two directions of meaning"—that which replaces the center, and that which supplements it—require the logic of addition, not the excavation of truth from beneath a deceptive surface. And this means, in terms of filmwork, that the images that we see cannot be interpreted in such a manner as to explain their true, hidden meaning. Like Legba, their truth lies in the trick, the work of the trick, the nastiness of the path and not the eternity of the final goal.

As the great cargo ship comes into the port of Cotonou at the opening of *Divine carcasse,*[9] we see the arrival marked musically as if anticipating a significant appearance.[10] The car is transported off the ship on a large truck, one that is the object of a high-priced bargaining session. The car appears as an afterthought, until we see Simon, a white man, looking at it, first with a pleased expression, then with some apprehension as the lift jiggles it in midair before posing it gently on the dock. He drives off, and is greeted by a group of Europeans whose relaxed dress might denote vacationers, or expats relaxing on a weekend.

We are being introduced, but to what? The Belgian Simon recounts his nostalgia for this old family Peugeot, remembering how his father would have to stop the car so Simon could open the door to vomit when its motion became

too unsettling for him. And so on. We are led into the characters, the details of their lives and relations, leaving us waiting for the plot to unfold, for us to learn what is going to happen to this congenial, easygoing man. Simultaneously, we see, quietly in the background, as he observes the whites or works at the kitchen, Joseph, an African man, Simon's "houseboy." Is he important, or just a supplement to the meaning whose establishment we continue to await?

The meaning never quite comes, because as Simon hands off his car to Joseph, Simon is gradually dropped, and Joseph's life enters center stage. We accompany Joseph and his wife to Joseph's village, and see the community celebrate the happy circumstances of his acquisition. His wife now stands apart. In a subsequent sequence she and Joseph are discussing their relationship with the village—she indicating her disapproval of his having taken the car there, opening them up to the villagers' possible disapprobation, meaning the threat of dangerous magic; he responding that they would have found out anyway, and that going there was a kind of insurance against malevolence. Again this is all by way of misleading us into thinking that a story is unfolding. Instead the story folds in, collapses gently on itself, as the car provides the frame for the plot's interactions, as only a car can.

And that is not as a person can. This car, becoming an African car, that is, a car that needs repairs, gets them as best it can, and becomes as functional as possible in accordance with Joseph's financial needs. The bricolage has begun. Joseph puts the car to use as a taxi, and in a sequence of shots, with portraits of the passengers, the car is further transformed into a studio setting. Couples, three men engaged in some kind of illegal transporting of goods, two men looking off, two adolescents reading schoolbooks, a sequence without direction, like a portrait gallery whose linearity does not resolve into a totality, does not move teleologically, but rather, like the car itself, travels along the roads of the city according to the passengers' wishes. They replace Joseph, whose own story takes him to a purification ceremony, with ancestral figures garbed in what appears as the dress of Gelede dancers.

After Simon has appeared on the scene, and gradually given us access to his character in a series of unpretentious episodes involving him and his car, we observe him one night preparing for a lecture on the Allegory of the Cave. The familiar opposition he constructs, between the ephemeral world of the senses and the eternal realm of ideas, punctuates his story, his "history," so that we are tempted to read his engagement with the car, and especially with Joseph, in terms of that contrast between the really foundational, significant realm of the eternal versus the trivial, the bodily realm. The figures of scantily clad women, the teasing of Simon about now being able to catch a good woman with his old-fashioned car, and his moodiness at night all lend themselves to this, or else prepare us for the revelation of some deeper Platonic truth to come. Instead, he finds a vodun figure in his car, and asks Joseph whether he hadn't placed a curse on the car, before casually giving the car to Joseph, almost indifferent to its considerable value for his African servant. The vodun appearing figure that overlooks Simon as he types the Platonic lecture notes on his computer adds to this

notion that a spiritual center functions like an ideal realm, shaping a material world that cannot give an accounting for itself on its own immanent terms.

But the car breaks down for Joseph as well. He, like Simon, appears to have been led increasingly into trouble, the car having somehow transferred its negative karma onto its owner. For one reviewer, the car is identified as a 1955 Peugeot, and corresponds to the period of late colonialism for the Belgians. Simon would be a nostalgic expat, rather than a modernist, and the indigo mood conveyed corresponds to the lost colonial world.[11] Joseph, however, is troubled by the disgruntled spirit of his maternal uncle, to whom he had failed to pay due respects on his death. This leads to Simon's observation that he himself hasn't visited the site of his mother's ashes, she having died two years earlier, because of his fear that that would bring closure to their relationship, ending her presence for him. Africans like Joseph, he remarks, are luckier in that their dead remain with them, and their relationship can be sustained. Joseph recounts that he has had a three-day ceremony of purification, and that though the car is still broken, he no longer cares and feels at ease with the world. He looks anything but.

The car stops running. Joseph, his wife, and Simon are all gone. The wreck, no longer reparable, is pillaged, put up on blocks, turns into a "carcass," a shell of a body with no more valuable engine parts. Another pile of metal in the car graveyard. Then a man passes by, observes it. He buys two of its doors, and carts them off to his workshop where he sets about to disassemble them and cut them up into strips. He is Simonet, a blacksmith, and gradually the iron strips are recast, with other discarded metal parts, into the figure of a statue, one whose name we later learn is Agbo, god of night watchmen. Four men come by, offer libations, thank the blacksmith-sculptor and pay him. They cart off the figure of Agbo, transport it in their pirogue to an island in the lagoon, where the whole community dances and sings in welcome to the god. We cannot live without gods, they sing. He reposes, at night, the dark-blue sky behind his features. The film ends with the transformation complete.

The European family car is "domesticated" into the Fon god. The car's fate is to become the material substance for an eternal being; Plato is recast into the ritual encounters with the ancestors, with the dance of welcome, the god's reestablishment in his proper sphere, centered and framed in his home where he is recognized and honored. But this repose has something missing from its frame, and this takes us back to the scene in which Joseph has consulted with the diviner who is paying homage to Joseph's family tutelary gods or ancestors, paying them homage and providing the needed sacrifice so that Joseph might prosper and share his prosperity properly. We learn, from the diviner's prayers, that Joseph's family also had traveled, had migrated to the region near Cotonou where Joseph's village was located. The clan names are evoked, including Keita, not a Fon or a Yoruba name, but a Mande name. Has Joseph and his family, too, been domesticated?

The logic of the film might be said to come to a resolution with the final shot of the god framed against the sky, the repose of a complete answer to the ques-

tion, where are you going? However, there is definitely a provisionality that could be read into every moment of finality that punctuates the car's journey, and that provides fodder for a reading of the car as supplement.

The car is literally supplementary in its introduction into the lives of the people, and at every stage in the film. Its arrival on the bed of the truck is marked by the discussion over the high price of the truck, a valuable, serious item, the car being only an afterthought to the men. Simon's presence also appears, initially, incidental, and it is not until we see him get in the car and drive off, and have the camera follow him to his destination, that we learn that the framing shot was "about" the car and not the truck or the men who were bargaining over it. Similarly, Simon's life in Cotonou is already provided for, apparently, before the arrival of the car. He brought it on a lark, not to fill a need, not to enable him to teach or get to work, or for any other reason central to his work. He speaks nostalgically about it; others fuss about it, love to honk its horn, and go out for a ride, singing boisterously. At first, Simon is caught in the mood and fun. Then we see him driving it alone. It breaks down, and the opportunity to meet Africans that this is supposed to provide him with turns out to be empty: no one comes, he remains alone and disconsolate. The car, which he stated was more than a machine, is perhaps, after all, just that for him. His annoyance at its failures to start, despite the new battery he had installed, marks its new way of being in Africa. But when he accuses Joseph of having placed the vodun figurine in the car so as to jinx it, he shows his disillusionment with its newly "Africanized" charms, and blithely gives it away.

Similarly Joseph appears in the background to the main group of the whites, a supplement to their society. The camera places him on the periphery of the action—never totally absent, never at its center. Yet the logic of the supplement is clear there as well: in this environment, the expats could not be expats, heirs of a colonial system, without the houseboy to define their relationship to Africa. And Joseph is clearly within that role: the kitchen boy who makes Simon's meals; the recipient of his boss's largesse; and finally the one called on to account for his absence. Even as we move into Joseph's world, the shift from marginal to center, from other to same, operates within the logic of the supplement.

There are continual moments of centering: the ritual dance where Joseph, at first marginal to the masqueraders, becomes the center of the ritual; the scene in which Joseph and his wife first bring the car to the village, and we see Joseph's wife standing apart, observing. In the subsequent scene, she, the marginalized other, becomes the center, and various rituals in which Joseph's security or problems are evoked also shift the center from the concern over the car to Joseph's relations with his ancestors. As the car moves us through these scenes, becoming a taxi, the images of the passengers, marginal to the action, to Joseph's life, to a center in which the eternal realm of ideas would provide meaning, supplement all the preceding concerns raised by Simon and Joseph. They become the newly framed portraits of the self whose center, whose essence, is not knowable beyond their appearance or poses. They take center stage, away from the expat and houseboy, away from the car's owner and his wife, and generate a decentered

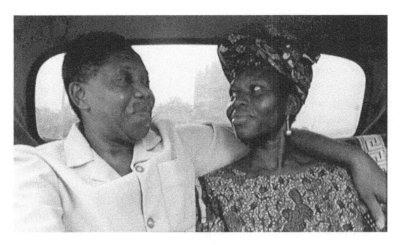

Figure 4.3. *Divine carcasse:* Portrait of a couple.

sequence of identity claims: here I am, here is what we look like, this is who we are. The portraits function as self-expression, with any notion of interior space generated by exterior appearance or looks. The camera's gaze replaces the internal thought or idea.

Yet that too is temporary, lasting only as long as the car can keep running and bring in the passengers and the money. This sequence ends with the squabble over payment for an illegal operation, and soon the car becomes irreparable.

The transformation into Agbo is wonderful—central, one might say. This, finally, is what it is all about. But even there, the logic of the supplement might be seen. What is the need for the carcass of the car after all the valuable parts are removed? Only the clear-sighted vision of the blacksmith makes it possible to appreciate the value of the doors that he transforms into the body of the god. Again, only the ritual celebration makes it possible for this transformation to occur. And yet, as the god is brought "home," to rest in its appropriate place, it must be greeted and accompanied by those other masqueraders already ensconced in the forms of the gods who dance the welcome to Agbo. Agbo is an addition, not the foundation of the spiritual world into which he is brought. He too supplements an already existing center, one that might have had space for him, had its own lack in need of supplementation, but that he does not create or even complete. For if he were to complete the pantheon, where would the site for an understanding of the sense of the completion reside? The logic of the supplement dictates that the system that presents itself as complete cannot formulate a critique of its own foundations; that is, it depends on the supplement, that which is beyond its completed form, to give definition to its sense of completion. The space that provides that sense must lie outside the completed presence, and this is the location of the trickster Legba—the space of the vicarious function.

At first Legba, preeminent Fon trickster god, lived with his mother-god,

Mawu, who directed the lives of the people. But the proximity of divinity and humanity was unsustainable, and Legba maneuvered so as to get Mawu to remove herself from the presence of the people, leaving him alone present to humanity as well as to the gods (Pelton 1980 77–79). Yet that presence, for both, is on the margins: Legba's place is finally established at the thresholds of people's homes. He is not allowed to enter, and neither does he remove himself to the realm of the gods. He is a supplement to every space with order, every form of order: he breaks the norms, the rules, the proper, the property and propriety of the culture in every way possible. For Pelton this is so as to reestablish the center. But that notion of center relies on an unchanging structure, an order outside of history, and Legba, like the divine carcass, cannot be separated from the process of transformation:[12] after all, trickster means shape-transformer.

What is at play is the necessity of the supplement within any system, and the ways in which the relationship of supplementarity makes it impossible to account for the supplement. Further, the logic of the supplement accounts for the ways in which otherness informs sameness, and thus reflects back on the colonial logic of self and other, of civilization and its other, superstition. "While he retained his criticisms of rationality, Foucault substituted the idea of an otherness at work within reason for that of a repressed alterity existing outside or beyond it. If madness or the other is always inside, then this means that it is always already a part of reason or the same; but it will also be exactly the element that reason is unable to comprehend, and will therefore work disruptively" (Young 1990, 72).

The Peugeot/Agbo figure works like the supplementary other that disrupts each system into which it enters, until it finds its final place as guardian of the night watchmen. We see it posed serenely against the sky, but unlike the figures whose abodes it protects, and unlike the masquerades that danced to its arrival, it remains outside the shrine that houses the other statues of the gods, in the courtyard. The final shot, from below, follows the quietly intoned chant, "The divinities protect us, we must remain faithful to them," and imposes a sense of its guardian nature; the final cut to a dark screen completes this impression of closure on the long voyage.

But the frowning figure of Joseph who stated that he was at ease, despite the loss of the car; the unease of Simon who accused Joseph of practicing sorcery against him; the final use of the car for transporting some kind of illegal goods; and even the solitary state of abandonment of the remains of the Peugeot's carcass from which the two doors were taken: all must be excluded from this final scene of "natural" serenity, and could only disrupt that serenity if they were seen to be linked to the presence of Agbo. The final stasis of the god, including the shot of that stasis, *has to exclude the presence of the camera in constructing it,* and all that precedes the stasis, all the motion and transformations that made the very notion of stasis possible.

This is exactly what Pelton finds in the trickster and, to be precise, the Fon trickster Legba. He informs its work with the qualities of synchrony, its functions patterned so as to establish the cultural order. Transformation is thus de-

Figure 4.4. *Divine carcasse:* The god Agbo against the sky.

fined as the actions internal to the larger system within which identities and relations are regulated, where the logic of the supplement remains entirely invisible: "Their story . . . emphasize[s] . . . the possibilities of persons relating by choice and chance, the best image of which is the human family, with its unique power to transform biological force into cultural structure" (Pelton 1980, 73). Legba heals the rifts that make human life possible "because it yokes together these two forces to bring forth a world less simple than the divine realm but stable because it has synthesized absolutely opposed potencies" (76). Legba's achievement is "to join by separating Mawu and the world, center and periphery, originator and originated. Thus Legba's mediation is authentic, a dynamic maintaining of true mutuality" (79).

In Lacanian terms Legba is *l'objet a* that functions to join others while itself remaining absent. In this he is like the Peugeot, an object whose purpose is to set in motion a series of actions, grounded in an unfulfilled desire, that will move the characters into a relationship with each other, while itself remaining an empty place, a "carcass." Žižek used the figure of the McGuffin to convey this term when he states that the characteristic Hitchcockian device, the "McGuffin," is actually "'nothing at all,' an empty place, a pure pretext whose sole role is to set the story in motion" (1992, 6). In identifying the McGuffin with *l'objet a*, Žižek defines it as "a gap in the centre of the symbolic order—the lack, the void in the Real setting in motion the symbolic movement of interpretation" (8).

For the structuralist anthropologist Pelton, that gap is completed by the trickster, but it is a completion that closes the circle on its supplements, a synchrony for which all diachrony must halt. In other terms, it is a historicism without any attention given to its own historicity, its own assumptions concerning history.

This is the cinema, then, that is assumed when Sembène sets off his version of an African cinema in contrast to the European or Hollywood versions. It is the reason why he is content to assume the mantle of griot when called upon to justify his cinéma engagé. In *Divine carcasse*, we also have the figure of the bricoleur, Simonet the blacksmith, who can take the pieces of wrecked cars, a bit here, a bit there, and forge a god. He also can set things in motion, with his creative energies, his words as well as his powerful acts—the acts and words that will bring home the guardian to his flock, as it were. But the act that directs our gaze to the final serene moment, the last shot of Agbo at rest, has to place off-frame that which, by its visible presence, would disrupt the completed order. In film, that is the camera itself, and behind the camera, that which makes the gaze possible—the need that is answered by the act of gazing.

It seems then all the more appropriate that the completed description of Legba includes the fact that he is the divine linguist—and even more, that he embodies the function in speech that joins together elements other than itself, that is, the copula. "He is a living copula, and his phallus symbolizes his being, the limen marking the real distinction between outside and inside, the wild and the ordered, even as it ensures safe passage between them" (Pelton 1980, 109). What better description of the god-guardian, poised on the threshold of the home. The joining linguistic function, extrapolated into the sexualized power to unite and create, is finally manifest in the feature on which the logic of the supplement relies: the verb spoken by the diviner that can, finally, only float along a chain of signifiers, even as its function is perceived as "'writ[ing]' the pattern of each adolescent's life through divination" (Pelton 1980, 111).

Derrida's description of the signifier carries over to this notion of the trickster when we regard the trickster not as completing the work of creating order, but rather as completing the sense of an order whose attempts to acquire awareness of its grounding can only result in a sense of disruption. The phallic nature of Legba conveys this function in its excess: "The *overabundance* of the signifier, its *supplementary* character, is thus the result of a finitude, that is to say, the result of a lack which must be *supplemented*" (Derrida 1978, 290, italics in original). In film that lack that sets in play the mechanism whose effects are felt as an overabundance is the McGuffin. In this case, it is a car—a trickster car, whose own transformation is felt as the supplementation of a lack, at every point in the film, and whose final status as "divine" cannot be wholly disjoined from its corresponding term, "carcass."

5 Toward a Žižekian Reading of African Cinema

Inside/Outside

The greatest shibboleth concerning African studies is that there is such a thing as an authentic African culture.[1] When this idea is explored briefly, the notion of a universal "African" identity gives way to local, ethnic, "tribal" customs on which an authentic culture presumably is based. That notion itself disintegrates on close scrutiny when one determines that the specific elements of culture, like language, are both local and changing. With the absorption of external words, practices, or beliefs, mutation marks all living culture, so that there are those who lament the loss of the authentic with change, and others who might welcome it as falling within the acceptable parameters of the culture.

All this rests upon an assumption that the culture in question is bounded. This too proves weak on close examination. For instance, Igbo religious practices vary from community to community, as does the language. Where is the real center; how far does one have to move before what defines a word or practice has changed enough to have lost its Igbo identity? If these questions have shaped anthropological formulations that give substance to the definition of culture, what they leave aside is the foundational assumption that any culture can be viewed as bounded, and thus separate from what lies without. There is the space we identify as inside, and that we define as outside.[2]

The field of African studies has been marked by this great spatial and cultural divide from the earliest days. Since the nineteenth century, that divide has taken on, in large measure, the binary opposition of Africa versus Europe, the west and the Rest of Us—again, outsiders and insiders. We can submit this binary to the usual deconstructive moves, look closely at the center, at the authentic African, ask where the specific qualities that define the inside reside, and attempt to duplicate some version of Negritude. Or we can substitute "culture" for "race," and substitute "authentic practices" for "racial essentializing." We can even substitute history for culture, if cultural essentializing is challenged. If we finally abandon any originary efforts, we can turn to relational terms, as with Glissant (1989), or to the notion of continual motion and change, as with Gilroy's *Black Atlantic* (1993). In all these instances there is an assumption that an African identity struggles with the infiltration of nonauthentic elements. That assumption is based on the notion that there is an inside/outside paradigm that shapes the study of African culture. And it is this binary that is necessary

for a notion of authenticity since the inside is the site of the authentic, and the outside is what gives meaning to that site.

I would want to go one step further, briefly, and that is to add that the variations of this paradigm have been basic to African studies for a long time. Historians have been bedeviled by it, necessarily it would seem, as soon as they adhered to the geographical boundaries that define Africa; culturalists and linguists have also had to establish spatial parameters that lend themselves to "points of origin," to "outside influences," to "authentic" speech or practices. And this division has been heightened by the racializing of historical events, by the conventional understandings of racial divisions, and by the refinements of racialist thinking, with categories of race reflecting divisions on the ground, economic realities, oppressive political and social practices, all the attributes of conquest, occupation, domination, and exploitation. "Inside" and "outside" are divided as sharply as "us" and "them," life and death, or poverty and wealth.

This, then, is not to deny the facticity of history. To the contrary, it is to assert that until the basic division of inside and outside is rethought, we will remain prisoners of the same intellectual moorings that supplied the foundations for a racist and oppressive history. It is a refusal to accept, once and for all, that the positioning and division of the terms "inside" and "outside" are natural and inevitable.

We can begin with Žižek's turn toward the Lacanian real as something that we cannot formulate into coherent elements of the symbolic order; as a space so absolute as to be termed "Real," and as supplying a material foundation to existence and to such experiences as orgasmic pleasure that resist reductions to linguistic formulations. I will want to expand our interest in the real beyond that of the inexpressible and largely indefinable substratum to material existence, to those objects that we can name, and yet whose function within the texts we explore resists symbolization (I am using the term "symbolization" here in the sense of integrating into the symbolic order, that is, making sense within a larger order of meaning).[3]

For Žižek, the real intrudes into those nonprogrammatic regions of the text where conventionalized ideological functions have their limits. Similarly, the problematics of the inside/outside begin with the slash between them, the limit that functions like the border for Mary Louise Pratt or Gloria Anzuldua, or the frame for Derrida, in that its beginnings and endings cannot be separated from the objects or space they are intended to set off. Is the frame part of the outside or inside, and if it lies between, where do the boundaries of inside and outside begin and end? Are we inside or outside when we seek to make these determinations? Similarly, where does the center/margin division locate the foundation for its division so that the margin is outside and the center inside? Where does the infiltration of the one by the other find its original location, its center of being, its meaning?

Derrida deconstructs this binary not to show that it must disappear, but to analyze the structure of power that underwrites it.[4] Žižek performs a similar task by attributing to the real the amorphous nature of the slash that divides

"us" from "them": "[the Real] irrupts on the very boundary separating the 'outside' from the 'inside'" (1999, 19). The perception of difference to which Žižek is alluding here is taken from a Heinlein story in which a couple is sitting inside a car while the world outside the car appears radically unreal and different from what is seen through the windshield when the window is lowered. Žižek points out that when we sit in a car, it seems more spacious than when we are outside, and that from the inside the world outside seems less vast and more distant or apart from us. In a real sense, there is a difference of relativity that marks our perceptions depending on where we are situated. And as with relativity, this perception of difference is accentuated with speed. It is astonishing how, when we are in an airplane, most of us who look through the window from the passenger's seat feel safely enclosed in a world that is not suspended thousands of feet up with nothing but air below us; and it is equally remarkable how this perception changes simply by moving to the cockpit and looking out from the pilot's windows.

When we travel, we move across spaces in which similar constructions of familiarity and strangeness are continually being made: our safe spaces are confined, defined by "our" world; the vast unknown is there, for "their" world, in "their" minds or in spaces hidden from us. Money immediately takes on this quality, as "our" money is immediately identified with value, and "theirs" with play. Žižek evokes this marker of difference, as with the example of the car, as "a barrier separating inner and outer, [with] the perception of the outside as a kind of fictional representation of spectacle" (1999:, 19–20).

From the beginning of contemporary African literature, say from *Things Fall Apart* (1958) or *L'Enfant noir* (1953), we are presented with the vision of a world that we, the spectators, must take as a spectacle: that is, "their" world, the "inside," which we see from the outside. This can be mitigated only very slightly: a non-Igbo African might respond less to this impulse as voyeurism, but barely. The worlds created by Achebe and Laye are distant in time and place from almost all potential readers of their texts, if not all readers, for a range of reasons. Some, it is true, will feel more the experience of recognition rather than discovery, but it is still only recognition of a familiar and similar world, not the image of the self.[5] And the range of experiences and emotions in these novels is such that the reader from the most remote and distant regions of Africa would still tend to respond to these texts along with the Nigerian or Guinean reader. And conversely, let it not be forgotten that the most ardent critic of *L'Enfant noir* was, in fact, a Cameroonian whose politics set him at odds with Camara Laye,[6] and who taxed Camara Laye with having invented an unrecognizably idyllic Africa during the colonial period.

Lacan and Althusser would term such a reference to *recognition* of the familiar self an act of *misrecognition* (*méconnaissance*), where the construction of a unified self as subject is accomplished by the repression of the sense of the self as divided and by the repression of the awareness of the act of construction itself of the unified self. The recognition of the authentic is of a piece with this pattern of misrecognition. For Lacan it is at the core of the mirror stage when

the ego is developed, when the sense of self takes primacy, when the need to construct a unified coherent sense of the self in relationship with the other is of central importance. For Althusser, misrecognition masks the subject's response to interpellation, and is characterized by the subject's subordination to the implied Subject that is addressing him or her in the interpellation. The implied Subject is adduced to be the source of the intentions or presence guiding the workings of the Ideological State Apparatus (ISA) that is responsible for addressing, interpellating the subject. In his or her response to the interpellation, the subject "recognizes" him or herself as the one being hailed, and that recognition is once again an act of constituting oneself as whole and unified—as having an ego-identity, the basis for being. Having an ego-identity, "misrecognition" as such, is another way of being "authentic" or recognizing and responding to "authenticity." From there it is a small step to being within the boundaries of the authentic and being outside them.

I want to evoke two aspects of this construction. The first is Žižek's, dealing with the effect of constructing the wall of separation; the second is my notion that we in African studies have too quickly accepted notions of what constitutes "inside" and what is "outside."

First, Žižek writes that as soon as we "wall in a given space," it appears more spacious than would seem to be possible to the outsider. "Continuity and proportion are not possible, because this disproportion, the surplus of inside in relation to outside, is a necessary structural effect of the very separation of the two: it can only be abolished by demolishing the barrier and letting the outside swallow the inside" (1999, 20). Of course, there is another move that is possible, and that is the deconstructive reversal that I would propose here. Let the west be the inside, the site of the authentic, and Africa the outside, the site of the specular voyeurs. (How few are the Dadiés writing works such as *Un Nègre à Paris* [1956] or *Patron de New York* [1964]!) This reversal makes "authenticity" appear less obvious, just as the power relations that were responsible for the original inside-Africa/outside-west now come into view, no longer hidden behind the screen of "normalcy." It all depends on who is "walling" in the given space: those enclosed or those enclosing. As the enclosed space is eventually nothing but the space of otherness, or, at the limit, Otherness, we can achieve the same effects of discontinuity and disproportion by reversing the terms and exposing their power relations.

In either case, the disproportion must arise from the projections and displacements that are written over the space of otherness, and those inscriptions take on the flesh of words and images in texts that represent insider and outsider space. We can see in this the origins of the fantasies that give new proportions to walled-in space. This Žižek identifies in science fiction works as "surplus space," the "excess of 'inside'" that consists of fantasy space (1999, 20). Here is the opening for us to explore the initial moves of Jean-Pierre Bekolo's films. We can see the development from *Quartier Mozart* (1992) to *Aristotle's Plot* (1996) by exploring the work of the slashes that divide: In the first film, insider/outsider divisions are overdetermined by gender, only to exceed the division by

fantasy projections; in the second, the dualism film/real life is displaced by the intervention of death, which results in a surplus in ideological projections. In both films, the slash that results from the projection of an outside world can be seen, becoming visible through fantasy as a surplus, and at those moments—as in the handshake of Panka in *Quartier*, or the transference of a character from the screen to real life in *Aristotle's Plot*—a double effect can be observed. On the one hand, the workings of the construction of the wall or divide will be laid bare; and at the same time, the amorphous, indefinable aspect of the real will surge forth. At those moments the binary will lose its force, and we will be left with the effects that fantasy and the real expose. In Lacanian terms, we are moving from the symptom to the sinthome, which Žižek glosses as "not the symptom, the coded message to be deciphered by interpretation, but the meaningless letter that immediately procures *jouis-sense*, 'enjoyment-in-meaning,' 'enjoyment'" (1998, 128–29). (For more on *sinthome*, see chapter 2.)

One of the useful functions of turning our attention from the binary terms to the slash between them, and reversing the terms, is that it is the only way in which we can accommodate the counterintuitive treatment that the symptom is accorded when we examine its ideological functioning. Here Žižek is of inestimable use to us as we trace the movement from the ontologizations of ideological filmmaking, what will be called the ontologization of the spectre, especially as was characteristic of first-generation African filmmaking, to the deconstruction of the characteristic ideological move that consists in translating the symptomatic reading into the terms of economic-political relations of power. The proper description of this process might be reversal rather than deconstruction; in fact, it will consist in reversing our expectations of reading for depth where the origins of the symptom are located, of moving beyond the readings that aim to go beyond the deceptive surfaces of ideological constructions so as to uncover the foundations of the ideology; of refusing the limitations of the notion of ideology as requiring decipherment and recuperation of hidden meaning. Instead, of such linear approaches we will favor a Moebius strip–type of movement along the trajectory, which slides us to the underside and back to the top and is simultaneously sideways and tilted. We are going to cling to these slippery slopes of the surface where the presence of ideology cannot be discounted. In fact, instead of moving away from and translating the real meanings of ideology, we move into the field of cinematic presentation where the notion of a nonideological space becomes meaningless; and that is because the concealments on which every visible image relies are found to be no less governed by ideology than is the case in what they reveal.

It is fantasy, the mechanism that governs the cinematic experience, that undergirds this approach. For Žižek, the material dimension, the "purely material sincerity" (1999, 91) that inheres in the commodities or objects that present themselves for our perception and exploration, is inseparable from the rituals on which ideology relies. It is in this materiality, in its expression in directly physical forms, like the Ideological State Apparatuses that govern the rituals of ideology, that fantasy grounds its expression: "this 'purely material sincerity' of

the external ideological ritual [that is, the ways in which an ISA functions so as to sustain society's relations of power], not the depth of the subject's inner convictions and desires, is the true locus of the fantasy that sustains an ideological edifice. The standard notion of the way fantasy works within ideology is that of a fantasy-scenario that obfuscates the true horror of the situation: instead of the full rendering of the antagonisms that traverse our society, for example, we indulge in the notion of society as an organic whole kept together by forces of solidarity and co-operation. However, here too it is much more productive to look for this notion of fantasy where one would not expect to find it, in marginal and, again, apparently purely utilitarian situations" (1999, 91). What "materializes" ideology, its outside, external space, is described by Žižek as no less ideological than its symbolic expression. We don't expect to trace a new and real path to that external, nonideological space. Rather, we will take as a new approach to the cinematic image, one that looks to the relationship between the apparently deceptive work of fantasy, and the apparently unapproachable space of the real, as the site where the typical gesture will be simultaneously to conceal in the act of revealing. Here then is our essential move: "[T]he relationship between fantasy and the horror of the Real that it conceals is much more ambiguous than it may seem: fantasy conceals this horror, yet at the same time *it creates what it purports to conceal, its 'repressed' point of reference*" (1999, 92; my emphasis). Žižek repeatedly makes this move of reversing expectations, of showing how an appearance belies or dissembles, concealing its opposite, or producing its opposite.

However, he doesn't stop there, as do Nietzsche, Marx, and Freud, whose modernism is thus limited by their replacement of a deceptive surface (or manifest level) by a real at the level of the latent, as with the Will to Power, or the repressed unconscious, or a class interest dissembled in the forms of the social and cultural superstructure. In other words, they read ideology symptomatically. Similarly, the social anthropologist would want to see the work of public representation both as performing an act of concealment and as producing a desired meaning.[7] When context is sought to provide the key to the text's full meaning, the assumption is that such meaning is always accessible. The notion of the "fullness" of the text is best described as premodern as it assumes, along with the reliance on the proper context, or the proper history, a fully adequate explanation not only for what the images convey but also for what they omit as well. In other words, the concealments—be they undisclosed motives, the perspectives of those presenting or reading the images, or the carefully chosen absences—stand to be explicated, and thus finally and fully revealed. Modernism would be somewhat more modest. If Freud sought to understand the latent or repressed contents of his patients' unconscious, it was so as to dissolve the symptoms, to effect a cure, not to expose the full contents of the repressed or to bring to a total conclusion the work of the mechanisms of repression or of analysis itself. Similarly, the limits Marx placed on our understanding of the workings of dialectical materialism could be seen in the indefinite status accorded the notion of the end of history.

Žižek cites Lacan's evocation of the modernist Joyce in terms of the endless work of the signifier, viewing Joyce as a multiplier of signifiers, as "the writer of the symptom" (1999, 43) whose texts might be read as infinitely expanding the "plural signifying process" (44). Such an expansion ultimately subverts the condensation of meaning into the unified text, as we would expect in realism, and it is this subversive quality that most marks the modernist moment. Žižek interprets this aspect of modernism as marking an absence at its core: "The lesson of modernism is that the structure, the intersubjective machine, works as well if the Thing is lacking, if the machine revolves around an emptiness" (43).[8] Thus futility, nausea, absurdity designate the existentialist modernist experience.

But for Lacan, neither the absence of Godot, the infinite repetitions of Sisyphus, nor the feeling of the absurd in response to the unanswered call for meaning, are satisfactorily accounted for by emptiness. The "Thing" reverts back to the real, equally unresponsive, but in its fullness beyond symbolization. In fact, it is the failure to incorporate the real into the symbolic that accounts for the absurd. Thus Žižek aligns Lacan with postmodernism by qualifying its move to reverse the relationship between what is apparent and what is concealed as showing "*the Thing itself as the incarnated, materialized emptiness*" (43). As another surplus, the site of the unresponsive *Thing* takes on the qualities of what exceeds desire's figures, and assumes an obscene (meaning both offstage, absent, and abjected) quality: "this absence, this empty place, is always already filled out by an inert, obscene, revolting *presence*" (44). Here we are very close to the African world of the spiritual realm that is typically defined and represented in terms of its opposition to normal human forms[9]—as seen in the figures that people Tutuola's and Okri's fiction, and Twins Seven Seven's paintings—and yet maintain enough of a familiar material form so as to evoke those powerful reactions of fear and repulsion.

Žižek refers to the fantastic act of creating that which is simultaneously revealed and concealed as the attempt to compensate for or fill the "hole of historical materialism," a lack that cannot be filled by an ideological interpretation that provides a totalized understanding. Instead, inherent in the practice of ideological interpretation is the limiting factor that arises from the act of constituting social reality: "a gap emerges in the very heart of historical materialism —that is, the problematic of ideology has led us to the inherently incomplete, the 'non-all' character of historical materialism—something must be excluded, foreclosed, if social reality is to constitute itself" (1999, 80).

In an attempt to account for that social constitution, Pelton (1980) posits that the work of the trickster is to complete the ordering of society by apparently disrupting it. The principle of structuralism to which he adheres is that disruption serves the larger project of order, of social construction. This has been adopted as a thematic principle of "traditional" African societies in the conventionalized notions of order that emerged in the period from the 1950s through the 1970s. But in the current period of African history, it might be more appropriate to turn to Mbembe's portraits of the autocrat, whose trickster-like

maneuvers can be viewed as only rearguard actions for a dying nationalism, and whose "non-all" character cannot be fully accounted for. Soyinka first adumbrated these types in his "not-I" figures in *Death and the King's Horseman* (1975). Death's quest for the appropriate victim evokes that figure in the gap in the material realm that is constitutive of ideology. It is no less to be found in Ben Okri's abiku figures as well. Bekolo leads us directly to this space at the beginning of *Quartier Mozart* (1992) as the sorceress, Mama Thécla, introduces us to the first of many images that perversely refuse the accounting of the spectre as ontological being: they are not mere symptoms, but sinthomes.

A symptomatic reading of the beginning of *Quartier Mozart* quickly runs into trouble with the ironic or tongue-in-cheek scenes. We see this best perhaps in the account of the man who survives a plane crash on his way home from America, only to fall over dead in a taxi. His wife places the blame on a "sorcière," but her tears and recriminations are undercut by the humorous depiction of him falling out of the car when the door opens. Mama Thécla is portrayed as the seer who is above and beyond the lives of the ordinary people; but her sorcery, which becomes apparent when she has Chef de Quartier look into her magic calabash, is portrayed in as light a manner as the death of the man in the taxi. The fantasy overrides the act of translating symptoms into a meaningful manifestation of a real cause, and to access the fantasy we are obliged to turn to the realm of desire and the dream world, the sites of resistance to symptom and of the emergence of sinthome. The key to understanding them turns on the notion of reversal.

The reversals I want to bring out are consonant with Žižek's description of the reversal of our expectations with respect to dreams and reality. Žižek sees as naive the ideological opposition between "hard reality" and the "world of dreams":

> As soon as we recognize that it is precisely and only in dreams that we encounter the real of our desire, the whole accent shifts radically. Our commonest everyday reality, the reality of the social universe in which we play our usual roles as decent ordinary people, turns out to be an illusion resting on a specific "repression": on ignorance of the real of our desire. This social reality then becomes nothing more than a fragile symbolic tissue which can be torn at any moment by the intrusion of the real; the most routine everyday conversation, the most familiar event, can suddenly take a dangerous turn, damage can be caused that cannot be undone, things can be said after which the tissue can never be repaired. (1999, 21)

The above fits exactly the patterns in *Quartier Mozart* which appear in three instances where the ordinary is suddenly infused with the phantasmagoric—with the stress falling on the light side of the "darkness." In the first instance, a stranger comes to town. No sooner does he shake hands with the shopkeeper Bon Pour than the rumor spreads like wildfire that his handshake renders men impotent. Bon Pour's shrieks elicit not only guffaws, but also bring out the entire quartier's familiarity with the intimate details of everyone's lives. The second is in the ordinary, banal sight of a wrecked car, which becomes transformed by

the magical atmospherics of Mama Thécla's sorcery into the site where Chef de Quartier is transformed into the young stud Mon Type. Again the symbolic dimensions of the magical transformation on the border between two worlds, or two genders, are rendered laughable as Mon Type "checks out" his genitals when he splashes water on his newly acquired male body. Lastly, as Chien Méchant sits down for dinner with his new wife and the rest of his family, the glass he picks up—our third banal object—suddenly bursts into pieces. The magic of the ordinary and the humorous meet as he declares that he is *blindé,* armed against magic, untouchable, and so on. Although serious points about phallocentrism are made in each case, such interpretations are limited by the fantasy, humor, and banality of everyday objects that push any hermeneutics to the surface of the reading. With the heightening of fantasy joined to desire in these scenes, there is a displacement of meaning by a pleasure cast into that particularly distinctive mode of Cameroonian humor.

Fantasy, the spiritual realm, and the African symbolic have been joined from the beginning of African literature and cinema in the same project. Žižek would give it a Lacanian interpretation, one that could be posited in a few different ways, but which all boil down the need to block off that which cannot be symbolized or incorporated into the symbolic order. The intrusion of the real into reality is combated by fantasy, while the attempt to constitute a symbolic spiritual order wards off the "lack" that marks the entry of the real. The fantasy-space is walled off so that reality can be given definition; but its surplus overflows as we come to understand that "reality" is constructed precisely to compensate for the lack to which desire gives rise, and that that desire is figured in the realm of fantasy itself. "As soon as we recognize that it is precisely and only in dreams that we encounter the real of our desire, the whole accent [on real and unreal] shifts radically" (1999, 21). The repression on which our sense, our illusion, of reality relies emerges from its hidden spaces, and the dream world takes on new significance as the only locus for the realities on which the ideological construction of "reality" must be based.

This reversal provides one of the ways for us to look at the representations of spirituality in a range of 1980s and 1990s films like *Finye* (1982), *Yeelen* (1987), *Finzan* (1990), *Keita: The Heritage of the Griot* (1995), or *Yaaba* (1989), in which the symptoms can be read ideologically as constructions of an African spiritual universe, and as that which locks in the dangerous surplus of the real. On the other hand, *Touki Bouki* (1973) and *Quartier Mozart* (1992) offer contrasting sensibilities to the mainstream represented by the films of Sembène, Cissé, Kaboré and their schools of Senegalese, Malian, and Burkinabe filmmakers.

Another way for us to look at the difference in sensibilities can be adduced from the way the "spectre" is treated in their films. Žižek and Derrida provide us with differing approaches to the spectre. For this, we will rely on Žižek's argument in his essay "The Spectre of Ideology" (1999). He begins with an understanding of ideology as generative of a body of assertions that reflect a set of social relations that entail social domination and conceal the elements of domination in the act of legitimizing it. We can recognize this nexus of domi-

nation and concealment as being the target for the body of African literary and cinematic works that purport to raise the awareness of the audience—conscientizing it—with respect to the duplicity of bourgeois or neocolonial rhetoric and practices, and to expose the material basis for the duplicity. Ideology here serves to hide and to permit domination, and the goals of exposing it are predicated on the notion that once reality is revealed to the audience, it will be possible to effect real change.[10]

Underlying this approach is the assumption that there is a bright line between the deceptive ideological claims and the truthful portrayal of reality—that is, that one can move outside of the space of ideology into the bright light of reality. This assumption guided the projects of Achebe no less than Sembène, both being equally concerned with combating colonialism or its aftermath. It is the marker of realism, predicated on long-term Enlightenment values.

Postcolonial discourse analysis, as well as poststructural theorizing, queries the notion that there is a nonideological space that lies outside the duplicitous range of ideology, that discourse can be transparent. Barthes delineates the mistaken presuppositions of "zero degree" writing and indicates the ideological function of naturalizing that undergirds the project of realism. The assumptions of transparency and mimeticism in realism stand exposed as serving a bourgeois project, that is, they are "ideological" in the first sense of being tendentious, rather than neutral, or symptomatic, in the sense given above.

This leads to the second understanding of ideology, Althusser's elaboration of the ways a society reproduces its relations of power and domination through the "rituals" of the ideological state apparatuses (ISAs), the interpellation of the subject by those apparatuses through processes that accord with those that lead to the constitution of the subject. The perspective from which Althusser views the action of ISAs is presumably one that enables him to perceive their functioning from the outside. This does not detract from a shift from purely discursive analyses of ideology to those that now take into account material practices, "rituals and practices [which] . . . performatively produced" the effects intended by ideology (Žižek 1999, 67), or, as Žižek reiterates, that "materialize reality" (1999, 70).

The materialization of reality, in Althusserian terms, is seen as the consequence of ideological processes that shape the ways large state apparatuses interpellate the subject. For Foucault, micro-institutional structures, operating at the level of "micro-power," materialize reality. On both macro and micro levels, there is an apparatus or discipline that functions by directly engaging the body, inscribing itself on the body, rather than functioning externally through direct force.[11] These two approaches are eschewed in much African cinema. In *Xala* (1974), the quintessential African film about neocolonialism, or in updated versions that focus on postindependent African government abuses, like *Zan Boko* (1988), or on patriarchy, like *Finzan* (1990), the ideological disciplining is conveyed directly through force, or through transparent instruments of the state's power, like the grand mosque in Dakar, and by its representatives like the "chef" in *Muno Moto* (1975), or the patriarchal father and husband figures in dozens

of similar films. This notion of power from above enables the symptomatic reading on the first level, whereas the notion of disciplining society through the interpellations of ISAs from above or with a plurality of apparatuses or micro-practices from below, shifts the emphasis from the direct use of coercion by the state or its instruments, the Repressive State Apparatuses (RSAs), to less obvious material practices. If a symptomatic reading must be recalibrated to account for the interpellation of the subject by ISAs, or for its disciplining by the construction of power from below, that reading must affect our perception of the subject in both cases. The unified subject on which the first symptomatic reading depends now gives way to a divided subject constituted by its relationship to the Other. Similarly, even as Foucault rejects the notion that the effects of power from below derive from the intentional acts generated through an ideological apparatus, he reinvests within the immediate physical and social landscape the mechanisms by which societal disciplining is effected. In both cases, the material objects function as immediate presences, as concretions of an encounter whose impact can not be wholly accounted for. At the limit there is always the encounter with the real (or *das Ding*) whose density resists the totalizing act of interpretation that would account for material presence. The paradigm that begins with an outside being that corresponds directly to an inside significance has now shifted to the site of resistant objects.

The immediacy of the effect of ideology on the material corresponds to the processes by which identity is produced; in a similar fashion, the effort to concretize the irreducible effects of desire results in what Judith Butler calls "corporeal signification"[12] (1990, 136). She writes, "words, acts, gestures, and desire produce the effect of an internal core or substance, but produce this *on the surface* of the body, through the play of signifying absences that suggest, but never reveal, the organizing principle of identity as a cause" (136). What Althusser describes as the subject that achieves "self-awareness" of its identity through the interpellation of the other, is here described as being produced through those physical and mental features that constitute a performance. Butler emphasizes the act of producing the internal self as a construction, a consequence of performance, and thus she highlights the deceptive quality of the reliance on an interior reality as foundational: "reality is fabricated as an interior essence" (136). "Inner" and "outer" divisions are socially produced, and, as Foucault would have it, disciplined in the inscriptions that are written through the "social politics of the body" (Butler 1990, 136). Finally, in the act of fabricating this inner reality, in this "misrecognition" of the self as the site of identity, the processes that play out their politics of social control, regulation, and disciplining, and finally the reproduction of the ratios of power, are displaced from view. In our obsessive need to read the real I, the real You, in your "true essence," we turn a blind eye to that which has produced, has fabricated, these identities—be they represented as individuals, genders, or "tribes." Bekolo's Chef de Quartier/Mon Type skewers this fabrication: two-in-one, less-than-one-and-double, s/he resists all essentialized readings, undoing the bar that separates inner from outer self.

Butler thus reverses the processes that ontologize the inner self. But can that reversal also be ideological? For Žižek there is a third level of ideological interventions, that is, the level of attitudes and practices that purport to be outside the regimens or mechanisms of social control. For Žižek, all such mechanisms must eventuate in some materialization. This final level is "neither ideology *qua* explicit doctrine, articulated convictions on the nature of man, society and the universe, nor ideology in its material existence (institutions, rituals and practices that give body to it), but the elusive network of implicit, quasi-'spontaneous' presuppositions and attitudes that form an irreducible moment of the reproduction of 'non-ideological' (economic, legal, political, sexual . . .) practices" (1999, 68). In this more diffuse and all-embracing concept, we can read the effects of media and late-capitalist practices as advancing an ideological project while functioning, like cinema, as though there were no cameraman making any choices of the shots and angles, as though commodities acquired value all by themselves and bore no relationship to the conditions of production. We read ideology with increasingly great finesse, until we reach the point where there is no more space "outside" the range of ideological functioning, and where its generalization would seem to destroy any attempts to demystify its practices, because if everything is ideological, so too are the demystifications, so too are the sites of enunciation of demystification; "conscientization" and even "performance" become another ideological move, all the more obscurantist in its delusion that it constitutes an uncovering of ideology.

It goes without saying that this devolution of ideological interpretive moves is also ultimately disenabling, since one can never arrive at a point from which to challenge the deceptive workings of ideology without being ideological oneself. Thus, postcolonial discourse analysis becomes yet another form of constituting ideology; Butler's formulations, and performance theory itself, would also constitute the site for ideology. And this position that detects the ideological in a range of theoretical positions becomes the ultimate ideological move: "*such a quick, slick 'postmodern' solution, however, is ideology* par excellence" (1999, 70). What grounds this inevitable turning of interpretation into trope, into an endless regression of symptom to symptomatic reading, is the paradigm that presents a surface, or outside, as always being opposed to its corresponding inside. "It is as if, at every stage, the same opposition, the same *undecidable* alternative Inside/Outside, repeats itself under a different exponent" (1999, 70).[13]

The reliance of ideology and demystification on a model of surface and depth conforms to Sembène's goal of exposing neocolonialist ideology. This depends upon two things: a faith in our ability to be guided into seeing and understanding the causative factors in all their depth; and a parallel faith that the resistance of even the most ephemeral of factors to ideological analysis can be overcome by solidifying them into concrete, three-dimensional figures—that the spectre can be ontologized. Žižek warns against the total dismissal of this ontologization when he asserts that the position from which we enunciate the claim that everything is driven by an ideological function, a position that apparently stands beyond that claim, is itself also ideological. If it were not, it

could not consistently make its claim without explaining where one stands when the line between such assertions and all the others that are tainted by ideology can be drawn. We are back with the dilemmas attending the division between inside and outside, at an apparent impasse.[14]

Symbolization always entails a "symbolic debt." It is here that the spectre emerges: "*This real (the part of reality that remains non-symbolized) returns in the guise of spectral apparitions*" (1999, 73–74; emphasis in original). Between "reality" and its untotalizable relation to the "real," there is inevitably a gap that is due to the failure of signification, of the constructions of the symbolic order, to escape the positioning of the one who does the signifying. In other terms, the site of enunciation can never be totally accounted for by the enunciation that is made from that site. Only an appeal to that dimension of the real that is irreducible to "reality," that nonsymbolized part that marks every effort to condense the material into the symbolic, enables us to escape the infinite regressions that result from this binary model of the inside/outside. And that irreducible real returns, according to Žižek's reading of Lacan, in the guise of the spectre, "spectral apparitions," the workings of fantasy and desire" (1999, 74).

The real returns. Though it cannot be totally represented or symbolized, still it cannot be totally excluded from that process. It returns as fantasy, as excrescence, as spectre, an apparition that serves to fill a hole that inevitably remains incomplete, since the work of the spectre is fated to fail due to the same paradox as that which marks all attempts to symbolize the real. Sembène's ontologization must remain incomplete. Žižek: "What the spectre conceals is not reality but its 'primordially repressed,' the irrepresentable X on whose 'repression' reality itself is founded" (1999, 74).

We give expression to our limited ability to accommodate the need for meaning with the figure of the spectre. On one level it can be conceived in terms of the unhomely, *unheimlich,* or the abject, which represents the shock at confronting our failure to recognize ourselves as whole, as fully integrated, unified consciousnesses. Or we can identify it with the glitch in our efforts to speak out plainly, the ghost that haunts the impulse to act as if our site of enunciation did not mark our speech, as if speech could be purely transparent. Žižek looks for the spectre in any totalizing gesture that attempts to bring resolution and closure.[15] This logic can be applied to any of our efforts to reduce social phenomena to symbolic terms, and Žižek represents it as a limit. For instance, "Class struggle is none other than the name for the unfathomable limit that cannot be objectivized, located within the social totality, since it is itself that limit which prevents us from conceiving society as a closed totality" (1999, 75). In his usually paradoxical fashion Žižek explains this as due to the fact that one cannot assume a position that is not structured by class struggle, thus excluding a neutral position that would permit us to locate class struggle within the "social totality" (75).

There is no reason why this analysis of class antagonism cannot be similarly applied to those other binary oppositions that have marked African cultural studies from the outset: not just the opposition of depth and surface, but of

inside and outside, and African and European. There is no position one can assume that situates the critical stance outside these binaries, thus enmeshing us in the ideological frame that accounts for the construction of this binary originally, that is, the ideology of authenticity, purity, and originary thinking, which eventually lies at the source of all binary constructions. Given this limitation, the inevitability of an ideological framing and the consequent insurgence of the spectre, we are left feeling trapped and incapacitated. We are confronted with the problem of dealing with a "non-symbolizable kernel" of the real whose expression in symptomatic terms is always such that the kernel itself remains inaccessible.

The problem is not resolved by dismissing the symptomatic excrescences, nor by reducing them to the closed categories of transcendental signifiers, *but by embracing their distortions.* "Distortion and/or dissimulation is in itself revealing" (Lacan, cited in Žižek 1999, 79). In the case of class struggle, it is the trauma around which social reality is structured that emerges in a symptomatic reading of class struggle and its concrete manifestations. In place of the explanation, the meaning of the text, the closed circle, we are presented with the spectre, the figure Žižek understands as "that which fills out the unrepresentable abyss of antagonism, of the non-symbolized real" (79). Here we come to the core of our dilemma: how to read the unreadable spectre. The response can take two inadequate forms:

—We can attribute the spectre to the intervention of some explicable higher force, thus foreclosing our freedom. This is the solution that depends upon "ontologizing" freedom, reducing freedom and its unreal apparition to the status of a comprehensible object, and at the same time attributing its existence to a non-material realm that remains inaccessible;

—or we can apply our explanatory scheme to that higher level which accounts for the spectre, or for our freedom, incorporating that level itself into our positive scheme—transferring the spectre into the "positivization of the abyss of freedom" (Žižek 1999, 80). The result, an "abyss" that must be accounted for one way or another.

In the battle between Reality and Illusion, or Reality and Fantasy, the spectre emerges into the visible space that we attempt to restrain and "gentrify" (Žižek 1999, 80) through ideology. The grand narratives that seek to domesticate the spectre would do so through an ontology that comes down on the side of a seamless real; the deconstruction of the grand narratives refuses that totalization, but in the process leaves us without meaningful access to the real. Here it is the paradox that provides Žižek with his solution: the real itself, including, as in this case of class struggle, the frame of historical materialism, cannot dispose of the problematic of ideology that we have signaled above, the limit imposed by the aporia or space that cannot account for the site from which the application of the theory of historical materialism is deployed. Alternatively, the social antagonism that rives society leaves no place from which to deploy a totalizing and thus ontologizing analysis. Derrida would insist upon the freedom engen-

dered in the resistance to this act of ontologization; Žižek would regard that hole in the real as not only irreducible, but constitutive. He refuses to accept an adherence to freedom that would deny that basic relationship on which our construction of the real depends, including in the real the void that gives rise to the spectre. The paradox is that we are never released from the openness of freedom, and the refusal of the void, while at the same time we are obliged to adhere to the real. Without this paradox, we have no claim to cling to the surface of the real, to the spectre, to the fantasy as both expressive of an inaccessible desire, signifier, or freedom, and as the product of an act of repression.

We would want to return to the surface as the site originally displaced in the study of African cinema, as well as to the rejections of the popular, the fantastic, the entertaining, the trivial, and the superficial, for two reasons: first, not to be trapped within the limitations of the ontologization of the spectre, the path on which we were set from the outset by the critical and aesthetic choices of African cineastes and critical theorists; but also because it is precisely in the exploration of those aspects of the surface that fantasy and spectral excrescences function as expressive of the lack in the real. The eye takes us back to a surface whose materiality, for Žižek, sustains an ideological edifice. His example here is taken from Pascal: it is in the act of praying that faith emerges, not in the preexistent belief itself. "The implicit logic of his argument is: kneel down and *you shall believe that you knelt down because of your belief*—that is, your following the ritual is an expression/effect of your inner belief; in short, the 'external' ritual performatively generates its own ideological foundation" (1999, 66).

Fantasy works like belief. "The standard notion of the way fantasy works within ideology is that of a fantasy-scenario that obfuscates the true horror of a situation. . . . However, here too it is much more productive to look for this notion of fantasy where one would not expect to find it, in marginal and, again, apparently purely utilitarian situations" (1999, 91). The most utilitarian of situations might be the ones in which we can avoid death, or Death. The ideological edifice on which the notion of "home," the origin of our being, is based can be easily discerned in the responses to the confrontation with death's messenger, Soyinka's wonderful "not-I bird."

Death and the Spectre

In *Death and the King's Horseman* (1975), we learn from the Elesin that when the Not-I bird came calling, his words were met by the congealing of his listeners into frozen beings. First the language became congealed into an automatic echoing response. "Not-I became the answering-name / Of the restless bird, that little one / Whom Death found nesting in the leaves/ When whisper of his coming ran / Before him on the wind" (Soyinka 1975, 13). Then the devotee of the dreaded god Ogun, the hunter, is congealed: " 'Not I,' shouts the fearless hunter, 'but— / It's getting dark, and this night-lamp / Has leaked out all its oil I think / It's best to go home and resume my hunt/ Another day.' But now he pauses, suddenly / Lets out a wail: 'Oh foolish mouth, calling / Down a curse on

your own head! Your lamp / Has leaked out all its oil, has it? / Forwards or backwards now he dare not move . . . / Ten market days have passed / My friends, and still he's rooted there / Rigid as the plinth of Orayan" (Soyinka 1975, 11–12). And so he runs through all the beings of creation, from lowly hyena to Ifa's diviner. What is the Not-I bird, or more precisely, its caller, and its call, but the voice of the spectre itself, and now in the form Žižek identifies with the Lacanian notion of the retreat from freedom. He cites Schelling to make this point: "Most people are terrified when they encounter freedom, like when they encounter magic: anything inexplicable, especially the world of spirits" (1999, 79). Soyinka goes Schelling one step further after mocking Ifa, the diviner's courier bird turned Not-I bird: "Ah, companions of this living world / What a thing this is, that even those / We call immortal / Should fear to die" (13). The hollow void in the real, the solid core of the world, would seem to be the echoing chamber of the call of the Not-I bird, were it not for the speaker, Elesin, whose bedrock of the ancestors gives stability and substance to the world. In the words of the praisesinger, "In their time the world was never tilted from its groove, it shall not be in yours" (10)—Elesin, whose imminent suicide is met by the boast, "Tell my tapper I have ejected / Fear from home and farm" (13), and whose assurance lies in his belief in the coils that link him to the central foundations of the real: "We cannot see / The still great womb of the world / No man beholds his mother's womb / Yet who denies it's there? Coiled / To the navel of the world is that / Endless cord that links us all / To the great origin. If I lose my way / The trailing cord will bring me to the roots" (18).

Yet the home of the ancestors would not seem to provide the grounding that Elesin's words indicated, and not so much because of fear of death. Rather it is at the site of Death, what Soyinka calls the passage, that not only the world of the living has its limits, but also the knowledge of the living. In Lacanian terms, it is in the passage where the object of desire (the *objet a*) that can never seem to find its target would seem to reside—the "elusive being of passage" where Elesin sought to achieve his union, on the threshold of death, with the beautiful young Bride. In the end, the refusal of death to work its congealing act on freedom dooms Elesin, and his solid universe, to the ignominy of an abject fate.

Despite Soyinka's best efforts to define that fate in metaphysical terms, it turns out to be the condition of colonization whose freedom, for the African community, excludes the possibility of death to come visiting. Elesin's ontologizing of the passage is based on his phallocentric boast that the seed that would bear his Memory could master death: "Memory is Master of Death, the chink / In his armor of conceit. I shall leave / That which makes my going the sheerest / Dream of an afternoon" (20). We can call this his fantasy of the spectre, what Žižek calls the miracle of freedom (80), and by insisting on depositing his seed in the passage, in congealing desire into Memory, into Mastery of Death, Elesin seeks to evade not fear or death but freedom. Soyinka would have us read that freedom metaphysically, not politically.[16] However, without reducing the play to the simplistic "clash of cultures" that he would rightly have us avoid, we can see that in focusing on metaphysical freedom he also avoids the

contradictions in the ontologizing of the "Yoruba mind" or the "Yoruba world." The "great coil of being" as the bedrock of reality has always had to deal with Soyinka's ironic guffaw, and in this play the one who becomes the despised "eater of leftovers" is the proud Elesin himself. When he finally succeeds in committing suicide, it is too late to assure the passage of transition that his death was intended to effect; and the interruption in that passage is brought by the ironizing intrusions of the clueless British administrator Pilkings. Where the antagonisms of the real, both Yoruba and British, are writ large is on the fantasies that conjure the spectres of both respective worlds. The bedrock of history, on which the author's note would have us rest these events ("This play is based on events which took place in Oyo, ancient Yoruba city of Nigeria, in 1946"), or the "still great womb of the world" (18) that we cannot see, cannot be accessed without "the elusive being of passage" (20), a being that is given definition, in fact, by its very elusiveness. In Lacanian terms, it is the lack in the real where the seed is deposited and where the anticipated change takes the form of the spectre. To hold to the real, to its surface of appearance in the play of forms, we may follow Soyinka in refusing to reduce it to a clash of cultures, or of metaphysical being, leaving off the reductive and reassuring interpretations of this elusive being as symptom. Like Žižek, we will look to the "locus of the fantasy that sustains [the] ideological edifice" in the surface of the real, in its "purely material sincerity," and not in the "depth of the subject's inner convictions and desires" (1999, 91), where clashes of culture or metaphysics are lodged and congealed. Freedom takes us back to the surface where the true face of the real can never be seen, except in distorted or dissimulated form, and we will attempt the unnerving work of contemplating that Medusa's head of a dissimulation that reveals and conceals simultaneously, bringing us to the "non-symbolizable traumatic kernel that found expression in the very distortions of reality, in the fantasized displacements of the 'actual'" (79). This is the challenge in Lacan's claim that "distortion and/or dissimulation is in itself revealing" because, as Žižek puts it, "what emerges via distortions of the accurate representation of reality is the Real—that is, the trauma around which social reality is structured," the Real, that is "foreclosed from the symbolic fiction, [and] that returns in the guise of spectral apparitions" (79).

Everything You Wanted to Know about African Cinema, But Were Afraid to Ask Žižek

The work of Žižek has provided a series of suggestive approaches to the immediate material realm in which a real that refuses to provide answers and a symbolic structured upon answers must meet. For instance, in his study of Hitchcock's films, he delineates three "modalities of desire" (1992, 5–6) that correspond to three types of subjectivity, each of which he associates with a stage of capitalism. In grounding his analysis on an economic base, Žižek provides us with a link we can use to discuss African modes of cinema.

The first period of Hitchcock's films he links to liberal capitalism, the second to imperialist state-capitalism, and the third to "post-industrial" state capitalism. In the first period, "the couple's initiatory voyage, with its obstacles stirring the desire for reunification, is firmly grounded in the classic ideology of the 'autonomous' subject strengthened through ordeal; the resigned paternal figure of the second stage evokes the decline of this 'autonomous' subject to whom is opposed the victorious, insipid 'heteronomous' hero; finally, it is not difficult to recognize, in the typical Hitchcockian hero of the 1950s and early 1960s, the features of the 'pathological narcissist,' the form of subjectivity that characterizes the so-called 'society of consumption'" (Žižek 1992, 5).

What interests me is how Žižek goes on to associate these phases, these modalities of desire and subjectivity, with characteristic *objects* whose crucial role in each film is determinant of its mode. These objects are also three in number, and they suggest parallel structures in a range of African films with a corresponding set of subjectivities in their relation to a world of objects and to the dominant economic system.

The first of the objects is described as the familiar Hitchcockian device, the "McGuffin," which is actually "'nothing at all,' an empty place, a pure pretext whose sole role is to set the story in motion" (1992, 6). In further elaboration, Žižek identifies the McGuffin with *l'objet a*, "a gap in the centre of the symbolic order—the lack, the void in the Real setting in motion the symbolic movement of interpretation" (8). This sort of invisible or absent object recurs in Djibril Diop's films from the start, as we can see in Paris itself, in *Touki Bouki*, whose absence haunts us in Josephine Baker's repetition of the words "Paris, Paris," in the song of the same name. In *Le Franc* (1994), the McGuffin whose absence drives the action is the money whose value has dropped by half with the devaluation that is evoked at the beginning of the film in the port scene, and that lies behind the quest of the musician to cash in his winning lottery ticket. "Xaalis," or money, whispered and caressed, from the money order of *Mandabi* (1968) to *Touki Bouki* (1973) to Mweze Ngangura and Benoît Lamy's *La Vie est belle* (1987), is the greatest signifier of lack in African popular cinema. It is not the fear of death, but the words "pay me" that haunt these texts of the poor, and "Paris" is the currency of the dreams, the desires, the fantasy of complete payment—the winning lottery ticket of the past.

Žižek identifies the "classic ideology of the 'autonomous' subject strengthened through ordeal" (1992, 5) with this first phase of Hitchcock's films, wherein the possibilities of taking action within an economy of the autonomous subject corresponds with liberal capitalism, and the absent object that accounts for the economy of desire would be *l'objet a*. When money, "Paris," or their metonomies—like the money order or the lottery ticket—function like *l'objet a*, one has to ask what consequences there are for this model when seen from the perspective of a desire generated within an African context. Poverty and its putative solutions are ringed by calls for exile and emigration (*Touki Bouki* [1973], *L'Exile* [1980], *Heremakono* [2002], *Tableau Ferraille* [1998], *Border* [2002]), for appeals to those empowered to help maneuver through the impossibly labyrin-

thine ways of the state bureaucracy or even a banking system set up so as to exclude the poor and illiterate. Relations of power inevitably drive the autonomous subject into situations and ordeals that appear insurmountable (*Certificat d'indigence* [1981]; *Mandabi* [1968]). When the mystery of the McGuffin stands revealed, as in Wend Kuuni's recollection of his past, the desire would appear to be joined to an impossibly utopian vision, one in which any real hope of addressing an imperfect system and seeking to change it has been completely lost. If liberal capitalism and the autonomous subject are in play here, it would seem that their positive features that normalize western ideological values cannot be evoked, and this would be because the benefits and powers are inevitably bestowed on that subject who in the end is the wealthy other—be it the European or the Europeanized African bourgeois. "Paris, Paris" signifies not only the absent ideal, but especially the ironic distance that separates that ideal from Mori in *Touki Bouki*, or that separates the money from the holder of the money order in *Mandabi*.

The second kind of object Žižek describes has a material form, and its function is to act as the object of exchange between characters whose relationship takes on a meaningful dimension as a result of that exchange. A key example might be the reels of film in *Aristotle's Plot* (1996) that function precisely to bring Essomba and the tsotsis into a relationship with each other. That relationship makes sense and motivates the action in the film in such a way as to account for meaning or sense—that is, to set up a symbolic order. Further, as Žižek states, here it is less the autonomous subject functioning in a liberal capitalist economy than the "heteronomous" subject functioning within a system of imperialistic state capitalism. If we focus on the diminished powers of the paternal figure, or Law of the Father, on whose authority is constructed the symbolic order, we could observe how in films like *Chef* (1999) or *Aristotle's Plot*, such figures have now been reduced either to the burlesque "Popauls" of Mbembe's postcolony or the silly Keystone Kop of *Aristotle's Plot*. Simultaneously, we see exacerbated the neocolonialism of the early period of independence into this far more debilitating condition of the failed state, of failed state capitalism and its far greater dependencies and incapacity.

These stages overlap and hearken back to a colonial model that has never quite disappeared or been worked through. The loss of Toundi's father in *Une Vie de boy* (1956), and his replacement by the white father priest or commandant, created a situation that made it impossible for the son, the "boy," ever to assume his father's position and become a man. And that impossibility haunts contemporary African literature and cinema still today, with perhaps one of the best figures for this seen in the imagery and characterization in *Guelwaar* (1992). The unforgettable scene of Guelwaar's wife berating her dead husband's clothes laid out on his bed, awaiting the actual corpse, deeply ironizes this absence of the Name of the Father, this lack in the Other that is translated into Guelwaar's dependence on his daughter, a prostitute whose income permitted him to survive in all his noble glory.

Žižek forces us to turn our attention to that corpse in *Guelwaar*, or those

reels of film in *Aristotle's Plot*, whose function of supplying a basis to the symbolic order depends upon their particular materiality. They are "unique, non-specular," not bound up in the dualisms that mark the mirror stage, and yet are necessary to bring together those opposing, dualistic elements that give definition to the symbolic order: in *Aristotle's Plot* the tsotsis and their opposite counterpart Essomba; in *Guelwaar*, the Muslims and Christians, antagonists whose whole battle coalesces around the stinking corpse of the dead hero.

The struggle at times is to find that object of exchange, the lottery ticket or money order that the woman at the lottery office or bank will actually accept. Their rejection is not on the order of a technicality, but of a larger order, that in which the disempowered must be excluded from the system in which wealth and the capacity to act are ensconced. In the most extreme case, we see such a poor figure cast into the role of that very object of exchange itself: that is, Draman Drameh, whose life is to be traded for the wealth of the people of Colobane in *Hyenas* (1992); or, similarly, those sacrificed figures, typically cows or bulls in Djibril Diop's films, whose sacrifice is required in order that an exchange might take place. In the process, however, something is lost, and the subject who seeks fulfillment through this exchange devolves into a marred being, a "heteronomous" subject, like the townspeople of Colobane who turn into something approaching hyenas.

For Žižek, what is unique about the object that has this non-specular function is that it itself has no double, no counterpart, "as if [it is] in search of its proper place, lost from the very beginning" (1992, 6). When Guelwaar's corpse was lost in the first half of the film, there was no concrete basis for the relationship between the Muslim and Christian communities: they did not exist for each other, but lived side by side. With the concrete intrusion of the corpse, what Žižek refers to as "a little-bit-of-Real," a disruption intrudes on their autonomous space, and they are forced to come into a relationship, a symbolic relationship marked by strife and disharmony, and by the creation of an environment in which negotiation becomes necessary. The "little-bit-of-Real" barely makes itself known to us: we get a glimpse of a decomposing corpse, which is quickly rewrapped and carried off. Yet without it, there is no coalescing of peoples and issues around a central concern, no way in which the principles Sembène wishes to evoke can be embodied in an articulated fashion. This failure of the symbolic order to assert its presence without this artifact of the dead man attests to the diminished presence of the "big Other," the figure on which the authority of the Name of the Father relies. Lacan identifies this diminished presence with the algorithm $S(\cancel{A})$ (that is, Sujet de l'Autre barré [subject of barred Other]) (Lacan 1968), which Žižek glosses as "the insignia, the index of the father's impotence: a fragment of reality which functions as the signifier of the fact that the 'big Other' is barred, that the father is not able to live up to his Name, to his symbolic Mandate" (1992, 8). When we consider the ironic distance between Guelwaar's title (noble), his inflated rhetoric of defiance in his magnificent speech calling on his fellow citizens to reject the handouts of the

donors, and his disregard for the realities of power, which results in his being beaten to death; when we further consider his dependency on his daughter's earnings as a prostitute, and his refusal to acknowledge their contradictory role in his life of fidelity to the Catholic Church; and finally when we observe his wife's telling his suit of clothes that she will have her piece to say to him when they meet up again in the afterlife, it becomes apparent just how this father is "barred," how he is not up to the eponymous name of nobleman he bears, and how it is only in his death that he is able to move the community and the younger people forward. Žižek speaks of the ending of films located within the parameters of this structure, and speaks of a happy ending, with a bitter taste. *Guelwaar* ends with an upbeat and defiant note, but it is sung while the cart and feet of the people trample on the grain that had been given by the various donor nations, a sight no less shocking and ambiguous than that repulsive image of El Hadj's body covered with phlegm at the end of *Xala* (1974). In both cases, justice may have been done, but not without some loss.[17]

The third and last of these objects/subjects/socioeconomic system clusters considered by Žižek involves the figure of "pathological narcissism" associated with late capitalism or globalization—a figure who appears in mocked dress when located on the terrain of the postcolony where globalization corresponds with the inevitable disappearance of the paternal superego altogether and its replacement with the completely dominating figure of the maternal superego. In *Looking Awry*, Žižek describes the disorder in the family generated under these circumstances: "The father is absent, the paternal function (the function of the pacifying law, the Name-of-the-Father) is suspended and that vacuum is filled by the 'irrational' maternal superego, arbitrary, wicked, blocking 'normal' sexual relationship (only possible under the sign of the paternal metaphor)" (1999, 99). For Žižek, the mother in *Psycho* (1960) presents such a figure, attesting to the "unresolved tension in intersubjective relations" (99). The kinds of objects that come to inhabit Hitchcock's landscape now assume gigantic and monstrous proportions: the birds in *The Birds* (1963), or the airplane and Mount Rushmore in *North by Northwest* (1959).

For the figure of the monstrous in African cinema, we would not turn to the failed despots, the Popauls of the second group of objects, but to those multitudinous shocking figures of disruption and fearfulness that embody the spiritual realm of evil forces, the favored haunt of contemporary video filmmakers in Nigeria and Ghana. Demonic figures, insurmountable forces motivated by desires associated with greed and lustfulness—all the markings of the absence of the paternal superego—are here translated into an African imaginary of what Denise Paulme (1986) called "la mère dévorante," and which we can take as a response to the conditions associated with the pandemics now facing much of Africa: AIDS, "la crise," "la conjunction," and the nightmare scenarios of brutal war, violence, and violation.[18] Even in Nigeria, where the sights of such horror are frequently visited in regions of conflict like the Oil Delta, or in neighboring states like Côte d'Ivoire, the effects can be seen in such films as *Thunderbolt*

(2000) where the dissolution of the conventionalized African family and the transformation of the husband into the one menacing his own wife correspond to the broader threat to the bonds that have sustained the social order.

Equivalent figures on celluloid in African film productions occur less frequently than in video productions, but can be found in similar configurations of globalization, with a significantly diminished paternal figure, and with the appearance of the monstrous often in spiritualized forms (compare *Les Saignantes* [2005]). Thus, even in the humorous situations in *Quartier Mozart* (1992), we can perceive this configuration: the father, now nicknamed appropriately, laughingly, Chien Méchant ("Mad Dog"); the figure of the man-woman Panka, whose handshake renders men impotent; the wrecked car of "transformations" where death or magic are located. In *Mossane* (1996), these figures of the fantastic appear as the "pangools" or ancestral spirits, whose ghostly presence menaces living beings and others. In more recent films, AIDS has supplanted the figure of the threatening European who corrupted, enslaved, or controlled his African puppets, as had been the case with various figures in *Emitai* (1971), *Xala* (1974), *Ceddo* (1976), or *Camp de Thiaroye* (1987). Now we have the African mother or wife who finds herself dealing with increasingly powerful threats to her home and family life, as in Abdoulaye Ascofaré's *Faraw* (1996), and in Fanta Nacro's "Puk Nini" (1995) or "Le Truc de Konate" (1998) where infidelity in the former, and the need to protect oneself from AIDS in the latter, prevail over all other concerns. Similar scenes mark Sembène's more recent *Faat Kine* (2000), another film in which the maternal superego prevails in the absence of the paternal superego, and where the oppressive figure of Faat Kine's father sets the stage for a succession of failed, impotent father figures in the next generation. Conversely, impotence and castration at the hands of the maternal queen Linguère Ramatou, whose figure rides high above all the ordinary townsfolk of Colobane, mark the key moment in *Hyenas* (1992) when the queen mother announces her desire to have the head of the town's most popular figure, the former philanderer Draman. In the end, he is transformed into another one of the monstrously spiritualized apparitions: he disappears, as though trampled/ transmogrified into some invisible form that is joined to death at the end. Rama descends into an equally ambivalent tomb: death as monstrous marks both their fates.

Unlike the figures of exchange that certify the possibility of a symbolic order, however diminished, here the monstrous signals the "impossible jouissance" of an object Žižek characterizes as having a "massive, oppressive material presence." That describes accurately the plowed field that greets the eye at the conclusion of *Hyenas*, where the landscape conveys the hideous end of the old order in which such figures as the teacher or hunter had once been able to assume an admirable shape. We had intimations of such irresolute desolation in the abattoir scene at the beginning of *Touki Bouki* (1973); and in fact, the surfeit of the material is best demonstrated in the carnival scene in *Hyenas,* in which the loads of refrigerators and air conditioners, exhibited amid the swirl and chaos of the festive nighttime scene, evoke the complete triumph of the material over the

spiritual. The "pathological narcissist" is clearly extended to the population in general—the children initiates, now riding the roller coaster; the women, including Draman's wife, so quick to betray him for the luxury goods; his friends, down to the last man, who join in the accusations against him—pathological to the point of turning into hyenas, with no one to control their endless appetites for more. This is the "society of consumption" (Žižek 1992, 5), Jameson's postmodern consumerist society where use value has disappeared in favor of an all-consuming exchange value, and where enjoyment assumes so great a material form as to end the clarity of vision required to sustain the symbolic order.[19] This completes the passage from *l'objet a*, with its assumption of coherence and order, to the demolition of coherence with the materialization of an impossible enjoyment: "The predominance of a certain type of object thus determines the modality of desire—its transmutation from the unproblematic chasing of an elusive lure to the ambiguous fascination with the Thing" (Žižek 1992, 9).

For Žižek, these three periods gradually render "visible the impossibility of the sexual relationship" (1992, 9), and the ending of *Hyenas* (like that of *Quartier Mozart*, or *Touki Bouki*) would certainly seem to bear this out. But hyenas, like abikus, have their own resonance, and the gradual diminution of the paternal figure cannot be said to have marked without contradiction the passage of African culture since Independence. The paternal figure has been barred since the colonial period, just as the devouring mother hasn't waited for globalization to make her appearance. What it is important to realize is that as each of these patterns emerges in the films we have noted, simultaneously they evoke or echo those earlier moments in the conjunction of modalities of desire, social patterns, and political conquest and domination. The monstrous figure located at the site of the void in the real has not had to wait for the globalized economy to make its appearance; nor has the "conjunction" or crisis taken on an unfamiliar form. The "Thing" that Žižek locates at the end of this trajectory was always present, always haunting an imaginary attempting to give form to that which was destructive and beyond representation. What is new is its ascension to a dominant position.

Though the images of the key Hitchcockian objects can be traced from the invisible *objet a* to the monstrous, and though the association with forms of subjectivity and the economic order can be made, the context within which an African perspective is developed cannot be cordoned off from the Žižekian paradigms. After all, the economic order is based on dominant players who require their workers' surplus labor at bargain basement prices. The perspectives of the two, those who enjoy the fruits of globalization and those whose labor is required to grow or produce them, are not the same, though they are linked. Nevertheless, we are still presented with a similar set of objects whose materiality cannot be displaced by some deeper quest for exegetical meaning. This is because their very form is a consequence of the incoherences within the symbolic order whose common sources cannot be completely explained away, and of disturbances that attest to an unassimilable element, let us say a void, within the real itself.

"The truth is out there." (*The X Files*, cited in Žižek 1999, 89)

The question is how do we access a nonsymbolizable real? How do we talk about it? How can we perceive it, work it into a symbolizable account? How do we move off the conventional center that has paralyzed us in dealing with an African cinema that has rigorously refused the dictates of a commercial, Hollywood, western mainstream cinema driven by financial exigencies to produce a limited set of genre types? How do we not only see the unseeable, but see anew? If this is the challenge of all film studies, it has a particular resonance for African film whose burden is double: not only that of all independent filmmaking vis-à-vis commercial filmmaking, with its overpowering apparatuses, but also that of its own dominant ideological foundation that has proved equally rigid and more resistant to change because of its assumptions of serving the utilitarian cause of ameliorating society. The exigencies of ideological commitment in an economy of liberation can be overwhelming; the few who resisted, Djibril Diop with *Touki Bouki,* or, for the next generation, Jean-Pierre Bekolo (*Aristotle's Plot* [1996]), Henri du Parc (*Bal Poussière* [1988]), or Mwezi Ngangura (*La Vie est belle* [1987]), have run the risk of marginalization. Eventually, after a long lacuna, Djibril Diop was able to make a second film, *Hyenas.* In this, Yambo Oualougem never succeeded.

We would want to accommodate a real that finds expression in these and other African films, and are confronted with the dilemmas stated above, encased within the question of where to locate that false trickster, the truth, especially if we give up on the search for the Truth of the profound depths. "The truth is out there" means that we follow Lacan's claim that "the unconscious is outside" (1999, 89). There are a number of different aspects to the "outside" that merit our attention. The first will be those spectral apparitions that purport to emanate from the invisible world of the real, of true being, of permanent being—the spirit world. This includes the familiar set of "African" images that has emerged since Tutuola constructed his palm-wine drinkard, with such figures as the abiku, the obanje, the eshus or tricksters, the oguns, and so on. Once the style was set, it was possible for others to compete for a similar cast, including most obviously Cissé's gods in *Finye* (1982) or the Kore men's society and its tutelary gods in *Yeelen* (1987). Sembène was not above a similar turn in *Emitai* (1971), and could not help giving us at least one marabout whose powers seemed to work in *Xala* (1974). Whereas Sembène has long since moved on, we can observe more recent films that continue in that same vein, such as *Mossane* (1996) or *Le Prix de pardon* (2001), the latter striking me as an especial throwback to the earlier work of the 1980s. What will be of interest here is to look to this range of spectral imagery not as anthropological symbols, but as concrete excrescences that perform ideological functions, in the sense that Žižek means when he states that "focusing on material externality proves very fruitful in the analysis of the inherent antagonisms of an ideological edifice" ((Žižek 1999, 89).

Although somewhat outside the scope of this study, it would seem that recent work on Nigerian and Ghanaian video films by Carmela Garritano (2000) and Jonathan Haynes (2000) point us in this direction. It should be noted that the blatant turn towards the supernatural and melodramatic in video films is accompanied by an equally strong manifestation of the social conflicts and often phallocentric preoccupations of the filmmakers—all of which display the "antagonists of the ideological edifice."

The spectral and the fantastic are all broadly represented across much of the range of African films, and their materiality is the object of our inquiry. But so too is a range of objects that have correspondence to aspects of subjectivity, those that are variously absent, present as a fragment of reality, and overly present. They are defined in terms of a relationship to presence, and as such are closely tied to the ways in which one works out one's relationship to l'objet a, the object of desire which cannot be symbolized—returning us to the inevitable "gap" in the center of the real. In attempting to recenter the material in a range of objects that resist being subordinated to the status of the symbol, we join Žižek in his focus on the materialization of ideology in an "external materiality [that] renders visible inherent antagonisms that the explicit formulation of ideology cannot afford to acknowledge" (1999, 89).

The material as the "imp of perversity" (1999, 89), the material manifestation of a conflict or antagonism that escapes ideological representation, has been evoked in a range of figures and scenarios that might be taken for irrelevant, humorous, or idiosyncratic elements, precisely because of their irreducible nature. Whatever is left of the symbol that cries out for interpretation after the work of interpretation is performed, what Chion identifies as the "rendu," opens a space where the subjective and the ideological can meet.

If we are to succeed in moving beyond the problematic limitations of an analysis of depth, it won't be by forgetting the work performed on the symbolic level, by the choice of a material manifestation of a symbolizable real, but rather by asking what relationship that symbolic, material world bears to what it conceals/reveals. The two approaches will have to work in tandem since we are now reading the work on interpreting symbolic meaning as a compensation—only this time as a compensation for a lack, for an unanswerable question, rather than for an identifiable trauma, a class interest, or a will to power.

6 *Aristotle's Plot:* What's Inside the Can?

"All filmmakers are gangsters who lack sufficient personality to be real gangsters."
—Bekolo's "Grandfather," *Aristotle's Plot*

"But if filmmakers were to become gangsters, what would become of the gangsters themselves?"
—Bekolo, *Aristotle's Plot*

"Cinema is my life," says Cinema, the leader of the tsotsis.
—Bekolo, *Aristotle's Plot*

Materiality, as I read it through Žižek, is quite different from the kind of materialist reading I would associate with the historic patterns of African cinema and its criticism where the material reality has been read as symptom—that is, as a sign to be translated into a framework for an ideological apparatus. The heavy boot of the policeman comes down on *Borom Sarret*'s medal and on the coin El Hadj tosses to the beggars in *Xala* (1974); the plowing and the long, diagonal shot of the peasant farmer who labors to ascend the hill so as to greet his master in *Harvest 3000 Years* (1975)—these and the thousand-and-one dense signs of obvious messages eventually came to weigh on the screen with their didacticism. We could say the materiality was itself burdened by its assignation of meaningfulness, and as such foreclosed the signifying process. This limited materiality to a monological significance and commensurate representations.

If this form of social realist ideology alone didn't sufficiently delimit materiality, then the heavily structured, class-conscious characterization that performed a similar function did. The model is seen in films like *Njangaan* (1974) or *Tauw* (1970) where the plot invariably is built around the oppressive patriarch, the oppressed mother, and either the rebellious son or the son as victim. When the child is young enough, as in *Nyamaton* (1986), we see him or her turn to begging, garbage picking, or thievery. The pattern might have been established in a tradition of such films, dating back to *Los Olvidados* (1950) or *Les 400 coups* (1959), which has been developed more recently in a series of African films that depict street children with increasing harshness (again the international model suggests the Brazilian film *Pixote* [1981], with some African

equivalents seen in *Dôlé* [2001, Gabon]; *Nyamaton* [1986, Mali]; and *Everyone's Child* [1996, Zimbabwe]). When these films are read just for their representations of the children, and not in terms of the principal plotline, one could add *Mapantsula* (1988), *In a Time of Violence* (1994), *La Petite vendeuse de Soleil* (1999), *Pièces d'identité* (1998), and many others in which street children figure. The above films contain images of children not only having "turned bad," but also having been forced into desperate circumstances, a notable example being *Everyone's Child*. In this respect, the Bunuelian sense of innate human cruelty and repression is much less prevalent, while the social commentary that seems almost artificially forced onto the frame of the tragedy in *Olvidados* appears central to most African films, as we see in *Tauw* or *Everyone's Child*.

On the other hand, it is possible to locate examples of materiality that do not *signal* a meaning as much as hide it; they do not signal it, but suggest it as something that cannot be overtly evoked, or that is actually the opposite of what it appears to be (Žižek 1999, 89). Most of all, such a materiality isn't used as a springboard to some level of meaning outside of it, but rather is an object that forces us to return to it, its *surface,* its appearance, its phenomenal externality, and even its gaze, rather than its hidden true meaning. Whatever is true about it comes into play through our engagement with its external appearance.

For instance, the film cans in *Aristotle's Plot* (1996) contain something we can never see. We see the reflection of the films on the faces of the audience, hear their discussion and critique of the films, see the billboards, even see the projector and projection light, but we never see an image or frame. What is the materiality that contains the films (like the cans that are welded shut), and why do we never see the films themselves? That conundrum is the key to *Aristotle's Plot*.

To begin, the contents of the cans that E. T. hauls around constitute his "cinema." It remains as invisible to us as any of the films being projected in *Aristotle's Plot*, all of which correspond precisely to what Žižek evokes as *l'objet a* in *Looking Awry* (1998).[1] There he evokes J-A Miller's description of the function of *l'objet a* as that which "stabilizes" reality. What frames reality? That is, what *sets off* reality so that we can perceive it? What gives it definition by establishing its contours and limits?[2] We could identify "reality" in several ways: social, psychological, physical, perceptual. The one key dimension here is that it is accessible, and thus perceptible. This places *l'objet a,* the subtracted, absent portion of the picture, in the role of that element whose inaccessibility to perception makes the perceptible possible. In this case, we are concerned with the cinematic reality that is conveyed through the visual image and audible sound, that quality of reality most immediately associated with the surface, and it becomes perceptible due to the "subtraction" of *l'objet a,* of that inaccessible object whose disruptive function sets in motion the procedures by which we make sense of "reality." Lacan identifies that subtracted, inaccessible element as a fragment of the "real" that incites desire and sets the hermeneutic processes in motion. "So *objet a* is such a *surface fragment,* and it is its subtraction from reality that frames [reality]" (cited in Žižek 1998, 95, my emphasis). Lastly Miller

quickly associates the subject "as barred subject"—as "want-of-being," with this same trait as *l'objet a,* its "lack," its absence or opacity, and especially with the effect of its absence in framing reality.

The absent cinema in *Aristotle's Plot* (a film about cinema, and that celebrates one hundred years of cinema!) obviously provides the organizing principle of the film. We enter the theater "Cinema Africa" and are soon greeted by the audience, the "tsotsis" or young gangster types, whose names are reflections or imitations of gangster actors or actor heroes, or even their characters: Nikita, Van Damme, Sadam (*sic*), Schwarzennegger (*sic*), Cobra, Bruce Lee, and the leader of the pack who calls himself "Cinema." Their taste runs only to gangster action movies that provide them with their role-playing subject-positions, their monikers, their language and style, their "look." They organize their own subject-positions around the absent projected images whose light flickers off their faces as fragments of the film's dialogue can be overheard. They truly pass through the desire of the other, constructing the shape of their desire not only through that of the characters on the screen but also through the larger world to which those characters belong, the cinematic Other.

E. T., their nemesis, is just the opposite—but only in appearance. He is presented as the serious African filmmaker—the Sembène Ousmane, Haile Gerima, Med Hondo, for whom a cinema engagé implies a political commitment, whose vision of an "authentic" Africa supplies the basis for the cinematic image. Instead of lack, entertainment, or pure image, mimetic reality provides the rationale for their African cinema. Again we access these films through the reactions their images and sounds generate with the audience. For instance, at one point the tsotsis are showing "authentic" African films in a village. We hear their ironic comments about chickens and other animals providing the action, with the sounds of the barnyard supplying the acoustic accompaniment. When they were watching a violent film in the city, we saw their fascination and heard their commentary on the action.

The film's protagonist, Essomba Tourneur, cannot escape the framing of cinematic reality any more than the others. As we are introduced to him early in the film, we learn he is a recent returnee whose intention is to bring serious, committed film to Africa. He encounters the reality of kung-fu, martial arts, and popular commercial films being shown in the movie theaters ("Cinema Africa"), and he resolves to substitute serious African films for the "junk." He is the presumed genuine African filmmaker, the social realist whose progenitors constituted that first generation of authors and filmmakers whose exile from and, for some, return to Africa signaled their commitment to social change—Sembène Ousmane, Mongo Beti, Ayi Kwei Armah, Ngugi wa Thiong'O, and Dennis Brutus, among many.

If this pattern suggests one kind of frame for the story of E. T., its limits are those of the symptom—that is, those of a reality that is knowable and comprehensible, and that provides a grasp that leads to complete mastery over the text. But what if the text signals its own "lack," its "want-of-being," rather than its fullness of being? What happens when that fullness is shown to be not merely

there, but *framed* and therefore grounded in that form of address marked by ideology and by desire? No film escapes those qualities that mark them as exceeding the social reality of mimetic reproduction. Thus, E. T. is already, by his name, both Africa (Essomba) and non-Africa ("Tourneur," after the French *tourne*, one who shoots films); someone who is real (visually a person, "there" with the others) and an outsider (a been-to; and not only the parody of the been-to but the image of that been-to). In other words, not only real (after all, the government is wary of him, is keeping its eye on him), but extraterrestrial, an "E. T.," an imitation of an imitation of an imitation of reality. If this is "Aristotle's" plot, the plot that holds the highest form of literary creation to be an imitation of reality, it is severely deficient in Platonic terms, for each one of those "imitations" signals another degree of removal from the only reality worth pursuing: the true, eternal forms of the ideal realm, the realm of ideas.

But even that doesn't suffice to frame E. T. He has to take his place with respect to the cinematic real, and that is not simply as the serious filmmaker, the "cineaste," but the cineaste as seen through the eyes of those for whom film is everything, that is, the tsotsis. And for them, thanks to their power of creating movie monikers—stage names, in lieu of real names—he is simply "silly ass." This not only mocks his pretensions in calling himself a cineaste but also ensconces him in *their* film world where the rapper, with his rhymes and nominalism, takes precedence over the political or cultural idealist. He is defined in relation to them, and they in relation to him.

E. T. and Cinema (the head of the band of tsotsis) are joined by the policeman (in fact, handcuffed to him), both at the beginning and toward the end of the film. The policeman is thoroughly unreal. His helmet looks like a masquerade; his authority seems silly, a mockery in keeping with Keystone Kops slapstick comedy of the sort that was in fact produced by the Belgians in their film series *Matamata and Pilipili* in the Congo during the 1930s.[3] He is both authoritarian with the public and subservient with his boss. In short, he fits in with the vision of authority presented so well by Mbembe (2000) as belonging to the realm of the Popaul type autocrat (see chapter 4 of *On the Postcolony* [Mbembe 2000]). Although *Aristotle's Plot* was shot in Zimbabwe, it was well before Mugabe self-destructed into that kind of autocrat. It would be more appropriate to see the models for the underlying autocracy being mocked as those appearing in the novels of Sony Labou Tansi, the plays of Soyinka, and especially the cartoons in *Le Messager*[4]—whose targets are all too well known.

These are the figures of an obsessive patriarchy, the butts of the attack in Teno's *Chef* (1999), now rendered in the ridiculous, impotent form of Bekolo's "chefs."[5] The form this figure took in Bekolo's earlier film *Quartier Mozart* (1992) was "Chien Méchant," another authoritarian figure with a silly nickname and a style so funny that his ultimate demotion, like that threatening the policeman in *Aristotle's Plot*, seems inevitably joined to his bluff and swagger. These are the signs of the absence of the Law of the Father and of the authority joined to the seriousness and reality of the symbolic order. With their reduction to comic status comes a shift away from the earliest forms of serious political

commitment whose own authority rested entirely within the symbolic, that is, under the sign of the Name of the Father. Whereas Teno substitutes his own subject position through the narrator's voice as the Name of the Father in place of the failed, mocked patriarchy in Biya's Cameroon, there is no such figure of authority in *Quartier Mozart* or *Aristotle's Plot.*

Standing over against these failed fathers are the mocking, unserious, unauthoritarian figures of the sons. In *Quartier Mozart* the mothers constitute something of a maternal superego: we see this with the witch, Mama Thécla, Samedi's two mothers, the women at the water taps and the generation of their daughters, all of whom provide a focus to the resistance to the phallocentric symbolic order with their own mockery of the Name of the Father as well as their own access to powers, at times mysterious, at times sexual. On the other hand, in *Aristotle's Plot* that maternal superego is largely absent. In its place is yet one other incarnation of the cinematic project, the figure of the actual filmmaker himself, Jean-Pierre Bekolo, who plays a cameo role, like Hitchcock, though here more thoroughly integrated into the plot. Bekolo appears as the barman whom the cop approaches to ask his key question, why do actors who die in one film reappear alive in another. If the cop can't distinguish between real and make-believe, this is not an issue of stupidity (though in his voiceover, the Bekolo-barman does call him stupid), but because his absence of knowledge implies the absence of the basis for the symbolic order (his ridiculousness functioning here like a form of paranoia where the absence of the "cut of castration" accounts for the failure to enter into the symbolic order and to distinguish the imaginary from the symbolic).

At one point the cop drives past the tsotsis in front of Cinema Africa: they jeer, and Nikita and Cinema make vulgar gestures, thus reinforcing the reduction of the Law of the Father embodied in the one whom the voiceover narrator qua Bekolo-barman later calls this "Keystone cop." Lacking the frame of the signifier, that is, the phallus (or signifier of signifiers), which would enable him to have access to the symbolic order ("are you saying I'm stupid," he asks), he embarks on a quest for the "truth"—why do the dead return alive in the next movie.[6] This is at the behest of his boss, the chief of police, whose own lack of grounding in a phallic reality accounts for that mission. The chief, like the cop, is represented in equally slapstick fashion as he sits on high, like a lifeguard, dispensing irrational orders in authoritarian style. Mbembe's autocrat in cartoon form again.[7]

This world of the absent Name of the Father isn't dissipated in the course of the film, as it might have been, say, by the filmmaker-bartender Bekolo, whose wisdom takes the form of the film's narrative voiceover (in the English version); rather, it prevails, so that by the end of the film, the news from Hollywood spreads that no one is dying anymore. Instead of the cop's inability to distinguish real from make-believe in the real world isolating him, by the conclusion of the film we have the end of the real world and its replacement by the imaginary order. The cop is seen now as not alone or handcuffing suspects, but drinking with others in a bar. And when he emerges and tries to apprehend a suspect,

his bullets can't stop the driver, just as E. T. can't be killed by a car. Thus, like the "real" E. T., that is, the one whose appurtenance to "another" world enables him to transcend "reality," this E. T.'s authority and powers are joined to a medley of cops and criminals whose distinctions are in the process of becoming lost in the tropes of cinematic magic. We are closer to the pathetic posture of Mbembe's autocrat than to Tauw's father in Sembène's *Tauw* (1970), or to El Hadj, when he slaps down his daughter Rama, in *Xala* (1974), or the father figures who marry off their daughters in *Muno Moto* (1975) and *Le Prix de la liberté* (1978). But *Tauw,* like the other films mentioned above, came out in the 1970s, whereas in Sembène's more recent works we have a wife telling off her dead husband's suit in place of the real man (*Guelwaar* [1992]), and a mistress dismissing her ex-husband ("Dehors") and lover ("entre toi et moi c'est fini" ["between you and me it's over"]), only to choose another man of her fancy (*Faat Kine* [2000]). Decidedly, the oppressive figure embodying the Name of the Father in the films of, say, Bassek ba Kobhio or Mansour Sora Wade (for example, *Ndeysaan* [2001]), is all too passé.

In place of the Name of the Father, we have the tsotsis who have no name of their own. "Cinema is my life," says Cinema, their leader. Cinema, the absent object that makes all the relationships possible in the film, provides the order on which the tsotsis base their rules and their nomenclature. We are introduced to the tsotsis toward the beginning of the film when they are in the theater "Cinema Africa." The show is about to begin, and the spotlight follows each one as they march in front of the screen while their moniker is called out. The theater is their home, their haunt. Cinema occupies their imaginary, or rather their imaginary takes over the cinema, occupies the space of the symbolic (the cinema hall), and conquers their space in that ambiguous relationship of hybridity in which the site of enunciation of the Other has become reterritorialized, internalized, and simultaneously maintained as an Other space.[8] They watch the screen, we watch the lights of the show flickering across their faces. This isn't Aristotle, but Plato—it's Plato's cave, the difference being that when they leave the cave, they take their monikers with them. They have become the shadows in a world with no ideal forms.

As the show begins, E. T. enters Cinema Africa and takes a seat. The tsotsis question him, and he identifies himself as a "cineaste." They promptly throw him out. E. T. then proceeds to forge a ministerial order of expulsion and takes it to the police, who lay siege to Cinema Africa. When the tsotsis surrender, they are expelled from the city. They repair to the countryside, plot their revenge, and during the night return to pull off a heist. They murder the projectionist and the single spectator, an African-American; they then steal the reels of film, and make off to the countryside. There they erect a new theater, the "New Africa," which Cinema proudly contemplates while proclaiming, "This is the real Africa." E. T. discovers the murders and theft, and sets out on a motorcycle after the tsotsis. Meanwhile they have started showing the stolen films to their new rural audiences.

At one point, when Cinema and two other tsotsis take a break from the "Af-

rican" film they are showing, Cinema turns from mocking the unsophisticated nature of the film and its audience to speculate on its opposite, a realism in which there would be scenes of him pissing. This dialogue occurs as he turns to urinate, and points with his finger as if in place of his penis. The phallic return takes the form of the gangsters creating a commercial enterprise, the "New Africa," based on their stolen reels of African film, ostensibly the very reels E. T. had shot. Their shift from being spectators in an audience to entrepreneurial exhibitors leads the gangsters to assume the roles of producers, directors, and actors. They create their own mock chase scenes, with donkeys and oxen supplying the carts' horsepower; Cinema recreates the scene of a car racing with squealing tires and dust trails. Some of the swagger and hyper-masculine role-playing begins to dissipate, and as they sit drinking at the bar after the countryside film showing, there appears through the doorway the figure of E. T., now scowling, menacing, and suddenly larger than before. More than Shane, he has turned into a lone gunman—Billy the Kid, Wyatt Earp—gunning for them. In the subsequent scene, he shoots them, one after another, until the remaining gangsters are seen shaking in fear (Cobra), or fleeing (Cinema) (just as the strictly macho Hector had turned tail and fled before the wrathful Achilles). Both pursuer and pursued meld into the film's roles, becoming film specters: "cinema" has overtaken them.

Each of the turns of the characters depends on their relationship to cinema as both a diegetic and extradiegetic object. The invisible film inside the cans, the object of the tsotsis' mistaken theft and of E. T.'s chase, is the unseen object that sets the action off—that is, the McGuffin. It is also stricto senso the *objet a* since it is the object of desire that is never rendered into a particular form, but rather is that fragment of the real that is responsible for desire to occur. It creates desire, but can only be chased, like Zeno's hare or the Homeric Hector, and can only be embodied in a substitute object, whose nature as a substitute guarantees the failure to satisfy the desire. And in the process, it "unleashes" the action, the plot, the cinema itself.[9]

But this is also the "cinema" that the tsotsis pursue in assuming the names and roles of their counterparts—the real Terminator, Schwarzennegger (*sic*), the real Cobra, Nikita, the real Cinema. And it is the cinema-identities that "Cinema" produces at the beginning when the cop demands his identity papers: Cinema shows him cards with the names Souleymane Cisse, Djibril Diop Mambéty, Med Hondo, Sembène Ousmane, and so on (but not Jean-Pierre Bekolo). It is the cinema as the point of reference for the narrator's grandfather's comments on cinema, and ultimately it is the extra-diegetic point of reference for the narrator's final claims that Africa invented cinema: "we got action, we got rhythm," and so forth. "What is an initiation ceremony," he asks. "Is there anything in cinema that is not African?"

"Cinema" passes from being the McGuffin to functioning as the symbolic object of exchange (stolen by the tsotsis, pursued by E. T.) that accounts for the symbolic relation between the characters (and that joins E. T. and Cinema to-

gether, literally, toward the end as they are both handcuffed to the cop). But instead of creating a neat passage to the third stage of cinema described by Žižek (1992) as the imposing presence of the real (as in Hitchcock's *The Birds* [1963]), Bekolo focuses on the role of cinema in that self-reflexive position that functions to empty out the distinctions between diegetic/extradiegetic, or insider/outsider, Africa/Aristotle, or Achilles/Hector. The hare and the tortoise meet in the final scene with the cop, E. T., and Cinema where the distinctions are blurred between reality and cinema in such a way as to place the film's spectators inside the scene, that is, in the place of the absent cameraman. In this regard, we are obliged to follow the same trajectory from spectator to characters and technicians as that of the tsotsis.

Bekolo prepares us for this final scene by contrapuntally posing diegetic action scenes with nondiegetic narrative voiceovers throughout the film. In a number of instances, he stages this counterpoint by evoking early filmmaking techniques. Most notably, we see this when E. T. is interpellated by the touts—white touts—as he walks past the car park with his cart full of film cans. Bekolo blocks the action in a straight horizontal line across the middle of the screen, holding the camera still as E. T. and the touts move in and out of the frame, first in one direction, and then back in the other. Player-piano music bounces away in the background, and the voiceover cements the silent-era effect, especially as it mimics the tightlipped wording of the intertitles, which not only explain the action but also give cryptic signals as a gloss on it. But the scene is ironic, of course, since the voiceover of the filmmaker-barman Bekolo remains cool and hip, incorporating MTV techniques in his filmwork, thus marking this scene as self-consciously tongue-in-cheek. In addition, the tongue-in-cheek quality is marked by the role reversal where the touts, normally ill-paid, outgoing African youths, are played here by middle-aged white men, whose "client" is the young black filmmaker who has come to be regarded by his fellow countrymen as mad.

Figure 6.1. *Aristotle's Plot:* E. T. walking across frame as touts importune him.

This reversal accords with the larger pattern of black-white relations signaled by the film's ironic title and articulated more or less directly by the narrative voiceovers (which are similar, but not identical in the French and English versions). In the English voiceover, Bekolo highlights the figure of his African grandfather, who is either giving his low opinion of the status of filmmakers as wannabe gangsters who lack moxie, or recounting the history involving the whites' domination and exploitation of black Africans. This skeptical attitude marks the tone of the narrator from the start when he informs us that this film is being made in honor of the centennial celebration of cinema. As the narrator-filmmaker recounts to his grandfather the name of all the famous directors engaged in the project—Martin Scorsese, Stephen Frears, Jean-Luc Godard, and others—he asks himself whether he hasn't been included as an act of Christian charity, if he hasn't gotten involved in a race in which the adversaries are already at the finish line as he is about to set out.

This white/black binary framing is both replicated and undermined continually throughout the film. For instance, at the very outset of the film (after the opening credits), we see E. T. pass in front of the Cinéma Africa theater. He laughs disparagingly at the sign "Action Packed Movies" and the accompanying posters of Western action and gangster films. When he enters the theater, and encounters the group of cinephile gang members, E. T. tells them he is a cineaste, that he makes serious African films, not "shit" like the films they admire and in which they locate their ideal subject-positions—thus establishing the alternative, race-based authenticity.

But if that group of white-produced commercial Hollywood or martial arts films is set in contrast to the works of African filmmakers like Med Hondo, Sembène Ousmane, Souleymane Cisse, and others, it is the latter group's names that appear on the cards the gang leader Cinema shows to the cop at the beginning when asked for his identity papers; and further, the African cineaste E. T. blurs the distinction between white and black since he acquired his training in Europe, where he learned to become an "African" filmmaker. If Cinema holds the deck of cards with African cineastes' names put to their faces, E. T.'s names are divided between those that are African (Essomba), French (Tourneur), and Hollywoodian (E. T.). If he mobilizes the police by forging an expulsion order from the Ministry of Culture to get the tsotsis out of Cinema Africa, he is also considered dangerous by the government, which has him followed. The blurring and crossing of stereotyped character lines carries over throughout the film: the tsotsis become entrepreneurs by exhibiting "African" films in the bush, whereas E. T. becomes a vengeful, Rambo-type lone killer who takes on the gangsters one at a time and defeats them in a series of Hollywood-style duels.

It is essential to read this film as a rescripting of postmodernism in an African guise, and *not* simply as an example of some *universal* postmodernist filmmaking in which the point of the crossovers and confusion is to highlight, self-reflexively, the qualities of the signifier as floating. Rather, it is important to distinguish this film from the quintessentially postmodern label by calling at-

tention to the crucial site of enunciation occupied by the narrator as he indicates that space in which African film itself comes to occupy the place of the desired, if unseen, object—the *objet a*. And as it is the space created by the displacement of the *objet a* that gives definition to the symbolic, it is important to note that both the site of enunciation for the narrator and the unseen film in the cans occupy and give definition to the space we define as Africa. *L'objet a* is no more immune to the cultural context that frames and gives definition to the symbolic than any other aspect of what we consider constitutive of the postmodern. What is at stake here is not some essential Africanness, but rather a challenge to the universalism implied by any definition of *the* postmodern as lying outside of its social, historical, and cultural context.

Žižek points to the moment in Hitchcock's work that provides this same crucial distinction—for him the point being that postmodernism is an extension of the modernist moment.[10] For me, the importance lies in the fact that Bekolo is engaging in a rewriting of postmodernism, from a self-consciously assumed African point of view. The tsotsis provide the vehicles for the postmodern, post-ideological, decentered subjects of Africa's marginalized youth, ones who are obviously neither "authentic" nor assimilated to any symbolic order. They occupy places that they themselves define only in terms of the Hollywood imaginary, and that are summed up in the name of their leader, "Cinema," a name that corresponds both to the theater where they see their films and the films we see them viewing (without being able to see the films ourselves). Still, they escape the quintessential blurring of boundaries between fantasy and the real, as occurs in Woody Allen's *Purple Rose of Cairo* (1985) where the characters' desire functions so as to enable them to cross that boundary and enter the world of the films they are watching. The cop tries to resist the confusion between name and object evoked by Cinema's name with his example of Thomas Sankara. (When E. T. explains that the cinema theater is called "Cinema," and that the gangster is also called "Cinema," the cop says, "Which comes first, the boulevard named Thomas Sankara, or Thomas Sankara?") But if the cop can't distinguish between signifier, signified, and referent, E. T., the "real" African cineaste, cannot convey the distinction between the idea and the reality or, in this case, between the name and the object, and can only identify Cinema for the cop by his name. The cop comes closest to the medieval nominalist, for whom only individual beings have reality, whereas E. T. is closer to the medieval realist for whom universal categories, like ideal forms, have reality.[11] Translated into psychoanalytic terms, for the cop the material symbolic order excludes the imaginary order, and in his nominalism he would go so far as to find universals equally unreal. This prevents him from distinguishing the imaginary from the symbolic. Between the cop as exemplar of the failed symbolic order, the failed Law of the Father, and E. T., incapable of establishing the separation of the real from the imaginary, only the tsotsis' own sense of themselves, with their introduction of themselves *to us,* can serve as a support for their roles. They appear in the spotlights for us to gaze at them, and in that *crossed* moment, when

we know they are somehow role-playing, we construct them as postmodern characters—but only by uneasily situating our gaze on them as emblematic of modern African youth, as the "lost generation."[12]

Similarly, we are uneasily interpellated by the voice of the narrator, whose sarcastic address, ironic references to his grandfather, and even his designation of E. T. as their "great" African filmmaker, leave us occupying an uncertain space, where we can't be sure of the location from which to gaze or to hear the words of the film—thus interfering with our construction of the ideological point of view. This is the spot identified by Žižek as the stain that "prevents [us] from achieving [our] self-identity" (1998, 126).[13] It is also the point at which we can separate Bekolo's postmodernism from Jameson's classic version of post-modernism, this corresponding to a similar point at which Žižek establishes a distinction between Derrida and Lacan.[14]

Jameson's use of the term "pastiche" in his reference to the "stereotypical past" (1991, 21) might seem best to characterize the montage effect of Bekolo's filmwork, especially when the past is presented as a self-conscious stereotype, that is, a parody. For example, the black cop tells a white prisoner who is being held in an outdoor cage to shut up, parodying race relations in Ian Smith's Southern Rhodesia (*Aristotle's Plot* is shot in Zimbabwe, in English), and to lend further postmodern self-reflexivity and playfulness to the scene, the white man cries out that they have the wrong man, that he is called "Jean-Pierre" (Bekolo's own given name, employed in both the French and English versions). Along the same lines, when the tsotsis take the names of the gangster/martial arts film stars, and as they appear in spotlights at their introduction, we seem to have perfect examples of simulacra, signs of Jameson's pastiche, in which history is turned into historicism, that is, a construction of the past, or, in this case, a past role in which the original itself is unreal.[15] To nail this technique to his foundation of postmodernism in late capitalism, Jameson associates this construction as an extension of the total hegemony of exchange value over use value.

All this reading of the tsotsis as simulacra would work, but in a kind of spatial vacuum, or, to be more accurate, on a constructed stage set that exists outside any geographical or historical frame. My claim would be that the referencing of the Europe/Africa relationship, especially as highlighted through the narrator's voiceovers, returns us to a position where we cannot ignore the site of our own gaze, the place from which we see and hear the voice of the narrator. Our site is implied by his address; our relationship to the tsotsis as simulacra is haunted by the frame of the Western action heroes placed within the African setting. Without that setting, we could not have the pastiche effect for which Jameson reaches, because there would not be a simultaneous address to the site that Žižek calls the stain or blot (1998, 93–94), the place we cannot occupy in such as way as to constitute ourselves. Here it is not a question of *being* an African or European in watching the films. If it were, then one could not claim that the subject-position is always already divided from the start and to the finish. But whether that division is conceived in terms of language, and its innate mark of *différance,* or subjectivity, that is inevitably constituted through the

Other—an Other that is itself always already marked by its own lack that it attempts to fill—*any claim to ontological wholeness is untenable.* The tsotsis' address is to that claim, and it is first presented to us in the form of the simulacrum: "Yo Sadam [*sic*]," "Yo Nikita," and so on are interpellations of projected images.

Were this film molded in the manner of the films *Ceddo* (1976), *Peasant Letter* (1975), *Wend Kuuni* (1982), or the novel *Things Fall Apart* (1958)—all classic protest or historical testimonial films or novels—the positions assumed by the spectators would not be troubled by the texts' address, would not be troubled by the parodic positioning of a narrative voice. In Derridean terms, this would be the conventional case of the classic realist text in which the purity of the gaze can remain untroubled only by ignoring the margins or frame of the text for which this pure gaze, this unified subject position, cannot account. Here we have the quintessential postmodern concern, which is with the position of the subject, and especially the subject as marked by *différance,* as marked by the inscriptions of a system already present in its attempts to constitute the pure gaze.

But Bekolo's concerns take us beyond the subject—or we might say, back from the subject to the object. And this is because *our* position as addressee for a narrative voice and diegetic context is continually evoked, and not simply as *the* addressee, *the* viewer or spectator, *the* auditor, but as the spectator caught within the binds of positions defined ironically as those of Aristotle and Bekolo's grandfather. And both positions are marked by a lack. The narrator evokes the second chapter of Aristotle's *Poetics,* which is *not* considered in the constitution of the western paradigm, and he evokes the African initiation ceremony in a world where the tsotsis are clearly initiated into the Hollywoodian real, and not the real of the "authentic" African world.

Bekolo's spectators are not the same as those of Sembène or Kaboré, not because they lack the self-presence of a universal unified subject, but because they occupy a split site of viewing, a site that is not clearly or comfortably identified through the certitudes of the film, but that is constituted "asymmetrically"—that is, in a location that is unseated, jostled off-center, *by the gaze of the film back onto us.* This is how Žižek describes this effect: "I can never see the picture at the point from which it is gazing at me, i.e. the eye and the gaze are constitutively asymmetrical" (1998, 125). By "gaze" here, Žižek is not referring to that of the spectator, nor of the gendered viewer, but of the objects or points in the film from which the spectator is viewed or addressed. This point is clearly present when the narrator in *Aristotle's Plot* addresses us; a narrator who is not seen, and whose place, whose points of reference ("my grandfather") only serve to dislocate the narrator, especially dislocating him as *the African filmmaker.* Bekolo further complicates the address since it is recognizably his voice that is heard as the narrator in the English version of *Aristotle's Plot* (as had been the case with Hitchcock), whereas it is the voice of another, an unattributed voice as it so happens, whose voiceover we hear in the French version of the film. Furthermore, the voiceover narrative is different in the two versions. Most notably, the character of the narrator's grandfather—let's call him "Bekolo's

grandfather"—is evoked often in the English version, and he functions as both an ironic corrective to the European assumptions about reality and truth, and as a kind of tongue-in-cheek ancestor for the Bekolo narrator-character. In short, he supplants the missing Name of the Father, but again not in person, not in real life, not as a real character, but only as a reflection in the mind of the Bekolo-narrator (as in "my grandfather said . . . ").

We become objects for this voice, and by extension for those figures in the film whose performance can be seen, at the least indirectly, as being addressed to us; and in the process our relationship to the film's narrative becomes split. We can't occupy the spaces to which the performances call us because *the act of calling us introduces a "blot," a "stain," a space for which the performance cannot account.* This is not least because there is always already the site that the gaze occupies as it is returned to us, as it turns to us; it is this that renders any gaze nontransparent. In this relationship between spectator and object, we become the objects of that performative gaze, objects that remain unseated. "Far from the self-presence of the subject and his vision, the gaze functions thus as a stain, a spot in the picture disturbing its transparent visibility and introducing an irreducible split in my relation to the picture" (Žižek 1998, 125).

Žižek, like Jameson, points to how nostalgia films domesticate or "gentrify" this process—attenuating that gaze of the other constructed within the film, and eventually commodifying the "gaze *qua* object" (1998, 114) through the illusory sense of command constituted as self-referentiality. This is where Bekolo's narrative voice complicates the attempt to construct his films as Jamesonian or Lyotardian postmodern. The referencing of Africa's role in the creation of film is really an act of reconstituting an African postmodernism, or, I would argue, postmodernism itself, and this is possible through the relationship of the narrator's voiceover and the spectators.

For Žižek, nostalgia films employ the fascination of one character for another as a device through which to focalize the viewers' own fascination, and in the process to obscure any awareness of the spectators that the objects at which they are gazing reflect back that gaze—reflect the gaze, and therefore establish sites from which the gaze and the process of that gazing can be returned. If, for Jameson, nostalgia films are another mark of the postmodern, it is important to distinguish the kind of nostalgia that marks a film like *Shane* (1953), in which the seriousness of the plot, the love triangle, and the little boy's adulation of Shane are intended to catch the viewers up in the fascination of the last of the Lone Ranger–type gunman. The violence of Rambo lacks nostalgia's deepened sentimentality wrapped around the past, nor does the fascination with violence require nostalgia, but rather the display of the reflected effects of the violence. In both cases, *Shane* and *Rambo* (1982), the effect of the returned gaze qua object, in Žižek's terms, is occluded by the suturing of the spectators to the characters through whom the fascination is viewed. The effect of parody is to disrupt the suturing, destabilizing the real and the effects of fascination. It is a mirroring of a self-reflexive effect, one that postmodernism has elevated to the status of the canonical, cool position from which one is secure to view any act.

This is where Lacan's notion of the gaze qua object intervenes so as to disrupt the security invested in self-reflexivity: whereas nostalgia or direct action don't function to obscure the suturing, the dissymmetry between the subjects' viewing and the gaze qua object intrudes so that there can't be any safe reintegration back into the viewer's symbolic. In Lacan's terms, it remains as a blot or stain, like "das Ding."[16]

Our viewing relationship to the tsotsis begins as they are introduced in the spotlight of Cinema Africa. They are presented for viewing by the invisible projectionist, through whose eyes we too see them spotlighted, and through the eyes of Cinema, who returns the greeting of each, except for Cobra whom he disparages. These are the interpellations that function "as if," as the setting and even Cinema's name create a visible stage setting for an imaginary performance. These simulacra figures carry the spirit of Cinema Africa—that is, the actual cinema in Africa, which is an imported form of films of violence. In E. T.'s attempt to describe them to the cop, we see another failed attempt to capture them. For E. T., the idealist, there is no foundation to their roles—imported film is "shit," as opposed to authentic African film. When Cinema calls African film shit, E. T. responds, if African film is shit then you are shit since you are African. Image is being.

Conversely, the cop can't find an appropriate language with which to describe, or understand, the real: Does the Thomas Sankara Boulevard come first or does Thomas Sankara come first? The real, material origins of the light and fantasy shows called Cinema escape the nominalists' search for authenticity through originary thinking, and he can't integrate into his literalist symbolic order an image of someone who dies in one film only to reappear alive in another.

In contrast to the fantasy of the tsotsis, both E. T. and the cop oppose a concept of authenticity that justifies their attempts at first to expel them, and subsequently to imprison or kill them. However, they are not only figures that are seen—objects on whom we, E. T., the cop, the projectionist, and Cinema gaze—but also figures who see as well. They are also viewers who are seen seeing, who generate a critical discourse on what they see, and thus implicitly return back the viewer's gaze as objects that gaze. Within the film's diegesis, they evoke the parodic self-reflexive quality of the postmodern. And this is all the more the case as they have assumed pop culture roles, have taken the monikers of pop culture icons, and thus enable the viewer to generate a critique that crosses from the high theory of metacriticism to the popular level of conventional genre film—another of Jameson's requirements for postmodernism.

Key to Jameson's conception of postmodernism is the "surface" reading that dissolves the bright line between "inside" and "outside." For Jameson, "contemporary theory" has discredited the hermeneutical model based on this distinction, and with it the foundation of depth on which it rests. The four depth models he sees as repudiated include the following: 1. the dialectical model of essence and appearance; 2. the Freudian model of latent and manifest; 3. the existential model of authenticity and inauthenticity; and 4. the semiotic oppo-

sition between signifier and signified (as we see played out in the dialogue be-
tween the cop and E. T. over whether the road called "Thomas Sankara" or
Thomas Sankara himself came first) (1991, 12). For our study, most signifi-
cantly, he concludes that these various depth models have been replaced by "a
conception of practices, discourses, and textual play" whereby "*depth is replaced
by surface,* or by multiple surfaces" (12; my emphasis').

Much postcolonial theory is often ill at ease with these postmodernist for-
mulae because they would seem to vitiate the central concerns of those cul-
tures formed around long-standing revolutionary or Independence struggles.
But as far back as the 1950s and 1960s, with the proto–magical realist novels
of Alejo Carpentier followed by those of Gabriel Garcia Marquez, and those
of Maghrebian authors like Kateb Yacine and Mohammed Dib, it was seen as
not only possible but necessary to disrupt the language of the colonizer along
with that of the classic realist text as a prerequisite to any effective revolution-
ary stance.[17] Soon Kourouma and Okara were refashioning French and English
in search of an African voice, and later Syl Cheney-Coker, Sony Labou Tansi,
and Ben Okri turned to magical realism. The Third Cinema of the late 1960s
and 1970s in Latin America, frequently shaped by the ideals of an "Imperfect
Cinema"[18] that disrupted the conventions and sheen of commercial Hollywood
film, carried forward the notions of a nonrealist or nonmimetic cinema of re-
volt. In a sense, Bekolo carries us beyond this tradition, with the contrapuntal
relationship between the narrator and the diegetic world of the characters in
which he breaks the flow of the action with the voiceover commentary. This
heightening of the narrative commentary directs our attention to the compli-
cated relationship between Aristotle and his grandfather, and more specifically
between Hollywood and African film. Thus we have a double concern with this
ironic postmodernist narrative voice, the Bekolo voice. First, it is there that the
gaze that falls on the characters in the film is most directly, that is, undiegeti-
cally, represented. At one point the English-language Bekolo-narrator says, "My
characters were out of control." At another point, the French-speaking narrator
(not in Bekolo's voice) refers to these same tsotsis as "les jeunes bâtards cul-
turels, comme il en existe de plus en plus dans le monde" (young cultural mixed
breeds, as can be found more and more in the world), a strangely judgmental,
or at least magisterial, designation that moves us away from the narrator's usual
ironic tone, from viewing the tsotsis as the site of the gaze qua object to that of
objects of the gaze.

What Lacan points to in his designation of the gaze qua object is the asym-
metrical reversal of the relationship between the subject who gazes and the
object of the gaze. What is crucial is not only that the object is seen as gazing,
and thus inevitably functioning to carry the subject's gaze back to him or her,
but that it is returned somehow, any which way, off center—"awry," in Žižek's
sense of the perspective from which we can view and actually see the skull in
Holbein's painting *The Ambassadors*. Designating the tsotsis as "bâtards cul-
turels" doesn't work to create a perspective that is "awry"—to the contrary, it
is straight-on, seeing from a normalizing point of view. When the English-

speaking Bekolo-narrator refers to his characters as being out of control, he generates a position already associated with dramatists like Pirandello and film-makers like Truffaut—leapfrogging over the magisterial, conventional, so-called griot narrative voice in *Wend Kuuni* (1982)—thus complicating the subject position of the narrator in his relationship to Aristotle and his grandfather. Thus, in the French narrator's version, he says that "les voyous aux chomage" (the unemployed gangsters) become "actionnaires" (stockholders), with a "culte à action": "La catharsis. Aristote devint Rambo" (The catharsis. Aristotle becomes Rambo). He moves his point of reference from high western theory to low pop culture, and thence to African folk wisdom: "J'appelle ça une théorie de l'amertume et de la douceur d'une noix de cola. Une violence nécessaire au salut de l'humanité. Inspirer la crainte et la pitié, telle est la mission. Car sans crainte et sans pitié, point de redemption. Inchallah. Amen." (I call that a theory of the bitterness and sweetness of a cola nut. A violence needed for humanity's well-being. To inspire fear and pity, that's the mission. Because without fear and without pity, no redemption. Inchallah. Amen.) If one were to reduce these juxtapositions of high and low culture, or western, African, Muslim, and Christian to "multiculturalism," that would serve once again to reinscribe the *particularities* of Bekolo's parodic positionality into the master symbolic order of a mainstream, recuperated, comforting postmodernism—one in which Jameson's notion of a late-capitalist consumerism would absorb any subversive elements. That would be possible if "Aristote devint Rambo" provided all the framing necessary for the narrator's position or sites of enunciation.

However, that site is not multicultural, or even simply polyvalent, but hybrid in Bhabha's (1994) sense, marked by *différance,* and thus it is a space that can't be accommodated by reinscriptions into a dominant symbolic. In the French narrative version, the narrator defines Aristotle melding into Rambo as a theory of bitterness and sweetness, that of the cola nut: "J'appelle ça une théorie de l'amertume et de la douceur d'une noix de cola" (I call that a theory of the bitterness and sweetness of a cola nut.) The "je" is positioned indirectly for us by his points of reference: Aristotle, Rambo, Inchallah, Amen, and the inevitable cola nut. In the English version, the cola nut is dropped, and in place of the first person maestro, we have reference to another character used as the tool for the jockeying for a position—the grandfather. The "elder" here stands in place of Aristotle and Rambo: "Catharsis. My grandfather calls it the bitterness and the sweetness of life." If "pity and fear" cement the reference to Aristotle's *Poetics,* "Inchallah" and "amen" place any "redemption" on the level of the simulacrum—models without originals. However, if it is particularly the Bekolo-African narrator's invocation of the grandfather, even more than the reference to the cola, that works to ironize and demystify the "authenticity" of the magistrate's site of enunciation, it is not to arrive at a deconstructionist's point of instability, but to destabilize the order on which the Afrocentrist notion of authenticity is grounded—the order of the grandfather. We can see this in the action sequence of the heist.

Having begun the sequence with the voiceover, Bekolo proceeds to turn the

action into an actualization of the demystifications, with the mocking murders of the "African" projectionist, the death of the mask through which the authentic African cinema "spoke" and was projected, and that of the African American spectator. At the end of the heist sequence, the narrative voiceover returns, and with it the stage is set for E. T.'s pursuit and battle with the tsotsis, the reversal of their roles, and the final denouement. The narrator's voiceover interventions frame the sequence in which the tsotsis are set into action, which in turn sets into motion the actions of E. T. and the cop. The threads of each subplot come together in the subsequent series of pursuits, flights, apprehensions, and denouements. Aristotle becomes Rambo; E. T. becomes the Terminator. Catharsis, anagnorisis and peripeteia, aphansis—Lacan meets Bekolo on African terms through the mediation of Žižek, and it is his analysis of the reversal of roles of subject and object that provides the clue for us to work out the key relationship between the bookends provided by the narrator's interventions and the intercalated action sequence.

At the beginning of the sequence leading to the heist, we see the tsotsis sitting in dejection on a rural hillside. The voiceover focuses our attention as the camera carries our gaze closer to the images of the tsotsis. We are divided between attending to the unseen person who is addressing us, and the images about which he is speaking. Even as the narrator's presence and remarks ("My characters were out of control . . . "[19] [Eke 2000, 22]) objectify the tsotsis, their galvanization into action seems to generate the scene that follows, complementing their shift from object of gaze to gaze qua object: they constitute, in their action, a commentary on the narrator's views of them, and therefore, by proxy, those of the spectator. The intervention of the narrator, and their action/response, reverses the point of view and the process of judging, passing through the narrator, back onto us. In short, the narrator, like the boy in *Shane,* is the proxy for the audience's fascination, and in his stylish self-reflexivity, he returns the audience's gaze through a self-conscious filter—but only "awry": "Far from being the point of self-sufficient self-mirroring, the gaze qua object functions like a blot that blurs the transparency of the viewed image. I can never see properly, can never include in the totality of my field of vision, the point in the other from which it gazes back at me" (Žižek 1998, 114). We have, then, the point in the voiceover from which we are addressed, that hybrid, unsettling space of "occult instability," as defined by Fanon (1968) and then Bhabha (1994);[20] and secondarily, the point in the tsotsis' response to the narrator's comments that constitute an indirect response to our gaze on them. Just as the unseen African film in the stolen canisters becomes the McGuffin that sets off the action, on the extradiegetic level of the narrator's comments, the unseen narrator connects us to the tsotsis, while simultaneously hooking us into his own sophisticated version of African cinema (one that affirms its own stance in the act of denying both European condescension and Sembènian straitjackets: "Why are African filmmakers always young, up and coming, promising, emerging, developing, until they are eighty-years-old and then suddenly they become the ancestors, the fathers, the wise old role models?" [Eke 2000, 21]). The point at which the

we the viewers connect the dots, and see ourselves as fitting the tsotsis—the "voyous," the "unemployed gangsters," as the narrator calls them—into a pre-ordained role created for them by image-machines, at that moment the tsotsis' gaze is returned to us. And if our gaze is mediated by the narrator in their direction, so too is it through him, through his gestures of possession ("my characters were out of control") that our gaze on the Africans, and their filmmaker, is reversed and returned to us. Finally, what seemed like a chance difference of voice and style between the English and French versions of the narrator's comments, when viewed in the light of the gaze qua object returning on us, now looms much larger as an address in which the audience not only sees something of itself, of how it is presumed to be looking at African youths, and at African film and its filmmakers, but also does so specifically within an Anglophone or Francophone setting.

It would seem clear that the Francophone, non-Bekolo voiceover is ensconced within a viewing world that has been constituted in both Francophone Africa and the hexagon: "Armés de leurs diplômes, les voyous au chomage ne tardèrent pas à se trouver un emploi. Actionnaires. Ils allaient voir une culte à action. La catharsis" (Armed with their diplomas, the gangsters didn't wait unemployed to find a job. Stockholders [actionnaires], they set out for a cult devoted to action. Catharsis). The voice is somewhat distant, ironic, and yet formal in its locutions, its use of the passé simple. The shift from the French, "J'appelle ça une théorie de l'amertume et de la douceur d'une noix de cola" (I call that a theory of the bitterness and sweetness of a cola nut), to the English, "My grandfather calls it the bitterness and sweetness of life," marks entirely this shift in address. The former ironizes the Francophonic, ethnographic theorizing in a manner that could be dated back to Ouologuem's reduction of Frobenius to Shrobenius, or of Senghor's elucubrations to comic-book shadow play; the English version, on the other hand, moves the site of authority to the grandfather, and it addresses an audience more likely to encounter the film in an American classroom venue, or a special showing in a university film series or conference, where the influence and issues of Afrocentrism are much more pertinent than in France, and are taken more seriously than in Francophone Africa. One need only recall the scene in Bon Pour's shop in *Quartier Mozart* (1992) where Atanga, Capo, and Bon Pour enter into a mocking discourse about their "black brothers" in the United States. If the above distinction of the two versions seems to rest upon rather slim reeds, one only has to consider the bookend narration that closes the sequence to see this difference in address emerge clearly. This occurs after the tsotsis have stolen the cans of film and have murdered the projectionist and the African American man. In French, "les jeunes bâtards culturels, comme il en existe de plus en plus dans le monde, pensaient qu'ils s'accaparaient du coeur de Hollywood, alors qu'ils ne faisaient qu'un retour forcé aux roots" (the young cultural mixed breeds, as can be found more and more in the world, thought they were capturing the heart of Hollywood, whereas they were only making a forced march back to their roots). In English, it is simply, "They thought they were going back to Hollywood. In fact they were going back to their roots." The

French version, intoned in the relatively deep voice of the narrator, smacks of the documentary filmmaker who stands apart from and above his subjects, reducing them to specimens—"comme il en existe de plus en plus dans le monde" (as can be found more and more in the world). However much Bekolo might have wanted to make a commentary on cultural mixing, here he slips into a tone that conforms with the worst of French attitudes of superiority when discussing "their" Africans. Both that unfortunate phrase and the equally pompous "jeunes bâtards culturels" (young cultural mixed breeds) are absent from the English voiceover, where the tsotsis are referred to simply as "they." In the lines that follow, in both versions, the ironic tone returns, and with it the destabilizing of the spectators' safe, neutral viewing position. Bekolo turns back the image-making with a focus on the racializing components that go into what we see and who we are when we construct meaning from those images. In French, "Si elle [la nature] a fait un blanc, il y a peu de chances qu'il vous refasse noir un jour. Too bad" (If she [nature] made a white person, there is little chance that it will remake you black one day. Too bad.). The English reverses the order of creation, and more importantly adds a crucial line that turns the ironic play on race as a natural given to the same reductive thinking about image-making, about cinema: "Nature never made the same thing twice. You can't be black one day and white the next. Nor was cinema born twice." Of course cinema wasn't "born," and by extension neither was racial identity. As Soyinka finished off Negritude with Tigritude, Bekolo finishes off race with cinema. In doing so, he brings us closer to the American audience for whom the binary of black/white has a totally different meaning from that usually given in French with its typical African/European binary (where European equals blanc).

There are two murders that occur in the heist scene before the "African film" is stolen by the tsotsis. Each of the two carries us back, self-referentially, to those voiceover bookends, with their different Francophone and Anglophone orientations. The first murder, that of the projectionist, is linked to the death of the mask. The second, that of the African American, is a parodic riposte to the sincerities of Afrocentrism. Both are demystifications of films like those of Sembène or Med Hondo, in the first instance, and of a Haile Gerima, in the second. Or, conversely, one might say they are continuations of the lighter tone, the parodic side of Sembène's work (compare the wedding scene in *Xala* [1974], or the unforgettable scenes of eating in *Mandabi* [1968]), and especially of blaxploitation tongue-in-cheek ripostes to white racism, dating back to *Sweet Sweetback's Baad Asssss Song* (1971), *Watermelon Man* (1970), and more recent versions like *Boyz in the Hood* (1991), or even Spike Lee's *She's Gotta Have It* (1986) or *Do the Right Thing* (1989).

Most distinctively, Bekolo's montage owes its effects to the rapid pace and sheen of MTV (where he acquired some of his training), which takes over from the voiceover. We can see this as the narrator's voiceover monologue is accompanied by an acceleration of images and effects that move us from the countryside, the "bush" to which the tsotsis had been expelled, to the city where they carry out their raid on Cinema Africa in the dark of night. Thus the voice-

Figure 6.2. *Aristotle's Plot:* Dark street on night of heist.

over begins with the group scattered on a hillside overlooking an empty plain and the road where their van is parked. As we move from the narrator's words "armés de leur diplômes" (armed with their diplomas) the camera pans down the hill to the road, van, and brush. In the background, under the sound of the narrative voiceover, Cinema is faintly heard issuing orders. As they are described as "actionnaires" (an ironic jeu de mots signifying investors as well as those devoted to action), they begin to demonstrate their "cult of action." By the time we reach the word "cola" ("l'amertume et la douceur d'un noix de cola" [the bitterness and sweetness of a cola nut]), we cut to a tight shot of the van quickly being loaded with each "gangster" picking up his gun, Nikita in the driver's seat. With "craint et pitié (pity and tear)," a close-up of the guns being picked up, and with the final "amen," the van is en route, the next shot taking us to the darkened city streets, an orange streetlight casting its glow on the ground, the shining lights of the shops and cars gleaming in the darkness. The strong diagonal line of the street, shot low enough to emphasize its dominance over the space and its integration into the darkness, moves us onto the familiar ground of film noir technique: a dark night, a van filled with armed thugs, a plan of action, a target to be hit—and finally the shift from the distance of the narrator's voice to the close, shrill wail of the saxophone over the jazz tones in the background.

The gangsters arrive, get out of the van, and assume their positions; Cobra and Van Damme slip around to the back entrance; with Nikita waiting in the getaway van, the four others head into the darkened theater. African cinema is about to be hijacked, and by a mistake will fall into the hands of gangsters, soon to become its most successful entrepreneurs. Two of the gangsters enter the projection room, and a cross-cutting sequence of shots puts in contrast the sleek visuals of the darkened room, with a glow of light across the top of the projector, the image-machine with its modern neorealist glossiness, set over against the

Aristotle's Plot 159

Figure 6.3. *Aristotle's Plot:* Looking at gangsters across top of projectors.

pseudo-African mask through which the bright light of the projector emerges in the auditorium of the theater.

The mask gleams and groans, a beast that is about to die. At that moment, the four who have entered the theater itself ascertain that there is only one viewer, an African American, whom Bruce Lee and Cinema surround and grab. As he calls out, "Hey," Bruce Lee tells him to "get the fuck out." He asks, "What's wrong man?" Bruce Lee, whose own accent is heavily South African, pauses, and says in a low voice, "He doesn't sound African." Struggling in the grip of the tsotsis as they force him to face Cinema, the man says in a clear African American accent, "Do you think you more African than me? I wear Kente cloth. I studied Swahili." The ironies of the film noir turn into farce, and in similar tongue-in-cheek terms the murders and theft are carried out.

The African American man offers a justification for watching the film Cinema calls "shit" by saying, "It's our roots man. If you don't know where you're coming from, then how do you know where you're going?" As Cinema responds, "Hey, I don't need directions from anybody," Van Damme draws his knife across the projectionist's throat and the beam of light coming through the mask grows dark. Pop Afrocentrism joined to Keystone Kop antics are reflected in the demise of the projectionist (actually played by another African filmmaker, Lionel Ngankane), who quickly drops down as the silly-looking African mask grows dark, and a shadow pantomime show begins on a yellow curtain. The silhouetted figures of the gangsters and the pleading African American man appear, and we hear each gangster load his gun and mime shooting him. He falls, to the sound of weird tonalities, and the curtain-screen turns red as he is hauled off by Cinema whose own dark shadow fills the screen.

Then we move back to a realist close-up of the film cans that are snatched to the sound of a jazzy soundtrack. Jazzy music, a darkened street of glowing lights, an orange streetlight, a getaway, and the return of the narrator's voice-

Figure 6.4. *Aristotle's Plot:* Shadow show of gangland-style killing.

over: "They thought they were going back to Hollywood. In fact they were going back to their roots."

Each gestures in its own way, the Francophone voice with its "si elle a fait un blanc, il y a peu de chances qu'elle vous refasse noir un jour. Too bad," and the Anglophone, "You can't be black one day and white the next. Nor was cinema born twice." For each, film noir cynicism simulates the fatalistic impossibility of the bad seed turning good, like James Dean or the Paul Newman of *Hud* (1963). The stylized hijacking and the mistaken goods, the playing at film noir mixed with elements of farce in the filming, and the voiceover fill our demand for action and meaning with parody and simulacra. If "cinema wasn't born twice," and if this sequence represents the African tsotsis' return to their roots, it is significant that Bekolo's choice of style and montage technique constitute his "African" response to the charge of celebrating a hundred years of cinema. The "African" drama might share a heritage of common techniques, might choose to assume a tone, style, and stance that returns to an African audience an image of their own modernist and postmodernist creating, but it is marked in its particular way by the meeting of the figure of the African images (or the grandfather) and the Western (Rambo), by a voice either in French or in English that reminds us that if cinema can't be born twice, if black can't become white and white black, still there is now, and has always been, a necessary meeting at any putative point of origin where any claims of priority, as those for Aristotle's *Poetics,* will be countered by an equal set of competing claims, including those for a grandfather's stories. After all, says the narrator, when enumerating the qualities of the African narrative (or initiation rite), "what don't we got?": "My grandfather's words started to fill my mind: What is an initiation ceremony? Crisis, confrontation, climax, and resolution. Sound. Story. Images, narration. Rhythm. Is there anything in this, in cinema, that is not African?" (We see the cop racing onto the scene and arresting Cinema and E. T.) "Fantasy, myth, we

got. Walt Disney, we got. Sex, action, violence, we got. Comedian, music, we got. Aristotle, catharsis, and cola nut, we got. What we don't got? Why don't we got an African Hollywood? Probably because we don't want to produce our cinema outside of life. Because when it is out of life, it is dead. Like a difficult childbirth. Which do we choose? The mother or the child? Life or cinema? Because when cinema becomes your life, you're dead. It is dead. We are all dead (the cop pisses)" (Eke 2000, 23; my corrections).

With this manifesto, Bekolo lays claim to the imaginary over the symbolic. A cinema true to life—faithful to the mother, the origin of life and symbol for life—would be swallowed by the maternal superego demands for total allegiance. Not only are "you" dead, if that choice is made, but so too is "cinema."

By the end, the symbolic order of the cop has collapsed, and he no longer has the power of life and death to wield over the people. A worldwide phenomenon, ostensibly beginning in Hollywood, brings all the dead people back to life.[21] Bekolo doesn't start on the quest to ask where that particular myth had its origins—after all, you want resurrection, "we got." If nobody is dying in Hollywood, nobody is dying in Africa either—and the report about Hollywood that comes at the end of the film occurs long after we see the African American man whose murder we had witnessed in the shadow show get up from the railway tracks and run off as the cop approaches.

The cameraman disappears at the end of the film; the border between life and death disappears; the narrator's last words are, "how can we tell fiction from real." Postmodernism or an African movie? The accent falls on the latter, on all that it's "got" at the end: the humor, the blues harmonica, the questioning of the authority of the symbolic order of the Other. A voice says, "Hey, where is 'what's up' coming from here in our African neighborhood?" And in the language, the defiant and raucous voices that seize the sound track at the end, its *rendu voix acousmatique,* we can recognize as Bekolo's ironic trademark the characters located in the "quartier," home of a young set of hip moviegoers who are tired of the Law of the Father that is both theirs and that of the Other simultaneously, and who take it upon themselves to recreate something we can call the postmodern African cinematic Imaginary. Inchallah. Amen.

7 *Finye:* The Fantasmic Support

Finye (1982) begins by seeming to establish the fantasmic. Žižek refers to the fantastic as the support for the symbolic: "Constitutive of fantasy's efficiency is the gap between the subject's everyday symbolic universe and its fantasmic support" (1999, 95). What that translates to is the need for the subject to find a unitary sense of self[1] at the price of participating in some measure of fantasy construction, and further that there is a direct link between what appears least fantastic, that which is utilitarian, and fantasy itself. There is, then, a contrarian dimension to fantasy: it represents not what it appears to be, an escape, but rather more of a coping mechanism that makes possible accommodation with the very splits, lacunae, and divisions within the self and Other that are fundamental to subjectivity, and it does this not by fleeing from but instantiating the Law. "[C]ontrary to the common-sense notion of fantasizing as indulging in the hallucinatory realization of desires prohibited by the Law, the fantasmatic narrative does not stage the suspension-transgression of the Law, but is rather the very act of its installation, of the intervention of the cut of symbolic castration. What the fantasy endeavours to stage is ultimately the 'impossible' scene of castration" (1999, 94). *Finye* provides us with all the ingredients for this staging: a set of dual patriarchal authorities in the form of the repressive and the loving father; a son in revolt; a prohibited maternal figure and a daughter cast in an ambiguous setting; and, finally, a firm sense of the ideological justification for revolt. Yet, at every point in which the real appears grounded in materiality, fantasy returns to reminds us of their inevitable jointure: each defines the other, each needs the other, each serves the functions of constructing a subjectivity that requires both in tandem.

There are two intersecting narrative lines in *Finye* (1982). In the first we have the story of the two "star-crossed lovers," the university students Ba and Batrou. Ba is the grandson of a poor but solid and influential Bambara chief, Kansaye, who links us to the figures of power and prestige in the past. When Ba is in difficulty, Kansaye turns to the gods and the sacred grove to seek assistance. Batrou is the daughter of the regional military governor who represents the dominant power of what would seem to be the authoritarian regime of Moussa Traoure (1968–1991) in Mali. The governor doesn't want his daughter to associate with Ba. Kansaye doesn't want the daughter of one associated with the new regime to be in his courtyard. Ba and his friends are apparently targets of the governor, which accounts for their having failed to receive passing grades for their exams. We follow the struggles of the couple to remain faithful to each other despite a series of obstacles that are presented to them.

In the second thread, we see that Ba has joined forces with those students who are secretly publishing pamphlets in opposition to the regime. They pose enough of a threat to the regime as to cause the ruling president to intervene directly in their protests, and in the end to force the government to change from military to civilian rule. Here the issues of power are presented in terms of a critique of patriarchal abuses so that the domineering attitude of the governor is captured in scenes dealing with his family life as well as his public response to the threats posed by the students. *Finye* is about change, the winds of change being brought by the new generations. As such, it might be tempting to read it along purely polemical lines. That would be to ignore its referencing of various realms of spirituality and dream worlds that exceed the frames of quotidian reality from the start.

The opening shots of *Finye* attests to fantasy's efficiency by first constructing a mystical universe, though they also simultaneously introduce a symbolic order with the appearance of sign-ideograms that are translated for us by subtitles: "The wind . . . awakens . . . the thoughts . . . of man." The images are accompanied by spooky, whistling sounds meant to evoke both the supernatural and the wind. We see the waves on a body of water (ostensibly the broad surface of the Niger), and then a young boy with a shaven head who walks up, his image superimposed on the water. He stands out as a "symbol" made especially evanescent by the camera's double exposure that permits us to see the water through him, and by the heavily signifying soundtrack. This "figure of youth" sets in motion the equally spiritualistic and unworldly march of the ideograms across a landscape captured in one long panning shot that carries us past the cliffs and then tracks over treetops, until a jump cut ends the spookiness, and we enter the realistic diegetic world of Ba studying for his exams. In "Fantasy as a Political Category," Žižek (1999) argues that ideology is staged, and that the viewer's point of identification permits us to recognize the vantage point of the ideology. This is the function of the establishing shots that ultimately settle on "reality," on Ba whose earthy appearance (with twigs of leaves in his hair, sitting under a tree) is set off by the preceding mystical signifiers and camera motions. The vantage point from which Ba is seen following the seemingly haphazard movement of the camera actually provides the basis for the establishment of Cissé's "truths."

The meeting of the fantastic opening scene and the subsequent reality of Ba's life occurs when we cut from the spooky wind to the shot of Ba studying under a tree. A woman carrying two calabashes passes by and he interpellates her in Bambara with the words "Peul woman," which explains both her appearance and her failure to understand his speech. She looks nothing like Ba's "modern" tennis-playing girlfriend Batrou, the former being a young, traditionally dressed, uncomprehending, smiling, shy woman who possibly lives by selling meals to a relatively poor clientele, and unlike the latter will not bathe naked with Ba or get stoned with him. But she does stop for him when he insists on looking in her calabashes for milk. She has nothing he wants and continues on her way. Ba's friend Seydou then appears, and looking backwards at the Peul

Figure 7.1. *Finye:* Mystic figure of a young boy superimposed on water.

Figure 7.2. *Finye:* Opening shot of Ba with twigs in hair.

woman trips and falls. Ba laughs and says, "You tripped and fell—all on account of a woman."

Unlike the heavy symbolism of the opening sequence, this is light fare, practically free from the insistent, overtly ideological scenario about to unfold. Ba's laughter, Seydou's tripping, and the language barrier between the Peul woman and the Bambara-speaking protagonist Ba, constitute only a flirtation

Finye 165

with the portentous signs concerning the "thoughts of man" or the "winds of change." The silly youth's dismissal of the woman's worth—"all on account of a woman!"—begins the motif that will lead to a direct challenge to the dominant authority of the governor and his soldiers, led by another young woman, his own daughter.[2]

The boy, the water, and the fantasmic wind-effects return at the end of the film to give closure to the heavy-handed symbolism of the imagery, the film's title (meaning "the wind"), and the symbology of the Bambara universe. The fantasmic is clearly joined in both the beginning and the end with the completely down-to-earth situations in which Ba's universe is located—that is, with the reality of his everyday symbolic order. The two central poles of the symbolic order, the ISA's constitutive of the educational and the political systems, come together around the figure of Ba, who is tightly joined to a generation of adolescent student rebels, here depicted as dependent on drugs and sex—a now generation offering the viewers a familiar portrait of contemporary realities. Into this order, Cissé introduces the twin ideological paths of political change: youthful revolt, which is nonetheless respectful of an authentic African traditional identity, and women's liberation. Ba's role is crucial in both these cases: his grandfather is the repository of the "authentic" African traditional spiritual force, and his girlfriend is the enlightened daughter of the regional governor.

Ba addresses the Peul woman because he wants milk to go with his coffee, which he is drinking so as to stay awake studying. We can incorporate this scene into one symbolic thread that traces the process of transition from this uneducated, traditionally dressed, Peul woman who doesn't understand, to Batrou, the educated, liberated young woman who clearly represents the hope for the nation to develop in the future. The thread thus depends on the initial aporia between Ba and the young Peul woman. At this point we don't know that Ba's father was a chief, and by implication possessed land.[3] Ba might have supposed the Peul woman had milk since the Peul are typically nomadic cattle herders who stand at the opposite pole of "modernity" from the college students. When we see Ba in the beginning of the film, he is studying for the end-of-year exams in accordance with a university system in which the student's entire success in passing or failing for the year, as well as for the diploma, depends upon this formal exam. We learn that Ba has already failed this exam in the past, and come to suspect that his soon-to-occur current failure is apparently due to political manipulations of the examiners, and not to his qualifications. In other words, there is an entire ideological apparatus that is assumed as a basis for this opening humorous scene that cannot be separated from the disastrous scenes that follow, and at their base, their trans-ideological base that is exposed in the lighthearted laughter at the sight of Seydou tripping, is to be found this inconsequential moment built on the language gap between Ba and the Peul woman[4] and the "chance" inclusions of a physical materiality, the phenomenological reality.

If the film's message is carried by the transcendental elements of the wind and the water, and by the ideograms that transcribe their spiritual truths, the fantasmic support can be sought in the protagonist's immediate physical pres-

ence and environment, with down-to-earth shots of the roots and ground that trip up Seydou, the dirt that is streaked across Ba's back as he labors with a wheelbarrow in prison, the grounds of the university across which the students flee, Ba's family compound, and the governor's compound—all the "grounds" on which the drama is constructed. We are anchored there, in this physical universe that nonetheless trips us up, lightens the burden of revolt and even of studying, with a comic, burlesque moment. The "wind" never moves us away from this foundation in an earthy reality on which the key opening pan and tracking shots are based. For instance, when Ba looks in the second calabash he sees slabs of what looks like raw liver in place of milk. The close-up of the meat is purely informative, but at the same time there is something slightly abject about this shot. Similarly, as Seydou trips and Ba breaks out in laughter, the woman turns and smiles at the sight and sound of laughter: the "message" must put up with her lightness that she shares with Ba. Finally, when Seydou speaks after being the occasion for all this hilarity, he says to Ba, "Have you been drinking?" Ba's laughter does seem excessive, and if it serves as a pretext to draw out the subsequent sexist comment, it also exceeds the ideological frame. The scenes depicting students taking drugs, first to enhance their abilities to study and secondly in dejection after their failure, are heavy-handed. However, as in the first scene with Ba, we might find there another form of excess, one that often stumbles through the scenes of heavy intoxication and echoes the call of the Not-I bird—bringing denial, humor, and the ontologization of the specter, here taking the forms of "lost youth" and corrupt authorities.

Fantasy soon invades each of the two ideological tracks signaled above, the educational and the political. The first third of the film is heavily invested in the themes surrounding the examination period: the students' studying, taking pills and swilling coffee to stay awake, and even taking the exam. We see them nervously awaiting the results, and listening in front of an administration building as an official reads aloud the names of those who passed, each student recording his or her joy or disappointment as their name is heard or not. The sequel of the celebration is thus marked by the mixed emotions, and by the realization that Ba and Seydou had failed. We can see the camera's engagement in undermining the established university order in the scene depicting the breakdown of the disappointed students. Ba and his friends roll huge joints and sit around moping. One woman in particular presents a broken visage whose sorrow causes Ba to cry.

Just as the symbolic rests upon the bed of fantasy, so too are the scenes of fantastical utopianism dependent upon abjection, though more likely in the way that the mirror stage is marked by both aggressive rejection, the response to the perceived threat to the ego, and by narcissism. Thus the slabs of liver are seen to be the hidden abject truth inside the enclosed containers, the calabashes of the attractive young Peul woman. Similarly, we slide along a chain that signifies "lost youth" at the gathering at one of Ba's fellow student's courtyard, where the dope is being freely smoked, to a vision of Ba where he and Batrou are inhabiting a magically charmed dreamworld.

We were led into this sequence by the symbolic ideology concerning the betrayal of the education systems by the authorities. Ba and Seydou are introduced by their female friend Sali to her father, and under his questioning we learn not only that Sali passed while they failed, but that they had helped her prepare her for the exam. Earlier in this scene we learn that Batrou's father, the governor, had banned Ba and Seydou from visiting his house. We don't know why, but there are several possible motives left open: the governor's young third wife Agna had been openly flirting with Seydou's friends and Ba, and when she returned home the governor beat her. Further, Ba and his friends now have a reputation as drug addicts, and Batrou has been warned to stay away from them. Finally, we see in both Ba's friend's father and Ba's own grandfather figures who embody the cinematic ideals of the traditional African patriarch, men who are not rich, but "of the people." The opposition of the new, corrupt political-military order and the old, relatively powerless, passé, traditional order is established and reinforced with each scene in which the governor has his chauffeur and servants serve him in his large residence, in contrast to the settings of ordinary townspeople's compounds.

As the students get increasingly high on drugs, the camera and soundtrack collaborate in the presentation of two young women who are particularly lost. The first looks dazed as she slithers almost uncontrollably toward one of the young male students who impassively looks on in a stupor; the second is another young woman who is lamenting incoherently as tears run down her face. The scene is particularly awkward. A young woman who is evidently stoned has to be helped off, and someone comments, "Is that the Bambara secret place?" Another person answers, "Leave us in peace." Thus the sacred grove is ironically evoked, prefiguring its serious but sad abandonment later by Ba's grandfather Kansaye. Ba is seen at the gathering with smoke wafting in front of him, and then staring at a young woman who is completely stoned, murmuring and crying. Her voice is heard as she says, "It's such a beautiful day," and her moans carry us as the camera's gaze, focalized through Ba, falls on her face. Then we hear her voice through the transition into the dream-scene with Ba and Batrou dressed in white and nuzzling each other. She functions as Ba's medium, and we enter his cine-trance so as to join in the fantasy of their sanctification/communion. The soughing of the wind replaces the medium's voice; Ba and Batrou's white robes and the river's waters replace the dreary scene of the failed, drugged students; a young boy with the calabash replaces the woman serving the students at her older husband's orders. Clearly we are in a moment of transfiguration of the world as experienced by Ba, and it is in this fantasy that he seeks to embrace the Law and its order that has eluded him so far.

This scene with the drugged students might be taken as exemplifying Žižek's claim that when one approaches the fantasmic kernel of one's being too closely, "what occurs is the aphanisis of the subject: the subject loses his or her symbolic consistency, it disintegrates" (1999, 97). Indeed, it is precisely at this moment when Ba approaches too closely this fantastic figure of the lost youth that his symbolic universe dissolves into his own opposing fantasies of love and

Figure 7.3. *Finye:* Ba and Batrou in Ba's fantasy.

apotheosis with Batrou. They are both seen dressed in white, and as the little boy of the opening and closing shots appears, he hands them each the calabash filled with water, which they drink. The boy then casts the calabash onto the waters, which carry it away. The dream sequence ends with tight close-ups of Ba's and Batrou's faces as they smile at each other, the wind continuing to moan, a "rendu effect"[5] that carries their appearance with its own whistling to the edges of a horror scene where we almost expect them to be transformed into vampires. Cissé holds the close-ups long enough for this apprehension to begin to take hold, and then jump-cuts as Ba is abruptly pulled back into reality: we see him stoned, stumbling down the street as a crowd of jeering children hound him, and two soldiers laughingly patronize him.

This scene, then, exhibits the "real" of Ba's desires. "Reality" is effortlessly penetrated by the fantasy world of Ba, uninvited, unexpected, and this completely undoes him. His composure, his graceful manners in declining the offer of tea made three times at the party, before politely accepting, are all lost in his awkward blows aimed at the children. Here is that intrusion of the real that fantasy cannot entirely defer—not real children chasing a real drunk, but worse, the real fear of losing one's hopes for a successful life and becoming just another failure, a joke, a junkie to be mocked by small "imps of perversity" (Žižek 1999, 89).

The encounter with the real of desire is particularly unsettling because fantasy cannot sustain the tissue it constructs to protect the vulnerable subject. Here is precisely the space for the combat of those two great ideological apparatuses, the political and the religious. The symbolic order is vested in the laughing soldiers who contain the threat posed by the children, the drugs, and the

fantasy; they embody the modern form of the political state in the time of the suns of independence. In contrast we have the equally powerful construction of the spirit world, with the little boy's gift of the water, the soughing of the wind, and the figures of the ram and the gods at the sacred grove. The ideology is constituted in terms of narcissism, the positive identity invariably accompanied by its flip side with the fears and aggression that mark the imaginary stage. We will eventually hear the voice of the beings from the other side of the universe, the gods, and will come to appreciate how it is that the brave children who stand up to the corrupt and oppressive authority have become the mouthpieces for truth in a new postindependent age. But we can't sustain these great ideological constructs without their accompanying fantasmic sides. *Finye* continually drives us to the edge, to this precipice of the symbolic orders where the extraordinary state of the unreal hovers.

Batrou's role in this battle between two male forces, at times embodied in the dueling presences of the governor and Kansaye, is particularly interesting since she brings in a third dimension. And that is the aporia or lack in the Other conveyed through her struggle with her father. At the very moment that Ba is waiting for the exam results, Batrou has taken one of her mother's infants with her to the market where she buys tomatoes. She is at her most maternal, or playing at the maternal with her father's child, as Ba is fending off the governor's youngest wife Agna's advances. In both scenes the castrating cut has not been experienced; in both there is the effect of the imaginary at work to deny the Other's prohibition against the possession of the phallus—here, in the case of Batrou, it takes the form of the infant (the classic form of the maternal phallus); and in the case of Agna, her possession of Ba. The final tight close-up of the faces in Ba's dream-fantasy of himself and Batrou accords with this imaginary closure of the unified subject having warded off the threat to its being, the threat ultimately taking the form of the prohibition from the Other. In the case of Batrou, as she leaves the idyll of the market, the harmony is broken by a dispute between two women sellers over getting her business. The tear in the fabric of the fantasy and the glimpse into the real of desire immediately follow in the subsequent scene in which Batrou's young stepmother Agna is seen visiting the students and making passes at Ba. On her return Agna is beaten by Sangaré, the governor. In Agna, the maternal is joined to a sordid exhibition of desire, exposed in front of Ba's friends and classmates. Yet at the same time, we are inexorably led away from the students' woes to the confrontation between Sangaré and Batrou, the locus for the struggle that lies at the heart of the debate between all the competing ideologies. In the end, the drama in *Finye* turns on two key scenes: the one in which Batrou speaks up in defiance of her father, and corrects him in front of the arrested students; and the final scene of Ba's release from prison, with the implied transformation of society, this occurring in the notable absence of Batrou.

The central issues in the film—those involving education, political protest, and, finally, the freedom of the woman, all come back to Batrou's role in the lives of the various protagonists. At one point, Kansaye chokes Ba in Batrou's

presence, then stops, turns to her and expels her from his compound. Similarly, Sangaré tries to stop Batrou from seeing Ba, and Agna tells Ba that unlike her, Batrou is just a child. But Batrou cannot be dismissed, as every relationship, every ideological issue ultimately turns on her actions. If the culmination of her role as figure of resistance is reached when she stands up to her father in prison and denounces him, her subsequent gradual disappearance from the film is all the more striking. What happens to Batrou? Why does she disappear?[6]

It might be possible to answer that question with a similar question: why do the gods disappear? In both cases we approach the limits of fantasy and the symbolic because we are also approaching the limits of the real in desire. Batrou is the object of Ba's fantasy, but she is also at the limit of the fantasy of change, that is, of the ideologies associated with political and with feminist liberation. As such, she should lead us to the frontiers of the Law whose embrace these fantasies ultimately seek.

The Law, as embodied in the authorities who enjoy real power, would seem to be distant from the sacred grove or shrine that Kansaye visits after Ba has been arrested. Underlying the dominant symbolic order there is to be found a dynamic site of contestation. Although we encounter the Other as an inalterable, eternal, distant being on whom we nevertheless rely as the source of our sense of ourselves and our language, the Law of the Father, like the symbolic order that it undergirds, is a function of the social and cultural conditions in which it is grounded. There is a direct link between the fathers who contest for control and dominance in *Finye*, and the Law of the Father that functions as the displaced site of the Other. Just as fantasy and desire are unreal and yet seek to embrace the Law, the fathers who struggle to control the patriarchal order are constrained by the limits of the real, their power and authority no less marked by the effects of the cut of castration, its repressive mechanisms, its disavowals, its concealments, and its displacements onto substitutive objects of desire. If it is in desire and fantasy that we can locate the real and its limits, it is in the symbolic with its codes of the normal and the real that we also encounter what is concealed and denied in the surfaces of the fantastic. That is the key to our "reverse anthropology": we look elsewhere for the objects of our investigation on the assumption that the immediate sense conveyed by fantasy or symbolic reality is inevitably a function of an act of repression and thus of concealments, and that it is only by engaging with the surface that we can come to terms with what fantasy generates and gentrifies.

This act of looking elsewhere for the site of the Law is framed by the complex shifting of authority experienced in the Bamako where *Finye* is set.[7] The governor is the immediate target of the protest against unjust authority, and he functions as a convenient locus of all the ideological protests. The students are attacked by his soldiers who arrest and beat them, and shave the boys' heads; he intimidates them into signing confessions. The governor is the target of their pamphlets, their protest campaign, and their demonstrations. When the minister calls the governor to force him to release the students, and when he speaks with the country's leader about the necessity of ending military rule and replac-

ing it with civilian rule, we understand that the dream embodied in the film for a just, nonpatriarchal society requires the overthrowing, not just the reforming, of this military governor, this colonel.

Similarly, *Finye* incorporates a large number of scenes whose purpose is to represent the governor as a sexist patriarch. He beats Agna, his brash, beautiful third wife; browbeats the others and his daughter Batou; imposes a regimen of servitude upon the women; and plays the role of the absolute monarch in his castle. He proudly proclaims to the arrested students, "Our authority is strong and it will last forever," and we understand that this authority is to be exercised in private over the women as much as publicly over the rest of the population.

Finye is about the need to change, and the governor is the principal target of change. However, the film complicates this message at the same time as it asserts it. The governor states to the students, practically in the same breath in which he proclaims his absolute authority, that he and his fellow officers took power themselves by force of arms. Mali had been ruled by Modibo Keita until 1968, and after a coup Moussa Traore ruled until 1991. *Finye* was made in 1982. Traore was notoriously repressive toward any oppositional voices, and was finally removed from office after demonstrations spread throughout the country and his soldiers had killed 150 demonstrators. While the film might seem prescient in its representation of a similar set of actions ten years before the fact, it was also the case that Cissé was ably assisted by the military when he shot *Finye*,[8] and the government's tolerance in this regard might have been taken as a token of its forbearance. Further, the film was not screened in Mali for some years, further distancing its protest from the audience most engaged in the issues.

But the relevance of Traore's regime for the film lies especially in the colonel-governor's claim that his right to rule was based upon his military colleagues' courage in seizing power from a discredited regime, that of Modibo Keita. And as Keita was Mali's first president, it is legitimate to read the governor's assertions as a claim to being the first truly autonomous government following independence. The patriarchal stance he assumes is then consistent with the rights of a government that claimed to have actually represented Africa's independence. However specious this might have been, what compromises the governor's position is more mundane corruption seen in the scene in which an unidentified woman meets with him in a secluded spot and tells him she has sold parcels of land and milk on his behalf for 500,000 francs. She asks him about depositing it in a bank, and he responds that he doesn't want a paper trail, making it plain that he is now abusing his power and acting corruptly. This fits with the accusation Batrou later makes to Kansaye that Sangaré is hostile toward Ba and Kansaye because he saw in their line of chiefs a threat to his own authority.

When Sangaré gets the call from the minister informing him that he must release the students, it is just after he has ordered his subordinate, a captain, to send them off to prison in the Sahara—the equivalent to shipping them to Siberia. He takes the call, reverses his order to the captain, and then sits at his desk looking deflated. Earlier he had been the colonel and the governor. We understand from the minister's conversation with the military president, clearly rep-

resenting Traore, that the colonel-governor was going to be replaced along with the other military figures in the government so as to appease public pressure. The governor is thus defeated by Ba, the winds of change blowing for the youth.

The same pattern obtains with Kansaye. Originally, when Ba gets stoned and returns to his compound, his grandmother douses him with well water. He begins to chase her just as Batrou shows up, and he strikes at both women. Kansaye then returns home and starts to choke Ba. Later Ba, repentant, submits to his grandfather's correction, a whipping, and Kansaye asserts, "No matter what you do or think, the rules of our ancestral house will never change." He also tells Ba that his father would never have behaved as Ba did. Kansaye is formidable, solid, indomitable. He is our Ezeulu, our chief, priest, and pater familias, the traditional equivalent to Sangaré whose greatest fault might have been to have insisted on playing a similar role in his household while his younger wife and older daughter clearly belong to another order—one that would have been pleased to identify itself as "modern." And the governor cannot entirely dissociate himself from that designation as his position is identifiably that which springs from modern power. Indeed he tells Batrou at one point he intends to send her to France for her higher education, and she tells him that he likes French too much (at which he smiles self-complacently).

At key moments in which the two patriarchs assert their authority, they respond to challenges by banishing women, and in particular Batrou. As Sangaré beats Agna, he tells her that if she were ever to speak disrespectfully to him again, he would throw her out. He tells his first wife of twenty-five years that if she doesn't control Batrou, he will repudiate her. And he tells the prison commander that he is to arrest Batrou just like the others. When Batrou speaks up to him in prison in front of the students and guards, he orders her to be thrown out. "Daughter of Satan," he cries, "I don't want to see you again."

Similarly, when Kansaye chokes Ba and throws him down, he then turns on Batrou, asking who she is. He learns she is the governor's daughter, and shouts at her to leave, which she does in tears. The drama of Islamic repudiation, the verbal act of ending a marriage, functions as a kind of unstated subtext here in a setting in which the visibly Bambara cultural terms overshadow the strong patriarchal values regionally characteristic of Muslims, marking society in general. The quiet murmuring protest of the grandmother imploring Kansaye's mercy in the name of Allah reminds us of this subtext.

The theme of banishment is complemented by that of abandonment, and they mark the structures of power that define the actions of both patriarchs. The governor threatens to send the students to prison in the Sahara; we understand this as a sentence of death, and indeed Seydou dies rather rapidly under the duress of the prison regimen. Kansaye's case is more complex. When he learns that Ba has been deported by the governor, he dons his religious robes, takes his elephant-tail whisk, and starts for the sacred grove where he can commune with the gods. Batrou then appears in his courtyard. He orders her to leave but she insists on staying and recounting her version of why the governor has it in for Ba, and how she will love him no matter what. Kansaye forgives her, and

then tells her, "Go, it is a matter for men now." She leaves, banished from what is now to be the scene for the men to play out their combat.

Her appearance in Kansaye's courtyard would seem to be an error in continuity as her father had just told the prison guard to take her off, presumably to her prison cell and not to be freed. He curses her and tells the guard to get her out of his sight. Nothing in the script leaves us to suppose this would have led to her release. But her fate is actually irrelevant for the denouement as not only does she disappear from this point on, but the film's action ends on the shot of Ba emerging from prison without her being present. Even the return to the mystical scene of the boy filling his calabash with water and handing it up to an adult doesn't restore her presence since we don't see who receives the water, and the implication that Ba would eventually succeed to the new position of authority would better suit the logic of the narrative.

The irony lies in the fact that both patriarchs effectively banish her. Her father says to the guard, "Get her out of my sight." Kansaye says to her, "Go, it's a man's affair." Her role, like her last words in which she avows her love for Ba, will be to wait for Ba to emerge into the limelight and to support him in the struggle. The narrative is at war with itself: it wants to free women, but so that they can freely serve their men. Kansaye's acceptance of her facilitates this subduing of Batrou. She gives up the authority she had enjoyed as the governor's daughter, the one who could be seen "slumming" with Ba and his friends. Now it is Ba's position as son of an important chief, and especially as grandson of Kansaye, that endows him with a stature worthy of the mantle of the new leadership. He is clearly destined by the winds to assume the patriarchal auctoritus, and all that is needed is for him to be given the token of that position, which is what we can take the ending with the boy handing up the calabash of water to imply.

The passing of the guard depends not only on the reversal of the government's position and authority but also on that of the traditional authority as well, and the key scene here occurs directly after Batrou has come to Kansaye for her last appearance and has obtained his blessing. He then leaves her for the sacred grove in order to obtain justice and revenge for the imprisonment and banishment of his grandson. He enters the sacred grove and quickly enters into a semi-trance where he can communicate with the gods.

We enter into this symbolic universe of the "authentic," the "traditional" African reality, through all the devices of the fantastic, with appropriately low camera angles, mystical images, ancestral statues, and disembodied voices. Ostensibly Cissé constructs this scene so as to mark another "winds of change" moment. After all, the gods inform Kansaye that they are leaving and he is now on his own. But the manner in which they inform him is through a disembodied voice from on high, with more spooky sound effects, and with the magical appearance of a pure white ram that trots through the grove and ambles off into the distance. The symbolic of the African spiritual universe is completely constructed as it announces its own deconstruction. This reminds us of Žižek's comment that ideology is never so completely ideological as at the moment it

announces it is being nonideological or outside ideology, when it is at a distance from ideology.

The same logic can be applied to Batrou's climactic speech in which she stands up to the governor in front of the students and tells him that she is now in revolt against his authority. She berates her fellow students for their cowardice in not following the example of Ba in refusing to sign the confession. This scene, like that of Kansaye at the shrine, is among the most compelling in *Finye*, and indeed the two stand out as among the most memorable in the canon of African cinema. But this is in part because they so successfully embody the very symbolic order whose image they themselves construct and convey. Batrou becomes the woman-in-a-state-of-revolt (which is all the more undercut by her subsequent pitiful final lines to Kansaye that she will always love Ba), and for that one moment she defies and defines the patriarchy in all its configurations of power. But she is simultaneously the self-conscious figure of woman-in-a-state-of-revolt as she announces her position rhetorically to her father: "Governor, if I can call you so since I have no other name for you. . . . Since I became aware of myself as a person I realized you and I had very different views. We don't seem to be of the same blood." As Melissa Thackaway puts it, "Defying him directly and in public, she uses his official title to show the psychological divide between them. She even questions her filial tie" and thus "renounces her father's authority over her as his daughter and political subject" (175). He responds, "Daughter of Satan," dismissing and disowning her. But though he can have her banished from his sight, he can't banish the scene, the order she has constructed. They are locked into the pas de deux of revolt and repression. The fantasy of this staged set is what completes the action: the reality of the student revolt cannot be completed without this ideological idealization of youth, and especially youthful women, in defiant refusal of the patriarchal father. The gods aren't entirely gone—they are reincarnated, ontologized, in the figure of Batrou, and neither sacrifice nor banishment can entirely conjure them away.

So why does Batrou disappear from the scene after seeing Kansaye? Why isn't she there among the crowd of students who call on him to lead them in their revolt after his return from the sacred grove? Why isn't she there when Ba emerges from prison, and especially to share in the ritual communion of the calabash of water at the end? Her father is no longer present to be the obstacle to her love, and Kansaye is won over to her as well, ending his role as obstacle. She disappears as Kansaye learns from the gods that he is henceforth on his own, that the old order has come to an end. If she was the fantasy that arose to keep the men from facing that fearful aspect of freedom, and especially of the freedom to be represented through the women and the changing relations with them, then when the battle has been won and the patriarch deposed, the basis for the fantasy will have been eliminated. Batrou, the object of Ba's dream, will have made the dream possible in her speech and defiance of her father, and in that act alone deposes him, clearing the way for Ba. The dream realized, its fantasy disappears. She is the star that Kansaye hears about from the voice of the oracle, the star that is departing, leaving the world for the men to sort out among

themselves.[9] The question of how the women, without this exceptional figure of Batrou, are to make out in this world, remains to be seen.[10] And if *Yeelen* is the answer, then it would seem that Kansaye's final words to her, "Go, this is an affair for men to settle," are somehow, inadvertently, like a Freudian slip, prophetic.

8 Hyenas: Truth, Badiou's *Ethics,* and the Return of the Void

There is a normal reading of *Hyenas* (1992), perhaps driven by Dürrenmatt's *The Visit* (1962), that would have Ramatou presented as the figure that introduces the nefarious effects of globalization to Africa. In this version, as with Dürrenmatt, the townspeople of Colobane are desperately poor and easily corrupted by money. They are desperate *because* they don't have money; they are poor with respect to their past, as we can see with the seizure of the furniture from the town hall, with the ragged attempts at dignified dress by the remaining town notables. They have fallen on hard times from whatever meager heights they might have attained in the past, as is brought home in the repeated references to the trains that now pass them by, that whoosh past their town to the more prosperous and important cities. They are nobodies, now living nowhere, where nothing can happen anymore. And even worse, they are in the process of all this: becoming nobodies, the town failing, and the final blows falling—all this even more devastating than that it would be if they had definitively fallen. Their fallen state is the sign of their failures.

In Africa these signs might be understood somewhat differently from the way we would see them in Europe. Dürrenmatt's *The Visit* is set in post–World War II Europe. It is in a Switzerland whose bankruptcy might be viewed as moral, or at least whose monetary bankruptcy might be understood as a metonymy of its moral bankruptcy. It is corruptible, as the offer of great wealth easily defeats the moral impediments to killing Herr Ill, but the consequences of its fall are not seen as relative to an outside world that stands historically in a relationship of domination, as is the case in *Hyenas* where Ramatou is a figure for the World Bank, and thus the powers of the west. The conformism to a materialist norm, the easy seduction of the morals of the people of Guellen through wealth, takes place in a Europe preoccupied with notions of the emptiness of an existence based solely on material comfort and devoid of answers to questions about the meaning of the universe. In other words, it is of a piece with the philosophers of the absurd, of existentialist literature and especially theater; of a piece with Ionesco's *Rhinoceros* ([1959] 1961), where everyone turns into the same heavy beast at the end, where resistance to stultifying conformism is defeated; or with Ionesco's *Bald Soprano* (1965), where there is no difference between Mr. and Mrs. Smith and Mr. and Mrs. Martin, etcetera. A theater of "etcetera"—a theater called "of the absurd," but really of the modernist sensibility preoccupied with notions of meaninglessness.

Those powerful readings overdetermine our responses to *Hyenas*. In part this

is because the careful reader will note how many details of Djibril Diop's version, as well as its structure, correspond to those in Dürrenmatt's play. It is a mistake to see *Hyenas* as loosely based on *The Visit*, as Djibril Diop's interview with Anny Wynchank (2003) leads one to conclude. It is best described as an adaptation. Even so, the African frame functions to shift its meaning as in Kristeva's sense of intertextuality, and it is crucial to understand that this shift to an African setting is not merely scenic, much less superficial. It is, in fact, fundamental because it sets out an ethical demand that carries us beyond the Theater of the Absurd and whose meaning is particular to the African circumstances in which it is set.

Again, there is a superficial and then more significant reading that we can obtain by first laying out the ostensible meaning, and then seeking to reverse it. Ostensibly Colobane is the figure of African poverty. The film begins with the "gueux" (people in tatters) emerging out of the dust of a horizon that had been filled with the heavy marching feet of a herd of elephants. The dusty men are headed for Draman's shop where they will settle in for a day of loafing. If they are lucky, he will offer them a drink since they don't have a sou, and maybe he will join them in a dance. There is nothing in their lives and nothing in their future; nothing to resist if someone were to offer them money. Indeed, the minute Ramatou offers the railway official money for breaking the company rules by causing the train to stop at Colobane where there is no officially scheduled stop, they all cry out, "take the money." Ramatou and Draman had been lovers when they were younger. When Ramatou became pregnant, Draman bribed two men to testify that they had had sexual relations with her, and she was thrown out of Colobane. Now old, held together by prostheses, but immensely rich, she has returned to take revenge. She offers a vast sum to the townspeople in exchange for Draman's life.

No sooner has Ramatou made her offer to the townspeople than they are dancing and singing about eating from her handouts and marrying her. To be sure the establishment of Colobane and Draman's wife Khoudia Lo immediately declare their fidelity to Draman, but in the subsequent scenes we see them succumbing, one after another, to Ramatou's offer of money.

She is as "rich as Croesus," for Dürrenmatt's Guellen, but as "rich as the World Bank" for Colobane, and therein lies all the difference in this first reading. This is because she is a been-to. Unlike Claire Zachanassian, whose departure and return are not fundamental expressions of Switzerland's dependency on a wealthy outside world, Ramatou's flight and return form part of the familiar pattern for a postcolonial Africa. And I mean "postcolonial" in that loose sense of an Africa marked by the colonial experience, so that we can see the pattern of been-tos extending from the generation of the time of Senghor and Birago Diop, who sought education and therefore status abroad, to the postwar exodus of the elite along with the impoverished who came to be associated with the lowest class of laborers, the streetsweepers and housekeepers of a wealthy Europe. In *Guelwaar* (1992), Sembène gives us the conventional figure of the successful been-to in Barthelemy, Guelwaar's son, who has been a "Frenchman," a

"whiteman," due to his acculturation to Europe: he now despises Africa and mimics the words of the western critics of Africa's corruption, laziness, and so on. He is also conventionalized as the lost son whose recuperation for Africa is represented as the desired goal.

How easy it is to read Ramatou in this way: she who is surrounded by her exotic servants, her Japanese guard, her ex-magistrate chamberlain. She had become a prostitute and by virtue of her selling out, selling herself to the system made available to her in the west, including their judicial and insurance systems, she has become as rich as the World Bank, *is* the World Bank who now owns everything of value in Colobane (read Africa), and has come to buy the last thing left in Colobane, its justice system, and with it the remainders of its sense of honor. She wants revenge, but from the point of view of Colobane brings wealth. They want her wealth, or actually her charity, and are indifferent to her desire for revenge. So a reading that gives us this spectacle of their debacle is set up for us, and we thus *reduce* Djibril Diop's work to the straightforward allegory of the politics of Third Worldism as Jameson (for whom the African text is invariably an allegory of the political situation in postcolonial times) would have it. This would be to strip Djibril Diop of his most compelling quality, that of the moralist, that is, the one for whom the fundamental issues are seen as involving ethics rather than politics or ideology in the narrow sense.

To get past this we must ask the question that disturbs the normal reading. For instance, if Ramatou (and her entourage) appear as radically different from the others in Colobane (a difference from the women of Colobane being most visible), how can she be seen as also the same? Similarly, if she is seen as introducing western materialism to Colobane, how can we also read her as *not* having introduced anything that wasn't already there? Most of all, if she is seen as corrupting the town, might we not also see her as creating the circumstances that will challenge the town, and especially Draman, to go beyond where they were before her arrival, to go beyond the narrow limitations of their lives?

Ramatou's difference is made apparent from the beginning—so apparent as to obscure any similarity she may share with the people of Colobane. When she forces the train to stop, she interrupts the mayor's speech to the townspeople in which he is prepping them to receive her, warning them not to behave like hyenas. The unexpected screeching of the train's emergency whistle signals her arrival, her interruption of their carefully laid plans to seek to get on her good side and wheedle money out of her. Her appearance with her entourage, her fabulous offers of money that stun everyone, her command of the situation, starting with her interruption of the mayor in his prepared discourse, all this establishes her difference, even as it conforms to another expected pattern, that of the African "grand," or in this case "grande"—what some would call the "big man," the "chef," the "oba"—and, in her case, as her second name "Linguère" (Queen) denotes, the ruler.

She had left as an impoverished, disgraced, pregnant, rejected, and unmarried seventeen-year-old girl. She has returned to take charge. Nothing could have been more different than this transformation, and nothing could be more

bizarre than her appearance and behavior. Finally, as Draman approaches her and touches her physical body, she reveals to him her artificial leg and hand, and he asks if she is entirely artificial. She is thus different in the way a prosthesis is different—she is unnatural, and as such acts as a foil to the others whose appearance and behavior all fall into the definitions of the natural.

This pattern could be explored closely in all the scenes in which she appears, increasingly pushing her into the niche of an allegorical figure rather than a real person from Colobane. But there is much that returns her to that reality, and without it the ethical charge of the film would be dissipated into the comfortable, closed meaning of an allegory. For one, she speaks Wolof, or more specifically she speaks the language that the people understand. She offers and they take—they speak a common language, and her words meet their expectations. When she makes the astounding offer of 100 billion francs (the exact amount is meaningless—it signifies infinite wealth), and they say they cannot sell justice, cannot betray their Draman, she smiles and responds, "I'll wait." Not only is she not dismissed for making an offer of that sort, it soon, in fact immediately, emerges that they and she are on the same page. They might say no, but she shows that soon it will be yes. She speaks the words that not only corrupt them but also correspond to their weaknesses. Also, she issues challenge in terms that correspond to their thinking and circumstances. She understands them as she is one of them; and she speaks as one born to the language, not as one who learned it as a foreign tongue. Her smile and assurance are not those of a foreign conqueror, but of a homegrown native speaker—and seducer.

With this reading, she functions in a tension between alternating poles, rather than as a fixed allegorical figure. And as we explore her character along different axes, we can see similar lines of tension emerge. For instance, she returns to recover a past, but also to foreclose the future. She asks Draman, whom she has clearly returned to see (she steps forward when he speaks to her at the train station, after telling the mayor to be quiet), to tell her what she had been like when she was young, and permits him to take her to the site of their original tryst. Yet she also opens up the memory of the abuse she suffered as a result of Draman's rejection of her: the corruption of the two witnesses, her expulsion from Colobane, the humiliation and disgrace, the loss of their daughter, and her life as a prostitute thereafter. Finally, the sequence that sets in motion her expulsion leads to the airplane crash and her resultant transformation into a prosthetic amalgam. She says she is too tough to kill; she appears increasingly unreal, and in her final descent down the stairs, into the darkness, leaves us with the impression of some mythic figure of darkness, of death. And she tells Draman, shortly before he goes off to his death and she to the darkness, that he will be hers in death.

So on the public level where she accuses Draman, puts him on trial, and evokes the testimony of Gana and the two castrati, she functions to provide an excuse for the introduction of material wealth to the community. She buys them off as Draman had bought off his two witnesses in the past and as he continued to buy the good favor of all his customers in the present with candy for

one woman's baby, with friendly chatter, with the drinks he offers Lat and the *gueux*—with all that made him the most popular man in Colobane. Ramatou ups the stakes dramatically, wildly outbidding him, winning easily as if there were no contest, buying justice along with all the surrounding lands and factories, purchasing with them the means of foreclosing the town's hopes and Draman's life. She buys death.

The announcements of her arrival, the crates of goods she provides, the transformation of every single inhabitant of the town into a "hyena," all are marked by the two words used to describe her wealth: the "World Bank." And the symbolism suggested by her entourage, including a Japanese female personal guard, three Fulani-looking "amazons," and her magistrate-chamberlain, all embody that status, concretize it in the form of the "grande's" personal servants. They indicate there is nothing and no one she can't buy, even if she has to wait. As the doctor and teacher visit her, begging her assistance to let the town rebuild itself on its own by facilitating their acquisition of the lands and factories across the river, she responds that she already owns them (along with the towns, the roads, the houses) and has shut the factories. Don't come to the lion's banquet, she tells them, unless you have a ticket. She sets the stage, she owns the banquet, so that even her hairstyle sets the trend for the wigs that will ultimately be worn by the townspeople as they congregate in the final scene to judge and condemn Draman.

The only continuity between the beautiful seventeen-year-old "wildcat" of Draman's memory and this prosthetically reconstructed elderly figure lies in the voyage of the been-to. This is not the "voyage of the hyena," the title of Djibril Diop's first feature-length film *Touki Bouki* (1973), because she is not the cowardly, herd-like figure of the hyena-trickster. She evokes the lion, the killer, the ruler—Linguère, the Queen of Darkness—not the scavenger eater of leftovers.[1]

But when she pauses to look one last time out across the ocean, as she is about to descend into the darkness, the setting dramatizes a more poignant ambiance, one associated with a past marked by suffering and victimization, not domination and rule. In fact the steps she descends form part of a bunker, one of a number that were built along the coast of the peninsula where Dakar is located and on the island of Gorée, to defend the city during World War II. She looks across the sea and her gaze falls on an island shimmering in the water. Her bunker appears to be on Gorée, the setting in fact of certain scenes shot in the film; but more importantly Gorée is the location of the most infamous of slave forts, the last step for thousands of slaves shipped across the ocean.[2] These shots of Ramatou are cross-cut with those of the townspeople marching solemnly along the edge of the escarpment: they are walking single file, in silhouette, hands behind their backs—evoking nothing so much as a line of slaves, a cordelle, bound and marching to their fate.

Ramatou's triumph is thus marked by death, entirely defined by images of death—both her own and Draman's, and that of the people in the past and the present. The void that she embraces is total, totalizing, demanding what Badiou (2001) calls fidelity to a simulacrum (74), one that successfully defines the to-

Figure 8.1. *Hyenas:* A cordelle of slave-like figures on the horizon, marching to Draman's judgment.

tality of death in terms of the infinite wealth associated with the capitalist, glob-alized, corporate World Bank.

Death and wealth might have something in common, if taken in a Freudian/Lacanian perspective as figures for the abjected or as transgressive signifiers of guilt associated with feces or dirtiness. Badiou presents us with an alternative, nonpsychoanalytical approach that opens up the possibility of exploring ethical positions in their relationship to wealth and power, and their manifestation in *Hyenas* in conjunction with death. To sketch out his ideas, we begin with his definition of truth: "I shall call 'truth' (*a* truth) the real process of a fidelity to an event: that which this fidelity *produces* in the situation" (42). Events are mo-ments in which we are compelled to act, to make decisions that are not driven by our material being or customary material engagement in the world, our or-dinary ways of being or understanding ourselves in the world. Before Ramatou's arrival, the deadbeat existence in Draman's shop was without event: the monkey splayed along the axle of the cartwheel spoke to the life of ordinary existence and of impoverished conditions. Badiou specifies that that is not all that life offers: "Let us say that a *subject* which goes beyond the animal (although the animal remains its sole foundation [*support*]) needs something to have hap-pened, something that cannot be reduced to its ordinary inscription in 'what is there.' Let us call this *supplement* an *event,* and let us distinguish multiple-being, which is not a matter of truth (but only opinions), from the event, which com-pels us to decide a *new* way of being" (41). In this sense, Ramatou's arrival is an "event."

The ending of *Hyenas* posits the "multiple-being" of the townspeople echo-ing the words of the schoolteacher that it wasn't greed but truth that decided

their actions: "For Justice, for justice." If this wasn't an opinion, it was one step removed, an act driven by that level of interest that motivates action understood in terms of "what is there"—ordinary material existence. Draman's actions were in opposition to that since his were marked by fidelity to the event. Fidelity is defined by two traits: first, as an outcome of action within an event, it represents an act that is not determined by the ordinary motivations and expectations built into "what is there," but reaches to what exceeds or supplements the ordinary situations of life. Events are singular, for Badiou, and the truth he wishes to evoke in response to an event emerges from breaking with the everyday situations in which we normally find ourselves. Had Draman yielded to the pressures placed on him, his actions would not have represented a break, would not have been marked by truth. And this points to the second quality of fidelity: the persistence of the action or commitment to that break with the everyday: fidelity is faithfulness to the break, faithfulness to the truth that emerges—it is the quality of keeping on going, of not giving up (Badiou 2001, 47). He sums up the ethic of a truth: "Do all that you can do to persevere in that which exceeds your perseverance. Persevere in the interruption. Seize in your being that which has seized and broken you" (47).

All concepts, like all signifiers, are meaningful in terms of their relationship to others, and specifically their relationship to what they are not. The space of what they are not we can call the void (le "vide"), and the qualities of the void emerge in the values placed upon death and wealth in *Hyenas*. To give us access to this space, Badiou develops the notion of the pseudo-event, the moment in which all the properties of the event would appear to be present, except for its qualities of singularity. He terms this a "simulacrum." Here we come to the crucial distinction between an event in which truth can emerge and a pseudo-event in which its opposite emerges.

Any kind of situation can be torqued into one that breaks with the norms and expectations of life as experienced by most people, where the ordinary reactions prevail. And one can break with the norm in more than one way. The void against which are set the circumstances of the event is neutral, and does not dictate the direction that a break with the situation would entail. As a result, the break with the event, as well as the fidelity it demands, is not addressed to a particular group but to anyone. It is "universally addressed" (Badiou 2001, 73). In contrast, the pseudo-event of the simulacrum is marked by an address to a particular group. Badiou's example is that of the Nazi break with ordinary German life: it is a break that addresses the German people, and the void on which it is grounded is not neutral, but the space cleared by the removal of the Jews. The address to the German people is intended to construct Germans as a set, and that depends upon what is excluded from the set for its consistency, its "truth." Thus the void, which is essential for any being to be differentiated as separate from others, here "returns" in the form of death, or "that deferred form of death which is slavery in the service of the German substance" (74). It is possible to have fidelity to this ideal, for it to represent a break with "what is there," and for it to be defined in terms of the void. But the void, in its return

as a particular, and not a universal, subject, assumes a content, and that is the action that clears the space in order that the German subject might be assumed. The content of that act of clearing, for Badiou, is war and massacre (74).

We might see the powerful effects of the void not in its specific contents, but in its effects—in what has been touched by it. Once we look for presence as an effect of the void, that which normally goes unnoticed emerges into an indirect form of visibility. Thus every moment in a work of art can be understood in terms of the void that makes its existence or presence possible; every figure, every scene, every disposition of the forms and colors can be seen in relation to what it is not and what has therefore made its emergence into particular existence possible. Every fidelity, like every form in art, takes its definition in relation to the void. Art frequently thematizes this concept, and two striking examples in Dutch seventeenth-century art depict this idea.

In Pieter de Hooch's *A Woman Preparing Bread and Butter for a Boy* (circa 1660–1663), we see a quiet scene of a woman dressed in a modest black dress with a white collar, holding a load of bread, and reaching with a knife to a mound of butter. Next to her a boy stands expectantly, holding a large hat, well dressed and attractively represented. They are in a bare room, with a pair of windows and a door looking onto a well-lit courtyard where tiles, an open door, and buildings fill in the space. Above the window, over the woman and boy, there is a framed painting, the contents of which are obscure, and to which our eye would not normally be drawn. The space is not black, but dark, with faded tones signifying a content that can't be seen. It *sets off* what can be seen, not only what is lit, but what has forms. And without the void to set it off, the visible forms would only be busy work, stuff without a center or focus or meaning, an endless parade of detail. Much of the seventeenth-century Dutch painting is filled with detail. But what permits nuance to appear are not the striking and brightly lit features, but the void/vacuum around which the solid can coalesce. If this void had content, if the features of the darkened painting were visible, it would not play this role since our eye would be drawn to it, we would discern its features and simply add them to the list of other elements in the painting. By deliberately leaving the contents obscure, the artist sets off what is visible and formed.

The second example is the church in Pieter Jansz Saenredam's *The Interior of Saint Davo, Haarlem* (1628). The painting depicts a large, Gothic-looking church (one would say cathedral) interior, in which the vast columns and arches dwarf a small pair of figures located to the left. As with much Renaissance painting, the patterned tiles of the floor are prominent, and displayed so as to highlight the lines of linear perspective that point back to the vanishing point on an unseen horizon. The church is filled with arches and spaces defined within the architectural features of the church, subtly given with shade and fading light falling on the patterned floor; and they fill in the world with their Gothic features. But it is the opened space in the middle of the church that makes all the architecture of the church come together and have form—in short,

Figure 8.2. The J. Paul Getty Museum, Los Angeles. Pieter de Hooch, "A Woman Preparing Bread and Butter for a Boy," ca 1660–1663. Oil on canvas. 68.3 [TIMES] 53 cm.

to be constructed as a building. This is the work of the void or lack that is not total or totalizing. It sets off life, but doesn't swallow it.

The void that sets off life in *Hyenas* are the dark images of death. Drought in Senegal, so devastating in the 1970s, is evoked by the teacher and mayor. The images of scavengers abide along with the notion that the people of Colobane are who they are because they are not "bouki"—hyenas, scavengers. "We are

Figure 8.3. The J. Paul Getty Museum, Los Angeles. Pieter Jansz. Saenredam, "The Interior of St. Bavo, Haarlem," 1628. Oil on panel. 38.7 [TIMES] 47.6 cm.

poor," says the mayor in his initial rebuttal to Ramatou's offer of money for Draman's life, "We're in Africa, but the drought will never turn us into savages." Scavengers live off the kill of other animals, and *Hyenas* is filled with shots of hyenas, vultures, as well as hawks and owls, the predator birds.[3]

Although Ramatou walks away from the plane crash having escaped death, as Queen (Linguère) of Night, she would seem more to embody death than to be one who faces it; she certainly embraces it at the end as the means to be definitively joined with Draman, or to own him completely. And she brings death to Colobane. It was the mayor's intention to resurrect and reconstruct the past so as to flatter her and wheedle money out of her. She cuts him off, and when the whole town assembles to honor her and sing her praises, she cuts through the verbiage of the praise-singer and states that truth is better than lies and praise. It is then that she announces her plan to reward the town for killing Draman.

His death is the film's void that makes visible the film's "event"—or, to put it in Žižekian/Hitchcockian terms, it is the film's McGuffin: that which we cannot see, and which drives the entire plot. Even when Draman's death is carried out, we can't see it, and when the crowd disperses after having pushed in on him as though to crush him, there is no corpse, only his coat. It is as if they had been

186 *Postcolonial African Cinema*

transformed into scavengers, hyenas, who picked his body clean; like vultures who performed the task of making the corpse disappear. But they leave a void at the center, so that he functions very much like the Lacanian *objet a,* the object of desire they pursue, but which, in the act of apprehension, proves to be elusive, to be inevitably elsewhere—inevitably displaced. He is the object of death that cannot be rendered in the Symbolic order; the lack in the real. For Badiou, when the void returns in the *simulacrum,* it has the form of a plenitude, of that which answers everything, fills all the needs for truth and action in the world. When the void of the *event* returns, it has no particular form, has no concluding answers, but is sustained by a universal address. Against the void is set the substance or plenitude whose vocabulary consists of answers. This is the essential aspect of Badiou's ethics: "What allows a genuine event to be at the origin of a truth—which is the only thing that can be for all, and can be eternally—is precisely the fact that it relates to the particularity of a situation only from the bias of its void. The void, the multiple-of-nothing, neither excludes nor constrains anyone" (73). Similarly, the McGuffin for Žižek is absent, though it addresses all those who enter into its sphere, into the film's diegesis. (The McGuffin itself is " 'nothing at all,' an empty place, a pure pretext whose sole role is to set the story in motion" [Žižek 1999, 6]). Finally, when the void is filled with a particular quality, like the Jews for the Nazis, what emerges is not the truth but its simulacrum. That which is "addressed" by the void here, like the substance of a real German identity, is not universal; the void takes on form, and in order to do the work of giving definition to that which it addresses, must be eliminated. It returns to face its own genocide.[4]

The two responses to the void are what mark the difference between Draman and Ramatou—the two polar figures who stand apart from the crowd that is transformed into hyenas.[5] To appreciate the difference one has to acknowledge the tension Djibril Diop sets up in both their cases. I will make the argument that Ramatou's response to death, to the void, is totalizing—totalitarian. Her role as World Bank is of a piece with the vision of the globalized capitalist system that has forced Africa to its knees and reduced its people to scavengers. But as she returns to the past, we discover a woman who had been abused systematically, and not just by Draman. She was also the victim of a patriarchy she returns to overthrow. Reading with resistance, we can view her and her entourage as that which the patriarchy fears in the female whose sexuality is constructed as dangerous, deadly, to men. Further, if she makes available to Colobane the option of selling out, it is selling out when there is nothing left to sell: they have nothing. In the opening shots the monkey draped across the wheel's axle in Draman's shop sets the tone for a place that has become empty, and the cross-cutting of the seizure of the town hall reemphasizes this. Thus she is not presenting much of a dilemma for most of the people. The poor sing, "I would marry her," in the scene *immediately* following her proposition to the town. And if the mayor and Draman's wife Khoudia Lo protest their allegiance to Draman, it is that same Khoudia Lo who states at the fair that she will buy *all* the appliances, an act whose gesture is commended by the announcer-griot as a sign of

her stature. It also signifies the dimensions of the betrayal of all those closest to Draman. Having nothing to sell, no real integrity, no objects of value, no "ineffable African soul or spirit," they sell the town grocer, the one who describes his life to Ramatou as empty, meaningless, and totally unsuccessful. If the intercut shots of the bull being sacrificed occur as Ramatou presents her proposition to the town to kill Draman, he is now miles and years from the figure of the black panther she remembers him as having been. He is only Draman; he cuts a silly figure when nominated by the mayor as his successor, when he "herds" the cattle again for Ramatou, when he hides from Khoudia Lo the bottle of wine behind his back so he can serve his friends, and so on. He is what Djibril calls, in the trilogy he set out to make after *Hyenas,* one of the "petites gens." He has nothing to bargain with in a deal worth billions.[6]

So her gifts really can be taken as such. The move to dismiss the "time of the hyenas" as crass materialism would have had a resonance in post–World War II Switzerland, but the situation is completely different in an Africa that has known real hardship and deprivation, real drought, starvation, and misery (highlighted by the TV images of lines of emaciated people lining up for food in what seems to be Ethiopia). The World Bank's "good offices" bring real subordination, and finally real enslavement, both historically and actually. That history of the west and Africa is what gives the tension to Djibril Diop's adaptation; it is what makes credible Ramatou's engagement with death as much more than idealistic or purely spiritual, or even allegorical. It is also real, in the material sense of real. Djibril puts the void, the hole, the death into this real because he refuses the Sembène solution of total materialism. And he does this by manipulating the figure of Ramatou from victim into executioner.

Ramatou brings us back to the role of the void that is essential to every event. For Badiou the void makes it possible to connect an event with those for whom it is an event. "[A]t the heart of every situation, as the foundation of its being, there is a 'situated' void, around which is organized the plenitude (or the stable multiples) of the situation in question" (68). "We might say that since a situation is composed of the knowledges circulating within it, the *event* names the void inasmuch as it names the not-known of the situation" (69). Badiou presents the *situation* roughly as what is conventionally referred to as context in cultural or literary studies. Event is the *exceptional moment* that is viewed from a perspective that stands outside the given context: it is both new and free from the constraints of interest that limit the conventional point of view. Thus it is not enough to remark on the space in the Saenredam painting of the church in Haarlem, it must be named in such a way as to thoroughly revise our understandings of the situation, that is, of the representation of the church, or of churches. The painting can't do that work, and neither can the artist. They present the space, and we must be open to its workings in ways that do more than repeat the truisms about seventeenth-century Dutch realism. The truth to which that naming refers is ours because we bring the empty space around which the massive church walls and columns are assembled into being as organizing principles, the space that makes possible the architectural real.

This is what Ramatou does when she tells the doctor and the teacher that to come to the lion's feast they must first have a ticket. She provides the material basis for the void—emptiness—that had been there all along. Even more, as the film begins with the emptying out of the town hall, we can say her goods provide the acts of filling that make visible the acts of emptying that had been at the core of all the institutions of Colobane (teaching, governing, religious practice, economy, and especially personal relations). One small example, almost unnoticeable: As the "chef de protocol" rushes off to the mayor to tell him that the City Hall has been seized, the mayor is leaving his home in argument with his wife. He yells to her that she should get out and go to Saraba. Now Saraba is the same city to which Ramatou repaired when she was expelled from Colobane, and it is also the city where the trains still stop. The failures of the past, its "emptying" out, are still taking place in the present. Ramatou makes it visible when she fills the lives of the people with "useless" commodities whose lack they never felt before. Having not had air conditioners, they never missed them and had fans they could wave. Now the "ladies" at the fair are told they won't need their fans any more: the air conditioners are the lack that they bring into existence the moment they come into the scene. Their name, of course, is "modern life," and it is that which Ramatou introduces with her wealth, gifts, and power.

Badiou presents three ways in which "Evil" comes into being, and all three are in response to an "event." The first is in the sense of "simulacrum or *terror*," which is "to believe that an event convokes not the void of an earlier situation, but its plenitude" (71). The second is *betrayal*, the failure "to live up to fidelity," and the third, which he names *disaster*, is to "identify a truth with total power" (71). Ramatou embodies all three of these forms of Evil.

Happiness provides the *simulacrum of truth* in *Hyenas*, but not in the sense that a John Stuart Mills would dismiss as the happiness of a self-satisfied pig as opposed to the higher aspirations of intellectual and spiritual beings. Rather it is because the happiness is presented as completely filling the emptiness created by Colobane's poverty and vacuity, its silliness. If the material happiness suffices to fill the void, it can do so only by totally denying the void. When the crates are presented at the fair, and the ladies sign up for their share (and especially with Khoudia Lo taking "all"), their presence fills the screen, as do the heavy bodies of the herd of elephants at the beginning and the end of the film. The *situation* in which Colobane finds itself is fully resolved by Ramatou's billions—the void disappears under the weight of the material goods she imports. The time of the hyenas that she inaugurates marks the return of the void, or more precisely, the return of what functions to avoid the void.

Badiou's formulation concerns the return of a specific name, "Jew," which functioned to set off the community of "Germans." The elimination of the Jews was the condition for the establishment of the "German communitarian substance." It is in this sense of a return that voids the void that Badiou writes, "The void 'avoided' [*chassé*] by the simulacrous promotion of an 'event-substance,' here returns, with its universality, as what must be accomplished in order that this substance can be" (74). The result was a fidelity to a simulacrum that ac-

complished its task of forming the German community by addressing death to everyone else: "That is to say that what is addressed to 'everyone' (and 'everyone,' here, is necessarily that which does not belong to the German communitarian substance—for this substance is not an 'everyone' but, rather, some 'few' who dominate 'everyone') is death, or that deferred form of death which is slavery in the service of the German substance" (74). The return of the void in *Hyenas* takes on the concrete form of the heavy boxes of goods exhibited at the fair, and as they chase away Draman, enabling the community of hyenas to form, it becomes apparent that their formation recapitulates the historical drama of enslavement to that higher communitarian substance that had informed the racial politics of slavery and colonialism.

At the same time that Ramatou's billions drive away Colobane's miserable existence, they leave in place a structural relationship that only resembles the developmental patterns of all-encompassing solutions, universal solutions. For Badiou, the *event* relates to the *particularities of a situation,* and that rests upon the void as its basis—that is, as the basis of which the only characterization possible for the encounter with the void is a truth. Colobane is presented in its particularities, but is joined to the general problem of poverty or "underdevelopment" in African terms at numerous reprises; for example, when Draman sees the TV images, when the mayor says we are Africans, but we are not savages, and in the final credits when Djibril thanks "Le Grand Friedrich" (Dürrenmatt) in the name of the people of Africa. Also, as the actual quartier of Dakar named Colobane is part of the city, and not on the outskirts as represented in the film, we are compelled to allegorize its situation. More importantly—most importantly—Badiou claims as the basis of a truth claim that though the situation is singular and particular, the truth that the *event* evokes is universally addressed. Here is where simulacrum, terror, and evil coincide, since the address of developmental progress that forms the simulacrum of truth in the film is *actually addressed only to the hyenas,* that is, those whose fate is always to be that of the eater of leftovers. Inasmuch as *all* the people in Ionesco's *Rhinoceros* turn into rhinoceroses, the address of the play to the conformist reductiveness and consumerism in modern society is universal. But in *Hyenas,* Gana stands above the crowd that wrecks Draman's shop, remarking on their actions to Ramatou, who responds, "The time of the hyenas has already come." She sets the model, she wears the hairstyle, and they *imitate* her in the final scene in their roles as judges; but they are only imitations of power, imitations of wealth. She has already stated, don't come to the lion's feast unless you have a ticket, and hyenas must wait till the lions finish eating. In other words, the extraordinary entourage with which she surrounds herself, the Asian woman, the three amazons, and the chief justice, are the *only* ones besides Ramatou invited to the feast, the only ones *actually* addressed by a prescription of material wealth. This is because the nature of the terror on which the prescription rests derives from the structural imbalance guaranteed by the processes of globalization that become instantiated in the very community constituted by the killers of Draman. The tragedy is deeply pathetic as we see the isolated figure of the hunter throw away

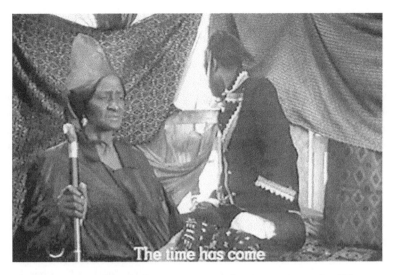

Figure 8.4. *Hyenas:* Gana looking into courtyard as Ramatou remarks, "The time of hyenas has come."

his hunting rifle and walk away in disgust and despair at the sight of Draman's lonely coat on the ground at the end, at the "Hyena's Hole."

The simulacrum of the truth is that of an address that purports to be universal—free markets to bring benefits for all, to raise all ships, to end misery, and so on—while actually addressing the needs of the few. This is the effect of what Badiou describes when he states that the void chased away, "avoided," returns with its universality in the form of a demand that must be met so as to ensure the closure of the elite community. That demand is death. The void returns as death, with the erasure of those whose departure assures the completion of the simulacrum-community. In post–World War II Europe, that message was presented in the form of the erasure of those who would be different, the beatniks, the blacks, the outsiders, the strangers. Here it is Draman, the one figure who refuses to accept his own sacrifice as an act of compliance with the demands required to ensure Colobane's happiness. Draman is *named* by the mayor as selfish, egotistical. His stance is the target of this naming, as he is the target of the terror.

Ramatou's fabulous wealth sets up the conditions for the community to be formed. There is no room for Draman inasmuch as it is a closed community, one that stands in opposition to what Badiou defines as being for a subjective fidelity—fidelity here designating the disinterested determination to pursue one's truth, to carry on. In fact, the community must be constituted by the exclusion of Draman, the "return of the void" taking the form of his elimination. This is a communitarianism grounded in the politics of much more than solidarity; it is total, totalitarian, based on the effects of exclusion and terror. Badiou's references to Nazi ideology and practice resonate with the familiar vo-

cabulary of terror, which is pitted against his insistence on the ethical impera-
tive: "Every invocation of blood and soil, of race, of customs, of community,
works directly against truths" (76).

So here is the model for Ramatou's simulacrum—where she and her entou-
rage constitute the few, and the people of Colobane the bouki, the hyenas,
everyone. The void that is "'chassé' by the simulacrous promotion of an 'event-
substance'" (74) returns with the demand that everyone join in the newly
formed community, the people all gathered at the Hyena's Hole at the end of
the film. Gana stands on the escarpment looking down on them as they elimi-
nate the one man who refuses to join them.

Ramatou refuses the doctor's and teacher's requests for help that would en-
able them to move the town out of poverty. The model of the lion's feast and
the hyenas is reflected in this pattern of the few over "everyone," and for this
"everyone" is a slave. "What is addressed to everyone . . . is death, or that de-
ferred form of death that is slavery in the service of the German substance"
(74). Before Draman knew what Ramatou wanted, he *ran* to get a light for
her, herded for her, performed for and serviced her, "enslaved" to her, to her
money, to money itself. After Ramatou's offer of money to the town in exchange
for his head, he goes to the police chief, the mayor, and the priest in the hopes
of enlisting them in his struggle against the death she now makes visible to
him. Their enslavement to her lion-substance, queen-substance, World Bank-
substance, is a foregone conclusion—as it is for the groups of children initiates
seen whirling in pleasure at the amusement park; for the poor, who sing, I would
marry her, right after her initial offer; and for all those who come into Draman's
shop and buy on credit, including his friends, the townspeople, the wives of the
notables, and eventually the teacher and Draman's own wife.

This series of encounters, including Draman's failure to flee by train there-
after, brings Draman face to face with death, that is, with Ramatou's power to
command and his inability to resist, or to enroll others in resistance. After the
sacking of his shop (when the time of the hyenas has begun), he stops trying
to flee from death (which is why the gatekeeper laughs and raises the gate for
his car). As he returns to the Hyena's Hole for the judgment and execution,
Draman circles the hunter three times before going to his fate. If truth is "het-
erogeneous" to opinions, his death is a clear choice to hold to truth and refuse
opinions (75).

If Ramatou is not there simply to seduce them into an evil materialism, if
the "substance" she embodies demands a void that surrounds it so as to give it
definition, then she needs to have Colobane at her feet if she is to play the role
of the queen. And if the queenship she enjoys is that of rule over death, like a
Ramatou bird that has seen the world and returned, then it is so she can look
down from on high over the corpse that is Colobane, or over the scavengers
they've become waiting for her to provide for them.

Betrayal is "breaking with the break that seized you" (Badiou 2001, 80); re-
verting to common opinions instead of challenging them. Did Ramatou ever
break with opinions, or did her break with Draman take the form of an opinion

that value equals money? Badiou establishes the contrast between Evil that is disastrous because of its "absolutization of its power" and the fact that truth lacks total power. Evil names the features of the world, not as opinion does, which is by consensus, but by power. But truth does not have "the power to name all the elements of the situation" (85), and Badiou calls this the "unnameable of a truth" (86). This is the void in the real that can't be named. For Lacan, it corresponds to jouissance. For Badiou political truth has its unnameables, and these are "the community and the collective" (86). "Every attempt 'politically' to name a community induces a disastrous Evil" (86). The *forcing* of the naming has its equivalent in the images at the end of *Hyenas*. Djibril Diop doesn't use the signifiers of speech, but visual signifiers to convey it—and it is modernity, the modern, which he "names" through the work of the plow, the image of the city on the horizon with the sound of the airplane, and finally Gana's overseeing of Draman's trial at the Hyena's Hole. The final work of Ramatou's intervention in Colobane is to effect the changes of modernity that bring to an end the lives of such figures as Draman Drameh, and the hunter who throws away his gun. The "work" we are encouraged to perform by the song heard as the final credits roll is not to resist modernity, but to resist being enslaved in a process in which the only role made available to the community, to Colobane's people, is submission and conformity.

The void in the situation in Ramatou's past is unnameable, but we know enough about its effects, which are inscribed on her body and translated into her great wealth, to associate it with the Great Disaster of the airplane crash. What it made of her, what she made of it, was a body comprised of metallic parts, a prosthesis-being, indestructible, dominant, and infinitely wealthy. The corresponding void in Draman Drameh's life is also seen in its effects where he becomes the one who is resolved to meet his fate before the tribunal of Colobane, one who ceases to defer before others, before Khoudia Lo or Ramatou, or even the community of Colobane at his final trial. His figure assumes an admirable form, and his final disappearance following the crowding in upon him at the end remains unnameable because any attempt to name it would reduce it to an imposed meaning and give it a totality, which Djibril Diop refused to do. This is because he doesn't give us access to the site/sight of what happens to Draman, only to the aftereffect, which is to see that all that is left is his clothes, as if he had been consumed by the hyenas down to the bone—or as if in his sacrifice, like the bull, he is transformed into something other than his body. He disappears, and in that act leaves the void around which is subsequently organized the sequence of images that follow and that connote the onset of a destructive modernity.

At the same time, the ambiguous images of the elephants and the landscape in which they are located set off those of the cityscape that is about to swallow up Colobane within its borders, to make of Colobane a poor quartier of a giant, modern African urban center.

There is no void, no break with the situation in which it is set. Djibril Diop's is the world of the break, and the lament of its loss. Ramatou and Draman

Drameh represent the two sides of that obsession, and somewhere in their difficult meeting and ending is opened up the space that makes possible both the workings of anger, hatred, death, and their counterpart in love.

We have reached the limits of the contours of the truth of *Hyenas*. It isn't community, race, and the red earth of Africa as such that is being challenged, but an African community that is constructed on an exclusionary principle, one that insists upon the rejection of those outside the simulacrum of truth. Soyinka's "the tiger doesn't need its tigritude to pounce" is not a truth of this sort since its address is not to the particular community that relies on the return of the void for its substance. In contrast, Ouologuem's (1968) figure of the Saif who plays at the images of Negritude to insure the perennial subordination of the "négraille" is of a piece with Ramatou's strategies of simulacrum, and of the necessity of the deadly return of the void. Blood and soil are one thing when evoked as an actual truth, whose address is both universal and revolutionary, as was the case of most Negritude poetry, with Césaire, Damas, Depestre, and even Senghor. But the complacent simulacra invoked by Ahidjo, Mobuto, and Idi Amin demonstrated with a viciousness how its conditions of address could turn truth to the instruments of terror and death, while serving the interests of the autocrat.

We can now see how Ramatou differs from Draman. Initially it was he who betrayed her in the name of a petty, materialistic self-interest. He betrayed their love when she became pregnant; he chose to marry Khoudia Lo for money; and he paid the price for this every time Khoudia Lo chirruped at his pusillanimity. He betrayed any sparks of initiative within himself as he sank into the routines of a life he himself regarded as a failure. On Ramatou's return, he adheres to the town's plan to play up to Ramatou for her money, continuing a pattern of deception and hypocrisy, all the more miserable as it was transparent. But from the moment he returns to his shop after his failure to flee Colobane by train, he accepts the necessity to play out the role of one who refuses the conditions of his demise while accepting his place in the community. This is his truth, and it is *evental* in Badiou's sense since he becomes one who redefines what it means to be a member of the community,[7] redefines the importance of the material basis for the community's existence. In other words, he comes to resemble quite closely Socrates who refused to escape from Athens and agreed to accept the judgment of the community as the condition for his sense of the truth (in the *Phaedo*). Draman went to his death like Socrates, he "kept going" (in Badiou's terms), he persevered; he didn't betray the truth, and didn't direct a terror against any others to affirm that truth. This Badiou would identify with fidelity, both in terms of "keeping going," but also in being faithful to what he calls the "Immortal" in oneself.

Ramatou does betray that Immortal, and in the name of a realism that holds in the necessary superiority and domination of the Lion. Her only possible site of a rendezvous with Draman is through the death for which she herself is responsible, that is, through her own responsibility for the return of the void. She

Figure 8.5. *Hyenas:* Ramatoulaye's descent into bunker, looking out at sea for last time.

is not death, then, but she who betrays her own "becoming-subject," that which emerges from fidelity, from keeping going. She has determined that the subject's position is now fixed, fixed into hyenas and lions, and that there is no more need to keep going, to continue. Her descent into the bunker at the end is not fidelity, it is a form of "waiting"[8]—what she had earlier indicated she intended to do in the face of the initial protests of faithfulness to Draman by his wife and friends at the scene where Ramatou initially announced her deal to the town. Her descent does not signal any change, nor even a form of entelechy, a realization of the actual being that she had always already been. In that sense, her correction of the griot's praisesinging at the town hall meeting is all the more telling: she had always been a thief from the beginning, and as a figure for the prostitution of Africa, always a courtesan of wealth as well. Even her child could not sustain its becoming, and died young. Her eyes fixed on the island in the setting sun, she sinks into the betrayal initiated so naively by Draman in their youth, the betrayal that accounts for her ceasing to be a wildcat and having become the Lady of Gold Parts whose arrival announces the complete demise of any truths.

For Badiou truth is announced through the articulation of a vision that eventuates in *changing* the *names* of any situation. The sight of the blank picture or of the empty space in the Dutch paintings must result in a new word for that effect that goes beyond mimetic realism or imitative truth. It must go beyond the Lacanian lack or the Badiouian void or vide. I cannot name it, it lies beyond our ken. But I can reach for its effects in my sense of their work as organizing principles that are themselves, like *objets a*, impalpable, something we can't seize upon, something that only makes possible something else. In fact, they are that which accounts for the fact that every situation has at its foundation its

Hyenas 195

imperceptible opposite that serves as a grounding for its own existence. Thus Ramatou's "Evil" is the foundation of Draman's truth, and it can be evoked not by its nature, but by its effects.

Those effects appear through the naming of the film, and of the times, with the term "hyenas." The process of naming carries its own authority. Throughout, everyone subscribes to a hypocritical vocabulary in describing the gradual process of sacrificing Draman. Draman too uses hypocritical terms at first in addressing Ramatou. But it is she who says that truth is better, and *forces* the truth out of the two castrated witnesses, forces Draman and the others to recognize what they had done. Once that comes out, they turn equally hypocritically to that language of truth to rationalize their betrayal of Draman. And most of all, just as Ramatou has unleashed their greediness and hypocrisy, so too does she impose its qualities on them as signs of their nature. "The reign of the hyenas has come," she proclaims, as though it was in no way the consequences of her own actions. In fact, so *total* is her power to impose that vision of the time of the hyenas that she succeeds in transforming our visual experience of that world, of the people of Colobane, of the figurative shape of the animals, into the world she constructs/evokes. This is the final form of Evil in the film: the evil to impose a total order of naming, made possible only through the total exercise of power. The *hyenas* are those over whom Ramatou rules, and the one foolish figure to stand in resistance to that world is Draman Drameh, certainly the least apparent, the least deserving, the least heroic of figures. Someone Djibril Diop might have held close to his heart *for those very reasons.*

Truth, states Badiou, does not have total power (2001, 85). Its limits lie in its inability to name completely any situation. Ramatou does assign a totalizing name, the time of the hyenas. But truth cannot assign a name to that void that enables words to define that which takes shape around the void. At the end of his life, Draman Drameh becomes the figure for that void in the process of naming; he refuses to speak any last words, and leaves in his place an empty coat, and more importantly, an emptiness in the signification of his death. His emptying out is unknowable, unnameable. He sets off Ramatou's total truth, and sets the stage for the words of the song that appear with the final credits, words that signify such things as carrying on, being faithful to your truth:

> Get up and work;
> Get to work and stop talking;
> Get up and work in the fields
> Get up and work the soil.

Some might take these words as ironic.[9] Far from it: they signify what Badiou means by keeping going, carrying on, persevering. They also signify what resonates most as the inspiration of Djibril Diop's work, a fidelity to that which we have seen in his earlier films as well, and that is a certain craziness. This emerges in Mory's appearance in *Touki Bouki,* his motorcycle adorned with horns, and in the surrealist moments that effect that same break with the real as we see in the excessive, carnivalesque moments and the animal imagery in *Hyenas.* But

Djibril Diop lifts us and carries us along with him, pushing us to ask for more, to insist on more. The music calls out, "get up and work," and we respond not as if to a totalizing vision, but to a special voice that issues invitations and not commands.

9 Toward a Postmodern African Cinema: Fanta Nacro's "Un Certain matin" and Djibril Diop Mambéty's *Parlons Grand-Mère*

So where does Africa fit in? This has been the question since a national liberationist theory of political struggle was developed in the 1960s, when a "postcolonial" order was concocted in replacement of the revolutionary struggle, and when Marxism, feminism, and psychoanalytical theory were deployed in the elaboration of post-structuralism, deconstruction, and postmodernism.

One camp initially sought a reterritorialization of the enemy's tools, so that an "African socialism" or an African womanism came to be posited in response to the original eurocentric ideologies or theories, making the unacceptable acceptable and useful. For other camps these efforts were either artificial (African socialism, ultimately, a state corporate economy, or the failed ujamaa experiments) or inevitably foreign (psychoanalysis usually portrayed as the product of a local Viennese thinker).

None of these objections to "western" theory responded to two crucial points. First, that key aspects of "foreign" thought have traveled throughout history across borders, and have been put to uses as good as adaptive thinkers could devise for them; and secondly, that the borders were never there in the first place, that hundreds of years of intercourse between Africa and Europe have guaranteed a mutual interdependence in the formation of their respective cultures. Local cultures were local only in geographical terms; the discourses that were instrumental in shaping them were marked by outsiders and others from the start. Gikandi (1996) has managed to make this point conclusively in establishing the African component in the development of "Englishness" as well as of European modernism ("instead of reading metropole and colony as oppositions, we should see them as antimonies connected through the figure of modernity" [18]),[1] and more broadly has established the basis for our thinking that there is no such thing as a purely European modernism. Not only was "European" modernism shaped in reference to the "primitive other," of whom an elaborated version for Africa and Africans had to be developed, but the same precise processes occurred in Africa—processes in the development of modernism, as is only now coming to be recognized and celebrated, as with Diawara's (2005) attention to rock and roll, and black and white photography in Bamako in the 1950s and 1960s.[2] This was true with respect to extensive musical cross-

currents, as well as film, clothing, and architecture, and many of the other aspects of culture that generally came to be identified with urban life. Thus when Louis Armstrong passed through Southern Rhodesia in the 1950s, he not only set off a musical and stylistic revolution[3] of copycats and cool cats but also encountered African rhythms and tonalities that reverberated in his own diasporic style (for example, in the rough tonalities of his singing).

Those who have enjoyed economic and political dominance in Africa's past have made sure that for years colonized people were raised to believe that all real culture was imported, foreign, non-African. At a certain moment, it must have become apparent that the Caribbean influences on highlife were not grounded in European musical styles. But as long as the dominant cultural mode was conceived as being shaped *in response to* European models, it remained impossible to see how the very culture against which one inveighed, with its eurocentric tradition, could also have been a product of Africa. Thus, for example, Negritude and later the anticolonial literature of the 1950s and 1960s was conceived of as oppositional. Had it been understood that a dialogic relationship did not exclude oppositionality, it might have been possible to see something of the self in the other, without having to wait for Mudimbe to make these points in his treatises of the 1970s and 1980s, including especially *The Invention of Africa* (1988).[4]

The exclusionary nature of theoretical concepts continues with the present developments of postmodern thought. The more we focus on MTV, or European and American architecture, the more we ignore the possibility that an African dimension cannot be excluded from postmodernism, and more to my point, that the west does not own postmodernism any more than it owns cinema. In fact, despite the calamitous economic structures of ownership in all major economic spheres, despite the prevalence of western commodities and systems of production and distribution, an African cinematic industry continues to be created. Sembène's wonderfully apt term "mégotage"[5] has come into its own as a descriptor of the products of Nigerian and Ghanaian video filmmakers and as a model for the persistence of African cultural production under adversity.[6]

The burden of this chapter is to look at Jameson's monumental study *Postmodernism, or the Cultural Logic of Late Capitalism* (1991), and then to ask how we can approach the question of an African postmodern cinema. The goal is not to hold up Jameson's formulations as models by which to measure the standard of an African postmodernism but, in a sense, to do the opposite: to ask what there is in an African postmodern cinematic practice that both defines it sui generis and also informs the more conventional western understanding of postmodernism itself, as conceived by Jameson, though he does not provide any references to an African set of practices.

This will enable us to see the limitations of Jameson's formulations—the exclusions that mark his theorizing, not only by virtue of absences but also by references to oppositional elements whose nature he ignores—and to see the usefulness of placing a number of current filmmaking efforts in Africa within the context of what we should identify as an African postmodernism.

One might begin, as does Diawara, with Malick Sidibé (Lamunière 2001) and Seydou Keïta (1997), style-conscious photographers who caught the whiff of the cool in Bamako studio portraits. Sidibé's collection *You Look Beautiful Like That* (2001) features dozens of young men and women in various attitudes of stylish modernism. Young men posing as boxers, or on motorcycles, with alarm clocks and radios, with modish suits and fedoras; both men and women in thick-rimmed glasses; women with stylish handbags and suits, and even bathing suits. These photos from the 1950s and 1960s redefine late colonialism, visually attesting to the urban sensibility of a generation that wanted to see itself as participants in a youthful world of cool hipsterism. Diawara's memoirs of the period (especially *In Search of Africa* [1998]) flesh out these impressions of a youth devoted to bebop, rock and roll, and its sequels in the 60s and 70s. But even the earlier Keïta's photos provide us with the details of a modernism that can be read in the less obvious mod stylishness of the Bamako residents, as in the portrait of a young woman leaning on a radio. The gloss on her apparel reveals how every detail speaks to a sensibility marked by close attention to modern style: "A young woman during the 1960s wearing a dress with puff sleeves called 'golf' (*golfu*). Her head-scarf is tilted 'à la de Gaulle.' She has small earrings along the edge of her ears (*nyènyème*), earrings hanging from her lobes (*dyisuuru*), a gold pendant called a bobbin (*dòòla*), a cornelian necklace (*tyaaka*), silver bracelets presenting seven days of the week (*sèmènin*), and a wristwatch" (Keïta 1997, 279–80). Most significant is her calm demeanor as she looks directly into the camera, leaning with both arms on the top of a large console radio, claiming possession of her image as owner of both her appearance and of the features of the sleek wireless box. Its smooth lines, with a tuning-fork image at the center for decoration, are extended by the fine lines of her eyebrows that appear to have been drawn like two large, smooth half-circles. She wears her scarf at a rakish angle, and expresses a beautiful counterpoint between traditionally crafted jewelry and urban dress.

One might find it ironic that the item Jameson (1991) chooses to represent the "waning of effect" in postmodernism is another item of apparel, a pair of shoes. He begins a series of images intended to evoke the passage from modernist expression to postmodern indifference to expression with Van Gogh's painting *A Pair of Boots,* that familiar metonymy of a peasant's hard life—the marker of Being for Heidegger. After showing a couple of pop and surrealist renditions of shoes, with Warhol's *Diamond Dust Shoes* and Magritte's *Le Modèle rouge,* he returns to the gritty neorealist images with Walker Evans's *Floyd Burrough's Work Shoes.* It is easy to define this sequence of paintings in terms of western art movements passing from the earnestness of Van Gogh to the jaded qualities of Warhol or Magritte, ending with what Jameson calls "something of a postmodern emblem: the uncanny, Lacanian foreclusion, without expression" (10). My point here is that we read this sequence differently when we understand that the modern moment was not enclosed within that European-American space that provides Jameson with his "cultural logic," that its frame is also marked by the "blot" or "stain" of what its look excludes by virtue of the framing. Our

Figure 9.1. Seydou Keïta, *Untitled Portrait of Stylish Young Man,* 1958.

turning to the Malian photographers imposes a vision that Žižek (1991) calls "awry," one that tilts the eurocentric out of kilter. The presentation of self and of object, especially object defined by exchange-value, are at the core of this perspective.

Africa's disadvantaged position within Jameson's formulation can be seen at the outset as he defines the current cultural age as one that is built around and on the commodity. The "cultural logic of late capitalism" is the logic of un-bridled consumption—or at least so it seems from the viewpoint of the California suburb or the New York penthouse. Africa too has had its sites of luxury: there were always palaces with their columns, their sculpted doors, and espe-

Figure 9.2. Malick Sidibé, *Portrait of Mlle Kanté Sira,* 1965.

cially their guardians. Now there are neighborhoods, entire quartiers inherited from the colonial period and developed into new, privileged spaces for the very wealthy inhabitants of every major city, where commodity consumption is vastly higher than the subsistence level of the poor. Jameson relies on a comparison to give substance to the extent to which postmodernism has surpassed modernism in all its effects, as if to say that where once "less was more," now more is all there is:

> Postmodernism is the consumption of sheer commodification as a process. The "lifestyle" of the superstate therefore stands in relationship to Marx's "fetishism" of commodities as the most advanced monotheisms to primitive animisms or the most rudimentary idol worship. (x)

What is crucial in this metaphor of the supermodern is how it relies on the same binary opposition that has been employed in the western understanding of self and other for hundreds of years, and that required increasingly an African "primitive other" to provide the basis for the "modern same." Now it is quantity and commodity, the building blocks of capitalism, that would seem to

Figure 9.3. Seydou Keïta, *Portrait of a Woman Leaning on a Radio*, 1958.

require the scarcity and subsistence level of poverty of the other for its under-
standings of self and culture.

Jameson goes on to define the alien presence of the other as constitutive of
capitalism itself, a form of "impurity" in postmodern theory that fails to rec-
ognize its dependence upon and incorporation of earlier modes of cultural pro-
duction in the current forms: "Like capital itself, it must be at an internal dis-
tance from itself, must include the foreign body of alien content" (xii). As long
as the social system remains basically the same, so too will the culture contain
the effects of the older forms, as in the persistence of realism or aspects of mod-

ernism in the self-consciously proclaimed new postmodernist age. But if the division within the self relies on the persistence of the dark, alien other to give substance to the sense of the foreign, to the need for internal distance, then one must ask how the trappings of postmodern culture are to be played out up on Dakar's Plateau, in the quartier of the rich and powerful, where the politics of wealth and control are no longer (and never were) simply couched in terms of the rich Africans adopting European identities. In 1974, when Sembène wrote *Xala,* the Badian (the bride's aunt/surrogate mother) calls El Hadj a toubab for refusing to sit on the mortar on his wedding day, prior to going in to his bride. But she doesn't call him a toubab for wearing suits, driving a Mercedes, or providing her with an expensive house. Already his modernism was that of the *African* businessman, and his consumption was that associated with his status as a member of the new *African* chamber of commerce.

If capitalism requires alienation, alienation requires aliens, and the question to be posed at the outset is where the African fits into the scheme that always ended up with Africans serving as the alien. Rephrased, if postmodernism is built on the cultural logic of inordinate consumption, and if the measure of what is inordinate is given meaning by its distance from African poverty and misery, then how can one account not only for an African form of postmodernism but also especially for an African presence in and redefinition of postmodernism that must now take it into account.

We must begin as always with the commodity as the foundation for the culture, and as we insist on contemporary filmmaking in Africa as postmodern, we must link this postmodernism to the form of the commodity that corresponds to the image in contemporary African film.

The Self-Reflexive Image as Candy

In *Parlons Grand-Mère* (1989), Djibril Diop Mambéty pays homage to Fatimata Sanga who plays Yaaba. Djibril Diop captures a moment in which Idrissa Ouédraogo is handing out cash to the children around the set so that they can buy candy. He tells them he will know if they don't share it with the others, warns them to be good, and then has them applaud his gifts. It is a warm moment, but also one that is resonant of other similar moments when the "big man" demonstrates his magnanimity through his gifts. It is ironized in Ben Okri's short story about political campaigning in Nigeria, "Stars of the New Curfew" (1988), as well as in the actions of the priest in Oyono's *Une Vie de boy* (1956), when he tosses candy to the children, and, indirectly, can be recognized in Soyinka's trope of the "eater of leftovers" in *Death and the King's Horseman* (1975). All these examples are based on a conception of maturity derived from the model of initiation, in which children or noninitiates are deemed incapable of controlling their appetites and are therefore lacking the responsibility of adults. Ouédraogo's warmth and easy collaboration with the villagers who form his cast convey something of the comforting values that inform *Yaaba* (1989) or *Le cri du coeur* (1994). Djibril Diop's film is intended as a commemoration

of those qualities, especially as Ouédraogo draws them out of Fatimata Sanga, the old grandmotherly figure who plays Yaaba, and the two children, Noufou Ouédraogo who plays Bila and Roukietou Barry who plays Nopoko.

Yaaba is a film that presents a scenario that is a familiar one in terms of the Hollywood narrative, that of the outsider who is proven to be right. We see the development of a friendship between an old woman, Yaaba, who lives on the outskirts of the village, and Bila, a rambunctious young boy who resists the general consensus about Yaaba and bravely faces up to the village bullies. When Bila's friend Nopoko falls ill following a fight with the bullies, Bila gets Yaaba to help. Despite the villagers' dismissal of her, she brings a healer she knows to treat Nopoko. Ultimately Nopoko is cured, but Yaaba dies.

Yaaba is the excluded figure of the single woman, so frequently accused of sorcery (as was also the case of Wend Kuuni's mother), and Bila is the disobedient child whose link to the community is preserved by his friendship with Nopoko and his mother, despite his father's strictness and misjudgment. In short, the outsiders are proven to have been right, the community is shown to need the independence and free thinking they represent, and the unconventional type is rewarded and valorized—not the usual message one expects of a film thought to celebrate the supposedly traditional, communal world in which *Yaaba* is set.

Djibril Diop Mambéty's *Parlons Grand-Mère* puts before us two questions concerning Jameson's propositions about postmodernism, leading us to ask how *Parlons Grand-Mère* sets the stage for a form of postmodernism that is off-center, or "awry," with respect to the formulas provided by Jameson. The two key propositions Jameson advances are, first, that postmodernism has pushed to the limit a cultural experience that is distanced from any historicity or historical consciousness; and, second, that it eschews grand narratives, and by extension, metanarrative theoretical formulations.

It is obvious that the grand narrative of historical progress addresses Africa and Europe (or the United States) differently. In *Les Bouts de bois de Dieu* (1960), Sembène set the stage for the African historical project, which was not to see progress, even dialectical progress, as an inevitably optimistic result of the European-African encounter. The novel's title (translated as "God's Bits of Wood," but really meaning "God's Children" in Wolof) was indicative of a claim of solidarity with the struggle of ordinary people. The target of the struggle was given in class terms, commensurate with an anticolonial political agenda. The latter has not disappeared entirely, but moved somewhat to the background, while other leftist authors have attacked the corrupt and oppressive regimes they face at home. Though the erosion of grand narratives has become widespread in the west, these grand narratives can be seen in conjunction with a number of competing, non-grand narratives, such as the feminist struggles over patriarchy, or those involving gay rights or affirmative action. Simultaneously, the impervious borders that delineated the boundaries of the grand narratives have been deconstructed, so that the mutual dependency of center and margin, which each relies upon for their own coherence and force, has undermined the

absolute divisions on which former political commitments were based. This has been translated into filmic terms, whereby the comforting ideology ensconced in realism, and especially realism as the favored vehicle for the elucidation of the historical past and corrupt present, gave rise to the dominance of historical, political, and social realist films. These were films bent on distributing the truth to the audience—an audience presumed to be in need of the truth. In short, this was a magisterial cinema—such as can still be seen in the films of Bassek ba Kobhio—that remained blissfully ignorant of its own phallocentric position, what Lacan called the position of one "censé savoir" (supposed to know). Jean-Pierre Bekolo has expressed his impatience with this cinema, especially when he ironically observes the use of the tag "ancêtres" for the presumed wise elders of that school.

At the end of *The Blue Eyes of Yonta* (1991), the hard questions posed by the post-revolution society—such as, how do we move forward without sacrificing the ideals on which the Revolution was based?—are answered by a dance. Unlike the ending of *Camp de Thiaroye* (1987), where it is clear what history demands of us, *Yonta* ends only with the demand of the young Yonta that she and her age-mates be allowed to find their own answers. The older revolutionary Vincent, now facing a midlife crisis of ethics and age, is shown to be on the edge of a breakdown. He is at the end of the grand narrative of history, and in a sense faces the same tumult of darkness as that experienced by Pays in *Camp de Thiaroye*. The latter's title is significant: the "camp," which signified the full horrors of the Europeans' war, of their civilization, marked the end of meaning, and certainly of faith in progress. Now the camp was relocated into Africa, and if it was intended only as a temporary holding pen for the demobilization of African soldiers, it soon was transformed into what Agamben (2001) (citing Arendt) has identified as the space where "everything is permissible."[7]

The alien presence, or void, within the grand narrative of history proved to be the endpoint of the narrative, just as the encounter with death in the works of Soyinka signaled a fourth stage from which it was impossible to extract meaning. Appropriately, then, it is possible to see in *Parlons Grand-Mère*, and in the short film "Un Certain matin" (1991) by Fanta Nacro, a modest postmodern counterpoint to the monumental battle waged by Jameson, Jencks, and Lyotard against the weight of modernism in western culture. It is crucial that we not lose hold of the fact that the dark space that the concentration camp came to represent for Europe signified a radically different response to historical progress and epistemological meaning from that suggested by the endings of *Camp de Thiaroye* and *Blue Eyes of Yonta*. For the latter two films, it was not simply an issue of coming to terms with the unrealistic expectations of liberation fostered by World War II or African independence, but of coming to terms with a historical frame into which the place occupied by Africa vis-à-vis Europe was always a disadvantaged one.[8] If the concentration camp signaled the end of a certain kind of belief or struggle in Europe, it did not signal such an end for Africa, but rather the end of a historical phase.[9] The very openness this portended for the future could only seem to be conveyed by such works as Ken Saro-Wiwa's

Sozaboy (1985) or Ben Okri's *Famished Road* (1991), where "everything is permitted" has had to be replaced by the uncertain return of the abiko, or by the tropes of the trickster, figures far from the certitudes of the revolutionary hero. Which is why it is Tiga in "Un Certain matin" or the crazy musician in Djibril Diop Mambéty's *Le Franc* (1994) who best convey something of what a postmodernist figure can convey in African cinema.

Nowhere is the challenge to postmodernism in African letters felt more than in the antagonism occasioned by the phrase "free play of the signifier." In cinematic terms, that free play is often understood in terms of its opposition to verisimilitude and plot closure. Thus, for example, the three different endings or versions of *Run Lola Run* (1998) might be dismissed as a useless exercise in the unreliability or constructedness of the narrative, an indulgence Africa in its present struggles could hardly afford.[10] However, we have seen that *Aristotle's Plot* (1996) employs the same device when all the characters are brought back to life, and Cinema and Essomba are carted off by the policeman.

In "Un Certain matin" and *Parlons Grand-Mère* a similar device is employed —one called for thirty years ago by Laura Mulvey in her seminal feminist essay, "Visual Pleasure and Narrative Cinema" (1975). There Mulvey argued, somewhat naively, that until cinema relinquished its insistence on hiding the processes of production, it would remain hopelessly phallocentric. The goal of a truly feminist filmmaking practice, she contended, was to make visible the act of filming, so as not to impose a constructed truth on a deceived or manipulated audience. More generally, the association of the gaze with the imperial position of male domination could not be unraveled without exposing the manufactured processes that made that gaze possible. The hidden camera had to be revealed. Similarly, arguments were elaborated by Stephen Heath (1978), Teresa de Lauretis (1987), and others that the well-constructed, linear narrative, and the project of realism, also served patriarchal or phallocentric purposes, just as Lyotard and Belsey argued that it reinforces the dominant values of the rising bourgeoisie in the eighteenth century.[11] If the simulacrum, the copy without the original (Jameson 1991, 18), best evokes the postmodern figure of a constructed reality, cinema's technique for evoking the simulacrum has been to reveal the presence of the camera. Even more, for Bekolo, the demystification of the process of filming has entailed the evacuation of the cameraman whose empty site is noted at the end of *Aristotle's Plot*. Both "Un Certain matin" and *Parlons Grand-Mère* turn on the self-reflexive move of exposing the act of filming, thus effecting what Jameson has identified as the central gesture of postmodernism, that of restoring the surface to the visual, rescuing it from its dismissal in search of depth (Jameson 1991, 12). Jameson cites Guy Debord who frames this issue in terms of the commodity, where its exchange function has come to supplant its use value: "the image has become the final form of commodity reification" (1991, 18). For us, the same question persists: does "commodity reification" come to take the same meaning in an Africa reeling from the effects of currency devaluation, restructuring ("la conjonction"), and massive debt repayment, as for those countries in which the real effects of these phenomena are not felt, and

where there is virtually no knowledge of these consequences abroad. In short, what is the effect of making known the simulacrum in Africa—the question central to "Un Certain matin" and *Parlons Grand-Mère.*

"Un Certain matin"

In "Un Certain matin," Tiga starts out his day unluckily. He first stumbles over his left toe, a bad omen. Next he trips over a black chick and kills it, another sign of bad luck. Now he is worried, and sure enough the sound of an owl greets his ears: three bad signs, a clear indication of trouble to come. We are introduced to the "superstitious" African, as Tiga's neighbor puts it, laughing at his fears, while from the outset the camera anchors us in an African real. The film's establishing shot is of the village. There is no camera motion: the village as site of the "African real" is furthered by Tiga's physical encounters and reactions, with close-ups of his stubbed toe, his pain and fear, the camera's lengthy close-up on the bloodied chick. Further solidifying this imaginary real, Tiga's manner reinforces the surface impressions: he inclines his head and returns greetings (signifying "traditional" through word and gesture), as we see in his responses to his friend Kouba who asks his advice about farming. His advice is "solid" in two ways: it is sensible, and it is geometrical (sowing a square field is better than sowing a triangular-shaped field, he states, because it gives the crops more air). He is established as a respectable and experienced farmer, despite being given to "superstition." He is also an artisan who goes to his fields to fabricate chairs— a solid builder of real objects. The "real" is thus pieced together, like his chairs: simply, tightly held together by cords *that we see him tie,* putting the chair together as one puts a film together, piece by piece, shot by shot, scene by scene. Further, he cites the three signs of ill luck and asks what misfortune awaits him: the constructedness of his fate thus is offered as a parallel for the constructedness of the narrative.

The camera shows him employing tools to cut wicker sticks used for the chair, and it focuses on the cord that he has soaked. It immerses us in materiality. As he puts the chairs together, we first hear the cries of a woman, which distract him from his tasks. One level of the real intersects and interferes with the other, and he is vulnerable because all he can see is the first level of the real. He continues tying the cord and putting the pieces of the chair together, the initial screams having stopped, as if the intrusion of that other world—with competing versions of the real, the imaginary—couldn't pierce his defenses. But then the cries and a man's angry voice return, and he has to get up to see what is happening. In *his* reactions to what both he and we hear, we are led into his world, his own symbolic universe. He initiates a reading of the events and sounds, and we follow him.

The presence of the two worlds to each other is not yet postmodern. Rather, it appears conventional and linear, and the three magic forebodings of something wrong appear either to have been forgotten by Tiga, or are being realized on a higher narrative level, without his being aware of it. He goes for his gun,

Figure 9.4. *Un Certain matin*: Tiga weaving back of chair.

and as he reaches the tree on whose branch it is hanging, the couple cease fighting and walk back to where they came from without a word: "A quoi ils jouent" [what are they playing at], he asks, unwittingly punning through the French subtitled verb (*jouent* equals play, in both senses of "play" and "act"). Tiga returns to his chair, looking over at them. Then we have a middle shot of him preoccupied with the cords and the wicker sticks as he puts the pieces together again, reaffirming the neatly tied-up symbolic order in which he has his place. We hear the sounds of birds or insects as we look directly at him through the weave of the wicker that takes the form of the chair's backing. He reaches one arm around the back of the chair to hold a piece in place. The other arm is seen partially hidden by the chair's back, while his face is obscured by the tops of the wicker stalks that he will have to trim in order to finish off the construction. The pieces are being lined up, but lack the "points de capiton" (upholstery tacks)[12] to finish the job.

There is a close-up of his hands reaching inside his shirt for a kola nut. Has he finished or is he only resting? We see only the close-up of the hands—a material real that insists on its presence. Then a middle shot that allows us to see him seated comfortably, looking over his handiwork in another chair. He resumes his place of work, returning to tie in place the remaining wicker sticks, and the cries return again, persistently, the woman running and calling out for help. He jumps down, parts the grasses, and peers at her. We see him looking at her; our gaze is focalized through him, and the shot of her action and countershot of his gazing suture us to him, to his point of view.

Toward a Postmodern African Cinema 209

That is how a film is put together, this film seems to be saying. Editing as a weaving, a tying together; chance actions returning as signs for the viewer to decipher. There is nothing "African" or "European" in this; no history to guide its meaning, to give the events a sense of unfolding or moving toward a goal. At most we can posit in Badiou's terms that this moment constitutes an event that will become for Tiga the occasion to take a real action and to persist in his intervention. All that is lacking is the sense of a simulacrum, a sense that this is not a real event but a setup; or else that it is an external intervention into his ordinary life, which he would be helpless to stop.

He picks up his gun and runs after the couple. We see and hear the screams of the terrified woman as the camera brings us closer, as Tiga is moved from the position of the passive viewer to one who is taking an active role, intervening, participating in the scene. He has crossed into that other world, and so do we as we now see the threatening man beat his machete on the ground, or on the woman's body—we can't tell which as it descends onto an object outside the frame. Then again she is running ahead of him; the madman apparently had been beating the ground in fury. He is off after her again, as Tiga closes in. We hear a shot. The man falls. The woman cries out, "Ouaï, ouaï," a cry of distress. Real distress, one might say, but one indistinguishable from her earlier cries. Then a distinctive voice is heard saying, "Merde, coupez" [Damn, cut]. We see the crew, the camera, the sheets used for lighting.

Then we see the woman holding the man who was shot, crying out his name, "Boureima," as the crew comes running up. Everything comes together with the obvious realization that this was a scene in a movie that was being filmed, and that Tiga had not understood this, that the events and their meaning have to be placed onto another order, that their apparent meaning was only a simulacrum, and that now her grief, which reveals an opposite emotional relationship to Boureima than her apparent fear, is what is genuine. We see what Tiga sees, what he must make sense of immediately if he is to escape. And then we see him running off.

Ensconced in this second reading of the events, this rereading of the real, we are once again drawn in by the camera's gaze, this time by the camera that is not revealed, into believing that this new configuration of the events is what is real—what is "really real." And if this new real, this fulfillment of the ill-starred prophecy is indeed what is real, it is still close enough to the previous series of mistaken perceptions as to leave us with the supplementary notion that the real takes its meaning from an ordering that is given, that is, an editing. Montage replaces fate, and verisimilitude superstitious belief. If not yet a virtual universe, this is at least a self-consciously constructed one, and it is important to ask what role an African symbolic order and imaginary play in this universe.

Of course, there are all the details of the real—the way a solid, material universe is conveyed through the most familiar elements of the village setting: the nosy, laughing neighbor woman, and the fact that early in the morning she is up pounding her mortar; the bad omens, the barnyard elements, the neighborly encounter with the unsuccessful or lazy farmer, the greetings and salutations,

and so on. That this could be a set, that this is a village transformed into a set, or a set into a village, only becomes an issue when we see that the inexplicable actions between the fleeing woman and the pursuing man were just part of a shot, one for which the apparently natural landscape had become the setting, if not just a set.

One could take any piece of this footage and find in it an aspect of an African symbolic order in which a hermeneutic possibility of mining the depth for its meaning becomes possible. And one could just as easily use the moment of the revelation that it was only a shot in a movie being filmed to deconstruct the symbolic order on which that same revelation of truth was grounded, so as to establish the inevitable constructedness of any symbolic order, and the inaccessibility of any real. But that gesture of revelation and realization never takes place in a vacuum: not in a historical vacuum, not in a socioeconomic or cultural vacuum. If postmodernism obeys the cultural logic of late capitalism, it is equally imperative that we ask, "whose late capitalism," or better, "whose perspective of late capitalism?" I believe that such a question makes relevant the seemingly chance event that Tiga is fabricating his wicker chairs in his fields, and that his acts of giving shape to a chair through the materials he has at hand give specific and concrete definition to the notion of reality as the product of a montage. It also reframes Jameson's emphasis on commodities as existing purely for their exchange value as we see here one of those chairs actually being *used* by Tiga to rest in while eating his kola nut. And in fact we don't know if this industrious Tiga has been making them for sale or for use at home. They are testimonies to his solid, creative efforts; to the kind of materials with which a reassuring world can be constructed, even if that world is interrupted, the work left unfinished—even if their solidity must soon give way to a shifting, uncertain set of signifiers.

Instead of locating this shift in perspective along the axis of modernism, with its self-reflexivity, or with postmodern uncertainty—as if all uncertainties were the same—we might better locate this rapid dismantling of an established and secure order in the contextual frame suggested by recent Sahelian history, in which the establishment in the region was turned on its ear by Thomas Sankara's revolution in Burkina Faso in 1982, and by the deposition of Moussa Traore, the longstanding Malian ruler, overturned by popular protests in 1991 (the year before "Un Certain matin" was made), both events with widely felt repercussions for the region.

Though such readings are certainly too programmatic and limited, they still are not irrelevant for a film that is shot in More, one of the national languages of Burkina Faso, and that represents a mixed-race film crew in the act of creating a lurid scene of violence in a seemingly ahistorical, somniferous countryside. If film can drop out of the sky, and turn everything upside down, so too can the efforts of a decent African man to right a wrong being perpetrated right under his eyes. And it would seem that each would have to be protected from the other if tragedy were to be averted.

The self-conscious reflexivity that takes the form of exposing an act of shoot-

ing a film—or a person—has to incorporate the presence of the African actor, or activist, and his moral compass, in the construction of an African postmodernism. And it will be the absence of this African presence, its conspicuous erasure, that will mark those European constructions of a postmodern virtual reality, as if the revelation of the act of construction, say, of wicker furniture in some Third World sweatshop, inevitably mustn't form a part of the culture of late capitalism. This is what is generally left out or expunged in the dominant notions of postmodernism.

The claim I am advancing here is that Jameson's postmodernism, and postmodernism as generally theorized, is viewed "from above." As Jameson places the focus on the economic basis for culture, it is useful to explore his definition of the "late capitalist" stage on which it is based.

He writes:

> What marks the development of [the term *late capitalism*] . . . is not merely an emphasis on the emergence of new forms of business organization (multinationals, transnationals) beyond the monopoly stage but, above all, the vision of a world capitalist system fundamentally distinct from the older imperialism, which was little more than a rivalry between the various colonial powers. (1991, xviii–xix)

This definition virtually ignores the view of the system from the point of view of the colonized who experienced their relationship with the colonizers, as well as with their own internal market systems, in terms that had nothing to do with the Europeans' rivalry with each other. Jameson returns to his definition a few sentences later, and brings in issues involving the colonized, or as we would now say, the postcolonial populations, but again in a fashion that reflects the eurocentric perspective with which the definition is cast:

> Besides the forms of transnational business mentioned above, its features include the new international division of labor, a vertiginous new dynamic in international banking and the stock exchanges (including the enormous Second and Third World debt), new forms of media interrelationship (very much including transportation systems such as containerization), computers and automation, the flight of production to advanced Third World areas, along with all the more familiar social consequences, including the crisis of traditional labor, the emergence of yuppies and gentrification on a now-global scale. (1991, xix)

Without belaboring the obvious and taking apart each point, one can easily see how the problems of the *flight* of production are seen from the point of view of the west, how the *emergence* of yuppies and gentrification, the *crisis* of traditional labor, and so on are generally seen as those of the west. The objects being produced in a globalized economy, or in Jameson's terms, that of transnationalist capitalism, look enormously different when they go on the market as $7 polo shirts that sell at Wal-Mart as opposed to Tiba's wicker chairs made for local market consumption. The problems of production and debt look different to those living in wealthy and poor countries, and when those problems meet, as, for example, in the production of cotton in Mali or Burkina Faso, they invariably entail an extraordinary imbalance in power and benefit. We can see

this as the wealthy countries, such as the United States and Europe, continue to retain the right to subsidize agricultural products, thus underselling local production in the Third World, while at the same time those same Third World countries are prohibited by conditions imposed by the World Bank from erecting trade barriers to protect their own farmers. And since the west is not obliged to borrow from the World Bank, western countries can and do erect trade barriers against cheaply imported Third World products. In short, the *crisis* from which Africa suffers is greatly influenced by western economic structures and powers, and is not experienced the same way in the west.

In "Un Certain matin," there are three objects for us to consider in terms of this large market structure. The first is the chair, a locally produced product for home or local market consumption. The second is Tiga's crops, whose nature is not stated. We could take cotton in the Sahel as an example of a crop whose local market value has been depressed to the point of rendering it almost worthless, and we could extend that sad example to coffee or cocoa, or other cash crops.[13] At best, the market offers uncertain returns to the African farmer; at worst, no return at all. Finally there is the film itself, the film we see in "Un Certain matin" being shot by a minimal, skeleton crew. The shot we witness could be part of a European production that panders to popular western representations of savage Africans; it could be part of a production of a popular film, in the manner of many current video films. The director, or cinematographer, is French; the market for the film is uncertain. Let us conclude that it most likely will resemble one of those African films (not unlike "Un Certain matin" itself) destined for the film festival market, with some educational or niche art house showings. In that case, we can consider it to be in the same relationship to the dominant commercial cinema being shown in the capital cities of Africa, and the rest of the world, as the crops or chair would be to the $7 polo shirt at Wal-Mart. We can't consider only those objects produced by the transnational corporations in our understanding of the culture created in a postmodern fashion without replicating the point of view for which only western interests are of concern.

At the heart of any postmodern cultural analysis there lies a critique of capitalism. It has shifted slightly in vocabulary terms from "late capitalism" (the term Jameson [1991] analyzes on pages xviii–xix) as having evolved from its earlier Marxist/Frankfurt school usages, linked to state capitalism and imperialism, to a notion increasingly distant from *state* configurations to "multinational," "transnational," and, since the publication of Jameson's text in 1991, "globalized" economies. We may now well be into a period of postglobalization, with the violent struggle among retrograde forces of American unilateral hegemony, its collaborating economic entities like Halliburton, and those multilateral, multinational, outsourcing companies like Nike or Wal-Mart and Shell Oil.[14] As usual, the rules of globalization, like the earlier rules of late capitalism, have meant one thing for the dominant western economic powers, and another thing altogether for Africa. And at the same time, both have been engaged in the same economic system, because the west has shaped the rules through the World Bank and the IMF, has imposed structural adjustments, and then has

restructured its rules as catastrophe has followed catastrophe, as debilitating debt has followed loans intended to foster development, and as African sovereignty has been eroded. All of this imbalance of power and wealth has meant that while Africa and Europe are dancing to the same tune, the African dance has taken the form of desperate young and middle-aged men seeking by any means to get into a fortress Europe or United States for any kind of job, with the Europeans responding with a greater degree of xenophobia than at any time in their history.

Thus, when Jameson writes that the new version of late capitalism, on which the concept of postmodernism rests, is "fundamentally distinct from the older imperialism" (1991, xix), it is clear that this is a vision of difference as seen only from the top down. From the point of view of the Katangese people living near and working in the mines of Mbuji-Mayi,[15] there is virtually no difference in their lot from the times of King Leopold to that of the present day De Beers or Zimbabwean generals who now own and run the diamond mines. The wealth still flows out of East Congo, the inhabitants are still driven in one way or another to furnish the labor that will provide the raw goods, and their lives are frequently marked by their impoverishment if not desperation.

We can't look for postmodernism in Africa in terms of an economy of wealth, and the wealthy in Africa have done very little to promote a new and vibrant form of African culture.[16] Our concern is with the sectors Karin Barber and her collaborators in her volumes on popular culture have done such a splendid job in analyzing,[17] precisely those areas bypassed in the Jamesonian or Lyotardian conceptions of postmodernism. These are not sectors that have been immune from the cultural productions in the west or elsewhere—where else in the world have popular audiences learned to sing Hindu love songs from Hindu romance films *without knowing the language*?

In fact, the "new international division of labor" has yet to come to African shores. The old patterns of emigration to wealthier countries have only grown more dramatic as the pathos of Africa's dysfunctional states and economic systems has deepened. But this has not stopped the production of culture or the pace of cultural exchanges on which the foundations of the African production of modernism and postmodernism have been based. If in some sectors, like those involving raw materials, agriculture, heavy industrial equipment, and arms, the basic nature of the flow of goods and wealth has not significantly altered, in other sectors, like literature, music, art, and film, there has been radical adaptation, change, and meaningful production.[18]

Rather than lamenting the failures of serious African filmmakers to create or sustain an indigenous market (something video filmmakers have now proven untrue), we might rather view African *independent* filmmakers as resourceful and successful at making films under conditions of economic duress. The measure of success might be seen in the continued output of significant films (whatever the markers needed to sustain them), rather than in the box-office receipts.

The scale of a globalized capitalist system upon which Jameson and Lyotard wish to build the scaffolding for a new cultural paradigm—requiring the

investment in billion-dollar megahotels and skyscrapers, MTV programs, and Hollywood blockbuster film projects, along with the Information Technology revolution—only serves to define one sector of what ought to be termed global postmodernisms. When it comes to the "disposition of the subject" (Jameson 1991, 9), we can see how both Fanta Nacro and Djibril Diop Mambéty (here, in the two films under consideration, along with Bekolo in *Aristotle's Plot*) have evoked the same qualities as those adduced by Jameson in his deconstruction of the older, expressive models of realism.

Jameson signals what he calls the "virtual deconstruction of the very aesthetic of expression itself, which seems to have dominated much of what we call high modernism but to have vanished away . . . in the world of the postmodern" (1991, 11). Key to our study is the notion that this deconstruction enables us to turn our attention to something we can call a surface, whose visibility returns once the preoccupation with depth and meaning has been dislodged from its privileged position. Nothing draws us more strongly *into* the characters' world and motivation than cries of pain and anguished appearances. Jameson describes how the aesthetic built on this model automatically implies the priority of an inner space that is projected outward in expression:

> The very concept of expression presupposes indeed some separation within the subject, and along with that a whole metaphysics of the inside and outside, of the wordless pain within the monad and the moment in which, often cathartically, that "emotion" is then projected out and externalized, as gesture or cry, as desperate communication and the outward dramatization of inward feeling. (Jameson 1991, 11–12)

As we have shown with "Un Certain matin," the moment that expression is received by Tiga, he interprets it, places it within a schema (man abusing woman), and acts. And the moment it is revealed to him, and to us, that this was merely a shot in a film, its inner reality evaporates, and along with it our automatic tendency to construct a symbolic order, to establish meaning and motivation as though meaning and order were natural givens and not constructs of a constituted order.

For Jameson, the "poststructuralist critique of the hermeneutic" (1991, 12) is to be generalized into the repudiation of the four models of depth: the dialectical one of essence and appearance; the Freudian model of "latent and manifest"; the existential model of "authenticity and inauthenticity," or "alienation and disalienation"; and, finally, the opposition between "signifier and signified" (12). In all these cases, "depth is replaced by surface, or by multiple surfaces" (12). Jameson would have the older "monadic" models of expression (as in Munch's painting *The Scream*) collapsing as the postmodern sense of the subject's "fragmentation" has replaced those modernist visions of the subject's alienation. In "Un Certain matin," the first image of the woman's fear is replaced, on the level extradiegetic to the first, by a second image of her grief and concern. But the second set of images cannot escape the effects caused by the exposure of her dissembling in the first, and we become, if not suspicious, at

least aware that we are watching her act for us—aware of our gaze and the camera's work in presenting her for our gaze. Her emotion is inevitably strained, and with it our propensity to explain it by analyzing her character and situation.

Where Jameson turns to nostalgia films, pastiche of a stereotypical past (1991, 21) and the simulacrum, we turn to the image of film as constructed under African conditions of production, under the sign of *mégotage* (this is Sembène's term for the piecing together of African films, as though from cigarette butts [*mégots*]). It is mégotage that distinguishes the African postmodern from the more expensively produced, sleek models that typically serve as Jameson's or Jencks's (1986, 1990) examples of the postmodern (the fabulously expensive, ultimately embodied for Jameson in Portman's Westin Bonaventure Hotel in Los Angeles).

Thus, it is not only the revelation of the act of filming that gives a postmodern sensibility to "Un Certain matin," but the particular vision of that act of filmmaking. The film does not end with Tiga's flight and the knowledge that he shot an actor; the specific local process of filmmaking here (as in Juan Carlos Tabio's *The Bicycle and the Elephant* [1994], Mambéty's *Parlons Grand-Mère*, Bekolo's *Aristotle's Plot*, Sissako's *La Vie sur terre* [1999], and Diawara's *Bamako: Sigi Kan* [2002]) is crucial. And at the same time, it is only indirect and to be inferred since the "actual" filmmaking process that we see represented in the film is only virtual. Still, it is not the verisimilitude of that representation that will serve to define an African specificity—such a claim is far from this or any other pretension to a postmodernist cultural sensibility. Rather, it will be in the constitution of a symbolic and imaginary order, not in a real, or adequation of a real, that the specificity of an African cultural text will be sought.

As Tiga runs off, a voiceover proclaims that one should always be on one's guard over thorns that lie in one's path, and the next shot gives us the sting that follows the thorns as the police show up in the village and propose to cart off Tiga's wife. The villagers gather together in the crisis, and commentaries are heard—the action returns to a familiar set of images, those that speak for the communal voice, conveying not just concern, but a familiarity that reassures the viewer that she is in touch with the normal world of everyday life again. After the "event," we have the attempts to restore the world as it was, to avoid the challenges posed by the interruption. Even the appearance of the police accomplishes this, as does the presence of the whites among the film crew. At the hospital, in the city, the doctors operate on Boureima while a worried woman, his co-actress, paces up and down. Tiga's son tells his mother he knows where his father is hiding and that he will go to him. His mother warns him to be careful: many dangers await him. Nighttime and anxiety in the city, danger in the bush—the norms of the cinematic real. Pan down a tree trunk: Tiga sits looking helpless and worried. Crosscut: The doctor emerges: good news, Boureima will live. Crosscut again: Tiga's son shows up at his father's hiding place, under a tree. He sits next to his father and asks him, "Baba, le cinéma c'est quoi?" (Papa, what is cinema?) Music comes up. We see men loading trucks marked "Information,

culture, cinéma," and a voice sings, "Cinéma, cinéma, cinéma, c'est quoi" in French and with More words, without subtitles.

The answer, in the song, is perhaps there for the More speakers. But those of us who are not More speakers can take the song, and the boy's question, as the final indicator that the answer, whatever its form, will be found in our awareness of the production of those images we have just seen. The process has been demystified by the audience's exposure to the film crew, and even to their vulnerability. After all, if thorns lie in Tiga's path, and if his mother advises Tiga's son to watch out for the dangers that await him, it is Boureima who got shot, and the lurid scene they were shooting presumably goes unfinished. On the other hand, this film that asks the question about itself is clearly finished, finished on a musical note that tells us that "African cinema" need not be composed of the lurid and violent scenes of men chasing and beating women, but of the everyday, the inconclusive, the *uncertain* that interrupts the routine and so brings into the break of day the sense of "un certain matin," the break in the norm.

It is very difficult to convey the feel that is given by the shots in the village, and the tonality of the singing voice at the end, yet it is in their codes—their *rendu*—that the familiar is evoked and shared. For much of African cinema, the comfortable feel of a singing voice establishes the mood and presence we have come to associate with key moments or denouements in African films. It can evoke that whole body of the wise, old, traditional African world often joined to the elders or ancestors, or other conventional signifiers of African wisdom, as in the voice of the griots. But it is also often in that private space of Wolof or pidgin English, or, as in this case, More, mixed in with French. What is striking here is that we don't take away from this film a nugget of African *sagesse* about life's unpredictable uncertainties or hardships, though these form the substance of both stories, but rather an overwhelming determination to expose the act of filming, and thus to demystify it. At the same time that its powers, like those of Tiga's gun, Boureima's machete, and the police are shown to be impotent in the face of their limited knowledge and scope, it is the son's question that gives us our final direction, telling us that the place to begin is with a self-reflexive interrogation over our own relationship to what we have seen—a relationship that has received the familiar images and that is responsible for developing an awareness of a new level of consciousness so as not to remain trapped within the familiar world by an all-too-predictable script.

This film thus answers Sembène's *Borom Sarret* (1963), which can only ask "where are we going with this independence," and not "what does film have to do with this question," "what does filmmaking and film viewing have to do with an African society and its issues." And more, "what does film have to do with our sense of the normal and the processes that collaborate in its construction." For Sembène, ideology remains completely external to *Borom Sarret*, it "directs" its meaning and thus functions so as to provide the tools for extracting meaning from the film. Fanta Nacro's little masterpiece of only about fifteen minutes succeeds in conveying as fully as *Borom Sarret* the sense of an African

environment informed by struggle and the vital questions that face a society in mutation. But it succeeds in getting beyond the limitations of realist representation that carry with them the ideological burdens of a familiar reality, that is, that replicate the underpinnings of what constitutes the basis for a symbolic order and thus its dominant values and phallocentrism.[19] I take this as the start for an African postmodernism in the sense that it subverts the constitutive devices conventionally employed in the construction of the school of filmmaking that was engendered by Sembène.

Parlons Grand-Mère

For Jameson, the ideal image that represents the notion of inside/outside, that is, of affect that moves from one's inner being through expression to the outside world, is Munch's *The Scream*. Here we have the last gasp of a modernism in which the inner is writ large on the outer, the vibratory lines of the man's scream now visibly inscribed on a landscape that takes the form of his anguish. Jameson represents this in terms of the individual monad, the boundaries of whose ego, or outer walls, have now moved or expanded to the point of encompassing the entire universe. *The Scream* belongs to a world in which the focus on the individual's angst, identity, and self-awareness is infused with the existential moral imperative to achieve authenticity, the subject often in the grips of emotions or states that emerge when one is closest to or could face death.

Something came to an end when the autonomous subject of such truth was displaced by the deconstructed figure, the hybrid figure, whose most significant trait was not alienation or some notion of one's sense of identity, but a division or difference, *différance,* that brought an end to the binary inside/outside. *Différance* as differing, as self differing from self, deferring the project of a self for-itself or aware of itself, as divided and reconstituted by the relationship with the other, displaces the site of self-awareness onto the in-between relationships implied by the act of enunciating, its locus marked not by subjectivity, but a sense of subjectivity along with "objectivity" or otherness. This is Bhabha's Third Space, that of neither subject nor object, nor any combination of the two. It is not indefiniteness or ambiguity, as in some vague understanding of postmodern relativity, that is at issue here,[20] but a relationship between/within the subject as self and other that brings an end to the individual as monad, to the relevance of the self-anguished cry of the monad that ultimately is expressive of an ego grounded entirely in what Lacan called misrecognition. This is more than what Jameson called the fragmentation of the subject (1991, 19) as the mark of the postmodern displacement of the modernist alienation of the subject. If we consider rather the subject as a deferred space always constituted in relation to the other, we can see how the repetitions of the narrative possibilities for E. T. and Cinema in *Aristotle's Plot* (1996), as for Lola in *Run Lola Run* (1998), succeed in presenting this new postmodernist sensibility.

"Répétition" is French for rehearsal. Djibril Diop Mambéty constructs "Parlons Grand-Mère" out of a series of shots usually centered on rehearsals for

Idrissa Ouédraogo's *Yaaba* (1989), creating a film that is emotionally in harmony with the characters and sensibility of the film, and yet formally completely at odds with it. *Yaaba* belongs to the genre of social realism, and especially a social realism that relies on the exploration of psychological types within a context conventionally dubbed "traditional Africa." We see almost nothing to suggest the existence of an urban space at the time in which *Yaaba* is set; no historical frame, no sense of a world inhabited by states that might intrude or have once intruded, or will ever intrude on the closed world in which *Yaaba* is set. The "inside" is the world of the village, and its frame is the surrounding landscape. The "outside" is what is beyond, as in what lies beyond the river. In contrast, *Parlons Grand-Mère* establishes the setting at the outset as Ouahiguiya, the time as the present moment, and the action as the act of filming *Yaaba*. With its loudspeakers, trucks, mobylettes, bicycles, clothes, mixed racial crews, and above all display of filming equipment, we are situated in an immediate present that corresponds with the time of the filming of *Parlons Grand-Mère* itself.

The issue of inside and outside is correspondingly shifted away from the world of the village versus the outside world, or versus the inner world of the problems of the individuals in that community (especially Yaaba, Bila, and Nopoko, and their relations with the rest of the village), to the inner space of the film itself, that is, to its diegetic space, and the extradiegetic world beyond the diegesis. This is represented by the continual *re-presentation* of shots from *Yaaba* (some looking like "actual" shots in the final version of the film), rehearsal shots, and finally, and most importantly, shots of the act of rehearsing or shooting *Yaaba*. The diegetic world is, in a sense, not the world of the *story* of *Yaaba*, but of the *film* of *Yaaba*, and the extradiegetic world is that of the *filming* of *Yaaba*. We are almost simultaneously drawn into the two, so that we cannot even separate the "reality" of the film from its being staged, composed, repeated, reshaped, and finally (cut) ended. What appears to be an homage to an old woman, Yaaba (played by Fatimata Sanga), is more an homage to the act of filming, an act that, when made visible, serves more than anything else to deconstruct the line between inside and outside.

A key sequence in which Djibril Diop achieves this begins directly after we see the actors playing Bila and Nopoko seated on the ground under trees, looking somewhat bored. The camera tracks around the trees and their listless figures. They are real children, objects of Djibril Diop's clear interest and affection, full cinematic figures from whom we could expect at any point the behavior of child actors on a set. Then the camera cuts to a framed shot of Nopoko whom we see in the foreground of a shot on location in the bush outside the village, a dirt path angling off diagonally behind her. The moving camera is now frozen as she approaches along the diagonal. We might recognize the shot and location as familiar; indeed, we are at the beginning of the scene that leads to the fight between Nopoko, Bila, and the three nasty boys, one of whom cuts Nopoko's arm with a rusty knife. Then Nopoko moves forward, the camera tracking her path as she reaches Bila and puts her hand on his shoulder, signaling her inten-

Figure 9.5. *Parlons Grand-Mère:* Djibril Diop Mambéty's portrait of Yaaba.

tion to stand with him against the three bullies. The effect of her positioning, set against the framed, backlit scene, is strange: the presence of the frame makes visible the technique of using a previously filmed backdrop for the shot, moving us away from an identification or suturing with the characters and their reality. From the immediacy of the shots with the children that preceded this shot, to the distancing effected by revealing the frame and its backlit scene, we move away from a sense of the real to a sense of the composed and constructed. The children cease to be real children and become real actors, the scene also shifting from real life to the film's symbolic and imaginary orders. We, too, cease observing real children and become spectators, an audience, now aware of our relationship to the images.

The three nasty boys visibly fly at Nopoko from *this* side of the backlit screen, from *our* side, their dark shapes highlighting the fact that they are not located on the terrain of the backlit scene. Then, shockingly, there is a cut to a shot of the upper torso of Yaaba—Fatimata Sanga—in the bush, no longer held within a visible frame in the shot itself, but now shown in the bush that fully fills the frame of the shot, shifting us back to the conventional point of view employed in location shooting, putting us back in "reality." The sound of the flute continues across both shots, tying the filmic real to the on-location real. Further, Yaaba is looking on, staring with interest at the fight we just saw beginning in a studio locale, as we were looking on. In other words, she stands in the location of the reverse-shot in a shot/reverse-shot setup that normally functions to suture the audience to the characters. Only now we are being sutured to a shot

of filmmaking and reverse-shot of "real life" film imagery. The sequence and camerawork function to place the outside and inside of film, the space outside and inside the frame, outside and inside the diegesis, *side by side* in a shot–reverse-shot relationship.

The resulting dissolve of inside/outside boundaries can only be called postmodern. And the music that ties the two shots, familiar sounds in West Africa, and especially West African films, keep us within a symbolic order that is conventionally African, dating back at least to such sound effects in *Wend Kuuni* (1982), another Burkinabe film.

The next shot returns us to the fight action of the film, but with the soundtrack of the solo flute. The visual effect of showing this fight visibly in front of the backlit frame accompanied disjunctively by extradiegetic music has the effect of alienating us from this key emotional moment of action in *Yaaba*. We experience it like editors, aware of its shape, but not involved in its drama. And then, quickly, we return to a middle shot of the full standing Madame Sanga, as the pace of the music quickens. A man, from outside the action of the film, apparently one of the crew (as we see by his dress, which distinguishes him from the villagers) enters, carrying a parasol and camp chair for the aged actress. From cine-action to "real life" action the passage is immediate, as though not crossing any physically real boundary. In fact, the only boundary here is in our own heads, in our positioning of ourselves vis-à-vis what we are observing; and the easy, unobstructed entry of the man into the shot gives us the sense that there is no boundary here to be transgressed.

The camera moves closer as Madame Sanga sits, the voice of a singer comes up, and we see the camera crew setting up for the next shot, which will be that of Bila and Nopoko's discovery of the dead Yaaba. We are being prepared for the transition that deals with the passage from concern over the monad subject, the well-formed character, to the monad film, the well-constructed "African" world (that is, *Yaaba* itself). Filming enables us to make this passage.

The appearance of the crew assistant who courteously supplies the large parasol and camp chair for Madame Sanga transforms the shot of her looking on, seamlessly passing from diegetic to extradiegetic, or, in parallel fashion, from narrative to metanarrative level, as though there were no frame that could mark off an "inside" or separate it from the "outside." The effect is shocking, but only to the extent that the viewer recognizes the shot of Madame Sanga looking on at the fight as actually part of the film *Yaaba,* that is, feels Madame Sanga's—Yaaba's—standing there be to part of the film's diegesis and not real life. With the intrusion of the crew assistant, "real life" no longer has a symbolic support, and the imaginary assumes an equal claim for the states of true and real.[21]

The intrusion of the crew assistant also prepares us for the transition to the next shot, which is that of the crew itself setting up the camera for the final set of takes at Yaaba's death scene. What is remarkable here again is the role of the music, what Žižek indicates as potentially having three possible statuses. The first is that of diegetic music, something that is performed within the space of

the film's diegesis, a good example being the music performed in Djibril Diop's *Le Franc* (1994) or in Sembène's *Xala* (1974), where it functions as more than a motif or background score. In the latter, it is part of the mechanics of the plot that sets El Hadj against the blind beggar who strums his own stringed instrument. Another diegetic example is the famous band L'Etoile that performs at El Hadj's wedding. Conversely, ever since silent film was invented, music has functioned extradiegetically as background for its mood-creating effects. This is sound as accompaniment and not part of the action itself. Lastly, Žižek cites Michael Chion's work where he focuses on the free-floating voice of a singer who cannot be identified, and whose melodies are more assertive than those of the background soundtrack. This Chion calls the "voix acousmatique," and Žižek describes it as "hover[ing] in some indefinable interspace" (1999, 15), a voice whose presence becomes increasingly insistent, without becoming subordinated to the demands of plot or character. In fact, in its insistent presence, it goes beyond the limited logic of the symbolic or the narrative imaginary and creates a space of its own.

Slowly, insistently, unobtrusively, Djibril Diop builds precisely such a "voix acousmatique" into the last seven minutes of *Parlons Grand-Mère*. It is immensely subtle, and in the end generates an effect that can be recognized as a signature of Djibril Diop while at the same time generating something of the particularly Senegalese flavor of the African cinematic postmodern.

As the children are first seen in the fight scene described above, the solo flute becomes the only sound heard. It carries into the cross-cutting to Yaaba standing in the bush looking on, and then back again to the fight that we see being filmed and that she is apparently viewing. This obviously is not part of the soundtrack of *Yaaba* where there is dialogue that accompanies the fight, and the cool, peaceful notes of the flute float completely above and beyond any effects linked to the fight. After the second shot of the fight scene, the camera returns to the image of Madame Sanga standing and looking on, a figure of tremendous silence and dignity, conveying African age without any of the loaded baggage of symbolism. Her presence is a commanding one, and as the still camera holds her figure before our eyes, the slight sound of a strumming kora-like instrument can be heard. The sound increases, the crew assistant appears with parasol and chair, the music continues, and as she sits one hears the familiar voice of a woman now singing in Wolof, in the manner of a praise-singer. Wolof, in Burkina!

In my first viewing of this and the subsequent scenes, I missed what was happening, but when I turned my attention to the music, it became obvious. From here on to the end of the film (including the final titles), the singing and musical accompaniment never stop! And what becomes clear is how the film from this point on is constructing an homage to Madame Sanga precisely as she is seen slipping in and out of her role as actor in *Yaaba*. Thus it is not incidental that the music begins as we see her in a classical posture *in the scene* in *Yaaba,* and that that shot continues with the intrusion of the assistant with the parasol and chair that takes us *out* of the scene in the film. Similarly, the next shot focuses

on the action of the crew as they go about setting up the camera for the shot they are about to film, that of Bila and Nopoko's discovery of the dead Yaaba, while the soundtrack continues with the acousmatic voice and instruments, thus carrying us forward to the shot of Yaaba that is to follow. The praise-singing voice takes precedence, and functions exactly as Žižek would have it: it imposes a presence that rides above the visual, diegetic action—this time the diegesis being that of the making of *Yaaba*. In fact, we can say that it moves us from that level of extradiegesis to yet another level—that which is extradiegetic to the making of *Yaaba* onto the level of the making of the film we are actually viewing, *Parlons Grand-Mère*.

The Wolof singing of a praise-singer is not something that can easily be ignored. It is praise-singing, meaning it insists, it compels, it demands attention. So as Bila speaks to Nopoko, obviously acting in the shot where he is going to touch Yaaba's still-seated body and watch her fall over as he calls out her name, and as we see him pass in front of the crew that is shooting the scene, we remain at a distance from this climactic moment in *Yaaba,* and from the shooting of *Yaaba,* because as is always the case with a praise-singer, her voice commands us to attend to Yaaba herself. It is she, now, and not the children or the filming that matters. And as she is appearing with them, in the act of being filmed with them, it is the figure of Yaaba in this context of the African film about her truth that seizes us.

Djibril makes this plain by interspersing the shots of the filming of this scene with shots of Yaaba walking alone, carrying her calabash of water, followed by a shot of vultures, and then finally by a pan shot of the entire crew assembled next to a large graffiti inscription of the word "YAABA" on an adjacent wall. The music never stops. We hear Ouédraogo coax the boy who plays Bila to add urgency to his voice as he calls out, "Yaaba, Yaaba." We hear Ouédraogo add a note of alarm with a rising intonation in the last "Yaaba"; we hear "Yaaba," see the word "YAABA," and see the woman "Yaaba" in various shots as she takes water from a pot, as her hair is being tressed by Nopoko, as she turns to smile, as she falls over dead in the scene, and as she walks with great dignity, fully dressed this time, to take her place among all the cast and crew for a publicity shot. Djibril brings us a tight close-up of her face. She fills the screen, the music never stopping. She becomes one with her praise-singing music, and as she joins the crew and cast for what we take to be one more shot, Ouédraogo moves next to her and crouches down, chatting and smiling. It is then that we see, for one brief moment, crouched down on the other side of her, the figure of a smiling Djibril Diop. The homage is complete.

Then Djibril becomes the griot himself (the music never stopping), and the fourth and last brief voiceover is heard, the voice of Djibril Diop Mambéty, saying, "L'âge de grand-mère. Elle est née sous la règne d'un certain roi dont nous ne disons pas le nom pour ne pas atteindre à sa jeunesse" (The age of the grandmother. She was born during the reign of a certain king whose name we will not pronounce so as not to reach back to her youth), and he adds, ambiguously, "imagine."

Figure 9.6. *Parlons Grand-Mère:* Djibril Diop Mambéty, Fatimata Sanga, and Idrissa Ouédraogo.

The homage to this "grandmother" is effected in the end by voice, music, and image. But the film is "about" the filming of *Yaaba,* of Ouédraogo's work as a filmmaker, not "about" Yaaba, or Madame Sanga, the actor who plays Yaaba. In a sense, then, the homage becomes a way of "rendering" reality in a physical, acoustic, visual way that rides above the logic of the symbolic code or the imaginary mimesis or simulacrum. Chion identifies "la voix acousmatique" as that which is *rendu*—rendered: "This kind of sound penetrates us, seizes us on an immediate level" (Žižek 1991, 40), exactly like the praise-singing and ultimately the praise-filming. It is accomplished by shots and action that move completely across the boundaries of diegesis and extradiegesis, of inside and outside. As Žižek says of the rhythmic beat in David Lynch's *Elephant Man* (1980), "Here we have *rendu* at its purest; a pulse that does not imitate or symbolize anything, but that 'seizes' us immediately, 'renders' immediately the thing" (1998, 41).

Conclusion

In discussing *The Unpleasant Profession of Jonathan Hoag,* Žižek evokes this amorphous presence of the *rendu* as yet another frame of the real, that unattainable fragment he also identifies with the "sinthome" as opposed to the symptom. Whereas the symptom is part of a coded message whose coherence lies within the symbolic order, the *sinthome* he defines as "the fragment of a meaningless letter, the reading of which procures an immediate *jouis-sense* or

'meaning-in-enjoyment'" (1999, 17). For us, this is the effect of the final praise-singing sequence: whatever messages are encoded in *Yaaba* or even in the meta-narrative about the making of *Yaaba*, there is a point where another dimension of what is experienced as real in Africa asserts itself, asserts its pull over us, without requiring translation into meaning.

Unlike the cinema of Sembène, or even Ouédraogo himself, that of Djibril Diop sits uneasily in the space typically generated by an overtly ideological set of claims. Within the structure of an ideology, the physical pull of the *rendu* compels us to attend not to the symptom but to the *sinthome*, not to the inside whose meaning or significance is translated into an effect on an outside world, one which we can interpret from the safe distance of the viewer or critic. That other, third space Žižek identifies over and over as the Lacanian real—at times through the workings of the *objet a, das Ding*, the *sinthome*, the *rendu*, or simply the void. In the works we have been considering, it cannot be ignored or kept out, precisely because it is what all the work of the symbolic or imaginary processes have been trying to suppress or overcome. It is what is written across the surface of each text as an unassimilable blemish, a face out of order, like that of Djibril Diop beaming out at us among the crew and cast of *Yaaba* in the final shot, or simply the void. Žižek describes this aspect as an effect of a world perceived at an angle, "awry," or a voice that persists in addressing us "without being attached to any particular bearer, floating freely in some horrifying interspace, function[ing] again as a stain or blemish, whose inert presence interferes like a foreign body and prevents me from achieving self-identity" (1999, 15). Lastly, he locates it as something that "irrupts on the very boundary separating the 'outside' from the 'inside'" (1999, 19). And, we might add, the surface from the depth.

If it can accomplish this effect of disjuncture, it must speak in accents that we can recognize, if not assimilate. If it can work its disruptive effects and irrupt in a way that disturbs the frame or boundary, it must be done in relation to a symbolic understanding that requires such frames or boundaries. All imaginary and symbolic constructions owe their coherence to the cultural codes in which they are embedded. Those codes, for us, in terms of the films we have studied, are varieties of African cinema. Those on which I have chosen to focus permitted me to establish tendencies I would associate with the *symptom* and others with the *sinthome*. It is the latter that has furnished us with African perceptions of cinema that can be identified with a postmodern sensibility, one that owes its traits not to the borrowed clothes of the dominant western culture, to a foreign, imported genre, but to its own cultural imperatives, its own images and music, its own capacity to seize us with the force of what is *rendu* in distinctively African terms.

Notes

Preface

1. Glissant puts it succinctly in *Caribbean Discourse* (1989) when he writes, "At this stage, History is written with a capital *H*. It is a totality that excludes other histories that do not fit into that of the West" (75). He adds, later, "One of the most disturbing consequences of colonization could well be this notion of a single History, and therefore of power, which has been imposed on others by the West" (93).

2. For an exploration of the link between "historicism" and western assumptions about progress and civilization as validating the west's historical domination of other cultures, see *White Mythologies* (Young 1990).

3. Although this position has become an accepted principle of postmodernism, the implications it holds for postcolonialism have generated considerable debate. Chris Bongie sums them up brilliantly in his discussion of the debate between Benita Parry, who argues for an "insurgent" agency, and others like Appiah who see in identity politics the consequences of romantic philosophers, like Herder, for whom *Volkgeist* eventuates in modern-day fascist racism. (See "A Glow of After-Memory" in *Islands and Exiles,* Bongie 1998.)

Introduction

1. "African Socialism" became a commonplace for a state-controlled economy, and in the cases of Nkrumah and Senghor who led the advancement of the term, became associated increasing with statism in the former case and neocolonialism in the latter. In no case was a liberal economic system replaced by socialism, and except for Tanzania, in no case did this not engender economic and political dependencies.

2. One of the earlier Senegalese films focused on this problem. It was Mahama Johnson Traore's *Njangaan* (1974), a film that dealt with a young boy from the village whose father confined him to a marabout in the city to learn the qur'an. There the marabout sent the boy, like his other "talibes," out to beg, and in the denouement of the film, the boy is hit by a car and killed. There is a similar subtheme to this plot in Sembène's *Tauw. Njangaan* had a considerable impact at the time as it followed a scandalous event in which a child who was begging in the streets was hit by a car and died.

3. There is a large body of literature on this topic, beginning with Terence Ranger's *The Invention of Tradition* (1983). Frederick Cooper and Ann Stoler's work *Tensions of Empire: Colonial Cultures in a Bourgeois World* (1997), and Stoler's *Race and the Education of Desire: Foucault's History of Sexuality and the Colonial Order of Things* (1995), have gone a long way in establishing a more sophisticated understanding of such terms as tradition and modernity, so as to destabilize the binary and to refocus our attention on the colonial dimensions of the common usage of those terms. Also relevant to the concepts of tradition and modernity are Paul Landau and Deborah D. Kaspin's *Images and Empires* (2002), and Simon Gikandi's *Maps of Englishness* (1996), which follows in the

paths established by Edward Said's *Orientalism* (1978) and Homi Bhabha's *The Location of Culture* (1994). Also see Jean and John Comaroff's *Modernity and Its Malcontents* (1993) and Kwame Gyekye's *Tradition and Modernity* (1997).

4. I explore this limitation in depth in my study of African women's writings *Less Than One and Double* (2002).

5. Sembène parodies the wedding guests in *Xala* (1974) who have returned from Europe and complain about seeing Africans everywhere: they say, "La negritude has really traveled," etc.

6. See my article "*Camp de Thiaroye:* Who's that hiding in those tanks, and how come we can't see their faces?" *Iris* 18 (April 1995): 147–52.

7. The seminal manifesto of Third Cinema is Fernando Solanas and Ottavio Gettino's "Towards a Third Cinema," in *Twenty Five Years of New Latin American Cinema* (1983).

8. I am using the term as Robert Young presents it in *White Mythologies* (1990), in his discussion of Althusser: "Althusser termed such a view [that history rolls forward to a predetermined end] 'historicism': an abstract philosophical scheme that imposes an overall process of transformation upon historical events" (54).

9. This is essentially the position taken by Frank Ukadike in *Black African Cinema* (1994).

10. Cf. Robert Young, *White Mythologies.* Young's argument is extensive. One might cite, for one instance, his account, in the first chapter of *White Mythologies,* of the relationship to the other in western philosophical approaches to knowledge: "In Western philosophy, when knowledge or theory comprehends the other, then the alterity of the latter vanishes as it becomes part of the same. This 'ontological imperialism,' Levinas argues, goes back at least to Socrates, but can be found in Heidegger. In all cases the other is neutralized as a means of encompassing it: ontology amounts to a philosophy of power, an egotism in which the relation with the other is accomplished through its assimilation into the self" (13).

11. Just as Paul Gilroy was to argue that the black political cause could not afford to abandon the goals inscribed in the revolutionary thought derived from the Enlightenment. Cf. *Black Atlantic* (1993).

12. Althusser's classic formulation of the notion of ideology as put forth here appears in his foundational essay, "Ideology and Ideological State Apparatuses." It was published in *Lenin and Philosophy and Other Essays* ([1969] 1971]).

13. This is the burden of Glissant's chapter "The Known, the Uncertain" in *Caribbean Discourse* (1989), that official histories serve to validate those who define what is official. He writes, "[T]he official history of Martinique (totally fashioned according to Western ideology, naturally) has been conceived in terms of the list of discoverers and governors of this country, without taking into account the sovereign beauties . . . that it has produced" (73). He goes on to construct a series of chronologies serving to demonstrate how the landmarks in the one are defined in terms of the relationship to Europe and the other to the Martiniquean black population—the latter being an "other history."

14. Cf. my article on this novel, and the issue of the afterword: "The Marks Left on the Surface: Zoë Wicomb's *David's Story,*" in *African Literature Today* 25 (Spring 2005).

15. Kine establishes her authority in the scene not by belaboring the bank manager but by vaunting her quality as "haut de gamme," i.e., not for the ordinary riff-raff. The

banker is lighthearted as the heterosexual norm remains undisturbed and the first-wave liberationist agenda is advanced.

1. Did We Get Off to the Wrong Start?

1. I might cite the title of the first essay I published on Sembène, "Sembene Ousmane's *Xala:* The Use of Film and Novel as Revolutionary Weapon," *Studies in Twentieth Century Literature* 4, no. 2 (Spring 1980): 177–188.

2. Mbembe gives a definitive statement on the processes of dissolution of the state under current conditions: "[T]he coherence of African societies, and their capacity for self-government and self-determination, are challenged by two sorts of threats. On the one hand, there are threats of *internal dissolution* [his emphasis]. These arise from external pressure, not only in the form of debt and the constraints associated with its repayment, but also of internal wars. On the other, there are the risks of a general loss of control of both public and private violence. This is combined with the persistence of fundamental disagreements on how to conduct the ongoing struggles for the codification of new rights and privileges. The outcome of these profound movements may well be *the final defeat of the state in Africa as we have known it in recent years* [my emphasis]" (68).

3. From the chapter "Toward a Critical Theory of Third World Films," a distillation of Gabriel's opus magnum *Third Cinema in the Third World* (1982).

4. Also cited in "L'Image apprivoisée," in *L'Afrique* 914 (July 12, 1978): 185–87.

5. Gramsci dubs hegemony "manufactured consent," by which he means the ascendancy of dominant ideological thinking in society, not due to force but to the control of social institutions by the dominant classes. This control enables "traditional intellectuals," those who seek to sustain the existing order, to insure the propagation of dominant ideas throughout society. (Cf. *Selections from the Prison Notebooks* [1971].)

6. Althusser's famous definition of ideology is "a representation of the imaginary relationship of individuals to their real conditions of existence." The gist of his argument is that this imaginary relationship is formulated as a response of individuals to being "hailed" or interpellated by social institutions, what he calls Ideological State Apparatuses (ISAs). As an individual responds to hailing, as when, for instance, a university calls upon a student to enroll, to attend class, to behave in class according to its expectations, that individual comes to "recognize" himself or herself as a particular subject, and in that act of recognition, subjects himself or herself to the implicit ideology that governs the structuring of the relationship between the student and the institution. Althusser sees this relationship that emerges from the act of interpellation in Lacanian terms, and thus he terms the student's recognition of himself or herself "misrecognition," that is, an attempt to confer the qualities of the unified subject on one's sense of oneself. (Cf. "Ideology and Ideological State Apparatuses," in *Lenin and Philosophy and Other Essays* [1969].)

7. If Kwame Anthony Appiah had not done such a good job in skewering David Rockefeller in "Is the 'Post-' in 'Postcolonial' the same as the 'Post-' in 'Postmodern'?" I would be tempted to elaborate on the brief prefatory statement made by Hamish Maxwell, the chair of Philip Morris Incorporated, whose words are placed before the table of contents as the first statement on the exhibit encountered by the reader. Suffice it to say that Jameson's contention that high modernism is a function of late capitalism could not have been demonstrated in a better example of this gesture of corporate pride by the

giant cigarette maker: "Philip Morris Incorporated is proud to sponsor what promises to be a landmark exploration of this artistic interaction. The idea of interchange between cultures is something we understand: we deal with people of all backgrounds in the United States, and in 170 other countries and territories." One could say something about secondhand smoke, but when the ironic response lies so close to the surface of the text what would be the point?

8. Arif Dirlik argues that postcolonialism arises with the conditions that marked the onset of global capitalism, that it was global capitalism that created the conditions of possibility for postcolonial thought, that postcolonial theorists enjoy a position in the academy that corresponds to those conditions. For instance, he writes, "Postcoloniality resonates with the problems thrown up by global capitalism" ("The Postcolonial Aura," 521, in McClintock's *Dangerous Liaisons*). He finds global capitalism more fluid than eurocentric capitalism: "This is also the condition of postcoloniality and the cultural moves associated with it" (522). "Postcoloniality . . . is also appealing because it disguises the power relations that shape a seemingly shapeless world and contributes to a conceptualization of that world that, while functional for the consolidation of hegemony, is also subversive of possibilities of resistance" (523). The argument continues, in detail, the ways in which postcolonialism has developed in sympathetic harmony with the exigencies of globalized capitalism.

9. Gikandi is building on Habermas's argument in "Modernity—An Incomplete Project," in which he argues that the project of the Enlightenment to establish a new, rational, and ultimately modern order, as still to be realized, that the events of the twentieth century have "shattered" the optimism around progress to which the Enlightenment had given birth. (Cf. Habermas, "Modernity versus Postmodernity," *New German Critique* 22 (1981): 3–14.)

10. Cf. JanMohamed's argument in *Manichaean Aesthetics*, which bases colonial mentality on these two mirror stage impulses, narcissism and aggression.

11. Here I am working through specifically the divided, alienated nature of this figure as it has been analyzed by Bhabha. For the mirror stage, see Jacques Lacan, "The Mirror Stage as Formative of the Function of the I as Revealed in Psychoanalytic Experience," in *Ecrits: A Selection* (1977). For Freud's work on the fetish, see Freud 1928, vol. 21, 152–57. For Freud, the fetish functions as a substitute for the maternal penis, which the child finds absent from the mother's body. The child wards off fear of what he or she perceives as castration by substituting the fetish for the perceived absent penis.

12. In classical Freudian terms, this is the response to the fear of castration: disavowal, and simultaneously projection of the repressed desire onto an object to which a narcissistic identification can be made.

13. Mudimbe supplies the bridge between Said, Foucault, and Africanist scholarship by his reading of Africanism as a form of Orientalism. What is at stake here is the discursive, textual construction of the world of the Other, and the disavowal or denial of the conditions of production of that discourse, i.e., the colonial relations of power.

14. Among the unfortunate stereotypes Sembène employs we might cite as most unfortunate that of the "Naar" or Moor, portrayed as a greedy shopkeeper, wealthier than his neighbors, exploitative and lascivious. The attacks on the Moors (or Mauritanians) in 1988–1989 were built in part on the resentments that had accumulated over the years, thanks in part to the mechanisms of stereotypes that contained more than a grain of aggression.

15. Cf. Catherine Belsey's clear exposition of this essentially conservative basis for realism in the first chapter of her *Critical Practice* (1980).

2. Sembène's *Xala,* the Fetish, and the Failed Trickster

1. I am grateful to Jeff Wray for helping me see these issues about the workings of film's effects through the mirror and motion.

2. This is Lacan's term for that moment in the mirror stage in which the child takes the "imago," the reflected, ideal image of itself to be the foundation for his or her ego or identity.

3. Žižek defines *l'objet a* as "'nothing at all,' an empty place, a pure pretext whose sole role is to set the story in motion" (1992, 6).

4. See the last section of this chapter and also chapter 5 for further elaboration of symptom and sinthome.

5. This is the label for Sembène Ousmane created by Françoise Pfaff in her authoritative study, *The Cinema of Ousmane Sembène,* in 1984. Since then that label has not only stuck, Sembène himself has commonly employed it in designating the role of the African filmmaker.

6. Gallop's amusing discussion of Lacan the prick occurs in her study *The Daughter's Seduction: Feminism and Psychoanalysis:* "Lacan's practice, in so far as it is traversed by resistances to metaphysical discourse and by irruptions against Oedipal paternalism, is only accessible in an earthier, less categorical discourse, attuned to the register of aggression and desire. Not simply a philosopher, but, artfully, a performer, he is no mere father figure out to purvey the truth of his authority; he also comes out seeking his pleasure in a relation that the phallocentric universe does not circumscribe. To designate Lacan at his most stimulating and forceful is to call him something more than just phallocentric. He is also phallo-eccentric. Or, in more pointed language, he is a prick" (36).

7. Trinh T. Minh-ha has inserted this concern into the voiceover of her film *Reassemblage* (1982) with the refrain "I do not intend to speak about, just speak nearby." Jay Ruby picks up on this theme with his chapter "Speaking for, Speaking about, Speaking with," in his study of film and anthropology *Picturing Culture* (2000). The "shift in authority" with which he is concerned involves "the possibility of perceiving the world from the viewpoint of people who lead lives that are different from those traditionally in control of the means of imaging the world" (196). I am extending that concern in both a feminist direction (Sembène in control of imaging the women's concerns), and an epistemological direction (the director in control of the knowledge needed to conscientize an audience). In this respect I am suggesting that Sembène's need to bring an audience lucidity or consciousness is in contradiction with such architects of Third Cinema as Solanas and Gettino (1971), or Espinosa (1971), for whom Third Cinema or an "imperfect" cinema should engage the audience in the process of analysis, rather than provide the audience with answers to social problems.

8. The conflation of author and character here is intentional. It is the mark, or fold, of the trickster.

9. In turning to Pelton's various West African trickster figures, I am *not* attempting to establish the basis for an ethnographic reading of Sembène's use of the figure, *not* suggesting anything like a direct correspondence between the Akan Ananse, the Fon Legba, the Yoruba Eshu, or the Wolof Leuk. It is rather the broader, semiallegorical turning of a figure, like that of a trope, that provides the structural model of the figure with which I hope to deconstruct the structuralist's reading of the film, and, more broadly, Sembène's own ideological structurations of the film as well.

10. Pelton makes this point further in his analysis of various Ananse tales, suggesting that it is only through disruption that Ananse can advance the cause of order: A [Ananse]

renews by the power of antistructure. His relentless willfulness is not some archaic version of laissez-faire, but a passionate entry into the rawness of precultural relationships to reclaim and restore their potencies, to make them available to new patterns of order" (1980, 50–51).

11. Elizabeth Grosz's definition strikes me as useful: "The representation of *two* sexes by a single, masculine or sexually neutral model" (25).

12. Cf. Lacan's "The Signification of the Phallus" in *Ecrits* (1977).

13. Cf. Laura Mulvey, "*Xala*, Ousmane Sembene 1976: The Carapace That Failed." Mulvey's disclaimer comes at the beginning: "The critical perspective of this article cannot include the 'nuances of folk culture,' or, indeed, other important aspects of African culture and history" (517). There is a certain disingenuousness, however, in her statement in that the essay turns on an interpretation of the role of the fetish, in history and in the film, part of which involves the notion that the meaning of the fetish depends upon the history that explains why the fetish was created as such in the first place. That is, one creates a fetish object for historical reasons, be they socially or individually historicized. Mulvey has no trouble looking for that history both in Senegal's colonial and neocolonial ties to France and in the role El Hadj plays in that world. Her essay is a model of clarity in the exposition of the role of the fetish in the film; but she accepts the history assumed by the narrator unproblematically. In the end Mulvey approvingly cites Teshome Gabriel's interpretation in which the allegorical meaning of the ending, where the beggars spit on El Hadj, signifies the rebirth of African manhood, now made whole through community" (533). Mulvey thus accepts the trickster's function, that of agent of transformation, as successfully negotiated. Derrida's critique of Levi-Strauss, that the center, the presence, implied in structuralist theory erects a phallogocentric order, goes unanswered (see Derrida, "Structure, Sign, and Play in the Discourse of the Human Sciences," in *Writing and Difference* [1978]).

14. For instance, when Serigne Mada restores El Hadj's virility, he twitches and squirms as if his erection were pressing outward toward the camera.

15. Bhabha (1994) gives a perfect description of this position of mimicry occupied by El Hadj. The "*ambivalence* of mimicry," he writes, "does not merely 'rupture' the discourse [of the civilizing mission], but becomes transformed into an uncertainty which fixes the colonial subject as a 'partial' presence" (86).

16. This is classic trickster behavior. "Narr" is a pejorative term for a Mauritanian. However, the stereotyped portrayal of the Mauritanian, visible earlier in *Mandabi*, serves Sembène's comic and pedagogical interests. It too depends upon a shared, secret knowledge: the kind that is grounded in notions of authentic identities and originary thought. For the audience it cements the outer vision of the corruption of the wealthy as built upon the exploiting and destruction of the poor masses.

17. Whose name means scavenger bird.

18. Cf. the passage in which Derrida exposes the same workings of presence and center in the *bricoleur* or mythmaker as in the engineer: "As soon as we cease to believe in such an engineer and in a discourse which breaks with the received historical discourse, and as soon as we admit that every finite discourse is bound by a certain *bricolage* and that the engineer and the scientist are also species of *bricoleurs,* then the very idea of *bricolage* is menaced and the difference in which it took on its meaning breaks down" (285).

19. I am grateful to Lamonda Horton-Stallings for this felicitous phrase, which she employs in her dissertation on the role of the female trickster figure in African American literature and film.

3. Cameroonian Cinema

1. Cf. Manthia Diawara's *In Search of Africa* (1998), in which he develops what seems like a long-term project to evoke that late colonial period in which he grew up, and which was marked by popular western music, dance, and visual arts that were appropriated and integrated into the youth culture.

2. In an interview with Teno, Olivier Barlet records the following comment on modernism: "Je ne parle pas de la modernité telle que la conçoivent les gens dans les rues africaines pour qui avoir une voiture ou un beau costume sera moderne [dit le Camerounais Jean-Marie Teno]. La modernité est toujours associée au système occidental et non comme une forme de progress qui ne serait pas forcément un mimétisme" (100). [I am not speaking of modernity such as the man in the African street conceives of it: to be modern would be to have a car or a nice suit. Modernity is always associated with the west, and not as a form of progress that wouldn't necessarily entail imitation.]

3. There are many studies of the history of African cinema, but the one that best constructs its colonial history is Manthia Diawara's *African Cinema: Politics and Culture* (1992). The important fact to retain is that African cinema was developed during the colonial period, had a particular historical relationship to colonialism, including in particular the pedagogical paternalistic ideology of the 1930s to 1950s, and that it was not until the early 1960s that we are to see the emergence of a true cinema of contestation. During this period, the particular space and audience behavior associated with film showings developed into their own disciplinary modes, ones somewhat at odds with the dominant European colonial practices. At every stage of change in the processes of exhibition, the discipline changed, with truly new practices emerging today with the emergence of video film showings in much of West Africa. Such showings are often scaled to small venues, private homes, where informal exchanges would seem most natural. In any event, the passage from the downtown theater for celluloid film to the quartier house for local video showings is a function of the economic and social changes brought about with the advent of globalized economies.

4. Cf. Catherine Belsey (1980), who analyzes the classical realist text following Barthes, as marked by a number of strategies that function to carry forward the bourgeois cultural project. The result is a closed text that reinforces dominant cultural values by assuming their normativity.

5. Cf. Todorov's useful summary of the relationship between the three first-person narrative positions: "[T]here is an impassible barrier between the narrative in which the narrator sees everything his character sees but does not appear on stage, and the narrative in which a character-narrator says 'I.' . . . Once the subject of the speech-act [the narrator or subject of the enunciation] becomes the subject of the discourse [or *énoncé*] as the protagonist, it is no longer the same subject who discourses. To speak of oneself signifies no longer being the same 'oneself.' The author is unnameable: if we want to give him a name, he leaves us the name but is not to be discovered behind it; he takes eternal refuge in anonymity. He is quite as fugitive as any subject of the speech-act, who by definition cannot be represented. In 'He runs,' there is 'he,' subject of the discourse, and 'I,' subject of the speech-act. In 'I run,' a spoken *subject of the speech-act* is intercalated between the two, taking from each a part of its preceding content but without making them disappear altogether: it merely hides them. For 'he' and 'I' still exist: this 'I' who runs is not the same as the one who discourses. 'I' does not reduce two to one, but out of the two makes three" (39).

6. Cf. Achebe's well-known statements: "Many of [my readers] look to me as a kind

of teacher" (1973, 2); and "The past needs to be created not only for the enlightenment of our detractors but even more for our own education" (9).

7. This might be seen as an updated version of Mongo Beti's *Main basse sur le Cameroun* (1972), and even though Beti is not interviewed in the film, his point of view prevails. He is among those Teno thanks in the film's credits. His specter would seem to be present. In this sense we can acknowledge that same Marxist presence termed a specter by Derrida, in his *Specters of Marx* (1994), a specter that appeals to justice, and whose haunting runs through the introductory chapter of f Gikandi's *Maps of Englishness* as well.

8. Cf. Ukadike's baseline, "From the beginning, the major concern of African filmmakers has been to provide a more realistic image of Africa as opposed to the distorted artistic and ideological expressions of the dominant film medium" (3).

9. In a recent trip to Cameroon, during July 2005, I found that it was less censorship than corruption and economic despair in the face of the regime's "main basse" that currently mark most Cameroonians' concerns. *Le Messager* continues to publish criticisms of the government, but the effect appears limited.

10. See Mbembe (2001), chap. 4, "The Things and Its Doubles."

11. A listserv thread on the topic of the assassination of Felix Moumié was begun on H-NET List for African History and Culture H-AFRICA@H-NET.MSU.EDU on March 24, 2006, and elicited a broad range of responses. The thread can be accessed at H-Africa's website, http://www.h-net.org/~africa.

12. Mbembe analyzes the cartoons of the satirical political journal in *On the Postcolony*, chap. 4.

13. Cf. Irigaray, *Ce Sexe qui n'en est pas un* (1977).

14. Cf. Butler, *Gender Trouble* (1990).

15. Indeed, so much is the written word emphasized in the film, it seems to be its true subject. We learn from the outset that Teno had wished to give the real history of his country with this film because "qui mieux que les écrivains sont les témoins de leur époque?" [who better than the writers who are the witnesses to their age]. He continues, following along the direction of Achebe's famous essay "The Novelist as Teacher," "les phrases révèlent ou déforment la réalité" [reveal or deform reality]. From this beginning we are presented with the words of Célestin Monga and then Pius Njawe who indict the Biya regime with their record of its failure. Then Marie makes her appearance, and leads us through scenes of the various libraries in Yaounde—those of the French, British, and German cultural centers—finally taking us to SOPECAM. This scene bridges to Teno's reflections on the national culture. Following the visit to bookstores, Marie leads us to the *marché des livres,* the sidewalk sellers of books who spread out their titles on the ground—what Teno refers to as the "cemetery of books." There in the market he comments on the foreign dominance of the book trade that brings "la mort de littérature dans le pays" [the death of literature in the country], and with that death the end of thought: "à travers la littérature c'est la réflexion qu'on assassine. C'est la mort de notre mémoire collective—une mort programmée, organisée" [through literature it is thought that is killed. It is the death of our collective memory, a programmed and organized death]. Then he cites a Chinese proverb: "Those who have no past have no present, and can't have a future."

16. In the poem the invading European colonialists are compared with the selfish weaver bird that takes over the nests of birds that have already built their own nests and laid their eggs. The weaver birds push out the native birds' eggs and lay their own, taking over the country, as it were. "The weaver bird built in our house / And laid its eggs on

our only tree / We did not want to send it away / We watched the building of the nest / And supervised the egg-laying" (Diop 1985, 107). In the Maman Caiman story Diop recounts how the mother caiman tells her foolish children a warning story about the fight between two peoples up north. The details of the story clearly indicate that it is a question of the lighter-skinned Moors and the darker Senegalese whose battles had had a devastating impact on the environment of the (native) crocodiles: a story "of the red color of the water after the passing of the white men, who had taught the black men to bow down like them to the rising sun. This exceeding red color of the river had forced her grandmother to leave the Senegal River. . . . " (46). The children are attracted to the tinsel and glitter that represents what the whites brought with them to Africa, and pay the price for not listening to their wise mother.

17. Ça se passe dans un pays où regnaient ce temps-là abondance et prospérité, le pays des alouettes. Un jour d'un pays lointain arrivent des chasseurs, ils sont d'une autre couleur. Les alouettes leur offrent toutes les bonnes choses qu'ils ont dans leur village. Les chasseurs ravis décident de rester au pays où ils trouvent dans l'abondance les choses qu'il leur manque chez eux. Ils disent aux alouettes: nous sommes frères; chez toi c'est chez moi. Tu va travailler pour moi parce que moi en ce moment j'ai beaucoup de besoin. Les chasseurs arrivent de plus en plus nombreux, et continuent de s'installer. Tous les jours, parfois sans manger, sans boire, les alouettes travaillent. Tout le village doit travailler, même les femmes et les enfants. Leur chant n'est plus qu'un plaint qu'on entend souvent très tard dans la nuit.

[This took place in a country where at that time there was abundance and prosperity, the country of the larks. One day from a country far away some hunters came. They are of a different color. The larks offer them all the good things which they have in their village. The hunters are delighted and decide to stay in the country where they find such abundance in things which are lacking in their country. They say to the larks: we are brothers; your home is our home. You will work for me since I need a lot at this moment. The hunters keep on coming, more and more, and continue to settle in, Every day, sometimes without eating, without drinking, the larks work. The whole village has to work, even the women and children. Their song is now only a quiet plainsong heard often late at night.]

18. The sound of the truncheon is another echo-effect: the original soundtrack is suppressed, and the man's surprised expression, the clunky sounds, the repetition of blows and sound, all have the effect of a slightly comic, slightly horrific exposure of some hidden secret. This is reinforced after we were treated to the conventional style of the 1940s and 1950s French documentaries, with their informative, all-knowing voiceover commentaries. The tie-in to reality is reinforced by the inclusion, following the beating of the unidentified man, of footage of Lumumba seen first being celebrated by the masses as he assumed the presidency, and then humiliated by soldiers who stuffed a cloth into his mouth as the young Mobutu looks on approvingly.

19. Note how the opening to Ferdinand Oyono's *Une vie de boy* begins with the same identification: Toundi refers to "us Frenchmen," that is, his compatriots in Cameroon.

20. Another example: a visit to the bookstore of Editions Clé becomes the occasion for the camera to catch the staged spoof of a shoplifting incident where a young boy hides a book under his shirt and sneaks it past the guard at the door.

21. Gikandi begins his argument by asserting, along with Cooper and Stoler, that "the great categories that came to define the modern age—race and citizenship, civility and authority, for example—were haunted, from the start, by the colonial question" (1996, 3). Like Said, he states that "colonized people and imperial spaces were crucial

ingredients in the generation and consolidation of a European identity and its master narratives" (5). Gikandi then argues that colonialism "provided the context in which modern identities were constituted" (9), and that "instead of reading metropole and colony as oppositions, we should see them as antimonies connected through the figure of modernity" (18). Of course, the metropole attempted to define itself through the exclusion of the Other, but rather than reading this as an aberration, Gikandi sees it, as does Said, as fundamental to the constitution of a European, or, in the case, English identity: it attests to the failure to complete the project of colonialism, to its "incompleteness"—a notion Gikandi reiterates. What is striking is how this failure is to be seen in both the African and metropolitan sense of itself as postcolonial, modern, and different: Gikandi reads postcoloniality as marked by "symptoms of a disjunctive moment in which imperial legacies have come to haunt English and postcolonial identities, their cultural formations, and their modes of representation" (19). The argument I am making here is that the cultural formations cannot be isolated; that they both intertwine and construct coterminously those moments we term modernity and postmodernity. As we continue to use the vocabulary of colony and metropole, of alterity and Otherness, our attention must turn increasingly to the spaces in-between these polar extremes, spaces marked simultaneously by both, and in turn definitive. Gikandi sums it up thus: "The times we live in are both colonial and postcolonial times. . . . [F]or both the colonizer and the colonized, the culture of colonialism came to provide the terms in which the idea of a modern culture took shape, both in the metropolis and the colonials. Colonialism was the foundation on which modern (and hence also postcolonial) thoughts, actions, and debates were built" (1996, 226).

22. For Jameson, the postmodern is marked by the disappearance of history, or rather of "history," since the awareness of historical moments as representations has resulted in "the disappearance of the historical referent" (1991, 25). The larger effect is felt in the sense of living in a perpetual present, one in which the postmodern subject is so seized by the present moment as to eclipse any sense of relationship to the past. In this case, we can claim a similar seizure by the moment in the African context, where the subject experiences a radical disjuncture from the governing authorities and their accounts of the national narrative. Reading Jameson in African terms severely dislocates his representation of the postmodern subject, but recasts it back in a postcolonial context in terms that conform to life under the autocrat. Jameson puts it this way: "Cultural production is thereby driven back inside a mental space which is no longer that of the old monadic subject but rather that of some degraded collective 'objective spirit': it can no longer gaze directly on some putative real world, at some reconstruction of a past history which was once itself a present, rather, as in Plato's cave, it must trace our mental images of that past upon its confining walls. If there is any realism left here, it is a 'realism' that is meant to derive from the shock of grasping that confinement and of slowly becoming aware of a new and original historical situation in which we are condemned to seek History by way of our own pop images and simulacra of that history, which itself remains forever out of reach" (25).

23. Its equivalent is to be found in Appiah's (1993) claim that a fundamental humanism guides the protest central to postcolonialism.

24. Tanella Boni evokes it repeatedly in Une Vie de crabe (1990). On the way to the market, the young Niyous marks the life of the quartier: "Elle rampe, elle vole, elle bourdonne. Dans vos oreilles, vos narines, vos entrailles. Oui, ici, la vie colle à la peau. . . . Ici Djomo-La-Lutte, la vie semble avoir été branchée sur du courant alternative, celui de la guerre, celui de la mort, celui de la survie. . . . Au marché de Djomo-La-Lutte, la surprise

n'a pas cours et le reproche ne se vend guère" (12–13). [It creeps, it soars, it buzzes. In your ears, your nostrils, your innards. Yes, here life sticks to the skin. . . . Here, at Djomo-the-Struggle, life seems to have been plugged in to alternating current, the current of war, of death, of survival. . . . At the market of Djomo-the-Struggle, surprises don't usually happen and reproaches are hardly to be found.] As Niyous and his handsome friend enter the women's hairdressers' market, the mixture of surprise, of foods, of cries mingle. "Le marché-aux-tresses est, à Djomo-La-Lutte, un lieu de fête pour les yeux. . . . Ce sont d'abord les cantinières qui marquent leur étonnement. La vendeuse de brochettes fumantes lève la tête, bouche bée. La femme-aux-escargots-frits, contournant un hangar, trebuche sur une pierre et rattrape de justesse la cuvette posée en équilibre sur sa tête. Puis un *pied-plat* file à toute vitesse vers une *natty-tresse* et glisse quelques commentaries au creux de l'oreille. Deux yeux manquant de discretion s'écrient brûle-pourpoint: "Chèèrê! Ton homme." (17) [The hairdressers' market at Djomo-La-Lutte offers a festival for the eyes. . . . First of all there are snack bar sellers who show their astonishment. The seller of smoking brochettes raises her head, mouth wide open. The woman-with-fried-snails, going around a storage shop, stumbles on a stone and catches her bowl balanced on her head just in the nick of time. Then a flatfoot running full tilt toward a braid-weaver slips some comments into the hollow of an ear. Two eyes lacking discretion open wide and she cries out, "Cherieeee! Your man."]

25. In his film *Bamako Sigi Kan* (2002), Manthia Diawara alludes to the destruction of the central market in Bamako as an attempt by the government to regularize its control over the public space. Similarly charges have been made concerning the burning or destruction of major markets in Accra (where the power of the market women was seen as contesting that of the government-supported economic forces) and Dakar's Kermel Market that was burned in 1994, and then rebuilt three years later. At the time of this writing (spring 2006) Dakar's central market, Sandaga, is facing a leveling by the city officials for reasons of safety. It will be replaced by a more "rationalized" commercial center.

26. This is, of course, one of the major points of Homi Bhabha's *The Location of Culture* (1994).

4. From Jalopy to Goddess

1. This is a Dennis Brutus poem from *A Simple Lust*, cited by Ndebele (2002).

2. Gikandi builds on Habermas's point that the incomplete project of modernity derives from the Enlightenment's efforts to develop objective science, universal morality and law, and autonomous art so as to rationalize everyday life (see Habermas 1981). For Gikandi (1996), postcolonialism attests, similarly, to the incomplete project of colonialism (18), just as Englishness is "symptomatic of the incomplete project of colonialism" (9). The link to modernism is seen in the argument that colonialism "provided the context in which modern identities were constituted" (9).

3. See Misty Bastian's brilliant treatment of *ogbaanjes* and Mami Wata as "the water deity who most northern Igbo now suggest is involved with *ogbaanje* births" in her article "Irregular Visitors: Narratives about *Ogbaanje* (Spirit Children) in Southern Nigerian Popular Writing" (Bastian 2002, 62).

4. The version of *Divine carcasse* on which this chapter is based is that distributed by California Newsreel. It is 59 minutes in length, somewhat shorter than the original Francophone version. Loreau wrote me that "en réalité il existe une version longue, de 76 minutes pour 'Les noms [n'habitent nulle part]' et de 85 minutes pour 'Divine.' J'ai du

faire des versions de 60 minutes pour la télévision qui coproduisait les films, versions dans lesquelles j'ai du couper des scènes qui me tenaient à coeur" (email communication, 1 December 2005).

5. "Mégot" (French, cigarette butt); "montage" (French, editing); "bricolage" (French, making do); "mégotage" (putting together a film on the cheap like a cigarette pieced together using butts).

6. I am using the term Robert Young employs in *White Mythologies* (1990) to designate that approach to history as both original and teleological. More specifically, it is the approach developed generally in the west to legitimize a progressivist view of history as one in which the west is the product of historical progress, that history is really History, objective, authorized, official, and designed so as to justify the terms of value, the hierarchies, by whose measure the west stands in the superior position.

7. Cf. Derrida's discussion in *Of Grammatology* (1997) of the metaphysics of presence which underlies western logocentrism (49 ff.).

8. Cf. Soyinka's poem "Death in the Dawn" from which these images are taken.

9. Loreau's Web site link provides all the details on the film's production, as well as her summary: http://www.cfwb.be/av/KIOSK/HTM/films/frecre.htm

DIVINE CARCASSE (1998)

Un film de Dominique Loreau. Docum. fiction—35 mm, 88′, dolby stéréo—bétacam, 59′, coul. Réalisation: Dominique Loreau. Image: Etienne de Grammont. Son: Jean-Jacques Quinet. Montage: André Delvaux. Musique: Philippe Woitchik. Interprétation: Alphonse Atacolodjou, Szymon Zaleski, Fidèle Gbegnon, Simonet Biokou. Production: Underworld Films, Carré Noir (RTBF-Liège), CBA, Office de Radio et Télévision du Bénin(ORTB), Sindibad Films avec l'aide du Centre du Cinéma et de l'Audiovisuel, le CGRI, la Commission européenne, le Plan 16/9, Image Création, l'ACCT.

Le film trace le destin d'une vieille Peugeot qui débarque à Cotonou, au Bénin.

Là, elle passe de propriétaire en propriétaire. On accompagne chaque propriétaire dans sa vie quotidienne: Simon, qui vit dans le monde clos des coopérants, puis son cuisinier, Joseph, qui en fait un taxi clandestin, puis des garagistes, qui tentent de lui redonner souffle chaque fois qu'elle tombe en panne.Jusqu'au jour où, irréparable, elle finit en carcasse abandonnée dans la rue.

C'est alors que Simonet, forgeron sculpteur, en récupère des pièces pour fabriquer une sculpture d'Agbo, dieu vaudou des "gardiens de la nuit," commandée par des sages du village de Ouassa.

Après un long voyage en pirogue à travers les lagunes béninoises, la sculpture devient le fétiche protecteur des habitants d'Ouassa.

[The film traces the fate of an old Peugeot which is brought to Cotonou in Benin. There it passes from owner to owner. We follow each owner in his daily life: Simon, who lives in the world of cooperants, then his cook Joseph who turns it into an illegal taxi, then mechanics who try to breathe life into it each time it breaks down . . . until the day when it can't be repaired and winds up an abandoned carcass in the streets. Then the blacksmith-sculptor Simonet recoups its pieces in order to make the statue of Agbo, Von-don god of the night guardians, ordered by the elders of the village of Ouassa. After a long journey in a pirogue across the *beninois lagunes,* the statues become the protector god of the inhabitants of Ouassa.]

10. Cf. Chion's notion of the "voix acousmatique," which will be discussed more fully in chapter 9.

11. http://www.filmthreat.com/Reviews.asp?File=ReviewsOne.inc&Id=1414

Phil Hall, Dec. 7, 2000. *Filmthreat.* 1998, Unrated, 88 min., Underworld Films. "The

age and make of the Peugeot is, of course, meant to reflect on the final glory years of European colonialism in Africa, which began its inevitable decay in the late 1950s as the African people pushed off the colonial occupation to claim freedom and self-determination. It is not surprising that Simon would rather drive a car that recalls the halcyon days of French colonialism as opposed to a new, sleek car from the US or Japan—some people love to live in the past."

12. E.g., "If there were only stasis, there could be no transformation, and wherever Legba moves, even where he moves away, the transformation that takes place creates a world for man" (Pelton 1980, 126-27).

5. Toward a Žižekian Reading of African Cinema

1. The bullet that renders all arguments over authenticity pointless is that there is no site where one can stand from which to evaluate the authentic. If one is authentic, the only knowledge one could have of it would come from standing outside of oneself and reflexively observing one's authentic being. That model of the divided subject, fundamental to all poststructuralist thinking, deauthenticates any attempts to assert the presence of the authentic, what Derrida terms the "metaphysics of presence." Butler (1990) carries this argument further in her claims that subject identities are performed, that the metaphysics of presence or substance rests conventionally on patriarchal, or, in fact, phallocentric assumptions that function like ideology, i.e., that naturalize, or authenticate, what retains and sustains existing systems of power.

2. Each is defined by the other; the border between them is both shared and separate from them; and we return to the problem of the supplement (see chapter 3).

3. Žižek gives a gloss on the difference between reality and the Real. For this study, when I refer to the Real, it is the Lacanian term, with a corresponding use of the Symbolic and the Imaginary. It is irrelevant whether these substantives are capitalized or not; however, the Real (or the real) is not the same as reality, the difference being explained by Žižek thus: " 'Reality' is the field of symbolically structured representations, the outcome of symbolic 'gentrification' of the Real; yet a surplus of the Real always eludes the symbolic grasp and persists as a non-symbolized stain, a hole in reality which designates the ultimate limit where 'the word fails' " (1992, 239).

4. Cf. Derrida's early, foundational essay "Structure, Sign and Play in the Discourse of the Human Sciences" in Macksey and Donato's *The Languages of Criticism and the Sciences of Man* (1980); and especially *Of Grammatology* (1967).

5. There is a resonance of time and place that distances both texts from contemporary readers, and indeed from the readership at the time of publication. I am not referring simply to the fact that the novels had European publishers, and that the African readers would have typically been educated Africans whose career trajectories led them far from any hometown or village, but that Achebe's Umuofia was a reconstruction of the past that Achebe effected after many conversations with members of the older generation. In Laye's case the reconstruction was viewed through the glass of nostalgia, the effect of which was to alienate many Africans of Laye's generation who were struggling against the political conditions that sustained colonialism instead of tacitly supporting them. See not only Mongo Beti's famous criticism at the time in which he claims not to recognize the conflict-free Africa Laye describes, but Adele King's thorough analysis of the politics of publication of Laye's work (King 2003).

6. Mongo Beti, "Review of *L'Enfant noir*."

7. Here it is Johan Pottier who deciphers the imagery associated with the Rwan-

dan genocide as performing the ideological functions described above, when he writes apropos the images used to capture the genocide:

> The photographer's input mostly goes undetected. Instantly readable, visually and conceptually, disaster images appeal to a vast humanitarian "industry" and public who believe they tell a full and objective story. That images may obscure more than they reveal is not often considered; there may be a reason for this. In the Rwandan context, by portraying Rwandans as helpless victims in need, the west can cast itself in the role of altruistic saviour; a saviour stripped of ambiguity. What this portrayal obscures, though, is the full text, the context. The disaster photographs do not inform on how a Rwandan refugee crisis went virtually unreported for thirty years, how the 1994 genocide in Rwanda related to the 1972 genocide in Burundi and to fears of a repeat genocide in 1993. . . . (2)

Pottier concludes that these images were motivated by the desire of the Tutsi Rwandan government to produce a certain image of the events and of the world community to view such events (3). "Context" thus supplies the key to the missing or hidden message that can be read in the absences that give definition to the images. Thus is the reading based on the "full text."

8. Žižek's gloss on the Lacanian employment of "The Thing" points to the relationship between the Real as resisting symbolization and the Thing as the impossible element that makes possible signification: "the Real resists symbolization, but it is at the same time its own retroactive product. . . . Lacan . . . affirms enjoyment as 'the real Thing,' the central impossibility around which every signifying network is structured" (1999, 41). Mladen Dolar glosses the term as follows: "[it denotes a] massive non-transparent presence; it is endowed with sublime and lethal materiality; it is the evocation of what Lacan (following Freud and Heidegger called *das Ding;* [it is] the object of the drive, the presence incorporating a blockade around which all the relations circulate" [Žižek 1992, 46]). Finally, Evans gives definitions of *das Ding,* following Lacan, as "dumb reality," "the thing in the real, which is 'the beyond-of-the-signified." "[It is] entirely outside language, and outside the unconscious" (Evans 1996, 205).

9. Benjamin Ray spells this out over and over. "[T]he concept of inversion [in African cosmological accounts] is important, for it explains the world in dialectical terms as the relation between two opposing spheres: order/disorder, cosmos/chaos. Whether the original state of affairs is conceived as cosmos or chaos, *it is always the opposite of the human situation*—hence it is sacred or divine" (1976, 38; my emphasis).

10. Cf. Laclau and Mouffe: "Sedimented theoretical categories are those which conceal the acts of their original institutions, while the reactivating moment *makes those acts visible again*" (2001, viii; my emphasis).

11. What Althusser calls Repressive State Apparatuses (RSAs), like the police, as opposed to Ideological State Apparatuses (ISAs), like the Church or educational system.

12. "According to the understanding of identification as an enacted fantasy or incorporation, however, it is clear that coherence is desired, wished for, idealized, and that this idealization is an effect of a corporeal signification. In other words, acts, gestures, and desire produce the effect of an internal core or substance, but produce this *on the surface* of the body, through the play of signifying absences that suggest, but never reveal, the organizing principle of identity as a cause" (Butler 1990, 136).

13. "First, there is the split within ideology 'in-itself': on the one hand, ideology stands for the distortion of rational argumentation and insight due to the weight of the 'pathological' external interests of power, exploitation and so on; on the other, ideology resides in the very notion of a thought not permeated by some non-transparent power

strategy, of an argument that does not rely upon some non-transparent rhetorical devices. . . . Next, this very externality splits into 'inner externality' (the symbolic order, i.e. the decentred discursive mechanisms that generate meaning) and an 'external externality' (the ISA and social rituals and practices that materialize ideology)—*the externality misrecognized by ideology is the externality of the 'text' itself as well as the externality of 'extra-textual' social reality*" (1999, 70; Žižek's stress). Finally, Žižek divides the extratextual social reality into the institutional Exterieur from above, Althusser's ISAs, and that which arises spontaneously from below, from extrainstitutional activities of individuals, as with Lukács's theorizing around commodity fetishism.

14. What leads us to this impasse is the notion that the relationship between this inside and outside can be resolved in an understanding of the basis on which the relationship, the division, resides. If for instance that which ostensibly lies outside reality, the ideological construction, serves to mask the real relations of power in reality, then we can fully define that relationship by showing how what is outside corresponds, point by point, to the relations of power inside reality. But the position occupied by the one who explains this always remains outside the explanation being given, and not merely theoretically, nor by chance, but inevitably. This, Derrida claims in *Specters of Marx* (1994), is because the symbolization of the real, which the readings of ideology is intended to unravel, is always incomplete, is always marked by a supplement to which this conundrum about the critical position itself attests.

15. For instance, the notion of the class struggle as accounting for historical change gives rise to "ever-new symbolizations by means of which one endeavours to integrate and domesticate it [class struggle] . . . but which simultaneously condemns these endeavours to ultimate failure" (Žižek 1999, 75). "Class struggle" becomes a transcendental signifier when its capacity to explain social phenomena is presented as though self-evident, transparent, etc., i.e., when its site of enunciation is universal, or is based on a text in Marx that becomes elevated to a noncontextualized site of enunciation. "Marx says" translates into "it is."

16. "The Colonial Factor is an incident, a catalytic incident merely. The confrontation in the play is largely metaphysical, contained in the human vehicle which is Elesin and the universe of the Yoruba mind" (Soyinka's author's note).

17. Sembène follows up with the dimunition of the paternal figures in his next two films, *Faat Kine* (2000) and *Moolade* (2004). In *Faat Kine*, Kine has eliminated from control over her life her father, her husband, and her lovers; in *Moolade*, the climax of the film turns on the failure of a husband to exert authority over his wife, despite his best effort to beat her. In fact, it is that effort that causes the women of the community to rally to the beaten wife's cause and especially to defy the men in their efforts to maintain the custom of female genital cutting. The "little bit of the real" that causes these relationships to congeal turns on sexuality and death. The cutting of the girls' clitorises was originally intended to bring them into the community of adult women. Now it is the *non-cutting* that brings them into that community, that actually forms that community, and it is death, their removal from the community, that now results from the genital cutting. The community of men, of the fathers, that we had seen coming together in *Camp de Thiaroye* (1987), here comes apart as we had seen in *Faat Kine*.

18. Žižek cites Christopher Lasch's description of the dysfunctional American family analyzed in his *Culture of Narcissism* (1980), to the effect that America's "pathological narcissism" was manifested in what Žižek terms the "ferocious maternal superego" whereby, according to Lasch, "Their unconscious impressions of the mother are so over-

blown and so heavily influenced by aggressive impulses, and the quality of her care is so little attuned to the child's needs, that in the child's fantasies the mother appears as a devouring bird" (Žižek 1991, 99).

19. An interesting variant of this can be seen in increasing representations of the excessive consumerism of Africans living abroad. In *La Vie sur terre* (1999), the protagonist is depicted as shopping in a mall supermarket in Paris for gifts to take back with him to Africa. At one point he faces an endless array of different brands of butter! The world of his father to which he returns in Mali is marked by austerity and relative poverty signaled by the continual difficulty in establishing a telephone connection. The protagonist's mode of transportation, on his return home, is a bicycle. Similarly, in *Hyenas*, Linguère Ramatou's billions are acquired in Europe, whereas the residents of Colobane witness the distraining of their town hall at the beginning of the film due to their bankrupt economy. This theme of the disparity in wealth is given particularly brutal, "noir" treatment in Hubert Sauper's *Darwin's Nightmare* (2004).

6. Aristotle's Plot

1. See *Looking Awry* (1998), chap. 5, "The Hitchcockian Blot," where Žižek spells out the role of *l'objet a*.

2. Žižek cites Jacques-Alain Miller's example in which a square, within a square, is removed, creating a hole. Miller then writes, "We understand the covert setting aside of the object [the interior square that is removed] as real conditions the stabilization of reality, as 'a bit of reality.' But if the object *a* is absent, how can it frame reality? It is precisely *because* the object *a* is removed from the field of reality that it frames it. If I withdraw from the surface of this picture the piece I represent by a shaded square [the interior square], I get what we might call a frame: a frame for a hole, but also a frame of the rest of the surface. Such a frame could be created by any window. So object *a* is such a surface fragment, and it is its subtraction from reality that frames it. The subject, as barred subject—as want-of-being—is this hole. As being, it is nothing but the subtracted bit. Whence the equivalency of the subject and the object *a*" (cited in Žižek 1998, 94–95).

3. *Matamata and Pilipili* was a series of films made in the Belgian Congo in the 1950s by Albert Van Haelst, a Belgian missionary and film enthusiast. The films were slapstick comedies, the purpose of which was to inculcate "civilized" values into the African audience, such as thrift, frugality, and honesty, using two humorous characters and their misadventures. The films are available now in a documentary version produced in 1996 by Tristan Bourland and distributed by Icarus Films.

4. Cf. Mbembe (2001), *On the Postcolony*, chap. 4.

5. Well-known examples of the patriarch already appeared in much of the work of Sembène, like *Tauw* (1970), *Vehi Ciosane* (1965), *Mandabi* (1968), *Xala* (1974), etc.; see also such films as Dikongue-Pipa's *Muno-Moto* (1975) and *Le Prix de la liberté* (1978); Bassek Ba Kobhio's *Sango Malo* (1991); Cheikh Oumar Sissoko's *Finzan* (1990); Souleymane Cissé's *Finye* (1982) and *Yeelen* (1987), etc.

6. Cf. Derrida's *Specters of Marx* (1994) where he addresses the issue of the "spook," the "revenant," which is rehearsed here with the mock return of the dead, the living-dead, the non-dead, all of whom carry the weight of their former lives, or, better still, former times. Thus the return of Marx, for Derrida, as a necessary ghost might be read here where the revolt of the sons of African cinema is predicated on the basis of the ancestors' return. The ancestors are presented in the form of the identity cards carried by the character Cinema.

7. Cf. images of Popaul in *On the Postcolony* (2001), 150–68.

8. After the voiceover states, "It was only a matter of time before the imagination becomes reality," they are seen viewing and commenting on a Terminator-type film. At one point, one of them states, "There's a contradiction somewhere. In the one film he is slaughtering his own. In this one he is protecting them." And Nikita opines, at the end of the scene, "Every year there's a new Terminator."

9. Žižek works through the issues of Zeno's paradoxes and *l'objet a* in chap. 1 of *Looking Awry* (1998), "From Reality to the Real." In *Everything You Always Wanted to Know about Lacan (But Were Afraid to Ask Hitchcock),* he works through the three different forms of object in Hitchcock's films, the McGuffin, the circulating object of exchange, and the objectification of the Real. These three objects represent the essential qualities of the Imaginary, the Symbolic, and the Real, respectively. In this case, the cans of film function both as McGuffin, and as the object of exchange whose function is to circulate among subjects establishing their location in the symbolic order (1992, 6–8).

10. Cf. his chapter "The Obscene Object of Postmodernity," in *Looking Awry* (1998). For instance, there he writes, "The opposition between modernism and postmodernism is thus far from being reducible to a simple diachrony; we are even tempted to say that postmodernism in a way *precedes* modernism" (145). Jameson makes similar arguments about the continuities between modernism and postmodernism, even as he makes a case for the relative differences between them (see Jameson 1991, 5).

11. The dialogue between E. T. and the cop appears to be another Keystone comedy routine, but it contains the gist of the nominalist disavowal of universals, cast in the form of confusion between signifier and signified. As E. T. brings the order of expulsion to the cop, the latter states, "I need details. Who's the real boss here?"

ET: Cinema
Cop: Is Cinema the whereabouts?
E. T.: You see, the whereabouts is Cinema Africa.
Cop: Is that the name of these tsotsis?
E. T.: This cinema is called Cinema Africa, and also Cinema is the name of the guy.
Cop: Oh, come come now. Are you telling me cinema is man, is place, is everything? Are you also cinema?
E. T.: I'm a cineaste. I make cinema. But this guy calls himself Cinema.
Cop: So, if the boulevard is called Thomas Sankara, do you think Thomas Sankara calls himself after the road or the road came after Thomas Sankara.
E. T.: I think Thomas Sankara came first.
Cop: So who's first, cinema or cinema?
E. T.: Cinema.

At this point, the cop, who had been seen shortly before passing in front of the Cinema Africa, being mocked by the tsotsis, abandons his effort to sort it all out, and states, "I'm gonna fix this damn cinema." The point of the floating signifier, of course, is that it cannot be "fixed."

12. In *Finye* (1982), as in *Baara* (1978), Cissé gives us the serious representation of the "lost generation." The same is true of a number of other films, like Cheick Oumar Sissoko's *Nyamanton* (1986), Amadou Seck's *Saaraba* (1988), and Moussa Sene Absa's *Ça Twiste à Poponguine* (1993). In *Aristotle's Plot,* it is the simulacrum of that generation.

13. Žižek makes a distinction between our act of looking at the film, and that of the objects in the film gazing back at us as spectators. There is a dissymmetry he describes here as constitutive of the "stain" that "interferes" with us, disrupting our sense of subjective self-presence: "Far from assuring the self-presence of the subject and his vision,

the gaze functions thus as a stain, a spot in the picture disturbing its tranquil visibility and introducing an irreducible split in my relation to the picture: I can never see the picture at the point from which it is gazing at me, i.e., the eye and the gaze are constitutively asymmetrical. The gaze as object is a stain preventing me from looking at the picture from a safe, 'objective' distance, from enframing it as something that is at my grasping view's disposal. The gaze is, so to speak, a point at which the very frame (of my view) is already inscribed in the 'content' of the picture viewed. And it is, of course, the same with the voice as object: this voice—the supergoic voice, for example, addressing me without being attached to any particular bearer—functions again as a stain, whose inert presence interferes like a strange body and prevents me from achieving my self-identity" (1998, 125–26).

14. Cf. "The Spectre of Ideology" in *The Žižek Reader,* where he delineates the gap between Derrida and Lacan, and by extension, himself (1999, 79–80). Here he puts it in terms of Derrida's commitment to the "spectre," the figure through which freedom is manifested in a non-ontological state; in contrast, he evokes Lacan's "cancel[ation] of our primordial indebtedness to the spectral Other" (80).

15. "Plato's conception of the 'simulacrum,' the identical copy for which no original has ever existed" (Jameson 1991, 18).

16. There are many passages in Žižek evoking these terms to describe the moment in which we encounter that inaccessible, troubling moment/space in the real that resists symbolization. In his chapter "The Hitchcockian Blot," he discusses it in terms of Hitchcock's tracking shot that winds up confronting that "blot" in the real: "None of this should blind us to its [the blot's] other aspect, however, that of an inert, opaque object that must trop out or sink for any symbolic reality to emerge (1998, 94).

17. Cf. Catherine Belsey's chapter on Realism in *Critical Practices* (1980).

18. "For an Imperfect Cinema," Julio Garcia Espinosa (1971); Fernando Solanas and Octavio Getino (1983), "Towards a Third Cinema."

19. The full text in English follows. This is a corrected version of the more approximate transcription that appears in Eke, Harrow, and Yewah, eds., *African Images* (2000), and is also roughly similar to the French voiceover that is cited later in the chapter. "My characters were out of control. The unemployed gangsters, armed with their degrees, rushed into the job market. They would take an oath of action. Catharsis. My grandfather calls it the bitterness and sweetness of life. The violence necessary for human salvation. Pity and fear is the mission. Without pity and fear, no redemption. Inchallah. Amen" (22).

20. *Location of Culture* (1994). The phrase, which Bhabha discusses at length, is from Fanon's chapter "On National Culture" in *Wretched of the Earth.*

21. When asked by the cop why dead characters are seen alive in subsequent films, the Bekolo-barman hedges his answer, giving the impression that he knows ("There is a special kind of knowledge"), and yet won't state why. He says, only a very few people die in my movies. We have to think: this character Bekolo is now indistinguishable from the real Bekolo in whose *Quartier Mozart* there are a few deaths: we have the man who falls over dead in the taxi at the beginning, and the motif of death with respect to Chef de Quartier/Mon Type who says, "Un garçon est mort le jour il est né" (a boy died the day he was born). In *Aristotle's Plot,* E. T. wipes out all the tsotsis, but as that ending is judged inappropriate ("As my grandfather used to say, death never kills anybody. Frightened, I decided to abandon Aristotle's methods. I had to bring the dead back to life. I had to change the rules"), the scene had to be "reshot." This time not only does no one die after the cop leads E. T. and Cinema away in handcuffs, by the end *no one can die anymore.* So

in a sense Bekolo is wrong in his serious response to the cop on both counts: finally, no one dies in *Aristotle's Plot,* and the "special knowledge" to which he alludes as explanation for the resurrection of dead characters becomes irrelevant. What accounts for the return of the Terminator character in *Terminator II* and his illogical loyalties, as discussed by the tsotsis is to be determined, at least in terms of what "counts," *outside* the frame of the cinematic truth.

7. Finye

1. Žižek cites Freud's reference to the *"einziger Zug,"* which he glosses as the unary feature, that which sustains identification (1999, 99).

2. The key line, "all on account of a woman," could be traced through *Xala* (1974) or *Finzan* (1990), *Ceddo* (1976), *Emitai* (1971), *Hyenas* (1992), *Le Prix de la liberté* (1978), *Le Prix du pardon* (2001), etc. Here is the everyday support for an African symbolic in which the woman's emancipation has had to bear the burden of representing the liberation of the nation either from patriarchy, from masculinist tradition, or from neocolonialism. Free the Peul woman and you free the nation, or, in this case, relieve the poor ordinary people of the heavy hand of the patriarchal military governor, and make possible a future for the youth.

3. Indeed we subsequently see Kansaye, Ba's solid grandfather, farming his land shortly before we see the governor illegally engaged in a process of selling land.

4. Žižek argues that moments like this that apparently function at an angle to the open ideological message make the functioning of ideology itself possible. He terms these "trans-ideological": "The point is not only that there is no ideology without a trans-ideological, "authentic" kernel, but rather than that it is only the reference to such a trans-ideological kernel that renders an ideology 'workable" (1999, 98). Here the "authenticity" of the trans-ideological kernel is produced by the encounter between Bambara and Peul; and soon we discover that the ideology constructed on this transversal authenticity is grounded in the ISA of education, an apparatus that leads us to the foundations of the authority in which the film's symbolic order is grounded.

5. Cf. Chion designates *rendu* as the effect of the soundtrack now assuming a dominant role in representing reality, as opposed to the visual dimensions associated with the imaginary or symbolic orders. Chion makes reference to the *voix acousmatique* as a free-floating voice, separate from any characters or figures in the diegesis, that nevertheless conveys a signifying quality to the scene. Žižek identifies the role of sound as Chion describes *rendu* as one in which the soundtrack becomes the primary frame of reference. (Cf. *Looking Awry* [1998] 93, and *The Žižek Reader* [1999] 12–13, 25–26.)

6. Perhaps the most famous case of a disappearing character is the postman in Sembène's *Mandabi* (1968). There it was simply a case that the actor had departed, and the ending Sembène had imagined couldn't be shot. Consequently the film ends with a montage of earlier shots, now in the guise of a concluding moral.

7. See Gardies (1989) on setting. Ostensibly, visibly Bamako, it is rendered a generic, symbolic setting for all such sites of struggle between the students and the authorities. This explains the apparent distance between the regional governor and the minister at the capital, a distance evoked by the minister's call to the governor, his reference to events in the street of which the governor is unaware, and the governor's apparent rule at a distance from the seats of authority in the capital (22–23).

8. Cf. Ukadike (1994) who comments: "Ironically, *Finye* was partly financed by the military government of Mali" (196), and who adds in his footnote, "The military even

helped Cissé with equipment, offering him whatever help he needed to get the film completed" (333, n. 44). However, given the oppressive, dictatorial nature of Traore's twenty-three-year reign, one might find Ukadike's conclusion a bit hard to swallow: "Tolerance and maturity prevailing, the government demonstrated that it is capable of listening to constructive criticism" (196). Traore was overthrown precisely because of his intolerance and failures to listen to constructive criticism.

9. Alternatively, she is the star that has replaced the twin powers that had ruled up till then, the powers of the chieftain's rule and traditional ways, and the power of the state. The twin powers are the stars that are now departing, and the small star that replaces their rule is what the winds of change have brought. The gods make this statement to Kansaye at the shrine: "I can see two stars darting across the sky. Between the stars shines a tiny star. It shines all over the planet. Djandjo, the sky is changing color. It is getting darker. Our knowledge escapes us. We have lost our divine forces. You must act according to your strength and what you know. Make offerings and go." As they dismiss him thus, they dismiss their role in the world as well: "From now on act according to your instincts." And one can argue that by ontologizing what Batrou represents, the new day, they have effectively dismissed her as a person, thus her transcendence and reincarnation as the new star.

10. Two other figures similar in their roles to Batrou come immediately to mind. The first, similarly placed between the rich and corrupt father and the courageous young boyfriend, is Rama in *Xala* (1974). Her role at the end is no less ambiguous than that of Batrou. In contrast, we have Hareyrata in *Faraw* (1996), the daughter who defies the Law of the Father now embodied in her mother Zamiatou, who fails to obtain either boyfriend or liberation, and yet who moves past the twin ideological symbolic patriarchal orders of the political and the traditional by asserting her own initiative.

8. Hyenas

1. In his brief comments on the film, Djibril Diop identifies a time when he was a young man living in poverty in Dakar. There are notes on the Web site http://spot.pcc.edu/~mdembrow/hyenas_program_notes.htm:

"[E]very Friday night a beautiful prostitute would come to the port district from her palatial home and treat the poor to a lavish meal. They named her Linguère ("Unique Queen" in Wolof) Ramatou (the red bird of the dead in Egyptian mythology). One Friday she failed to appear, and Mambéty decided that she had perhaps returned to her native village, the village which he imagined had at one time driven her out and to which she had now returned in triumph."

2. Evidence that Gorée actually functioned as a major slave fort, or even as a slave fort at all, is now in dispute (cf. Philip Curtin's celebrated dismissal of claims that it was a slave fort as a sham, cited in *Le Monde* in December 1996 and in a CNN Interactive report: http://www.cnn.com/SPECIALS/1998/africa/senegal/ and in Web site of *The Seattle Times*: http://seattletimes.nwsource.com/html/nationworld/2001989239_slavehouse27.html).

However, in the popular imaginary, not to mention the tourist trade, Gorée is still very much the emblem for the slave trade. As for the island where Linguère Ramatou's gaze falls, it is apparently L'Ile aux Serpents, an island Djibril Diop is reputed (by Laurence Gavros in a personal communication) to have identified with prison and hard labor. The reason for this could be found in its history, recorded in *West Africa: The Rough Guide*,

which indicates that it has acquired a malevolent reputation. "L'ilot Sarpan (named after a French soldier banished here) was soon corrupted into l'Ile aux Serpents," of which it has none. The Lebu traditionally believe that sea spirits live on the island" (Hudgens and Trillo 1999, 191). According to Gavros, Djibril Diop once remarked that the island held for him the reputation of a site of banishment for prisoners doing hard labor.

3. Moussa Sow emailed me on the figure of Ramatou, writing: "In Wolof Ramatou also is a name of a bird, a protected bird, that nobody eats or kills. It is considered a holy bird that Fulanis—from Senegal at least—catch sometimes and make wishes before they let it fly. The Fulanis believe that God will make those wishes come true. . . . Linguére Ramatou, as she 'flies' back to Colobane, becomes a 'Grande,' just like the bird Ramatou that builds its nest within Fulani huts without being frightened, because it is the 'God's bird.'" Personal communication, Sept. 28, 2004.

4. Cf.: "In the case of Nazism, the void made its return under one privileged name in particular, the name 'Jew.' There were certainly others as well: the Gypsies, the mentally ill, homosexuals, communists. . . . But the name 'Jew' was the name of names, serving to designate those people whose disappearance created, around that presumed German substance promoted by the 'National Socialist revolution' simulacrum, a void that would suffice to identify the substance" (Badiou 2001, 75).

5. In an interpretation somewhat at variance from my own, Sada Niang wrote me an email with the following comment: "I am not as optimistic as you are about the willingness of the people of Colobane to root out Draman. In fact, I think that their desire to face the 'void' formerly installed by Draman and other characters like him is minimal at best. I think they all fear and loathe Linguére Ramatou, but in silence, and that the one who dies in the end is Linguére, not Draman." Personal communication, Sept. 28, 2004.

6. At the current rate of exchange, 500 CFA are worth one dollar. Thus 100 billion, half her offer, would be $100 million, a sum in Senegal that might be thought of in terms of $100 billion in a western country.

7. If we wish to interpret her bargain with the community as a kind of challenge to its integrity, to rise above the materialist tides overwhelming Africa, then it is ironic that if Draman were to be thought of as the only one to meet that challenge, it is at the price of his life; and if he were to fail at that challenge, i.e., become materialistic and accept her values, her bargain, he would still have to lose his life.

8. Again a simulacrum—this time of persistence or perseverance.

9. In a review of the film Michael Dye writes of the ending, "One is left with a reading based on assumptions, and a song that warns of the Ramatou bird and counsels "Get to work and stop talking . . . to find freedom." The song is a mockery of the work ethic." Quoted from an article entitled, "Hyenas, A Parable of Decay," 1988; http://www.und.ac.za/und/ccms/amp/reviews/hyena2.htm.

9. Toward a Postmodern African Cinema

1. Cf. Simon Gikandi, *Maps of Englishness* (1996).

2. Cf. Manthia Diawara, "Self-Representation in African Cinema."

3. Cf. Isaac Kalumbu's dissertation *The Process of Creation and Production of Popular Music in Zimbabwe* (Ph.D. Diss., Indiana University, 1999), in which he details Louis Armstrong's visit to Zimbabwe (publication forthcoming).

4. Cf. *L'Autre face du royaume,* V. Y. Mudimbe (1973, 102). Mudimbe develops a key image for the condition of the African intellectual as trapped between two worlds:

To adopt an image, everything takes place as if the African intellectual were trapped in an elevator that perpetually goes up and down. In principle, a single gesture would be sufficient to stop the machine, get out, and rent an apartment or room; in sum, live and experience the reality of the world. But apparently, he does not understand that the initiative to escape belongs to him. (102)

5. The term "mégotage" is a play on Levi-Strauss's "bricolage," by which he meant, in *La Pensée sauvage* (1962), the informal piecing together of mythological thought, as opposed to formal dogma or "modern" scientific thinking.

6. Cf. Jonathan Haynes, ed., *Nigerian Video Films* ([1997] 2000).

7. "Hannah Arendt once observed that what comes to light in the camps is the principle that supports totalitarian domination and that common sense stubbornly refuses to admit to, namely the principle according to which anything is possible. It is only because the camps constitute a space of exception—a space in which the law is completely suspended—that everything is truly possible in them" (cited in Agamben 2001, 39).

8. This sets the principal quality of postcolonialism for Appiah who defines African opposition to colonial and neocolonial hegemony as grounded in humanist values. See "Is the 'Post-' in 'Postcolonial' the 'Post-' in 'Postmodern'?" first published in *Critical Inquiry* 17 (winter 1991), and republished in *In My Father's House*.

9. Cf. Césaire's *Discours sur le colonialisme* (1955), in which he taxes Europe for having accumulated the largest pile of corpses in history, and goes on to advance a progressivist argument in terms of decolonization.

10. Cf. the impatience with which Mbembe's *On the Postcolony* has been greeted.

11. Cf. *The Sexual Subject: A Screen Reader in Sexuality* (1992). This volume contains Stephen Heath's essay "Difference" (*Screen* 19, no. 3 [autumn 1978]: 51–112). For Belsey, see her argument on realism in *Critical Practices* (1980), and Lyotard makes the similar argument in *The Postmodern Condition: A Report on Knowledge* (1993).

12. Lacan's term for what stops the chain of signification from continuing endlessly.

13. In the case of cocoa, African countries have long exported cocoa beans rather than processing the beans into chocolate. I have long wondered about this fact since the Nestlé chocolate or cocoa is commonly imported back into countries like Cameroon, where it is sold at a much higher price than it would be if locally processed. There is some locally produced tea, like Ndu tea, that is cheaper than the imported varieties. I recently learned that the tariffs established by the industrial world imposed this system of exportation of raw materials on African countries. Thus, Cameroon can export the raw beans with little or no tariffs set on their importation to Europe, whereas any processed chocolate would meet high tariffs. In short, crops like cocoa, tea, coffee, and cotton cannot be processed into industrial or consumer goods that would compete with European finished products. The irony is that it was Europeans who introduced and imposed the cultivation of these crops on their colonial subjects, and who now continue a globalized economic hegemony through its system of loans and tariffs that keep African economies down while profiting European/American economies. As Africans seek to escape this trap by migrating north, they are met with the Fortress mentalities of the First World that clearly exhibit what Gikandi has termed the unfinished project of colonialism.

14. The arms trade, which notoriously has been virtually unimpeded by any barriers to international trade, demonstrates the incredible power not only of large-scale multinationals, but of the entire network of small arms dealers, with figures like the Russian Victor Bout whose notoriety only hides the unnamed and significantly more powerful manufacturing and trading interests linked directly to the Russian, Bulgarian, Slovakian, and other East European arms manufacturers, and to networks of traders involving Is-

raelis, Chinese, South Africans, Belgians, Britons, and many others. The legal and illegal flow of arts into the African continent (Rwanda, the DRC, Burundi, Liberia, Sierra Leone, and the Sudan) has gone without any attempts to enforce UN-mandated embargoes on that trade. Cf. the devastating Amnesty International Reports on this situation, including *DRC: "Our Brothers Who Help Kill Us"—Economic Exploitation and Human Rights Abuses in the East* (AI Index: AFR 62/010/2003, April 2003), and *Democratic Republic of Congo: Arming the East* (AI Index: AFR 62/006/2005, July 2005). In addition, Global Witness produced a report titled *Under-Mining Peace: Tin: The Explosive Trade in Cassiterite in Eastern DRC* (Global Witness 2005).

15. Another devastating Amnesty report on the conditions of the largest of the Congo's diamond mines, the ones at Mbuji Mayi, underscores the brutality of the situation. Amnesty International, *Making a Killing: The Diamond Trade in Government-Controlled DRC* (AI Index: AFR 62/017/2002, October 2002).

16. A thread that addressed this topic appeared in Toyin Falola's enormous African discussion list in June of 2005, with the principal target for the discussion George Ayittey (*Africa Unchained: The Blueprint for Development* [2004[; *Africa in Chaos* [1998]), who took the popular position that the African elite and leadership had squandered much aid in a corrupt fashion. Thus he writes, in reference to the G8 Summit of June 2005 that "Tony Blair's set of proposals, which actually fall short of the 100% debt cancellation (not forgiveness or relief), is a good place to start. It does not commit the error of simply throwing money at a bad situation. It marries the concerns of reform and the urgent need to save and improve lives on the continent. More importantly, it attempts to redress the anti-Africa trade practices of western nations, who in effect have stifled African agricultural and proto-industrial production through their hypocritical subsidies and tariffs. My only disappointment with the plan (besides the failure to recommend the cancellation of all of Africa's debts) is the fact that its call for reform is one-sided in that it does not demand the reform of western financial institutions and global capital transfer practices in order to make it impossible for corrupt African leaders to bilk the continent of aid money, which are then used to finance and lubricate investments and accounts overseas" (dated Tuesday, June 14, 2005, in Toyin Falola's listserv "Africa Dialogue Series": http://www.utexas.edu/conferences/africa/ads/index.html, subject: USA/Africa Dialogue, No 781: "G8: Ayittey on Ochonu's."

17. The Barber collection of exceptional quality is *Readings in African Popular Culture* (1997). Other excellent works that explore African popular culture include Barber's *The Generation of Plays: Yoruba Popular Life in Theatre* (2000), Frederick Cooper and Ann Laura Stoler's *Tensions of Empire* (1997), and Paul S. Landau and Deborah D. Kaspin's *Images and Empires* (2002).

18. There has been a growing disparity between the production of African culture abroad and at home. Thus, whereas African film has been made available relatively widely in the west, in film festivals and specialized university courses, it has remained largely unviewed at home; similarly, in the manner that Nigerian novels, like Ben Okri's or Chris Abadi's, are widely disseminated abroad, in Nigeria it is poetry that is read and sold for the local readership. This information was provided at a conference in Virginia (Colloquium on African Literatures and Cinema, and Contemporary Theories, March 4–5, 2005, Washington and Lee University, Lexington, Virginia) by Pius Adesanmi, who edited with Chris Dunton a special issue on New or "third generation" Nigerian writing in *English in Africa* 32, no. 1 (May 2005).

19. Cf. Lyotard's discussion of the legitimation of knowledge and especially the appendix that contains the section on realism (73–79) in *The Postmodern Condition* (1993).

20. This truism about postmodernism strikes me as the weakest point in Appiah's essay on the "post-" in postmodernism and postcolonialism.

21. The fact that terms like "real life," "real," and "true" are set off in scare quotes indicates not a postmodern sensibility as such, but an effect of the erasure of the boundaries that give those terms their closed significance.

Filmography

Absa, Moussa Sene. *Tableau ferraille.* 1998. ADR Productions, Canal Horizons, Kus Productions, La Sept Cinéma, MSA Productions. Senegal. 92 min.

Allen, Woody. *The Purple Rose of* Cairo. 1985. Orion Pictures. USA. 84 min. 35 mm.

Ascofaré, Abdoulaye. *Faraw, Mère de sable.* 1996. Mali. 90 min.Babenco, Hector. *Pixote.* 1981. Embrafilme, HB Filmes. Brazil. 128 min. 35 mm.

Ba Kobhio, Bassek. *Sango Malo.* 1991. Diproci, Fodic, Les Films Terre Africaine. Cameroon. 94 min. VHS.

——. *Le Grand Blanc de Lambaréné.* 1995. LN Productions. Cameroon. 94 min.Bathily, Moussa. "Le Certificat d'indigence." 1981. Ministère de la Culture de Sénégal. Senegal. 29 min.

Bekolo, Jean-Pierre. *Aristotle's Plot.* 1996. JBA Production, BFI. France/Zimbabwe. 70 min. 35 mm.

——. *Quartier Mozart.* 1992. Kola Case, Cameroon Radio Television. Cameroon. 80 min. 16 mm, blown up to 35 mm.

——. *Les Saignantes.* 2005. Quartier Mozart Films, é4 Television. France/Cameroon. 92 min. Digital betacom.

Bourlard, Tristan. *Matamata and Pilipili.* 1996. Belgium. 55 min. VHS.

Buñuel, Luis. *Los Olvidados.* 1950. Ultramar Films. Spain/Mexico. 85 min. 35 mm.

Cissé, Souleymane. *Finye.* 1982. Mali. 100 min.

——. *Yeelen.* 1987. Atriascop Paris, Burkina Faso Ministry of Life and Culture, Centre National de la Cinématographie (CNC), French Ministry of Cooperation and Development, French Ministry of Foreign Affairs, Les Films Cissé, Les Films du Carrosse, Mali Government, Midas, Ministère de la Culture de la Republique Française, UTA, Westdeutscher Rundfunk (WDR). Mali. 105 min.

Dangarembga, Tsitsi. *Everyone's Child.* 1996. Media for Development Trust. Zimbabwe. 90 min. 35 mm and VHS.

Diawara, Manthia. *Bamako Sigi Kan.* 2002. Ka-Yelema Productions. Mali/USA. 76 min. DVCAM (Sony PD 150).

——. *Rouch in Reverse.* 1995. Arte, ZDF, Formation Films. France/USA. 52 min. Betacam, VHS.

Dikongué-Pipa, Jean-Pierre. *Le Prix de la liberté.* 1978. Cameroun Spectacles. Cameroon. 90 min.

——. *Muno Moto.* 1975. Avant Garde Africaine. Cameroon. 100 min.

Djadjam, Mostefa. *Borders.* 2002.. Centre National de la Cinématographie (CNC), TPS Cinéma, Vertigo. Algeria/Morocco. 102 min.

Dos Santos, Nelson Pereira. *How Tasty Is My Little Frenchman.* 1971. Condor Filmes, Luiz Carlos Barreto Produções Cinematográficas. Brazil. 84 min.

du Parc, Henri. *Bal Poussière.* 1988. Focale 13. Côte d'Ivoire. 90 min.

Ecaré, Désiré. *Visages de femmes.* 1985. Films de la Lagune. Côte d'Ivoire. 105 min.

Faye, Safi. *Lettre Paysanne* (Peasant Letter). 1975. Safi. Senegal. 90 min.

——. *Mossane.* 1996. France/Senegal. 106 min.

Ganda, Oumarou. *L'Exile*. 1980. Cabas. France and Niger. 90 min.

Gerima, Haile. *Harvest 3000 Years*. 1975. Haile Gerima Production. Ethiopia/USA. 150 min.

Gomes, Flora. *The Blue Eyes of Yonta*. 1991. Arco Iris, Eurocreation Productions, Instituto Portuges de Cinema, Radio Television Portuguesa, Vermedia. Guinea Bissau. 90 min. VHS and 35 mm.

Hitchcock, Alfred. *The Birds*. 1963. Alfred J. Hitchcock Productions, Universal Studios. USA. 119 min. 35 mm.

———. *North by Northwest*. 1959. Metro-Goldwyn-Mayer. USA. 136 min. 35 mm.

———. *Psycho*. 1960. Shamley Productions. USA. 109 min. 35 mm.

Ivanga, Imunga. *Dôlé*. 2001. Ce. Na. Ci., Direct et Différé. Gabon. 80 min. VHS, DVD.

Kaboré, Gaston. *Wend Kuuni*. 1982. Direction du Cinéma de Haute Volta. Burkina Faso. 75 min. VHS.

———. *Zan Boko*. 1988. Burkina Faso. 95 min.

Kalatozov, Mikhail. *The Cranes Are Flying*. 1957. Ministertvo Kinematographi. Soviet Union. 97 min.

Kar-Wai, Wong. *Chungking Express*. 1994. Jet Tone Production Co. Ltd. Hong Kong. 102 min. 35 mm.

Kelani, Tunde. *Thunderbolt*. 2000. Nigeria. 110 min. VHS.

Kiarostami, Abbas. *And Life Goes On*. 1991. The Institute for the Development of Children and Young Adults. Iran. 95 min.

———. *Taste of Cherry*. 1997. Abbas Kiarostami Productions, CyBi2000. Iran. 95 min.

———. *Ten*. 2002. Abbas Kiarostami Productions, Key Lime Productions, MK2 Productions. Iran. 94 min.

Kotcheff, Ted. *Rambo: First Blood*. 1982. Anabasis N.V., Carolco Pictures. Inc. USA. 97 min. 35 mm.

Kouyaté. Dani. *Keita: The Heritage of the Griot*. 1995. VHS. Burkina Faso. 94 min.

Lee, Spike. *Do the Right Thing*. 1989. 40 Acres and a Mule Filmworks. USA. 120 min. 35 mm.

———. *She's Gotta Have It*. 1986. 40 Acres and a Mule Filmworks. USA. 84 min. 35 mm.

Loreau, Dominique. *Divine carcasse*. 1998. Underworld Films, Carré-Noir RTBF, Centre du Cinéma et de l'Audiovisuel de la Communauté Française de Belgique, Office de Radio et Télévision Bénin, Sindibad Films, Belgium/Benin. 78 min. 35 mm.

Lynch, David. *Elephant Man*. 1980. Brooksfilms Ltd. USA. 124 min. 35 mm.

Mambéty, Djibril Diop. *Badou Boy*. 1969. Senegal. 60 min. 16 mm.

———. "Contras City." 1968. Senegal. 16 min. 16 mm.

———. *Le Franc*. 1994. Waka Films. Senegal. 44 min. 35 mm.

———. *Hyenas*. 1992. ADR Productions, Thelma Film AG. Senegal. 110 min. 35 mm.

———. *Parlons Grand-mère*. 1989. Mali. 34 min. 16 mm.

———. *La Petite vendeuse de Soleil*. 1999. Maag Daan. Waka Films. Senegal. 45 min. VHS and 35 mm.

———. *Touki Bouki*. 1973. Cinegrit, Studio Kankourama. Senegal. 85 min. 35 mm.

Mogotlane, Thomas, and Oliver Schmitz. *Mapantsula*. 1988. David Hannay Productions, Electric, Haverbeam. South Africa. 104 min

Nacro, Fanta. "Un Certain matin." 1991. Burkina Faso. 13 min.

———. "Puk Nini." 1995. Burkina Faso. 32 min.

———. "Le Truc de Konate." 1998. Burkina Faso. 33 min.

Ngangura, Mweze. *Pièces d'identité*. 1998. Congo/Belgium. 93 min. VHS and 35 mm.

Ngangura, Mweze, and Benoît Lamy. *La Vie est belle.* 1987. Congo/Belgium. 85 min.
Ouédraogo, Idrissa. *Le cri du coeur.* 1994. Les Films de l'Avenir, Les Films de la Plaine. Burkina Faso. 86 min.
———. *Yaaba.* 1989. Arcadia Films, Les Films de l'Avenir, Thelma Film AG. Burkina Faso. 90 min.
Pontecorvo, Gillo. *The Battle of Algiers.* 1965. Casbah Film, Igor Film. Algeria. 117 min.
Sauper, Hubert. *Darwin's Nightmare.* 2004. Mille et Une Productions, Coop 99, Saga Film (I), Westdeutscher Rundfunk (WDR) (co-production), arte (co-production). Tanzania/Austria/France. 107 min. 35 mm.
Sembène Ousmane. "Borom Sarret." 1963. Senegal. 20 min. 16 mm.
———. *Camp de Thiaroye.* 1988. ENAPROC/Films, Doomireew/Films, Kajoor/SATPEC/ Sociéte Nouvelle Pathé Cinéma. Senegal. 153 min. 35 mm.
———. *Ceddo.* 1976. Films Doomireew. Senegal. 117 min.
———. *Emitai.* 1971. Films Doomireew. Senegal. 103 min.
———. *Faat Kine.* 2000. Films Doomireew. Senegal. 120 min. 35 mm.
———. *Guelwaar.* 1992. Channel IV, Films Doomireew, France 3 Cinéma, Galatée Films, New Yorker Films, Westdeutscher Rundfunk (WDR). Senegal. 115 min. 35 mm.
———. *Mandabi.* 1968. Comptoir Français du Film Production, Films Doomireew. France/Senegal. 105 min.
———. *Moolade.* 2004. Ciné-Sud Promotion, Centre Cinematographique Morocain, Cinétéléfilms, Direction de la Cinematographie Nationale, Films Doomireew, Les Films Terre Africaine. Burkina Faso. 124 min.
———. *La Noire de. . . .* 1996. France/Senegal. 65 min. 16 mm.
———. "Tauw." 1970. Senegal. 24 min. 16 mm.
———. *Xala.* 1974. Société Nationale de Cinématographie/Films Doomireew. Senegal. 123 min.
Singleton, John. *Boyz in the Hood.* 1991. Columbia Pictures Corp. USA. 107 min. 35 mm.
Sissako, Abderrahmane. *Heremakono.* 2002. Duo Films, Arte France Cinéma. Mauretania. 95 min.
———. *La Vie sur terre.* 1999. Haut et court, La Sept Arte. Mauritania/ Mali/France. 61 min.
Sissoko, Cheick Oumar. *Finzan.* 1990. Mali. 107 min. VHS.
———. *Nyamaton.* 1986. Mali. 94 min.
Stevens, George. *Shane.* 1953. Paramount Pictures. USA. 118 min. 35 mm.
Tabio, Juan Carlos. *The Elephant and the Bicycle.* 1994. Channel IV, Instituto Cubano del Arte e Industrias Cinematográficos (ICAIC). Cuba. 81 min.
Teno, Jean-Marie. *Afrique, je te plumerai.* 1992. Les Films du Raffia. Cameroon. 88 min. 16 mm.
———. *Chef.* 1999. Les Films du Raffia. Cameroon, 61 min. 16 mm and video.
Tilley, Brian. 1994. *In a Time of Violence.* Afravision. South Africa. 150 min. VHS.
Traore, Mahama Johnson. *Njangaan.* 1974. Les Films Sénégalais Associés. Senegal. 100 min.
Trinh T. Minh-ha, 1982. *Reassemblage.* Senegal/USA. 40 min. VHS.
———. *Surname Viet, Given Name Nam.* 1989. Vietnam/USA. 108 min.
Truffaut, François. *Les 400 coups.* 1959. Les Films du Carosse, Sédif Productions. France. 99 min. 35 mm.
Twyker, Tom. *Run Lola Run.* 1998. X-Filme Creative Pool, Westdeutscher Rundfunk (WDR), arte. Germany. 81 min. 35 mm.

Van Peebles, Melvin. *Sweet Sweetback's Baad Asssss Song*. 1971. Yeah. USA. 97 min. 35 mm.

———. *Watermelon Man*. 1970. Columbia Pictures, Johanna. USA. 97 min. 35 mm.

Wade, Mansour Sora. *Ndeysaan* [a.k.a. *Le Prix de pardon*]. 2001. Films du Safran/Kaany Productions. Senegal. 90 min. 35 mm.

Bibliography

Achebe, Chinua. *Arrow of God*. London: Heinemann Educational Books, 1964.

——. *Hopes and Impediments*. London: Heinemann Educational Books, 1988.

——. *Morning Yet on Creation Day*. London: Heinemann Educational Books, 1975.

——. "The Novelist as Teacher." In *African Writers on African Writing,*. ed. G. D. Killam. London: Heinemann, 1973.

——. *Things Fall Apart*. London: Heinemann Educational Books, 1958.

Adesanmi, Pius, and Chris Dunton, eds. Special Issue on New or "Third Generation" Nigerian Writing. *English in Africa* 32, no. 1 (May 2005).

Agamben, Giorgio. *Means without End: Notes on Politics*. Trans. Vincenzo Binetti and Cesaire Casarino. Minneapolis and London: University of Minnesota Press, 2001.

Althusser, Louis. *Lenin and Philosophy and Other Essays*. [1969] Trans. Ben Brewster. London: New Left Books, 1971.

Althusser, Louis, and Etienne Balibar. *Reading Capital* Trans. Ben Brewster. London: New Left Books, 1970.

Amadi, Elechi. *The Great Ponds*. London: Heinemann Educational Books, 1969.

Amnesty International Reports. *DRC: "Our Brothers Who Help Kill Us"—Economic Exploitation and Human Rights Abuses in the East* (AI Index: AFR 62/010/2003), April 2003. *Democratic Republic of Congo: Arming the East* (AI Index: AFR 62/006/2005), July 2005. *Making a Killing: The Diamond Trade in Government-Controlled DRC* (AI Index: AFR 62/017/2002), October 2002.

Amselle, Jean-Loup. *Mestizo Logics: Anthropology of Identity in Africa and Elsewhere*. Trans. Claudia Royal. Stanford: Stanford University Press, ca. 1998.

Appiah, Kwame Anthony. "Is the 'Post-' in 'Postcolonial' the 'Post-' in 'Postmodern'?" In *In My Father's House*. New York and London: Oxford University Press, 1993.

Ayittey, George. *Africa in Chaos*. New York: St. Martin's Press, 1998.

——. *Africa Unchained: The Blueprint for Development*. New York/London: Palgrave/MacMillan, 2004.

——. "G8: Ayittey on Ochonu's." In Toyin Falola's listserv "Africa Dialogue Series" (http://www.utexas.edu/conferences/africa/ads/index.html). Subject: USA/Africa Dialogue, No. 781. Accessed November 20, 2006.

Awoonor, Kofi. "The Weaver Bird." In *The Penguin Book of African Poetry,* Gerald Moore and Ulli Beier, eds. London: Penguin Books, 1998.

Bâ, Hampaté. *L'Etrange Destin de Wangrin*. Paris: 10/18, 1973.

Badiou, Alain. *Ethics: An Essay on the Understanding of Evil*. Trans. Peter Hallward. London and New York: Verso, 2001.

Barber, Karin. *The Generation of Plays: Yoruba Popular Life in Theatre*. Bloomington: Indiana University Press, 2000.

——. *Readings in African Popular Culture*. Bloomington: Indiana University Press, 1997.

Barlet, Olivier. *Les Cinémas d'Afrique noire: le regard en question*. Paris: L'Harmattan, 1996.

Barthes, Roland. *Le Dégrée zero de l'écriture*. Paris: Editions de Seuil, 1953.

Bastian, Misty. "Irregular Visitors: Narratives about *Ogbaanje* (Spirit Children) in Southern Nigerian Popular Writing." In Stephanie Newell, ed., *Readings in African Popular Fiction*. Bloomington: Indiana University Press; and Oxford: James Curry, 2002.

Baudrillard. *Simulations*. Trans. Paul Foss, Paul Patton, and Philip Beitchman. New York: Semiotexte, 1983.

Belsey, Catherine. *Critical Practice*. London: Methuen, 1980.

Beti, Mongo. *Main basse sur le Cameroun: autopsie d'une décolonisation*. Paris: Éditions François Maspero, 1972.

———. "Review of *L'Enfant noir*." Special issue, "Trois Ecrivains noirs." *Présence africaine* 16 (1954): 419–20.

Bhabha, Homi. *The Location of Culture*. London and New York: Routledge, 1994.

Bongie, Chris. *Islands and Exiles*. Stanford: Stanford University Press, 1998.

Boni, Tanella. *Une Vie de crabe*. Dakar: Les Nouvelles Editions Africaines du Sénégal, 1990.

Boughedir, Ferid. *Cinéma africain et decolonisation: étude des conditions culturelles et économique de l'émergence de cinémas nationaux independents en Afrique dans la période postcoloniale*. 5 vols. Doctoral Thesis, France, 1976.

———. "Les Grandes tendances du cinéma en Afrique noire." *CinémAction* 26, 1983: 48–57. Republished in "L'Image apprivoisée," in *L'Afrique* 914 (July 12, 1978): 185–87; in *Le cinéma africain de A à Z*. Brussels: Organisation Catholique International du Cinéma, 1987; and in translation as "African Cinema and Ideology: Tendencies and Evolution," in *Symbolic Narrative/African Cinema*, June Givanni, ed. London: BFI, 2000.

Butler, Judith. *Gender Trouble*. New York: Routledge, 1990.

Césaire, Aimé. *Discours sur le colonialisme*. Paris: Présence africaine, 1955.

Cham, Mbye. *Black Frames: Critical Perspectives on Black Independent Cinema*. Cambridge, Mass.: MIT Press, 1988.

Chatterjee, Partha. *The Nation and Its Fragments: Colonial and Postcolonial Histories*. Princeton, N.J.: Princeton University Press, 1993.

Comaroff, Jean, and John Comaroff. *Modernity and Its Malcontents:* Chicago: University of Chicago Press, 1993.

Cooper, Frederick, and Ann Stoler, eds. *Tensions of Empire: Colonial Cultures in a Bourgeois World*. Berkeley and Los Angeles: University of California Press, 1997.

Cotter, Holland. "The Face and Soul of Africa." *The New York Times,* sec. "Weekend." Sept. 20, 2002, B32.

Dadié, Bernard. *Patron de New York*. Paris: Présence africaine, 1964.

———. *Un Nègre à Paris*. Paris: Présence africaine, 1959.

Davies, Carole Boyce. *Black Women: Writing and Identity: Migrations of the Subject*. New York: Routledge, 1994.

Davies, Carole Boyce, and Anne A. Graves. *Ngambika*. Trenton, N.J.: Africa World Press, (1986) 1990.

De Lauretis, Teresa. *Technologies of Gender: Essays on Theory, Film, and Fiction*. Bloomington: Indiana University Press, 1987.

De Lauretis, Teresa, and Stephen Heath, eds. *The Cinematic Apparatus*. London: Macmillan, 1980.

Dembrow, Michael. "Notes" on *Hyenas*. Portland Community College. http://spot.pcc.edu/~mdembrow/hyenas_program_notes.htm.

Derrida, Jacques. *Of Grammatology*. (1967) Trans. Gayatri Spivak. Baltimore: Johns Hopkins University Press, [1976] 1997.

———. *Specters of Marx: The State of Debt, the Work of Mourning, and the New International*. Trans. Peggy Kamuf. New York and London: Routledge, 1994.

———. "Structure, Sign and Play in the Discourse of the Human Sciences." In R. Macksey and E. Donato, *The Languages of Criticism and the Sciences of Man*. Baltimore, Md.: Johns Hopkins University Press, 1980.

———. *Writing and Difference*. Trans. Alan Bass. Chicago: University of Chicago Press, 1978.

Diawara, Manthia. *African Cinema: Politics and Culture*. Bloomington: Indiana University Press, 1992.

———. *In Search of Africa*. Cambridge, Mass.: Harvard University Press, 1998.

———. "Self Representation in African Cinema." In *Africa Remix: Contemporary Art of a Continent*, ed. Njami Simon. London: Hayward Gallery, 2005.

Diop, Birago. *The Tales of Amadou Koumba*. Trans. Dorothy Blair. Burnt Mill, Harlow, Essex: Longman, 1985.

Dipoko, Mbella Sonne. *Because of Women*. London: Heinemann Educational Books, 1970.

———. *Black and White in Love*. London: Heinemann Educational Books, 1972.

Dirlik, Arif. "The Postcolonial Aura: Third World Criticism in the Age of Global Capitalism." In *Dangerous Liaisons*, Anne McClintock, Aamir Mufti, and Ella Shohat, eds. Minneapolis: University of Minnesota Press, 1997.

Dürrenmatt, Friedrich. *The Visit*. Trans. Patrick Bowles. New York: Grove Press, 1962.

Dye, Michael. "Hyenas, A Parable of Decay," 1988. http://www.und.ac.za/und/ccms/amp/reviews/hyena2.htm. Accessed September 1, 2005.

Eke, Maureen, Kenneth Harrow, and Emmanuel Yewah. *African Images: Studies in Cinema and Text*. Trenton, N.J.: African World Press, 2000.

Emecheta, Buchi. *Joys of Motherhood*. London: Allison and Busby, 1979.

Espinosa, Julio García. "For an Imperfect Cinema." *Afterimage* 3 (summer 1971): 54–67.

Evans, Dylan. *An Introductory Dictionary of Lacanian Psychoanalysis*. London and New York: Routledge, 1996.

Fanon, Frantz. *The Wretched of the Earth*. (1961). Trans. Constance Farrington. New York: Grove Press, 1968.

Foucault, Michel. "Georges Canguilhem: Philosopher of Error." *Ideology and Consciousness* 7 (1980):, 53–54.

———. *Discipline and Punish: The Birth of Prison*. Trans. Alan Sheridan. [1975.] New York: Vintage Books, 1995.

Freud, Sigmund. "Fetishism." In *Standard Edition of the Complete Psychological Works of Sigmund Freud*. Vol. 21. Trans. James Strachey. [1928.] London: Hogarth Press and the Institute of Psycho-Analysis, 1953–1974.

Gabriel, Teshome. *Third Cinema in the Third World*. Ann Arbor, Mich.: UMI Research Press, 1982.

———. "Toward a Critical Theory of Third World Films." In *Cinemas of the Black Diaspora*, Michael Martin, ed. Detroit: Wayne State University Press, 1995.

Gallop, Jane. *The Daughter's Seduction: Feminism and Psychoanalysis*. Ithaca, N.Y.: Cornell University Press, 1982.

Gardies, André. *Cinéma d'Afrique noire francophone: l'espace-miroir*. Paris: L'Harmattan, 1989.

Gardner, Helen. *Art through the Ages*. (1959.) New York: Harcourt Brace Jovanovich, 1980.

Garritano, Carmela. "Women, Melodrama, and Political Critique: A Feminist Reading of *Hostages, Dust to Dust,* and *True Confessions.*" In Jonathan Haynes, ed., *Nigerian Video Films.* Ibadan: Kraft Books for the Nigerian Film Corporation, 1997; expanded 2d ed. Athens: Ohio University Press, 2000.

Gikandi, Simon. *Maps of Englishness: Writing Identity in the Culture of Colonialism.* New York: Columbia University Press, 1996.

Gilroy, Paul. *Black Atlantic.* Cambridge, Mass.: Harvard University Press, 1993.

Glissant, Edouard. *Caribbean Discourse.* (1981). Trans. J. Michael Dash. Charlottesville: University Press of Virginia, 1989.

Global Witness. *Under-Mining Peace: Tin: The Explosive Trade in Cassiterite in Eastern DRC.* Washington, D.C.: Global Witness Publishing, June 2005.

Gombrich, E. H. (Ernst Hans). *The Story of Art.* (1972). Oxford: Phaidon, 1978.

Gramsci, Antonio. *Selections from the Prison Notebooks.* Ed. and trans. Quintin Hoare and Geoffrey Nowell Smith. New York: International Publishers, 1971.

Grosz, Elizabeth. *Sexual Subversions.* Saint Leonards, Australia: Allen and Unwin, 1989.

Gyekye, Kwame. *Tradition and Modernity.* New York: Columbia University Press, 1997.

Habermas, Jurgen. "Modernity—an Incomplete Project." In *The Anti-Aesthetic: Essays on Postmodern Culture,* ed. Hal Foster. Seattle: Bay Press, 1983. First published as "Modernity versus Postmodernity," *New German Critique* 22 (1981): 3–14.

Hall, Phil. *Filmthreat.* Dec. 7, 2000. http://www.filmthreat.com/Reviews.asp?File=ReviewsOne.inc&Id=1414. Accessed September 1, 2005.

Harrow, Kenneth W. "*Camp de Thiaroye:* Who's That Hiding in Those Tanks, and How Come We Can't See Their Faces?" *Iris* 18 (April 1995): 147–52.

——. *Less Than One and Double.* Portsmouth, N. H.: Heinemann Educational Books, 2002.

——. "The Marks Left on the Surface: Zoë Wicomb's *David's Story.*" *African Literature Today.* 25 (spring 2005): n,p.

——. "Sembene Ousmane's *Xala:* The Use of Film and Novel as Revolutionary Weapon," *Studies in Twentieth Century Literature* 4, no. 2 (spring 1980): 177–88.

Haynes, Jonathan, ed. *Nigerian Video Films.* Ibadan: Kraft Books for the Nigerian Film Corporation, 1997; expanded 2d ed. Athens: Ohio University Press, 2000.

Heath, Stephen. "Difference." *Screen* 19, no. 3 (autumn 1978): 51–112. Reprinted in *The Sexual Subject: A Screen Reader in Sexuality.* London and New York: Routledge, 1992.

Hudgens, Jim, and Richard Trillo. *West Africa: The Rough Guide.* London: Penguin Books, 1999.

Ionesco, Eugène. *The Bald Soprano.* Trans. Donald Allen. New York: Grove Press, 1965.

——. *Rhinoceros.* (1959). New York: Holt, Rinehart, and Winston, 1961.

Irigaray, Luce. *Ce Sexe qui n'en est pas un.* Paris: Éditions de minuit, 1977.

Jahn, Janheinz. *Muntu.* (1958). Trans. Marjorie Grene. New York: Grove Press, 1961.

Jameson, Frederic. *Postmodernism, or The Cultural Logic of Late Capitalism.* Durham, N.C.: Duke University Press, 1991.

——. "Postmodernism and Consumer Society." In *Postmodernism and Its Discontents,* ed. E. Ann Kaplan. London: Verso, 1993. This essay reappears in revised form in Jameson's *Postmodernism, or The Cultural Logic of Late Capitalism.* Durham, N.C.: Duke University Press, 1991.

JanMohamed, Abdul. *Manichean Aesthetics: The Politics of Literature in Colonial Africa.* Amherst and London: University of Massachusetts Press, 1983.

Jencks, Charles. *Post Modernism.* New York: H. W. Abrams, 1990.

——. *What Is Post-Modernism?* New York: St. Martin's Press, 1986.

Kalumbu, Isaac. *The Process of Creation and Production of Popular Music in Zimbabwe.* Ph.D. diss., Indiana University, 1999.

Keita, Seydou. *Seydou Keïta.* André Magnin, ed. Zurich and New York: Scalo, 1997.

King, Adele. *Rereading Camara Laye.* Lincoln and London: University of Nebraska, 2003.

Lacan, Jacques. "The Mirror Stage as Formative of the Function of the I as Revealed in Psychoanalytic Experience." *Ecrits: A Selection.* Trans. Alan Sheridan. New York: Norton, 1977.

——. *The Seminar, Book XX: On Feminine Sexuality, the Limits of Love and Knowledge: Encore.* (1972–1973). New York: Norton, 1998.

——. "The Signification of the Phallus." *Ecrits: A Selection.* Trans. Alan Sheridan. New York: Norton, 1977.

Laclau, Ernesto, and Chantal Mouffe. *Hegemony and Socialist Strategy.* (1985). London, New York: Verso, 2001.

Lamunière, Michelle. *You Look Beautiful Like That: The Portrait Photographs of Seydou Keïta and Malick Sidibé.* Cambridge: Harvard University Art Museums; New Haven, Conn.: Yale University Press, 2001.

Landau, Paul, and Deborah D. Kaspin. *Images and Empires.* Berkeley: University of California Press, 2002.

Lasch, Christopher. *The Culture of Narcissism.* London: Abacus, 1980.

Laye, Camara. *L'Enfant noir.* Paris: Plon, 1953.

Levi-Strauss, Claude. *La Pensée sauvage.* Paris: Presses Pocket, 1962.

Lyotard, Jean-François. *The Postmodern Condition: A Report on Knowledge.* Trans. Geoff Bennington and Brian Massumi. Minneapolis: University of Minnesota Press, 1993.

Mamdani, Mahmood. *Citizen and* Subject. Princeton, N.J.: Princeton University Press, 1996.

Mbembe, Achille. *On the Postcolony.* (2000). Trans. Murray Last, Steven Rendall, and Janet Roitman. Berkeley: University of California Press, 2001.

McClintock, Anne. *Imperial Leather.* London and New York: Routledge, 1995.

Miller, Jacques Alain. "Non-Sense without *Jouissance.*" http://www.lacan.com/lacinkXXI2. htm. Accessed November 20, 2006.

Mudimbe, V. Y. *L'autre face du royaume: Une introduction à la critique des langages en folie.* Lausanne: L'Age d'Homme, 1973.

——. *L'Ecart.* Paris: Présence africaine, 1979.

——. *The Invention of Africa.* Bloomington: Indiana University Press, 1988.

Mulvey, Laura. "Visual Pleasure and Narrative Cinema." *Screen* 16, no. 3 (autumn 1975): 6–18.

——. "*Xala,* Ousmane Sembene 1976: The Carapace That Failed." *Third Text* 16–17 (autumn/winter 1991): 19–37. Reprinted in Patrick Williams and Laura Chrisman, eds., *Colonial Discourse and Post-Colonial Theory.* New York: Columbia University Press, 1994, 517–34.

Ndebele, Njabulo. "Rediscovery of the Ordinary." In Stephanie Newell, ed., *Readings in African Popular Fiction.* Bloomington: Indiana University Press, and Oxford: James Curry, 2002.

Nganang, Alain Patrice. "Jean-Marie Teno ou comment filmer une société autocratique." *CinémAction* (Cinémas africains, une oasis dans le desert?), no. 106 (1st trimester, 2003): 209–13.

Niang, Sada. Personal email communication, Sept. 28, 2004.

Nwapa, Flora. *Efuru*. London: Heinemann Educational Books, 1966.

Ogunyemi, Chikwenye Okonjo. *Africa Wo/Man Palava: The Nigerian Novel by Women.* Chicago: University of Chicago Press, 1996.

Okri, Ben. *The Famished Road*. London: Cape, 1991.

——. *Stars of the New Curfew*. London: Secker and Warburg, 1988.

Ouologuem, Yambo. *Devoir de violence*. Paris: Editions du Seuil, 1968.

Oyono, Ferdinand. *Le vieux nègre et la médaille*. Paris: Julliard, 1956.

——. *Une vie de boy*. Paris: Julliard, 1956.

Paulme, Denise. *La Mère dévorante*. Paris: Gallimard, 1986.

Pelton, Robert. *The Trickster in West Africa: A Study in Mythic Irony and Sacred Delight.* Berkeley: University of California Press, 1980.

Pfaff, Françoise. *The Cinema of Ousmane Sembene, A Pioneer of African Film*. Westport, Conn.: Greenwood Press, 1984.

Pottier, Johan. *Re-imagining Rwanda: Conflict, Survival and Disinformation in the Late Twentieth Century*. Cambridge: Cambridge University Press, 2002.

Radhakrishnan, R. "Nationalism, Gender, and the Narrative of Identity." In Andrew Parker, Mary Russo, Doris Sommer, and Patricia Yaeger, eds., *Nationalisms and Sexualities*. New York and London: Routledge, 1992.

Ranger, Terence. *The Invention of Tradition*. Cambridge [Cambridgeshire]; New York: Cambridge University Press, 1983.

Ray, Benjamin. *African Religions*. Englewood Cliffs, N.J.: Prentice Hall, 1976.

Read, Herbert. *The Philosophy of Modern Art*. (1952). New York: Horizon Press, 1953.

Rubin, William, ed. *"Primitivism" in 20th Century Art*. New York: Museum of Modern Art; Boston: Distributed by New York Graphic Society Books, 1984.

Ruby, Jay. *Picturing Culture: Explorations of Film and Anthropology*. Chicago: University of Chicago Press, 2000.

Said, Edward. *Orientalism*. New York: Pantheon Books, 1978.

Saro-Wiwa, Ken. *Sozaboy*. Port Harcourt, Nigeria: Saros, 1985.

Sembène, Ousmane. *Les Bouts de bois de dieu*. Paris: Le Livre Contemporain, 1960.

——. *Le Dernier de l'empire*. Paris: L'Harmattan, 1981.

——. *Le Docker noir*. Paris: Nouvelles Editions Debresse, 1956.

——. *Vehi Ciosane, ou Blance-Genèse. Suivi du Mandat*. Paris: Présence africaine, 1965.

——. *Xala*. (1973). Trans. Clive Wake. London: Heinemann, 1976.

Solanas, Fernando, and Octavio Gettino. "Towards a Third Cinema." *Afterimage* 3 (summer 1971): 16–35. In *Twenty Five Years of New Latin American Cinema*, ed. Michael Chanan. London: BFI, 1983.

Soyinka, Wole. *The Lion and the Jewel*. London: Oxford University Press, 1963.

——. *Death and the King's Horseman*. New York: Hill and Wang, 1975.

Stoler, Ann Laura. *Race and the Education of Desire: Foucault's History of Sexuality and the Colonial Order of Things*. Durham, N.C.: Duke University Press, 1995.

Thackaway, Melissa. *Africa Shoots Back: Alternative Perspectives in Sub-Saharan Francophone African Film*. Bloomington: Indiana University Press, 2003.

Thompson, Kristin, and David Bordwell. *Film History*. New York: McGraw-Hill, 1994.

Todorov, Tzvetan. *Introduction to Poetics*. Minneapolis: University of Minnesota Press, 1981.

Towa, Marcien. *L'Idée d'une philosophie négro-Africaine*. Yaoundé: CLE, 1979.

Ukadike, Nwachukwu Frank. *Black African Cinema*. Berkeley: University of California Press, 1994.

Vieira, Luandino. *The Real Life of Domingos Xavier* (1974). Trans. Michael Wolfers. London: Heinemann Educational Books, 1978.

White, Luise. "Cars Out of Place." In *Tensions of Empire,* ed. Frederick Cooper and Ann Laura Stoler. Berkeley and Los Angeles: University of California Press, 1997.

Wicomb, Zoe. *David's Story.* New York: Feminist Press, 2001.

Wynchank, Anny. *Djibril Diop Mambety, ou le voyage du voyant.* Ivry-sur-Seine: Editions 3, 2003.

Young, Robert. *White Mythologies: Writing History and the West.* London: Routledge, 1990.

Žižek, Slavoj, ed. *Everything You Always Wanted to Know about Lacan (But Were Afraid to Ask Hitchcock).* London and New York: Verso, 1992.

———. *Looking Awry.* (1991). Cambridge, Mass., and London: MIT Press, 1998.

———. *The Zizek Reader.* Elizabeth Wright and Edmond Wright, eds. Maiden, Mass.: Blackwell, 1999.

Index

Italicized page numbers indicate illustrations.

tion, 125–126; on identification as enacted fantasy, 240n12; on metaphyics of presence, 239n1

Camp de Thiaroye (1987). See Sembène Ousmane

Ceddo (1976). See Sembène Ousmane

"Un Certain matin" (1991). See Fanta Nacro

Césaire, Aimé Discours sur le colonialisme (1955), 248n9

Chef (1999). See Jean-Marie Teno

Chion, Michael, on "rendu" 139, 162, 169, 217, 222, 223, 224, 225, 245n5

cinema engagé, 1, 24, 42

Cissé, Souleymane, xiv

 Finye (1982), xv, 165; fastasmic or fantasy and, 163–164, 166–171, 174, 175; ideology and, 164, 170; Keita and, 172, 245–246n8; Law of the Father and, 171; patriarchy and, 163, 164, 168, 172–175; real and, 169; symbolic and, 163–164, 166–169, 171, 174; symbolism and, 165–166; Traore and, 172, 245–246n8

classical realism, 5, 8; Belsey and, 8, 16. See also realism

colonialism: Bhabha and, 39–41; class construction and, 28; narcissism and aggression and, 39, 230n10; realism and romance and 37

Davies, Carol Boyce: Ngambika (1990), 19

Death and the King's Horseman (1975). See Wole Soyinka

Derrida, Jacques: on borders,116–117; on Enlightment, 10; on excess of occluded term, 9; Of Grammatology (1967), 13; on Levi-Strauss, 62, 18, 105, 232nn13; on metaphysics of presence, xiii, 36, 53, 105, 238n7, 239n1; on logocentrism, phallocentrism, 13; Spectres of Marx 234n7, 241n14, 242n6; on supplementarity, 107, 114

Diawara, Manthia: African Cinema: Politics and Culture (1992), 233n3; Bamako Sigi Kan (2002), 27; film criticism and, 26; on markets 237n25; In Search of Africa (1998), 12, 233n1; Rouch in Reverse [1995], 27

différance, 27, 218; Aristotle's Plot (1996) and, 151; Bhabha 218

Dikongue-Pipa, Jean-Pierre, xiv; Muno Moto (1975), 22; Muno Moto (1975) as cultural tendency, 25; Le Prix de la liberté (1978), 22

Diop, Birago: "Maman Caiman," 83, 234–235n16

Dipoko, Mbella Sonne: Because of Women

(1970), 20; Black and White in Love (1972), 20

Divine carcasse (1998). See Dominique Loreau du Parc, Henri: Bal Poussière (1988), 20

Dirlik, Arif, 45; on postcoloniality and global capitalism, 230

Emecheta, Buchi: Joys of Motherhood (1979), 20

Emitai (1971). See Sembène Ousmane

Enlightenment, 11–12, 75, 78; Foucault's criticisms and, 10

Faat Kine (2000). See Sembène Ousmane

Fanon, Frantz: Wretched of the Earth (1968), on three-fold path of liberation, 22–23

fantasy, 119–124, 128–129; Quartier Mozart (1992) and, 123, 125; 136. See also Cissé Finye (1982) and Žižek on fantasy

Faye, Safi, xiv; absent Law of the Father in Mossane (1996) and, 136

feminism, 7–8, 13, 19, 20, 28; African feminism, 228n4; Chef (1999) and, 78; Faat Kine (2000) and, 102; Finye (1982) and, 245n2; Sembène and 60

fetishism, 39–40, 230n11, 230n12; commodity fetishism, 53; Freud and, 47; Xala (1974) and, 44–47

Finye (1982). See Souleymane Cissé

Foucault, Michel, 10; on apparatus, 124–125; Discipline and Punish (1995), 66, 68–69, 71; on plague, 72, 74; on panopticon, 73–74, 75, 82

Franc, Le (1994), see Djibril Diop Mambéty

Gabriel, Teshome, xiii; on gold and wax, 44–45, 232n13; on three stage model, 23, 24

Gallop, Jane: on Lacan, 231n6

Ganda, Oumarou: L'Exile (1980), 16

Gardner, Helen: on movement away from Realism, 32–33

Gerima, Haile, xiv

Gikandi, Simon, 5; on Habermas, 230n9; Maps of Englishness (1996), 27, 37–39, 40, 68, 198, 227n3, 235n2, 237n2; on travelers' world, 38, 41

Gilroy, Paul, 19

Glissant, Edouard: Caribbean Discourse (1989), 11, 227n1

Globalization, 7, 20, 248–249nn13–16

Gombrich, E. H., 30, 32

Gramsci, Antonio, 28, 229n5

Graves, Anne Adams: Ngambika (1990), 19

Guelwaar (1992). See Sembène Ousmane

Hegel, G. W. H., on self-awareness, 10
hegemony, 28
historicism, 5, 10, 12, 17, 20, 28, 105, 227n2;
 Robert Young and, 238n6
history, 11-12, 13, 15-18; Althusser and, 15-
 16, 17, 28, 80, 81; Jameson and, 236n22;
 Teno and, 235n15
Hitchcockian phases: first phase, 132; object
 of exchange and 133; periodization via
 Žižek and, 131-133, 133-137, 243n9; sec-
 ond phase, 133; third phase, 135-136
Hooch, Pieter de: "A Woman Preparing Bread
 and Butter for a Boy" (ca.1660-63), 184,
 185
Horton-Stallings, Lamonda, 232n19
hybridity, 7, 80
Hyenas (1992), see Djibril Diop Mambéty

ideology, 12; Althusser and 17, 28, 229n6; ex-
 ternality and, 240-241n13; Finye (1982)
 and, 170; Žižek and, 120, 124-128, 138
imaginary, 15
inside/outside divisions: Bekolo and, 118-119,
 138, 153; ideology and, 241n14

Jahn, Jahnheinz: Muntu (1958), 20
Jameson, Frederic: Aristotle's Plot (1996)
 and, 150, 153; on expression, 215; on his-
 tory, 236n22; on late capitalism, 212-215;
 on Munch's "The Scream,," 215, 218; on
 parody and pastiche, 86, 87-90, 92; on post-
 modernism, xv, 153-154, 155, 199, 200,
 212-214, 215; on simulacrum, 84; on sur-
 face vs. depth, 153-154
JanMohamed, Abdul: on narcissism and ag-
 gression, 39, 230n10
Johnson Traore, Mahama, xiv

Kabore, Gaston, xiv; Wend Kuuni (1982) and,
 221; cultural tendency and, 25
Kalatozov, Mikhail: The Cranes Are Flying
 (1957), 16
Keïta, Seydou, xii, 200, 203
Kingsley, Mary, 41
King, Adele: on Laye's publishers, 239n5
Kiorastami, Abbas: on the ordinary, 96, 97

Lacan, Jacques, 10; on mirror stage, 117-118,
 231n2; on symbolic order, xiv. See fantasy,
 imaginary, Law of the Father, mirror stage,
 misrecognition (méconnaissance), objet a,
 real, sinthome, symptom, symbolic order
Laclau Ernesto and Chantal Mouffe: on sedi-
 mented theoretical categories, 240n10

Landau, Paul and Deborah D. Kaspin: Images
 and Empires (2002), 227n3; on tradition
 and modernity, 227n3
Lasch, Christopher: Culture of Narcissism
 (1980), 241n18; on dysfunctional family,
 241n18
Laye, Camara: L'Enfant noir (1953), 117, 239n5
Law of the Father, 133; absent, 134-136, 143-
 145; in Aristotle's Plot(1996), 144, 162; and
 diminished role in Sembène, 145, 241n17;
 Finye (1982) and, 171; and Name of the
 Father, 133, 134
Loreau, Dominique, xiii; Divine carcasse
 (1998), xiv, xv, 105-114, 111, 113
Lyotard, François: on postmodernism, xv, 20,
 206, 207, 214, 248n11, 249n19

Maldoror, Sarah, 16
Mambéty, Djibril Diop, xiv, 19-20, 182, 191,
 195, 220, 224; as auteur cinema, 25, 42;
 awry, 225; "Contras City" (1968), xv; Le
 Franc (1994), 132; Dürrenmatt's The Visit
 (1962) and, 177, 178, 190; excessive con-
 sumerism and, 242n19; Hyenas (1992),
 xv, 94; inside/outside and, 219, 220-221;
 Ionesco and, 177, 190; maternal superego
 and, 136; modernity and, 193; McGuffin
 and, 132, 186, 187; objects of exchange and,
 134; objet a and, 187; "Parlons Grand-mère"
 (1989), xv, 204-205, 206, 218-225; the real/
 reality and; 219-221, 225; rendu and (see
 Chion and Žižek), 225; Touki Bouki (1973),
 xiv, 20, 132, 133; voix acousmatique and,
 224, 225. See Badiou
Mamdani, Mahmood, 12, 67, 87
Mami Wata: Faat Kine (2000) and, 103, 104;
 Misty Bastian on, 237n3; ogbaanjes and,
 237n3; Ogunyemi on, 103
Mandabi (1968). See Sembène Ousmane
Matamata and Pilipili, 242n3
materiality: Žižek on, 119, 126, 129, 133, 136-
 137, 140-141
maternal superego, 135-136, 144, 162. See also
 Slavoj Žižek
Mbembe, Achille, 18, 67, 70; on the autocrat,
 69-71, 121-122; 74, 81, 87, 144, 145; on dis-
 solution of state, 229n2
McGuffin, 3, 113, 114, 132, 133; in Aristotle's
 Plot (1996), 146, 156; Hitchcock and, 132;
 in Hyenas (1992), 186; l'objet a and, 132;
 Mambéty and, 132
Med Hondo, xiv
mégotage, 105, 106 238n5 248n5
mirror stage, 15. See also Jacques Lacan

Index 265

Index 267

KENNETH W. HARROW is Professor of English at Michigan State University. He is author of *Thresholds of Change in African Literature: The Emergence of a Tradition* and *Less Than One and Double*. He has edited *Faces of Islam in African Literature, The Marabout and the Muse: New Approaches to Islam in African Literature*, and *African Cinema: Postcolonial and Feminist Readings*. He is also the co-editor, with Maureen Eke and Emmanuel Yewah, of *African Images: Recent Studies in Cinema and Text* and has published numerous articles on African cinema.